THIS IS A CARLTON BOOK

Text copyright © 2000
Design copyright © 2004

This edition published in 2004 by
Carlton Books Limited
20 Mortimer Street
London W1T 3JW

The text and photographs in this book were originally published as *Complete Photography Manual* by Ailsa McWhinnie and *The Digital Photography Manual* by Philip Andrews.

ISBN 1 84442 665 3

A CIP catalogue record for this book is available from the British Library

Printed and bound in Dubai

Designer: Michelle Pickering
Executive editor: Stella Caldwell
Editor: Anne McDowall
Picture researchers: Philip Andrews, Alex Pepper
Art director: Clare Baggaley
Production: Lisa Moore

CARLTON
BOOKS

PHOTOGRAPHY
a practical guide

AILSA McWHINNIE

PHILIP ANDREWS

CARLTON
BOOKS

CONTENTS

Digital Photography 194

Introduction

It is now almost two centuries since a way was discovered of recording life-like images by exposing silver halide crystals to light. The process became known as photography and it revolutionized the art of depicting what we see around us. Suddenly commissioning a portrait no longer meant sitting motionless for hours on end as the artist tried to capture your likeness – remaining still in front of one of these new "cameras" for only a minute or so would result in a much more realistic result, if that was what you wanted.

Since then, while materials and equipment have improved beyond all recognition, the basic process has remained almost unchanged. True, the old glass plates have long been replaced by conveniently packaged rolls of film. Exposures have been reduced from minutes to fractions of a second and the landscape photographer no longer needs to carry his darkroom around with him to develop his pictures one at a time as they are taken. But the process of exposing light-sensitive material inside a dark box and treating the result with a series of chemicals would still be recognized by those early pioneers.

It has taken nearly two hundred years for something new to come along. In the short time since they appeared, digital cameras have started to outsell their conventional counterparts and every new home computer now comes packaged with one of the many image-manipulation programs on the market. Even one-hour developing of your holiday snaps seems a long time to wait when you can see your results immediately on a small LCD screen and print them out at home. Gone is the uncertainty of whether they are sharp, or overexposed – and realizing, when it too late, that your son was sticking his tongue out and Auntie has a lamppost growing out of her head. You can just re-take the photo and even e-mail it to friends and family at home without leaving the beach.

So why, you may ask, would anyone still want to travel around with a bag full of expensive film – and face another huge bill for getting it all developed? Well, just as photography has not put an end to painting, pixels still seem a long way from replacing old-fashioned chemistry. For those who cannot imagine why, this book should help explain. Digital photography has provided photographers not with a replacement, but with an alternative.

Browsing through the shelves in your local bookshop, or the ever-increasing range of photographic magazines in print, you would be forgiven for thinking that conventional and digital photography are two completely separate disciplines: the first all about composition, lighting, focal lengths and exposure – and the second about sitting in front of your computer with a camera full of files to download. However, this is not the case. Why do so many imaging software programs sell themselves on their ability to correct mistakes, to turn bad photos into acceptable ones? Wouldn't it be so much better to take good pictures in the first place? And the best hardware and most expensive software in the world will not tell you what to point your camera at, or when to press the shutter. Technology can bring consistently acceptable results within anybody's grasp, but it won't turn you into a great photographer any more than the latest digital recording studio will make you a great songwriter.

Of course, having the right equipment for your needs is important. But that does not mean that the more you buy and carry around with you, the better your photos will be. Expensive equipment does not guarantee great pictures. That's why this book has a section covering the choice of

cameras, formats, lenses, filters and so on – to help you chose what you need for the kind of photography you want to do.

There are chapters on special techniques – using flash, close-up and studio photography – areas where knowledge and skill are just as vital as buying the right hardware. And for those who do not intend to trade in their darkroom for a laptop just yet (or ever!) it will even take you through the basics of traditional black and white printing.

And then come the digital chapters – explanations of the new technology and detailed help on how to capture, manipulate, store and print your pictures. But the great thing about this single volume is not simply that it saves you buying two separate books to find this information – it recognizes the need for all photographers these days to understand both aspects of their hobby or profession.

Like many people, my photography started many Christmases ago with the gift of a Kodak Instamatic that took square pictures of dubious quality, on film loaded in a strange plastic cartridge. For indoor shots, there was a curious cube containing four blue flashbulbs that rotated when you wound the film on. It all seemed very high-tech to me at the time, compared to my parents' old fold-out bellows contraptions. Over the years the contents of my camera bag have increased greatly in quality, cost and, unfortunately, weight. And now, like everyone else, I am faced with the digital revolution. Many people have already taken the plunge and "gone digital". Others are sticking to the film and equipment they have come to know over many years' experience. An increasing number, however, are realizing that both have something to offer, keeping the two options open to use according to the situation.

Like any new technology, digital photography in its infancy was not the attractive proposition it is today. Cameras were bulky, expensive and very basic. Quality, compared to today's standards, was laughable. It was little more than an experiment – at best a novelty. For quite a few years the serious photographer had two very good reasons not to go digital. High cost and poor results. But as with mobile phones and personal computers, every week that goes by sees prices coming down and performance going up. Traditionalists will still tell you that a digital file from even the best camera stores only a fraction of the information contained in an old piece of film. That is true, and will remain so for some time to come. But unless you intend to enlarge all your snaps to the size of your living room wall, a fraction of the information is all you really need. Again, it is a choice to be made by you, depending on your requirements.

Digital photography is moving on at an amazing pace. Digital is replacing film in the holiday snaps market and increasingly among more serious enthusiasts. Its convenience and speed have made it the first choice among press and sports photographers. The ease of reproduction and manipulation make it ideal for publishers with short deadlines and creative artists who want more from their pictures than simple copies of what they see around them. And yet new films are still being launched, processing laboratories remain on every high street and professional landscape photographers can still be seen out there loading single-sheets film-holders into their plate cameras.

Whether you are a confirmed traditionalist, a long-term film user thinking of making a change, a digital convert or a complete beginner wondering what to buy, this book will help you improve your photography and get the most from your equipment. But whatever your preferences or plans – do not just read the half of the book that you think applies to you! Taking good pictures is about photography, not cameras, filters or pixel numbers. The digital camera owner still needs to know how to take a picture, not just manipulate one. And as for the digital chapters, even the most entrenched film user might be surprised to discover what they are missing…

Phil Robinson

Traditional Photography

know your camera

What to look for in an SLR

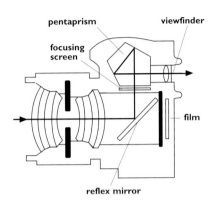

pentaprism viewfinder

focusing screen

film

reflex mirror

LEFT: This diagram demonstrates the fact that what you see through the viewfinder is what you get on film when using an SLR camera. Light travels through the lens and bounces off the mirror into the pentaprism, which in turn bounces it through the viewfinder.

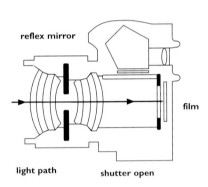

reflex mirror

film

light path shutter open

LEFT: When the shutter is released, the mirror flips up, allowing light to hit the film emulsion. Because, when the shutter is released, light does not hit the pentaprism, the photographer sees only black through the viewfinder for the duration of the shutter speed.

When buying an SLR, you need to find a camera that matches your standard of photography – or the standard you hope to attain. If you want only to point and shoot, it is unlikely you will want to buy the most complicated and well-equipped camera since you will not make full use of its potential. If you are keen to learn as much as possible about photography, buy a camera that will allow you to grow in expertise.

Your camera needs to suit you. It needs to fit into your hands comfortably so that you can reach every dial, wheel and button when you need it. Do not buy a camera if it is so heavy you will never bother to take it out with you, or if it is too complicated for your level of interest. If you are just starting out in photography, the most important thing is to buy a camera you can operate yourself – one you can really take control of.

Camera features

There are several main features to take into account when choosing a camera. First, there are its metering modes (see Chapter 2, page 45). Most modern SLRs have a choice of up to three metering modes, which will help you obtain the best exposure in a variety of circumstances.

Some cameras feature a built-in motor drive, which allows you to shoot two or three frames per second while keeping your finger on the shutter release button. With other cameras you will need to buy a separate unit if you want to have this feature. Although useful for some action photography, a motor drive is not essential.

There needs to be a wide range of shutter speeds – from at least one second to 1/1000 second, although a lot of modern SLRs provide an even wider range than this. There should also be a "B" (or "bulb") mode, which allows you to lock the shutter open for as long as you need to – this is vital for any kind of low-light or creative photography.

Most modern cameras also feature a built-in pop-up flash unit. While useful for a touch of fill flash or for standard portraits, it will not have either the versatility or the range of a separate dedicated flash unit.

Most 35mm SLRs designed nowadays will also automatically set the speed of film that you are using, via a DX coding system. However, as you advance in your photography, there may be times when you might want to override this feature, so look for a camera which allows you to do this.

Last, but far from least, the camera's viewfinder must be bright and clear, not only so that you can see your subject with utmost clarity and focus on it perfectly, but also so that you can read the exposure markings within the viewfinder.

Camera formats

The term "format" in photography means the size of film a camera takes: this includes 35mm, APS (Advanced Photo System) and 120 – also known as medium format. In addition, there is a type of film called sheet film, which comes in 5 x 4 in. and 10 x 8 in. sizes.

It is not just the size of the film that determines a format, but also the size of the image created on that film. Medium-format cameras all use 120 roll film, but negatives of several different sizes can be produced on that film, depending on the camera being used. To confuse the issue, some cameras are able to produce negatives of more than one size. Many medium-format cameras also feature interchangeable backs, so that you can swap film speeds and types mid-roll, and also shoot Polaroids to check that the exposure is correct.

Generally speaking, smaller-format cameras are better for fast-moving subjects, such as sports and news photography, while medium- and large-format cameras are more suitable for stationary subjects, such as landscapes and still life, or for classic studio portraiture. However, fantastic pictures can sometimes be made by breaking these rules.

35mm

No film format is more flexible than 35mm. The 35mm negative size is 24 x 36 mm, which, with today's high-quality films, is large enough to produce pin-sharp results on a good-sized enlargement. Accompanied by a wide range of lens focal lengths, the 35mm camera body is suitable for almost any subject. Sports and wildlife photographers use it because the cameras can be hand-held and moved quickly to follow action. The system also has very advanced auto-focusing capabilities, with lenses which are long enough to fill the frame with a very distant subject.

BELOW: **The 35mm SLR comes in many shapes and sizes, varying in sophistication from the simple point-and-shoot model to the extremely high-tech and complex.**

BELOW: **Many basic compact cameras are also 35mm in format, although APS (Advanced Photo System) is quickly catching up.**

LEFT: **A 35mm transparency at actual size. Being the smallest of the "serious" formats, it is the most versatile.**

6 x 4.5 cm

This crossbreed of 35mm and medium format is often dismissed as being of limited use. In fact, the 6 x 4.5 cm (also known as 645) can be very useful. The smallest of the medium-format family, it is also the most portable and provides an accessible entry point into the world of the larger negative. For the photographer who likes the flexibility of 35mm, it is a camera that has the appeal of both easy handling and a better quality result.

Some manufacturers are developing 645 cameras which are close to 35mm SLRs in terms of features and functions. For some time, 645 cameras have featured comprehensive exposure metering systems, automatic film advance and exposure program modes. Now there are a number of models on the market which are shaped almost like a 35mm camera, and which also have autofocus systems.

The 645 has always been popular for portrait and fashion photography and the relatively lightweight body, with its 15 exposures per roll, also appeals greatly to travel photographers.

Use of 35mm is becoming more common in areas of photography which have traditionally been the reserve of the larger formats. As film quality improves and fashions change, it has become acceptable in certain circumstances to break with convention. A grainy still life, for example, can be very attractive and is more difficult to achieve on a larger film format. While fashion photography has always been a mixture of the studious medium format and the less formal 35mm, increasingly nowadays portraits and weddings are being shot in the latter's more carefree style.

BELOW: **When used with its shorter lenses, the 645 system can still be hand-held rather than always having to be tripod mounted.**

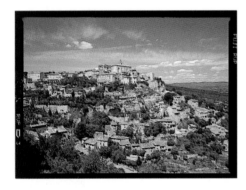

ABOVE: **A 645 transparency at actual size. A format often used for travel photography, the larger image size means an improvement in quality over 35mm.**

6 x 6 cm

The square negative produced by the 6 x 6 cm camera is thought wasteful by some photographers and indispensable by others. Capturing 12 exposures per roll, the 6 x 6 cm camera has a very loyal following amongst portrait and wedding photographers. Users also point out that they can make either a landscape or a portrait format image of the same picture by cropping at the printing stage.

Another advantage of the 6 x 6 cm camera is that it never has to be turned on its side, which is something that has to be done with one providing a rectangular negative.

Most medium-format cameras use a viewing screen that shows the image laterally reversed: that is, anything on your left will appear in the right-hand side of the viewfinder, while anything on the right will appear in the left. Photographers soon become accustomed to this reversal when shooting landscape format pictures with a waist-level finder, but when the camera has to be turned on its side, life becomes very difficult. The problem can be overcome by the use of a prism finder to turn the image back the right way round, but these are often expensive.

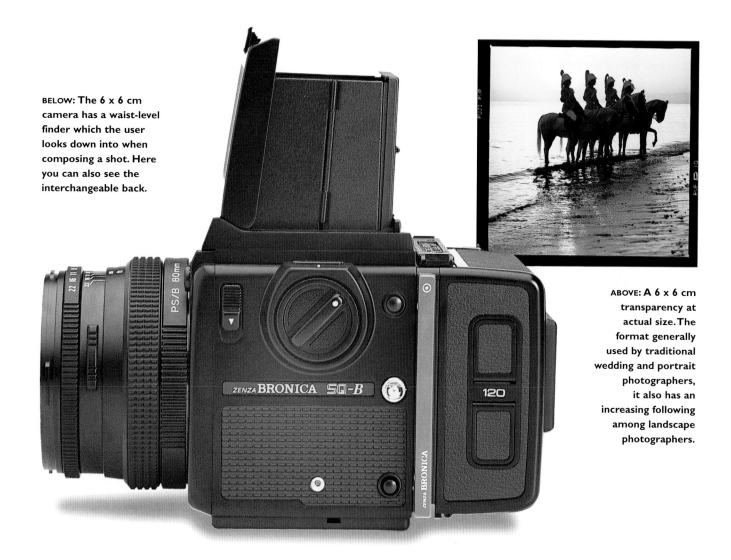

BELOW: **The 6 x 6 cm camera has a waist-level finder which the user looks down into when composing a shot. Here you can also see the interchangeable back.**

ABOVE: **A 6 x 6 cm transparency at actual size. The format generally used by traditional wedding and portrait photographers, it also has an increasing following among landscape photographers.**

BELOW: **A 6 x 7 cm transparency at actual size. Also known as the "ideal" format, the results are perfect when a big enlargement is called for.**

6 x 8 cm/6 x 9 cm
6 x 12 cm/6 x 17 cm

Cameras which produce pictures with these dimensions are quite specialized. Models that deliver a 6 x 8 cm or 6 x 9 cm image are either bulky studio machines for product and portrait photography, or compactly designed rangefinders. Images with a long edge of more than 12 cm are classed as panorama cameras and produce a long, thin image which is particularly suited to landscape photography.

6 x 7 cm

With a few exceptions, 6 x 7 cm cameras are truly studio based. They are almost impossible to hold by hand so a sturdy tripod is a must, but the results make the extra trouble worthwhile. The 6 x 7 cm negative is enormous and can be enlarged to poster size with no noticeable grain appearing. The best-known 6 x 7 cm cameras are the Mamiya RB67 and RZ67. These are heavyweight professional workhorses that feature revolving film backs so you don't have to turn the camera on its side to shoot in portrait format. There are, however, 6 x 7 cm cameras which are more like a 35mm rangefinder in design and are far more portable.

The 6 x 7 cm negative is often described as the "ideal" format for publication because its ratio means that it can be enlarged to fit perfectly into a full page of the standard magazine size.

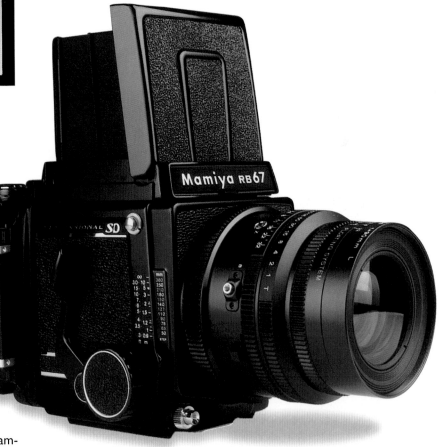

ABOVE: **Similar in looks to the 6 x 6 cm format, the 6 x 7 cm camera needs to be used with a robust tripod.**

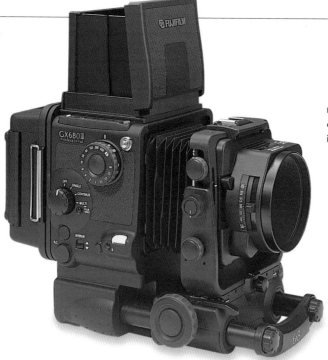

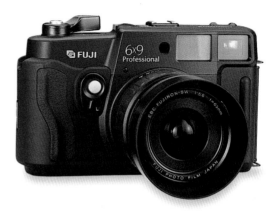

LEFT & BELOW RIGHT: The 6 x 8 cm and 6 x 9 cm cameras are more specialized formats, used both in the studio and in the landscape.

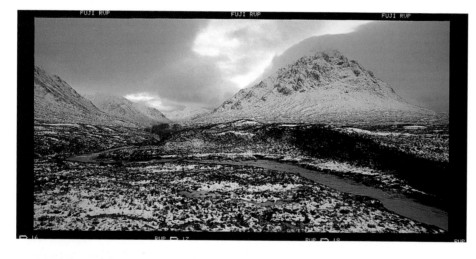

LEFT: A 6 x 12 cm transparency at actual size. The panomama image perfectly conveys a grand sweep of landscape.

BELOW: A 6 x 17 cm transparency at actual size. Careful composition is required when using this format.

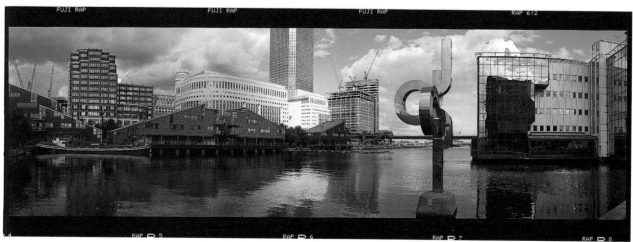

BELOW: **The 5 x 4 in. camera. Focusing is achieved by adjusting the length of the bellows, rather than turning a ring on the lens.**

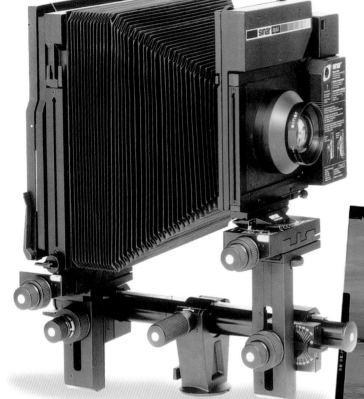

photographers ever – Ansel Adams – worked solely with large-format cameras, using a 10 x 8 in. plate camera as a matter of course.

Large-format cameras also allow the photographer to control converging verticals, perspective and depth of field to a minute degree. This is because they have what are known as "camera movements", where the lens can be moved up, down or sideways in relation to the film plane.

BELOW: **A 5 x 4 in. transparency at actual size. Complete sharpness from the front to the back of the image can be achieved with this format, thanks to the camera movements which are fundamental to large-format photography.**

5 x 4 in. and 10 x 8 in.

For the sharpest and most grain-free images you need a large-format camera such as the 5 x 4 in. or the 10 x 8 in. Very basic, they have none of the automatic functions of a 35mm camera. Most consist simply of a plate to hold the lens and a plate to hold the film, with a light-excluding bellows in between. Strictly for tripod or studio stand use, these cameras are most often used for images which require maximum sharpness, detail or enlargement – in particular, landscape, architecture and product advertising. One of the greatest landscape

How to choose the right lens

A lens's focal length will dramatically affect the outcome of a photograph. If you choose one that is too wide your main subject will be lost among a mass of extraneous detail. If you choose one that is too long you could be cutting out the detail which puts your subject into context.

The focal lengths of lenses are split into five categories: ultra wideangle, wideangle, standard, telephoto and ultra telephoto. Wideangle lenses cover the greatest area, allowing you to include a larger expanse of a scene in the picture, while telephoto lenses fill the frame with distant subjects.

A common mistake is to confuse a zoom lens with a telephoto lens. A zoom lens is any lens which can alter its focal length smoothly between one point and another. Thus, an 18–35mm lens is as much of a zoom as a 70–200mm lens; however, only the latter is a telephoto.

It used to be the case that certain lenses were considered suitable only for certain jobs, but nowadays opinions are more flexible. The following is a brief guide to the main uses of each type of lens, but remember, these are just conventional guidelines and you do not have to stick to the rules.

BELOW: **As you can see from the illustration below, an ultra wideangle lens will translate a huge range of information onto film from the scene in front of you, while an ultra telephoto lens has a far narrower angle of view. Overleaf is a sequence of images which demonstrates the narrowing of the angle of view, the longer the lens used.**

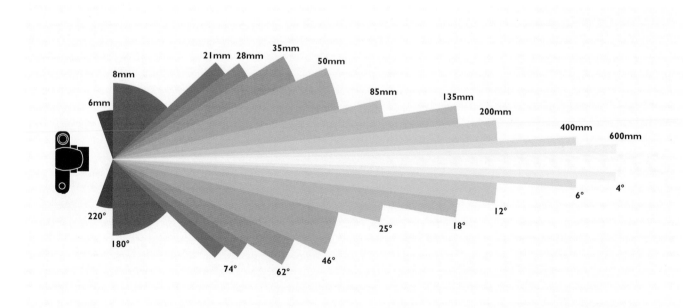

20 mm

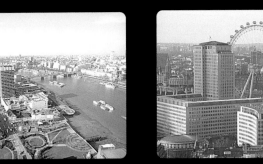

100 mm

24 mm

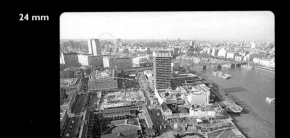

135 mm

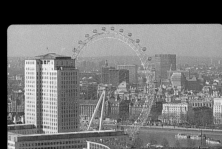

35 mm

200 mm

50 mm

300 mm

70 mm

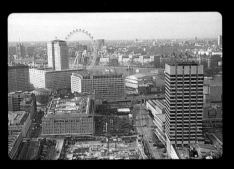

400 mm

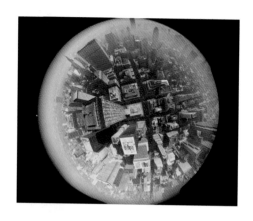

LEFT: **A true fish-eye lens will give a circular image which, although dramatic and eye-catching, is of limited use.**

Ultra wideangle lenses – from 6mm to 24mm

The great things about really wide lenses are the depth of field and the distortion they provide. Even at the widest aperture you are likely to get complete front-to-back sharpness and a sense of exaggerated depth to your pictures. To make anything significantly big in the frame you will have to get quite close to it. This will make anything in the background tiny by comparison.

Objects at the edges of the frame will appear bent and bowed like the sides of a barrel, and the horizon will appear to curve down at the edges if it is positioned in the top half of the frame.

Used carefully, ultra wideangle lenses can produce unconventional portraits and wacky still-life images. Any wideangle lens which produces a round picture as opposed to a rectangular one is known as a fish-eye lens and, although the effect is eye-catching, it is rarely used and often considered to be a gimmick.

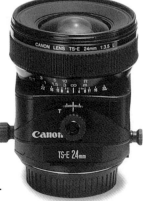

Wideangle lenses – from 28mm to 35mm

Wideangle lenses allow you to include a lot of detail in your shot – and are especially useful when you can-

not move back far enough to use a longer lens. When you are photographing buildings in a street, a large group of people, or a landscape with a lot of foreground interest, the wideangle lens is ideal. Objects or people close to the lens will appear large in the frame, while those further away from the camera will look smaller.

When using a wideangle lens, try to avoid tilting the camera up or down, otherwise you will end up with converging verticals. These occur when you look up or down at an object whose sides are parallel – such as the sides of a building – instead of head-on. For example, if you look up at a tall building when you are very close to it, the edges appear to lean in towards each other. This effect is exaggerated with a wideangle lens, although it can be corrected with perspective control – also known as a shift-lens. This lens has a rising front element which allows you to include the top of a building without having to tilt your camera. The only time when converging lines are acceptable is when they are obviously exaggerated, or when they are horizontal and leading the eye into a landscape.

ABOVE: **Converging verticals become a problem when the camera is tilted upwards to take a picture of a straight-sided subject. Architectural photographers can overcome this with specialist perspective control, or "shift" lenses (left).**

Standard lenses – from 35mm to 70mm

Not many photographers use a 50mm lens as a matter of course these days. However, if you were to restrict yourself to it for a whole day, you would find it quite an interesting lens. Standard lenses are said to provide the same angle of view as that of the human eye: that is, the amount of information we see through a 50mm lens (although some would argue more heavily in favour of the 35mm lens) is the same as what we see with the naked eye. The founder of the Magnum photo agency, Henri Cartier-Bresson, uses only a Leica rangefinder camera fitted with a 35mm lens for his photography, for precisely this reason.

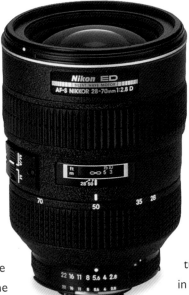

LEFT: The 28–80mm lens is a standard zoom and will cover a lot of photographic needs.

Telephoto lenses – from 70mm to 200mm

The most important characteristic of the telephoto lens is that, as well as appearing to bring your main subject closer to you, it also compresses the image. This makes it ideal for portraiture, as it flatters such features as larger noses. It also works beautifully in the landscape, when mountain ranges which stretch for miles into the horizon suddenly appear almost as "layers", stacked one behind the other. This compression also allows you to relate a distant object to a closer one – such as two rock formations in a landscape.

Whereas wideangle lenses increase depth of field, telephoto lenses reduce it. This has the effect of making a portrait subject stand out from their background – particularly when the lens is used in conjunction with a wide aperture – because that background is rendered as an attractive blur.

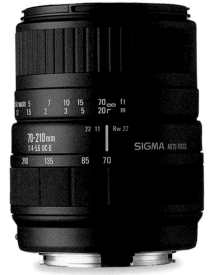

ABOVE: The 70–210mm lens is a useful route into telephoto photography, without the expense of fixed-focal-length lenses.

RIGHT: When a telephoto lens is used, the background is thrown out of focus, making your subject stand out very clearly.

Ultra telephoto lenses – from 300mm upwards

Ultra telephoto lenses tend to be used chiefly by specialist sports and wildlife photographers, allowing them to capture the action while safe in a hide, or from the other side of a football pitch. As these lenses are expensive, many people look for an alternative by investing in a 2x teleconverter, which doubles the focal length of a telephoto lens (so a 200mm lens, for example, would become 400mm). The quality isn't quite so good as that provided by a lens, and you lose a couple of stops of light, but a teleconverter will provide an acceptable result.

Incidentally, it's a myth that the paparazzi use 12,000mm lenses to see inside your bathroom! Not many photographers could hold such a lens still, let alone afford one.

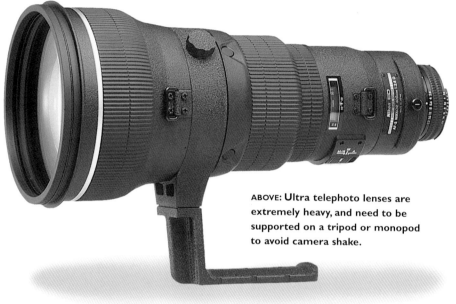

ABOVE: **Ultra telephoto lenses are extremely heavy, and need to be supported on a tripod or monopod to avoid camera shake.**

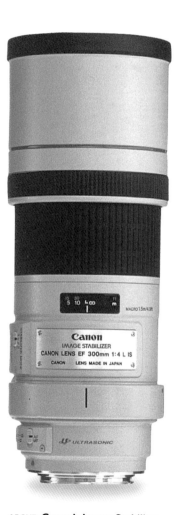

ABOVE: **Canon's Image Stabilizer lens has a shifting optical system which reduces the likelihood of camera shake, making it easier to hand-hold. It has the equivalent effect of using a shutter speed of two stops faster.**

ABOVE: **A long telephoto lens is essential for wildlife photography, allowing the user to fill the frame without frightening away a timid subject.**

23

How to choose the right film

It cannot be stressed enough how important your choice of film is to the final image. Even if you own the most advanced camera around you will not obtain good results if you use film of inferior quality or film that is simply the wrong type for the job.

There are three principal types of film: colour negative, colour transparency and black and white negative. Your choice depends upon the medium in which you want to see your results. Generally, colour transparency (or slide) film is considered to be of superior quality to colour negative (or print) film. Capable of recording more detail, and with greater colour saturation, slide film has a less obvious grain as it goes through just one stage of processing: the film is developed and is then ready for viewing. Colour negative film, however, has to go through two stages: it is developed, then printed. This results in a slight degradation in quality.

Which brand?

The photographer is spoilt for choice when it comes to brands of film, but such a wide array can make it easier to choose the wrong one. No two films are the same, and no single film can effectively cover every subject in every set of circumstances that you are likely to want to shoot. Some films will produce a warm tone in your pictures and others attempt to boost natural colour. Some films seem cool in tone while others reproduce colours almost exactly as they appear in real life. Some are designed to deliver soft, muted colours to flatter the portrait subject while yet others give contrast and colour saturation for deep blue skies and lush green fields in landscape photography.

It is most important to be prepared to use more than one type of film and to try new ones. One of the best ways to find a film you like – although it is slightly laborious

BELOW LEFT: **This picture was taken on Fujichrome Velvia, which is an ISO 50 film and is renowned for its contrast and colour saturation.** BELOW RIGHT: **This photograph was taken on Fujichrome Provia 100, which has an extra stop of speed and is less contrasty than Velvia.**

ABOVE LEFT: Taken on Kodak Ektachrome, this image has a general yellow cast, while the picture ABOVE RIGHT was shot on Kodachrome, which has a more magenta cast.

LEFT: A film which displays low contrast characteristics and renders flesh tones accurately is ideal for portraiture as it is more flattering than a contrasty, saturated film would be.

– is to shoot the same subject using several different types, then compare the results to see which one you like best for that subject. But be aware that you will probably prefer one type of film for one subject – landscapes, for example – and another type of film for a different subject, such as portraiture.

Slide or print?

Slide film tends to be more contrasty than print film and more difficult to expose correctly. It also has less exposure latitude (see page 26). The contrast and superior quality of slide film make it a more suitable choice for the reproduction of photos in magazines and books because it produces a bolder-looking image. However, when shooting something like a portrait, the photographer requires less contrast and less detail in order to flatter the subject's complexion. For this task it is customary to use print film. The latter is grainier and less capable of rendering every blemish in entirely sharp focus, while the reduced contrast smoothes the surface of the skin.

Film speed

After deciding whether to use print or slide film, you then need to choose the appropriate speed for the photographs

ISO 50

ISO 100

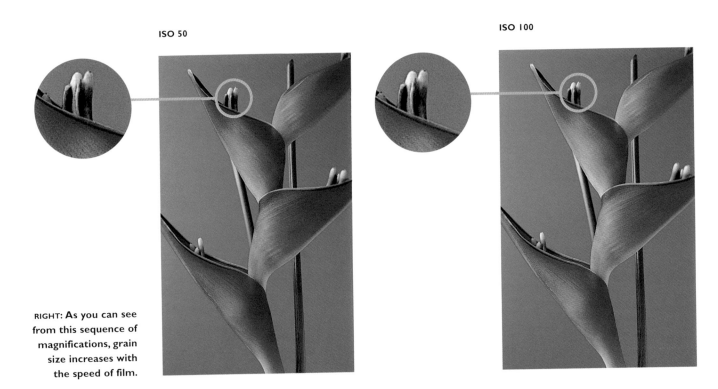

RIGHT: **As you can see from this sequence of magnifications, grain size increases with the speed of film.**

you wish to take. Films come in a variety of speeds, which determine how sensitive that film is to light. The speed is expressed as an ISO (International Standards Organization) number. A fast film, say ISO 800, will provide an image in lower lighting conditions than one shot on a slow film such as ISO 100.

If life were this simple, we would all load ISO 800 film in our cameras for everything. But there is a trade-off: the faster the film, the larger the grain. In the past it has been considered good practice to load with the slowest, finest-grain film possible for the lighting conditions, but there is now slightly less cause for concern since advances in technology have meant that film grain size has been reduced substantially over the years.

Slow, fast and faster films

Anything between ISO 25 and ISO 100 is considered to be a slow film. The colours will be very saturated and grain will be extremely fine, but it means you will be shooting at very

slow shutter speeds so you will need to use a tripod. The resulting slide or negative will be capable of considerable enlargement with very little loss in quality.

Next up you have ISO 200 film, which is fine for general use in a compact camera, but if you really need the extra sensitivity – for example, if the light is fading and you need to record as much detail as possible – you should go for ISO 400. The difference between ISO 200 and ISO 400 in terms of quality and colour saturation is

What is exposure latitude?

Exposure latitude is nothing to be afraid of! It refers to the ability of a film to produce an acceptable image, even when it has been over- or under-exposed. Slide film has less exposure latitude than print film and will only produce an acceptable image up to half a stop either way, whereas print film is more flexible and will provide a decent print even if over- or under-exposed by anything up to three stops either way.

ISO 400

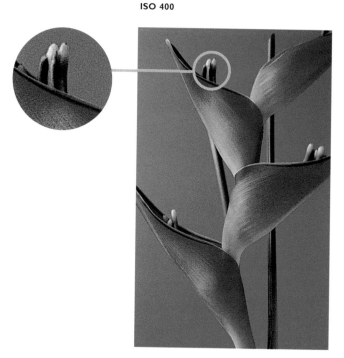

ISO 1600

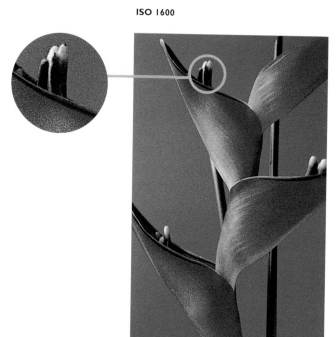

minimal, but the extra stop provided by ISO 400 could make the difference between getting your shot, or packing up and going home.

After this we reach the realms of the truly fast film. Those of ISO 800, 1600 or 3200 are perfect for low-light or indoor situations, or those where flash is not permitted. The grain will be very pronounced, but this can often enhance the atmosphere of the final image and in some cases is more desirable than a completely grain-free result. Do not forget, however, that as a rule the faster the film, the less its colour saturation and sharpness.

Uprating a film

This is also known as "pushing" a film. If you find yourself in a position where you only have ISO 100 film in your camera bag, when you could really do with ISO 400, all is not lost. You can simply override your camera's film speed setting, to rerate the film at ISO 400. It is vital, though, to label the film canister if you have uprated it, and to inform the

laboratory when you take the film in to be processed. You should also be aware that if you uprate a film on which you have already taken some pictures, and then have it processed according to the new speed at which you have set the camera, you will lose the photographs you took before uprating.

Although it is wise, if you want to be sure of the results, to uprate by only one or two stops, there is no harm in experimenting by pushing a test film up to four stops, just to see how the results turn out. You may like it so much you decide to make it part of your own individual photographic style!

Specialist films
Tungsten-balanced film

If you were to use ordinary, daylight-balanced film under tungsten lights, your result would be a picture with a very strong orange colour cast. Tungsten-balanced film is designed to correct this cast, without the need for filters or flash.

Infrared film

Infrared film is available in both colour and black and white, and is a ready-made special effects film. Greenery and foliage make ideal subjects for black and white infrared film, as they are rendered white in the resulting print. You should use the film in conjunction with a deep-red filter (a Wratten 87) and refocus according to the infrared index marker on the lens barrel. Infrared film also needs to be loaded and unloaded in complete darkness to avoid fogging.

Colour infrared film is altogether less predictable since it can turn the scene into several different colours. These colours vary according to the filter, although a Wratten 12 yellow filter is recommended. Green foliage will be recorded as red or magenta.

It is essential to bracket up to two stops each way with either colour or black and white infrared film, as it is extremely tricky to get the exposure just right. (See "Bracketing" on page 44.)

The importance of processing

There is another stage in the photographic procedure which it is essential to take into account. All the time, effort and expense spent on selecting the perfect film for your purposes will be worthless if your film is badly processed. Again, shoot several rolls of film of the same subject, but have them processed at a number of different laboratories, avoiding the high street processor or local chemist if at all possible. Instead, choose a professional processor or one that deals with both professionals and the general public. When you have found a company that provides a good service and good results, stay with it. You may end up paying more than you would at a high street store, but it will be worth it.

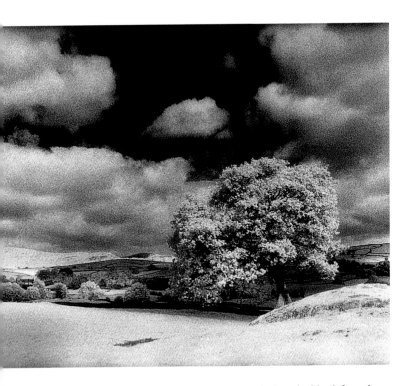

ABOVE: The defining characteristic of black and white infrared film is that vegetation is rendered as white, while blue skies become very dark.

ABOVE: Colour infrared is very unpredictable and it is difficult to repeat its effects – but that is part of the enjoyment of using it.

Useful accessories

Many of us cannot resist any gadget that claims it will change our photographic life, and it would be easy to fill several camera bags with such bits and pieces. However, although we would never quite get round to using many of them, there are a few things you will find genuinely useful.

Tripod

Almost as essential as the camera body itself, a tripod helps to keep the camera still during long exposures. If you intend to produce anything worthwhile in landscape or architecture photography, you will definitely need one. Get the best and sturdiest model you can possibly afford because – unless you lose it – you will only need to buy it once. There are plenty of low-priced designs available, but when it comes to tripods, you get what you pay for, so be wary of the really cheap models.

When buying a tripod, you will also have to invest in a tripod head. There are two main types – ball and socket, or pan and tilt. There are arguments for and against each type, but essentially the ball and socket has a smooth, seamless movement which is ideal for following moving subjects, while the pan and tilt head is better for general photography and can be positioned very accurately.

Monopods

Like a tripod but with only one leg, a monopod is ideal for sport or wildlife photography, where you need to brace the camera. A monopod gives you something to lean on without restricting your movements in the way that a tripod does.

ABOVE: **A tripod is essential for stability when using long shutter speeds.**

Cable release

After spending all that money on a tripod, it would be a shame to jog the camera as you pressed the shutter release button. To avoid this, use a cable release to trigger the shutter.

Lightmeter

There are times when the light-meter in your camera will not pro-vide the result you see in your mind's eye. The camera's meter can only take a reading of light reflected from a scene, although there are times when the incident reading provided by a lightmeter will yield a better result (see page 44). If you tend to shoot with print film and are accustomed to how your camera meter works, you are unlikely to require a lightmeter. Many professionals use one in addition to the camera meter just to be sure that the reading they have is correct.

Spirit level

This may seem to be a surprising addition to the camera bag, but many otherwise delightful pictures suffer from the unintentional sloping of horizontals. A spirit level can make a big difference.

Lens hood

Flare is one of photography's greatest enemies. Caused by stray light entering the lens (such as when sunlight falls directly onto the front element), it bounces around inside the lens, reducing contrast as it goes and sometimes leaving aperture-shaped marks on your pictures. The simple cure is to use a lens hood. It will not provide a per-fect solution if you are shooting directly into the light, but it will protect the front element of your lens from extraneous light.

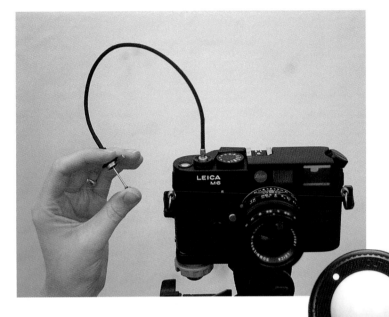

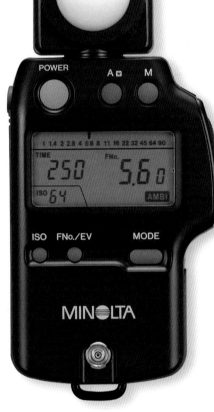

ABOVE: **Not all cameras nowadays have a cable release thread, but a cable release is a vital tool to prevent the camera moving when the shutter is released.**

ABOVE: **A lightmeter will ensure that your exposures are accurate at all times.**

getting the
basics right

Aperture and shutter speed

The first step in taking control of your photography is to learn how the aperture and shutter speed relate to one another, and to recognize how they affect the look of the final image. If you have been accustomed to using a compact camera you will find that shutter speed and aperture control give you a whole range of new choices and freedom of creativity.

Exposure is the process of allowing light to pass through a certain-sized hole for a certain length of time. The size of the hole is what we call the aperture, and the time the light is allowed to pass is called the shutter speed. What is important is that the right quantity of light reaches the film. For a particular scene of a certain brightness there will be a variety of apertures and shutter speeds you can use.

When you halve the length of time you allow the shutter to remain open – for example, from 1/250 second down to 1/500 second – you need to double the size of the aperture – for example, from f/16 to f/11. Every time you move a stop either way on either the shutter speed or the aperture dial, you either halve or double the amount of light admitted. If your camera gives you a meter reading of f/8 and 1/125 second, you will get the same exposure on film if you shoot at f/5.6 and 1/250 second, f/4 and 1/500 second or, in the other direction, f/11 and 1/60 second. This is known as the reciprocity law. But shutter speeds and apertures have a far greater impact on your photography than merely getting light onto the film.

Controlling shutter speed

Imagine looking through a window. The window has a set of curtains which you are holding in your hands. Those curtains are closed. You hear a car outside and you want to see it. If you open and close the curtains very, very quickly you might not be able to tell whether the car is moving or not. You will see there is a car there, but the length of time you were able to spend looking at the car might not have been long enough for you to determine whether it was parked or in motion.

If you had kept the curtains open for a little longer, you would have been able to see quite clearly whether the car was moving. This is how shutter speeds work. Shutter speeds determine how long you let the film see the subject. If the film does not get a good long look, how can it know the subject is on the move? If you let it have a long look it will see the subject is moving and will show it in the final image.

Thus we can see how the shutter speed basically determines whether your subject looks as if it is moving or not. You might want to freeze your subject's movement with a fast shutter speed or you might want to show that it is moving by using a slower shutter speed. However, do not be trapped into thinking "fast-moving subject, therefore select fast shutter speed" when showing that the subject is moving might be far more interesting.

Controlling apertures

An aperture is more than just a hole in the lens which lets the light in. The size of that aperture governs the appearance of your final result just as much as a fast or slow shutter speed portrays the movement of your subject. The aperture controls not only the amount of light entering the lens, but also how much of the depth within your picture is rendered sharp and in focus.

When we look at a photograph, what we are seeing is lots of tiny circles of light which build up the image of the subject. The bigger circles, to the human eye, create an out-of-focus subject, while the small ones create a subject that looks sharp. The point onto which the lens has been focused produces the smallest circles, while a certain amount of information in front and behind that point is constructed of circles small enough still to appear sharp to our eyes. This area is called the depth of field.

Depth-of-field preview

We can control the depth of this area by using different-sized apertures. A small aperture produces smaller circles

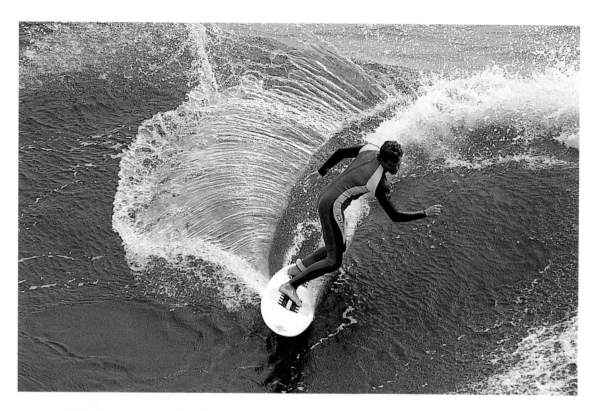

LEFT: **A fast shutter speed captures the surfer crisply, as well as the wave created by his board.**

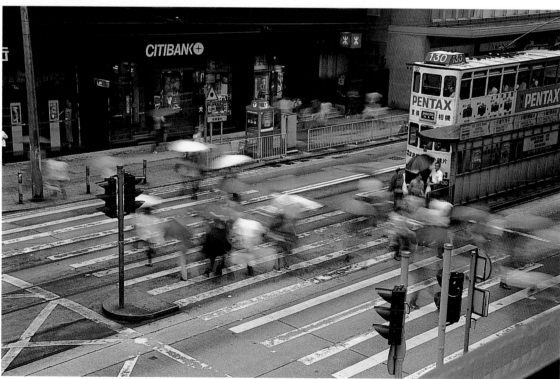

LEFT: **A slow shutter speed renders some of the moving people as a blur, creating a sense of hustle and bustle.**

of light (called circles of confusion) so that the area that appears sharp to us is larger than when a wider aperture is used. Here we must remember that smaller apertures have larger numbers. Thus f/16 represents a smaller hole than f/5.6.

A simple exercise will soon demonstrate this principle to you. If you have a depth-of-field preview button on your camera, set the aperture on its widest setting and focus on something reasonably close (2 metres or so) using a standard lens. Looking through the viewfinder you will see the amount of focused image available at the maximum aperture of your lens. Now close the lens aperture down to f/8 and use the depth-of-field preview to check the difference. Whatever is in the background of your picture might not be entirely sharp, but objects should be a lot more recognizable than they were before. Now close down to f/16

BELOW LEFT: If you want to render sharp everything in frame – from near to far – you will need to select a small aperture, around f/11 to f/16.

BELOW RIGHT: A large aperture of about f/2.8 allows you to use selective focusing, where you focus on one part of the subject, knowing that the rest of the image will fall out of focus. The viewer's attention is then drawn to the sharper area of the frame.

and check the difference again. By opening and closing the aperture with the depth-of-field preview activated, you will be able to see immediately what difference the aperture makes to the amount of the scene you can render sharply.

There is a little more to depth of field than the aperture, however. The two other elements you need to think about

LEFT: At f/2.8, with the focus on the dome in the foreground, the domes in the background are blurred.

LEFT: At f/5.6 the domes are sharper ...

LEFT: ... and at f/11 all the detail in the frame is sharp.

are the focal length of your lens and the distance your subject is from the camera. In basic terms, the longer the focal length of the lens you are using, the shorter your depth of field; and the closer your subject, the shorter your depth of field. Conversely, for the maximum depth of field you should use a short focal length lens (i.e. a wideangle) and focus on a subject that is a long way away.

You can use depth of field either to show the whole scene in front of you in focus or to highlight just a single object as the main subject by rendering it the only sharp point of the picture. It is a powerful tool and one you need to think about every time you look through the lens.

ABOVE: **A depth-of-field scale on a lens allows you to adjust your focusing to ensure your pictures are as sharp as possible.**

Maximizing your depth of field

When shooting landscapes, it is usually desirable to have in focus as much of the scene in the viewfinder as possible. For this you cannot rely on your camera's systems, even if you have depth-of-field mode.

Imagine a scene where you have a few rocks and some vegetation in the foreground, a great lake with a sprinkling of islands in the middle ground and vast snow-capped mountains in the background. You are using a wideangle lens and everything fits into the viewfinder, including plenty of beautiful blue sky and a few puffy white clouds.

If you let the camera's automatic system have its way, it will focus on whatever is in the centre of the frame, which will probably be the base of those mountains. These lie at infinity. Next, to get as much of the scene in focus as possible, you close the lens right down to its smallest aperture. Two problems arise: first, the smallest aperture on your lens will not deliver the best quality or the sharpest image. Secondly, when you are focused at infinity you will need a tiny aperture to make the depth of field stretch far enough forward to get that foreground sharp.

Since the depth of field extends for one-third in front of the focus point and two-thirds behind the focus point, by focusing on infinity we are effectively throwing away two-thirds of our potential sharp area. As far as the lens is concerned, infinity is as far as you can focus and anything at the infinity point or beyond will always be sharp anyway. All we need to do to get those snow-capped mountains into sharp focus is to include them at the extreme of the depth of field.

Hyperfocal focusing

Using the thirds rule, we can focus one-third of the distance into the scene and check with the depth-of-field preview that the infinity point is still sharp. If your lens has a depth-of-field scale on it, there is an easy way of doing this. Focus the lens at infinity and set the aperture to the second smallest setting. On the depth-of-field scale you will be able to read off the closest focused point for that aperture.

This represents a third of the way into the picture. Then adjust the focusing barrel so that it falls at that point. You have just maximized your depth of field. This means that now you have infinity in focus and you have brought the depth of field forward as far as it can go. Using the depth-of-field scale or the preview function on the camera, you can now check how much foreground is in focus.

This technique is called hyperfocal focusing. The focus point which sits one-third of the way into the scene is called the hyperfocal point. You should use this technique for all your photography – not just landscapes. It is relevant to any shot where you want to get as much of the scene in focus as possible, and it can apply to still-life and human-interest pictures just as much as to landscapes.

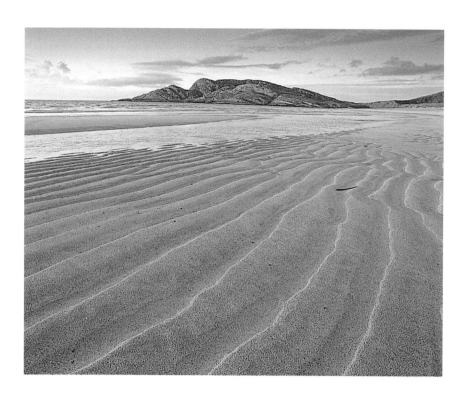

ABOVE: **Hyperfocal focusing is essential for a composition such as this, where there is a distant subject and a lot of foreground.**

Camera shake

Camera shake occurs when we are unable to keep the camera completely still, and is not always a result of slow shutter speeds. The first step to avoid it is to ensure you are holding the camera correctly — that is, as firmly as possible and with your elbows tucked tightly into your sides. Camera shake is more likely to occur when using longer telephoto lenses, and often the only option is to resort to a tripod or monopod, which is something you should consider using as a matter of course anyway. However, camera shake can also occur when a camera is tripod-mounted, especially if you do not use a cable release to trip the shutter, as the pressure of your finger on the button could be enough to cause the problem.

There is a basic rule about avoiding camera shake: when hand-holding the camera, never let the number in the shutter speed exceed the number in the focal length of your lens. For example, if you have a 70mm lens attached to your camera, do not use a shutter speed slower than 1/70 second. But of course, you do not have a 1/70 second setting on your camera; therefore you must round the number up. In this case, it would be 1/125 second. By the same theory, if you have a 180mm lens do not use it with a shutter speed slower than 1/250 second, or with a 400mm lens, slower than 1/500 second.

Previsualization

This is rather an awkward term to use, and sometimes puts people off as it is often perceived as being a little pretentious. Essentially, it simply means anticipating how you want your photograph to look, and knowing how to adjust and control your camera so you obtain that result. Usually photographers have an idea of what they want before they release the shutter, so previsualization is essential to good results.

Rather than allowing the camera to perform a random selection of exposure, aperture, shutter speeds and metering, by taking control of all these elements you have an almost infinite number of different results open to you. You not only need to think about your shutter speed (whether to freeze the movement or let it blur in the picture) and your aperture (whether to use a shallow depth of field to emphasize a single part of the scene or a deeper one to focus on everything), but whether the subject needs to be shown exactly as it is or whether you would prefer it to be reproduced on film lighter or darker than it is.

A tool of the trade

The camera is only a tool in your hands. 'The camera never lies', so the saying goes, but in fact you can make it lie as much as you want. When you look at a scene through the lens, you can decide how you want to represent it on film.

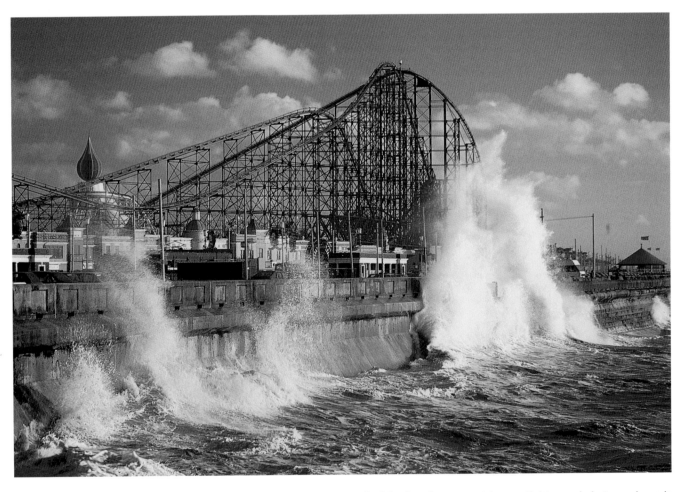

ABOVE: **Anticipating the moment is essential to good photography, as is shooting a lot of film to ensure that at least one of the frames is successful.**

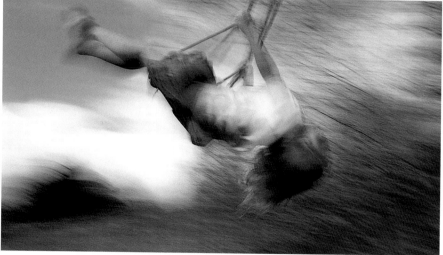

ABOVE: Although this is a colour picture it has a monochrome feel, and the deliberate slight underexposure adds to the ghostly feel.

LEFT: Panning and using a long shutter speed at the same time increase the sense of carefree movement.

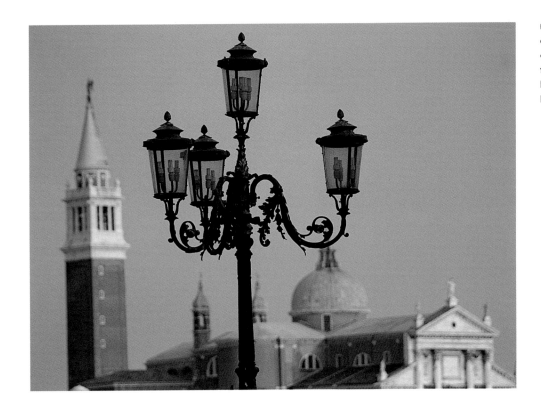

LEFT: **Using a small aperture draws attention to the ornate lamp-post in the foreground, while giving a blurred impression of the buildings beyond.**

The dark bits don't have to appear dark. If you give them enough exposure they can appear as mid-tones – give them more and they can even appear overexposed.

Previsualization is also about the parts of the scene you want to include in your picture. This does not only mean cropping the ugly building or the telephone wires from your beautiful landscape, it is also about using selective focusing to render "invisible" elements of the scene you would rather not show. A shallow depth of field can hide all manner of background sins. Dustbins can become vague black shapes and a jumble of vegetation can be transformed into an attractive, non-distracting green patchwork behind a single rose head.

Previsualization is also about knowing how you want your foreground and background to interact. You need to make decisions about such things as how much foreground to include and which lens will make the most of the effect you are looking for. If you want the foreground to have an

impact then fit a wideangle lens to give it size and importance. If you just want a hint of foreground in front of a distant subject, use a telephoto lens and drop the foreground out of focus.

The repeatability factor

Whatever you do, the important thing is that it was intentional; if called upon, you should be able to do it again. Leave nothing to chance and understand how you manage to create every effect you achieve.

It is important to remember that you have control of the pictures you take. Do not feel you have to recreate on film with absolute precision the scene in front of you. True creativity comes when you take what you are given and make something else from it. That requires you to think about how it will look on the light box or in the album – and that in turn requires previsualization. It's just a shame there isn't a better word for it!

Obtaining perfect exposures

The ability to obtain a perfect exposure is the most important thing you will ever have to learn about photography. And it is not simply about whether a photograph has been overexposed or underexposed, it is about being able to judge what exposure is correct for the circumstances. While most cameras in this age of auto-everything culture will do the job for you, there are still situations where even the most sophisticated automatic metering system will let you down. There is no substitute for reading the handbook

ABOVE: A general scene consisting largely of mid-tones is easy to meter accurately.

and working things out for yourself. Using your own judgement is not as daunting a skill as some people might suggest, and taking some time – and potentially wasting a few frames – will give you the satisfaction of being able to obtain good results every time.

Get rid of the greys

Perfect exposures come from understanding the pattern of light and shade in a scene and knowing how you want this to appear in your final image. Achieving the right exposure is not about reading what is there but about interpreting what is there and setting an exposure that will deliver the photograph you are looking for.

You need to be aware that your camera often interprets the scene differently from the way you do. The most important thing to remember is that your camera assumes that, whatever the predominant tone in your scene, it is a mid-tone grey. So if your scene is predominantly white and you

let the camera expose automatically, it will reproduce as a mid-tone grey. If your scene is predominantly black and you let the camera expose automatically, again it will reproduce as a mid-tone grey.

In very simple terms, the answer to these problems is to allow more light to fall upon the film emulsion (by opening the aperture or using a longer shutter speed) if the scene is mainly a bright tone, and to allow less light to fall upon the film emulsion (by closing the aperture or using a shorter shutter speed) if the scene is mainly dark. This may seem illogical, but it is the only way you will reproduce the scene accurately on film.

Find the mid-tone

Purists will insist that you should know exactly where the mid-tone is and what the exposure value of that tone is. Although you need not always adhere to it without exception, it is a sound principle. You need to measure that mid-tone and then decide if you want it still to be a mid-tone in the final print. By opening the aperture or lengthening the shutter speed you can change a mid-tone to a light tone. Just remember – and it is worth repeating – that your camera meter will look at anything and give you a meter reading which will render that thing as a mid-tone. If your subject is naturally lighter than mid-tone you will need to give additional exposure to the reading from the camera. If your subject is darker than mid-tone you might like to give it less exposure than the camera recommends.

Contrast range

There will, without a doubt, come a time when the contrast range of the scene in front of you far exceeds the ability of the film to record that range. While print film will record detail in a scene with a contrast range of anything up to three or four stops, slide film is far less flexible. Since very bleached-out areas within a photograph can be distracting, it is often best to expose for the highlights – often, but not always.

ABOVE: **White subjects are tricky to meter. Overexpose slightly and bracket to ensure that the whites are correct and not rendered as a mid-tone grey.**

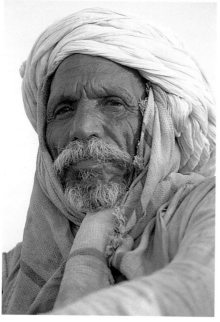

ABOVE: Dark subjects are also difficult to meter correctly, as they will fool the camera into overexposing. You need to reduce the reflective metered reading by a half to one stop to ensure the blacks are black.

FAR LEFT: The contrast between the man's dark skin and the white of his clothing is another potentially difficult situation. You will need to decide which is the more important part to reproduce correctly, and meter for that.

NEAR LEFT: Overexposing was essential to make sure the white wall was correctly exposed.

43

The classic example is when the sky in a landscape photograph is far brighter than the ground. If you expose for the sky, your foreground will have no detail. But if you expose for the ground, your sky will be completely washed-out in the resulting photograph. While this is the perfect time to use a neutral density filter (see page 53), if you do not have such a filter, you will need to decide which part of the scene is more important and meter accordingly. This is when bracketing can prove invaluable (see below). Many photographers also make a point of deliberately underexposing slide film by a third or half a stop, as it can result in deeper, more saturated colours.

Incident and reflected light

Your camera's metering system reads only the light reflected from the subject, not the amount of light falling onto it. An incident meter, however, takes into account only the intensity of the light falling on the subject. Incident-light readings are taken using a hand-held lightmeter, the advantage being that it provides a more accurate reading because it is not affected by the brightness of the subject itself. The exposure will be correct because the subject's colour and the reflectivity of its surface can influence the amount of light reflected to the camera.

Bracketing

Bracketing is the perfect — and sometimes the only — way around a tricky metering situation, but you still need to meter the scene accurately in the first place, otherwise you could end up with a sequence of wasted pictures, all underexposed or overexposed.

Basically bracketing means shooting the scene at the exposure suggested by your camera, then also shooting at third, half or whole stop intervals, both over and under this reading. For example, if your camera suggests a reading of f/8 and 1/125 second, you take an exposure at that reading, then go on to expose at, say, f/8-and-a-half and f/11; you then also expose at f/5.6-and-a-half, and f/5.6. One of this sequence of five pictures should produce an acceptable result. It is a technique really worth using only when you are shooting with slide film, since the latitude of print film will usually allow appropriate exposure.

As an alternative, if you do not want to alter the shutter speed or aperture, you can bracket by using the exposure-compensation dial on your camera. Some cameras have an automatic bracketing facility which does the work for you.

BELOW: **Bracketing was required here as the sky was influential over the scene and there was quite a lot of contrast between shadow and highlight areas.**

+2 stops +1 stop as indicated −1 stop −2 stops

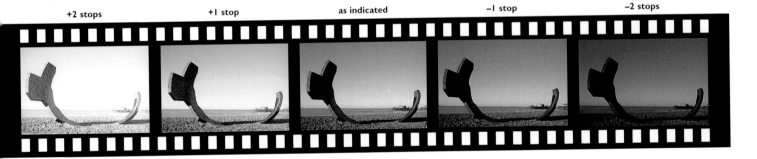

Using TTL metering

When it comes to an SLR's TTL (through the lens) metering system (as opposed to using a hand-held lightmeter), it is not what you have, it is what you do with it that counts. Some 35mm SLRs have several metering systems, which will cover almost any metering situation you care to think of. Some have only one metering system, but this does not mean you have to be restricted by it. If you know and understand it well enough, it will serve you as well as a camera with several. The main difference between these systems is the way each of them reacts to the light levels in certain parts of the viewfinder.

Shutter and aperture priority

These are very simple modes to use. You use shutter priority when the shutter speed is more important than the aperture. For example, if you want to capture a fast-moving vehicle, you would set manually the shutter speed – 1/500 second, say – and the camera would automatically set an aperture to give you the correct exposure. Aperture-priority mode is the same in reverse. If you are shooting a landscape where depth of field is of prime importance, you may set an aperture of f/11 or thereabouts

and the camera will then select a shutter speed to give you a correct exposure.

Centre-weighted metering

This is the most common of the metering systems. It works by measuring light from all over the viewfinder, but pays extra attention to what is going on in the centre of the picture area. The image is split into two parts – the centre circle and the surrounding area. The centre circle influences the exposure slightly more than the surrounding area: the split is usually something like 60:40.

The system works well when your subject is in the centre of the viewfinder. Even if it isn't, in most cases the system will produce an average that won't be far off. However, this system is unsatisfactory when faced with non-average scenes. If you have a lot of sky in the picture, your land area will be underexposed, or if your subject is off-centre as well as being unusually light or dark, the system will fail to give the right result. Large expanses of light or dark tones will also throw the metering off course. As you progress in your photography, you will become familiar with the system and learn to recognize situations when it will give you the wrong reading, so you can compensate your exposure to overcome any problems.

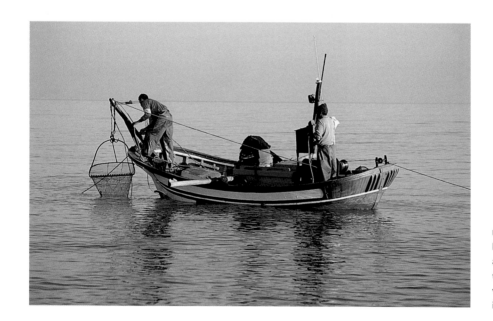

LEFT: **As the subject here is fairly large and in the middle of the frame, centre-weighted metering is a suitable option.**

Matrix/Evaluative/ Honeycomb metering

This is another averaging metering system. It has three names because different manufacturers use different words to describe it. (Nikon uses 'matrix', Canon calls it 'evaluative', while Minolta and Pentax call it 'honeycomb pattern'.)

In the simplest terms, the system breaks the scene into a number of parts and reads light information from each. This information is then fed to a central computer which delivers the average reading. Depending on the sophistication of your camera, the scene can be split into anything from four to sixteen parts. Some systems allow for brighter areas at the top of the scene as this is where the sky usually is. Others can also detect when the camera is turned on its side for a portrait-format picture and then adjust for where they expect the sky to be. The more sophisticated systems use information from the autofocus system to detect which area the subject is in. The metering can then be adjusted to give most importance to this area.

For all its clever and sophisticated technology, this is still just an averaging exposure system and it will not work when faced with anything unusual. The white Scottie dog in a bath of milk is still going to be underexposed and the nun driving a black limo will still be overexposed. Too many photographers think matrix metering is the answer to all their prayers, but if this was the case, modern cameras would not feature centre-weighted and spot-metering modes as well. And they do.

Spot metering

Spot metering is probably the most useful – and the most misunderstood – of all the metering modes. This system allows you to isolate a single part of the scene to take a light reading from only that part. The actual spot is usually in the centre of the viewfinder and varies in size depending on the model of camera – anything from 2% of the image area to about 8% (which is strictly called partial metering because it is hardly a spot!).

LEFT: Because there is a fair amount of sky in this scene, as well as a lot of contrast between shadow and highlight areas, matrix metering needs to be selected for an accurate exposure.

The way it works is that you point this spot at anything in the scene and it tells you how much light is being reflected from it. The mistake many people make is to believe that the reading given by the spot is the one which will deliver the correct exposure for that object. But as we now know, if you point it at a white object, the meter will tell you what exposure you need to make that object appear as a mid-tone. And if you point it at a black object, it will do the same. The trick is to find the object in the scene in front of you that you want to reproduce as a mid-tone in your final image and point the spot meter at that.

Once you have learned how to use spot metering correctly, it will prove to be the most accurate of the metering systems. You will have to invest a bit of time in learning how to use it, but it will be time well spent.

RIGHT: **With a backlit subject, spot metering from the front area, which is in shadow, is essential to make sure the light does not wrongly influence the meter reading, and render the shadow area underexposed.**

The grey card

Many photographers swear by the 18 per cent grey card, but there are equally as many who can live without it. A grey card is exactly what it says, and if you take a meter reading from it, you will get the correct reading to reproduce a mid-tone in your photograph, but only if you meter from it in an area where it reflects exactly the same light as is reflected from your subject. It is a very common error to take a reading from a grey card — or its equivalent — in the shade, despite the fact that the main subject is bathed in bright sunlight, or vice versa.

Apart from the fact that grey cards become worn out or get lost very quickly, it does not take long to learn which other items also reflect an 18 per cent tone of grey. Some camera bags, for instance, are deliberately designed to do so, or, alternatively, a white person's hand — minus one stop — can be used to equal a mid-tone. A grey carpet tile or a lawn are also good standbys.

Filters and how to use them

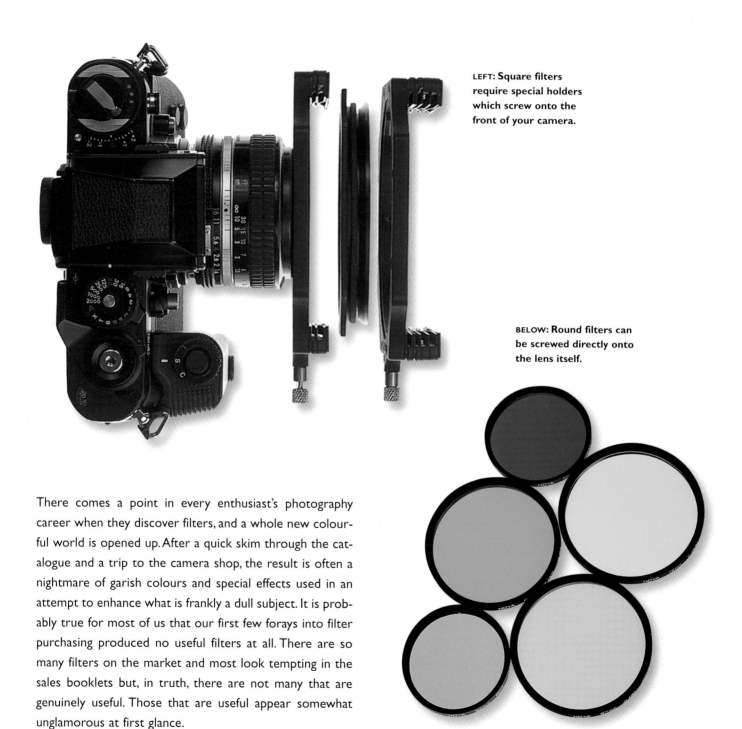

LEFT: **Square filters require special holders which screw onto the front of your camera.**

BELOW: **Round filters can be screwed directly onto the lens itself.**

There comes a point in every enthusiast's photography career when they discover filters, and a whole new colourful world is opened up. After a quick skim through the catalogue and a trip to the camera shop, the result is often a nightmare of garish colours and special effects used in an attempt to enhance what is frankly a dull subject. It is probably true for most of us that our first few forays into filter purchasing produced no useful filters at all. There are so many filters on the market and most look tempting in the sales booklets but, in truth, there are not many that are genuinely useful. Those that are useful appear somewhat unglamorous at first glance.

Light filters

Filters, as the name suggests, are in the business of filtering. For the purposes of photography, they filter light. Essentially, they allow certain types of light to pass through, while stopping others. In some subject areas this ability to control the type of light reaching the film is critical to the technical quality of the result, while in other areas the use of a filter can enhance the picture to suggest a situation that isn't quite true, but which is better than reality. Filters can be used to emphasize certain aspects of the scene, to alter the contrast or to change the way different colours or tones relate to each other. Filters are a very useful aspect of picture taking but they can only enhance or improve what is already there. They do not work miracles, nor should they be the purpose of the photograph. You cannot make a great picture by taking a bad picture and adding a filter. A filter can only help you when you have a good picture already. No amount of special effects or bright colours is going to improve a dull subject or a bad composition.

What are filters and filter systems?

Filters are made from one of three materials: glass, plastic or a tough resin. Generally speaking, those made of glass are of better quality; they are more expensive and the most worthwhile investment.

While filters are undoubtedly useful, the negative side of using them is that they degrade the quality of the image. You may spend a lot of money buying the best lens you can afford and then stick a cheap filter over it. This instantly reduces the quality of the lens, as you have now effectively given it a plastic front element. Plastic filters scratch easily and these scratches disperse the light as it passes through them, giving a soft-focus effect. The difference between plastic filters and glass filters is similar to the difference between plastic sunglasses and glass ones. It doesn't take too long for the plastic lenses to get scratched and then it becomes very difficult to see through them clearly. Glass

lenses are far more durable and will deliver a sharper image for much longer.

The tough resin filters are cheaper than the glass types and represent a realistic compromise between cost and quality.

Whatever type of filter you choose, you must keep both sides clean and dust-free at all times. Do not be tempted to keep them loose in your camera bag as any type of filter will become damaged if it is not protected. You should treat your filters with as much care as you would an element of one of your lenses.

Filter shapes

There are two basic shapes of filter. There is the round filter in a metal ring that screws into the front of your lens; then there is the square or rectangular filter that slots into a filter holder that in turn screws to the front of your lens via an adapter. There are pros and cons to each shape, but for the enthusiast there is little to recommend the screw-in filter. Although they tend to be made from glass and are therefore of very high quality, what works against them is that you have to acquire a separate filter for each lens thread size. If you have three different-sized lens threads and use a polariser with each of the lenses you will need to buy three polarising filters, which

will be an expensive exercise. And you will need three of each of the filters you use with all three lenses. In the end you could end up with a bag full of round filters and no room for the camera!

With the rectangular system, you need only a cheap adapter ring for each size of lens thread. The adapter ring connects the lens with the filter holder, so the same filter can be used with each of your lenses. With the rectangular system you need only one polariser.

Buy big

There are a number of filter manufacturers who offer enthusiasts filters in two sizes – generally "amateur" and "professional". If you are likely to use a lens wider than

28mm or a wide-apertured telephoto zoom, it is best to buy the larger "professional"-sized filters to start with. Many make the mistake of starting with the "amateur" range, only to find they are not physically big enough to cover the front element or the angle of view of some lenses. It is better to buy big from the outset rather than find that later you have to buy duplicate filters in a larger size for some of your lenses. The big filters fit even small lenses but the small filters have adapter rings for thread only up to 77mm.

There are other reasons to recommend the rectangular system for specific filters and these are dealt with in the sections on those filters. Also some filters are best bought in the round, screw-in version for practical reasons. More on both of these subjects can be found later.

Types of filter
UV (Ultraviolet)

This filter is so useful for all types of photography that most photographers keep one on the lens at all times. Its purpose is to cut out ultraviolet light in the atmosphere to enable us to capture clearer photographs. Often in a landscape situation – and particularly for distant scenes at altitude – there may be an atmospheric haze that partly obscures colour and objects close to the infinity point. A UV filter will reduce this haze to allow the lens to collect sharper detail. Without such a filter, the haze you see with the naked eye will be exaggerated in the resulting picture, because film sees UV light while we do not.

As these filters appear colourless they have little effect on the pictures where you might not actually need the filter. This means there are no side-effects if you keep the filter on the lens all the time. These filters are not expensive and serve to protect the front element of the lens from dust, dirt and scratching. For this reason, most photographers buy a filter for each of their lenses in the screw-in version and keep it in place constantly. It is cheaper to replace a UV filter after an accident than the front element of a lens.

ABOVE: **The advantage of square filters is that they can be moved up and down in the holder so that the graduated area corresponds with the horizon of your composition.**

Polarizers

Polarizing filters are used to cut out reflections from non-metallic surfaces. Using a polarising filter, it is possible to see through the reflections on the surface of water, or on a plate of glass.

Light waves vibrate in all planes at right angles to the direction of travel, while polarized light can vibrate only in one plane. The polarizing filter prevents waves vibrating in certain planes from passing to the film, allowing through only those waves vibrating in the plane that is parallel to the lines in the filter. In practice, this is like trying to fit a slice of bread into a toaster. Unless the bread is parallel to the slot, it won't go in and any slices that aren't parallel will bounce off. A polarizing filter is like a series of toasters in line that only allow light vibrating in the right plane to pass by.

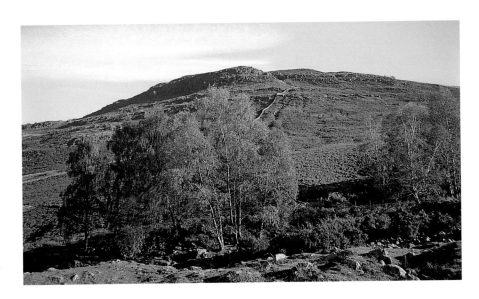

RIGHT: **Without the polarizer the sky is rather washed out.**

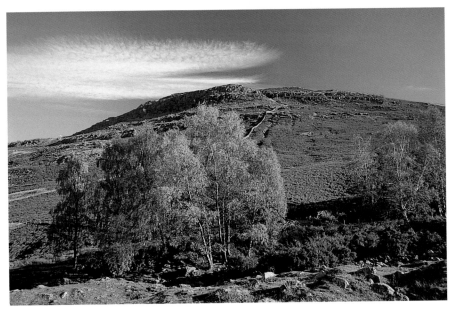

RIGHT: **With the polarizer fitted, the blue of the sky is intensified, highlighting its contrast with the white clouds.**

By turning the filter, you can alter the type of waves you allow past. It is simply a matter of turning the filter while the scene is being viewed through the viewfinder until the desired effect is achieved.

The greatest benefit of the polarizer is the deepening of colours by the removal of reflections from their surface, and the emphasizing of a blue sky at right angles to the sun. Polarizers have little effect on the sky when the sun is high, but can create spectacular effects in early morning and late afternoon. For this reason, it is a popular filter with landscape and architectural photographers. These filters are also useful for copying work where the original is covered by a sheet of glass or has a glossy surface.

There are two types of polarizer for your camera: linear and circular. It is safer to buy the circular version because the linear type can interfere with the autofocus and auto-exposure functions on some SLR cameras.

Neutral-density

A neutral-density filter should be completely colourless, but shaded like a pair of sunglasses. The purpose is to reduce the amount of light reaching the sensor (in this case, the camera film) without altering anything else, particularly colour. These filters come in different strengths for controlling exactly how much light can reach the film. They enable the photographer to use slow shutter speeds, wide apertures or fast film in conditions that would not normally be suitable. If, for example, you want a very shallow depth of field and lots of grain, you would use a combination of wide aperture and fast film. However, if it is a very sunny day and your camera is loaded with, say, ISO 3200 film you may not be able to do this. The camera might recommend f/8 at 1/2000 second, but you want to use f/5.6. As 1/2000 second is the fastest shutter speed setting on your camera, you would be unable to open up by one stop and maintain a correct exposure. Fitting a 0.3 ND filter would reduce the amount of light hitting the film emulsion by one stop, so you could set an aperture of f/5.6. The same would apply if your lens

did not have a small enough aperture to accommodate a particularly slow shutter speed.

If you buy a neutral-density filter it is worth buying a good one, as cheaper models are not completely neutral. If the dye in the filter is not a true grey or colourless tone, the filter will affect the colour of the shot. Often lower-quality ND filters will give your photographs a magenta cast. Filters that can't be classed as neutral in tone are often called "grey" filters instead of "neutral". Grey filters have their uses, but some are better than others.

Depending on the manufacturer, the strength of the ND filter is expressed as a decimal. A filter that reduces the light flow by one stop is labelled 0.3, while one which cuts out three stops of light is labelled 0.9. Neutral-density filters also come in graduated form.

BELOW: These are *graduated* neutral density filters. Each 0.3 of filter strength is equivalent to one stop of light. To compensate for a meter reading difference of three stops between sky and land in an image, you would fit the 0.9 grad.

0.3

0.75

0.45

0.9

0.6

Graduates

A graduated filter is just that – graduated. It has a colour or tone that graduates in strength across the filter. The idea is that you can filter one side of the image while leaving the other untouched. The introduction of the colour or tone does not usually start for some time, so there is often a good-sized section of completely clear filter. These filters, especially the coloured ones, are put to all sorts of questionable uses, such as turning half a building pink while the other side looks normal. However, they can also be very useful.

Graduated filters are popular in landscape photography for controlling the appearance of the sky. If the sky is considerably brighter than the land area in your frame, it is

TOP LEFT: **Unfiltered shot.** TOP RIGHT: **With 0.3 ND grad.** BOTTOM LEFT: **With 0.6 ND grad.** BOTTOM RIGHT: **With 0.9 ND grad.**

desirable to reduce the sky's brightness so that it will balance with the meter reading from the foreground. To do this, we can use a graduated neutral density filter. The darker area sits over the sky area to darken it, while the land remains unaffected as it is covered only by the clear part of the filter. In this way we can produce a more balanced exposure that shows detail in both land and sky areas of the picture.

Tobacco filters are usually graduated and used to colour the sky in a landscape. They act partly as a neutral density filter, by balancing the exposure for a bright sky and a darker land area, but add a warm brown tone to the sky as well. This can create a stormy feel to the image.

As not all landscapes are composed with the horizon in the centre of the frame, it is useful if the area where the clear glass meets the toned glass can be shifted to cover different horizon positions. For this reason, round graduated filters are not worth buying. As a round filter screws into a permanent position in the lens, the crossover area, or join, will always be in the same place. If you decided you wanted a lot of sky in the shot, so positioned the horizon close to the bottom of the frame, you would need to shift that crossover area also to the bottom of the frame. With a rectangular filter you are able to do this by sliding the filter down in its holder.

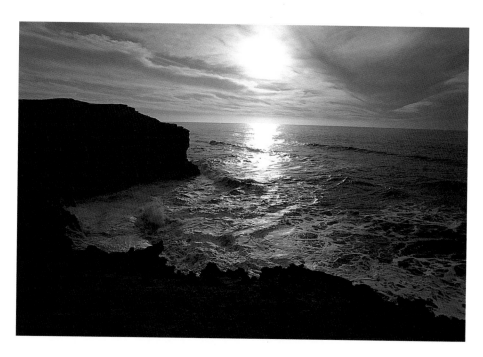

TOP: Unfiltered shot.
ABOVE: The same shot, with a tobacco filter fitted. This type of filter is not always everyone's cup of tea! However, used in some circumstances – to intensify the colours of a sunset, for example – it can enhance the atmosphere of an image.

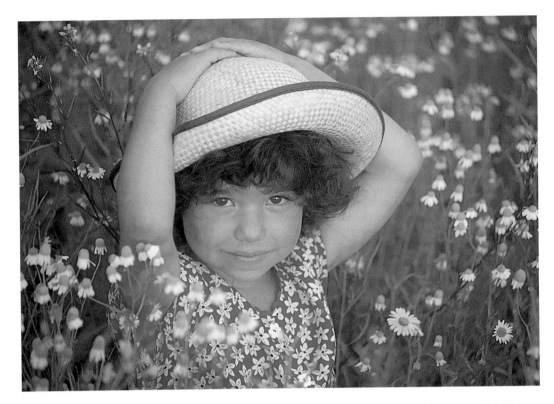

RIGHT: **Unfiltered shot.**

RIGHT: **The same shot, with a soft-focus filter fitted. Note how this type of filter makes the highlight areas bleed into the darker areas of the picture.**

These filters do not have to be used upright. If you have a scene that has an area of extreme brightness on one side you can swivel a graduated neutral density filter on its side to balance the exposure from one side of the image to the other.

In the studio, graduated filters are useful for producing graduated backgrounds on plain surfaces, and you can choose exactly where the graduate will start.

With all graduated filters you can increase or decrease the abruptness of the join between clear and toned glass using the aperture settings. For a subject at the same distance a smaller aperture will produce a sharper join area than a wider aperture. Also, when shooting close objects with a wideangle lens you will find a harsher join than when shooting distant subjects with a telephoto lens.

Soft-focus

It might seem a little strange to spend money getting the sharpest lens you can afford, only to fit a filter over it that takes that sharpness away, but that is just what many portrait photographers do. The problem is that some lenses are just too sharp and show every line, crease, spot and blemish, and that's not going to make you popular with your subjects! Soft-focus filters just take the edge off the sharpness to hide the bits that portrait sitters want to forget about. There are different strength filters for producing different amounts of softness from just a tiny touch of softness to complete fog. It is always best to avoid extremes, and extreme softness can often look like 1970s glamour.

Soft-focus filters are useful in areas of photography other than portraiture, although this remains their staple employment. A still-life shot that requires a soft atmosphere will benefit from a mild filter, as will certain types of landscape. These filters are all very well as a labour-saving device but often the effect is better created through the use of soft lighting rather than a degradation of the lens quality.

Colour-correction

When we shoot with normal colour daylight-balanced film in daylight or with flash, we record colours as they appear to our eyes. Whites will appear white. If, however, we want to take pictures using normal household lighting, we will find that whites take on a yellow appearance and every other colour will be influenced by a yellow cast. This is because the light from tungsten (domestic) lighting does not give off the white light with which normal film is designed to be used. To correct this and other colour casts caused by lighting that is not white, we use colour-correction filters. For tungsten lighting you should fit a blue filter over the lens to effectively neutralize the yellow cast. The shade of blue we use depends on the type of tungsten lighting and special filters are produced for different coloured bulbs. This colour depends on the wattage of the bulb.

Fluorescent lighting records as green on daylight-balanced film and this requires the use of a magenta filter to reverse the colour cast. Fluorescent lighting comes in many different forms and many different colour casts, so you will need to check carefully which particular shade of magenta or colour combination you need for each light source.

Rather than use a filter to correct the cast from tungsten lighting, you could instead use a film that is balanced for use in tungsten light. Should you decide, however, to use this film in daylight you will need to compensate for the built-in blue cast of the film. To do this you will need to fit a yellow/orange filter over the lens.

Skylight

A skylight filter is designed to combat the coolness of the light that comes from a very blue sky. These filters are slightly pink in colour and this pinkness helps to warm up the picture a little. On a bright day, particularly in snow, when there is a large expanse of blue directly overhead, water and reflective objects will pick up some of the blueness of the sky. The sky can act as a large reflector and push cool light over the landscape. The skylight filter helps to correct this colour cast.

TOP LEFT: **Unfiltered shot.**
TOP RIGHT: **With 81A warm-up filter.**
BOTTOM LEFT: **With 81C warm-up filter.**
BOTTOM RIGHT: **With 85EF warm-up filter.**

Warm-up

Sometimes outdoor light can appear cool. This is especially true on overcast days or when you are photographing in the shade. For landscapes and portraits, particularly, it is often desirable to add a bit of warmth to the image to make the shot or subject more attractive. To help us with this sort of situation, there is a range of warm-up filters on

Not strictly filters

There is a group of attachments for the end of your lens which are often labelled 'filters', despite the fact that they are more accurately light or image modifiers. Filters in this category include prism attachments, which produce the subject repeated a number of times all round the screen, and split-screen filters, which allow two focus points through the use of different dioptre sections in the same filter. Also sometimes classed as filters are the magnifying lenses that allow close-up work with your normal lens.

If you want a rainbow in the shot you can buy a clear filter with a rainbow painted on to it – but it is not advisable! There are many other special-effects filters that produce, for instance, a star-burst on lights and bright spots, filters that leave motion trails behind the subject and hundreds that turn the subject a range of different revolting colours. Most are best avoided.

TOP: **Unfiltered shot.**
ABOVE: **With sunset filter fitted.**

ABOVE LEFT: **Unfiltered shot.**
LEFT: **With sunset and blue graduated filters fitted.**

the market. These are basically yellow filters in a variety of strengths from a very pale tone to a quite heavy one. While restraint is the usual watchword with filtration, and just a touch of warm-up is always better than a shot that shows obvious use of a filter, heavy yellow or orange filtration can look very effective with certain subjects. Generally, though, we should try to apply a quantity of warm-up that looks natural and not false. Like fake tanning, it is too easy to turn a subject's face yellow instead of a healthy gold.

It is worth having a strong orange filter, like the one used to correct daylight for use with tungsten film, to add a sepia-style aged look to landscapes or architectural shots. In the right circumstances this will look very attractive.

Intensifiers

Sometimes we want to make a certain colour brighter and deeper than it really is, but without affecting the qualities of the other colours in the shot. Intensifiers are designed to do just that. Usually available for reds or greens, they highlight the chosen colour, adding extra density on top of what is already there. The success of these filters varies, and you might find that whites in the scene also take on a shade of the intensified colour. In truth they are not perfect, but can work well if you do not have much in the way of light or white tones in your shot.

FACING PAGE

TOP LEFT: **Unfiltered shot.**

TOP RIGHT: **With yellow filter fitted.**

BOTTOM LEFT: **With orange filter fitted.**

BOTTOM RIGHT: **With red filter fitted. It is easy to get carried away with the extreme contrast between sky and foreground created by the red filter. However, often a little more restraint is called for, so use a yellow or orange one too, then make up your mind!**

Filters for black and white photography

It might seem a little odd that coloured filters should have a place in black and white photography, but they do. To understand this we need to remember that coloured filters do not so much add colour to an image as prevent certain other types of light from passing through them.

There are five principal filters that are regularly used with black and white films. These are red, yellow, orange, green and blue.

Red

Light skies in a landscape will often reproduce as a plain blank white or grey in a black and white image. This is because the film cannot see much difference between the white of the clouds and the blue of the sky. A red filter can inject a certain amount of drama, creating strong contrast between the two. On the colour wheel, red and blue appear as opposite colours, thus a red filter will hold back the blue. As hardly any blue can reach the film, any areas that appear blue before your eyes will appear black in the final image. By using a red filter on a sky you can create white clouds against a black background.

The disadvantage of the red filter is that sometimes the contrast it creates is too great. Green is also opposite red on the colour wheel and thus returns darker tones under a red filter. In a landscape picture you could easily end up with a dramatic sky and dark land and trees, which might be too much in the way of dark tone for your liking. Also, patches of water that reflect the blue of the sky will appear dark. So you can see that a red filter, while very useful, can become a problem in itself.

Yellow and orange

Often the answer to the heavy contrast issue is to use a weaker filter. Both orange and yellow will do the trick, as the effect on greens and blues is not quite so extreme. You will still get the detail in the sky of white against blue, but without such a marked

contrast. Of the two filters, orange is the stronger, while yellow makes just a small difference.

Yellow and orange filters have other uses apart from in the landscape. When copying old pictures it is often difficult to attain a decent level of contrast because of the absence of real whites from faded or sepia prints. By matching the base colour of the print with the filter colour as much as possible, you will allow more light from the should-be-white areas to pass, creating a better white on the final print.

There is a favourite trick performed in colleges all over the world, where red wine is spilt onto an important document. The document is then copied using a red filter to allow extra light to pass from that area so that the stain disappears in the final print. As a practical exercise it is remarkably pointless but it does demonstrate the magical power of the filter in black and white image-making.

Green and blue

Green filters obviously make greens lighter and reds darker, as do blue filters with blues and reds. The uses for these two colours are rather more limited in general photography than the warmer colours, but are most useful if you wish to render grass or skies lighter than they actually are.

Filters in infrared photography

In black and white infrared photography the red, yellow and orange filters have a similar effect to that which they have on ordinary black and white film – blues and greens become darker. But the filters also serve to promote the effect of infrared radiation so that things that reflect it will appear white. You will end up with some greens (those of living foliage) appearing much lighter than other greens (a green car, for example).

When we take pictures with colour infrared slide film, filters again have an important part to play. While not actually controlling the quantity of infrared reaching the film in the same way as with black and white film, red, yellow and orange filters will alter the colours used to represent colours and brightness in the scene. There is also a special infrared filter that can be used with either black and white or colour slide film. This filter is not particularly popular since it is difficult to use owing to the fact that it lets no visible light through. Therefore, when it is fitted over the lens, your viewfinder will be black. In black and white photography this filter produces excellent results and a great infrared effect. In colour the effect is a monochromatic version of the black and white film but in black and red. This is also very effective.

Filters, factors and metering

Depending on the filter you are using, there are two different ways of metering. For plain-coloured filters and effects that cover the whole image area, you should fit the filter and then meter in the usual way. With graduated filters there are two schools of thought. One says that you should take a meter reading first from the area which will be covered by the clear part of the filter, set that reading manually, fit the filter and take your picture. The other suggests that you just fit the filter and take an average reading. Both work, but the latter will be accurate only if you balance the light and dark areas perfectly (e.g. by fitting a 0.6 ND grad to compensate for a sky which is two stops lighter than the land). If there is still a discrepancy between the filtered and unfiltered parts of the frame, you should use the first method.

If you do not have a built-in exposure meter, you will have to read off the "filter factor" on the filter case. The factor tells you how many stops to adjust the exposure by when the filter is fitted. A filter with a factor of 4 requires an extra four stops of exposure above the non-filtered reading. The alternative is to hold the filter over the sensor of your hand-held lightmeter.

composition

Landscapes

Lenses in the landscape

The type of lens you choose will alter dramatically the outcome of your pictures (see Chapter 1, page 19). If you were to use too wide a lens in the landscape, you might end up with a mass of bland, uninspiring foreground, while the true focal point of your composition is a pinprick on the horizon. On the other hand, if you combine a wideangle lens with a low viewpoint, you will convey all the drama of the landscape.

Using too long a telephoto lens risks cutting out all foreground interest and other elements which set your landscape image in context. However, its advantage is that it can also compress the "layers" of, for example, a mountainous landscape, to make them seem closer to each other than they would otherwise appear. As ever, it is a question of experimentation and practice, and eventually you could find

it becomes second nature to select the right lens for the type of image you have previsualized.

Exploring the landscape

One of the most common mistakes a photographer can make is to turn up at a wonderful spot, take a couple of quick snaps, then hop back into the car and drive away, assuming the job's well done. While he or she may well have made a decent photograph, nine times out of ten that photograph could have been improved with a little time and exploration.

The way to achieve a photograph which stands out from the rest is to explore the landscape you are in. This might mean walking for a few hours, circumnavigating mountains, climbing hills or fording rivers – but it could also mean simply moving a few steps to the left or right, moving forward

ABOVE & LEFT: **This sequence demonstrates how varying your viewpoint and moving just a short distance one way or another can transform a picture. The top left picture was taken with a 28–70mm zoom at the 28mm end, and shows a lot of foreground, which some might feel is a little distracting. By moving further around the edge of the lake, the photographer was able to exclude the reeds in the foreground, but still use a relatively wide setting – around 35mm. Only a few paces to the left, a log protruded from the water, giving a focal point to the bottom third of the frame. Then, turning the camera on its side, and again moving in one direction or the other, the photographer was able to choose between the simplicity of a log as foreground interest, or the texture of reeds.**

or backwards a few feet (assuming you will not fall into a ravine as a result), or raising or lowering your tripod by a few inches.

Experiment with both horizontally and vertically framed images and consider the difference this makes to the scene in front of you. You might find that framing a sweeping panorama vertically gives an added sense of depth from foreground to background. Alternatively, you might decide that the lake in the foreground which initially appeared essential to the composition is worth sacrificing in order to convey the sense of a 180° view.

If you have a focal point you want to include in your frame – a church, a tree or an interesting rock formation, say – move your camera around to decide whether that focal point looks best in the top right-hand corner of the frame, the bottom left, or even smack in the middle. And don't just shoot it from the first angle at which you come upon it. Walk all around it, studying the foreground and background which will be included in the frame.

The rule of thirds

The rule of thirds is central to all types of photography – not just landscapes. And although some argue it is a cliché, it works almost without fail. Imagine a grid placed over your composition – three vertical lines and three horizontal lines. The theory goes – if you are taking a landscape shot, for example – that your sky should take up approximately the top third, the middle distance the middle third

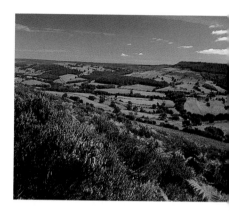

ABOVE: **The decision about whether to shoot a landscape in horizontal or vertical format can drastically change the emphasis of a composition.**

and the foreground the bottom third. Then you might have a nice little rustic barn nestled in one of the four bisecting lines created by this imaginary grid. It's all very pleasing to the eye, and nine times out of ten your result will be a satisfying image. However, after a while you may find that the rule of thirds feels just a little too safe, and the maverick inside you is just dying to take a crowbar to rules like this. Well, go ahead!

Breaking the rule of thirds

If your instincts tell you to plonk your focal point slap bang in the middle of your frame, then follow them. If your instincts tell you to cut out the sky altogether and simply reveal the shapes and undulations in the landscape, then that is worth trying, too. Composition is such a subjective craft that it is

FAR LEFT: **Adhering to the rule of thirds is almost guaranteed to produce a pleasing result.**

NEAR LEFT: **However, breaking the rule of thirds – perhaps by placing the subject in the centre of the frame – can sometimes produce a more dynamic composition.**

Change your viewpoint

Taking a low viewpoint can dramatically increase the impact of a photograph, especially when combined with a wideangle lens. By crouching down low, you suddenly find you have a strong foreground interest with which to draw the observer into the picture. If shooting from a low viewpoint, look out for strong shapes and texture and, in particular, diagonal lines that start from the outer edges of the frame and extend to a point within the frame. Completely still conditions are vital when shooting low down – unless you specifically want a hint of movement in your picture – because you'll need a very small aperture to ensure everything in frame is sharp from the foreground to the background.

The other advantage of a low viewpoint is that it discourages the photographer from including too much sky in

often impossible to say what is right and what is wrong. However, it is not just whether or not to adhere to the rule of thirds which makes a landscape photograph. It also comes down to the type of viewpoint you take.

ABOVE: **The plume of smoke from the factory provides the main emphasis of this picture, with the varying textures of the wet roofs in the foreground adding an interesting contrast.**

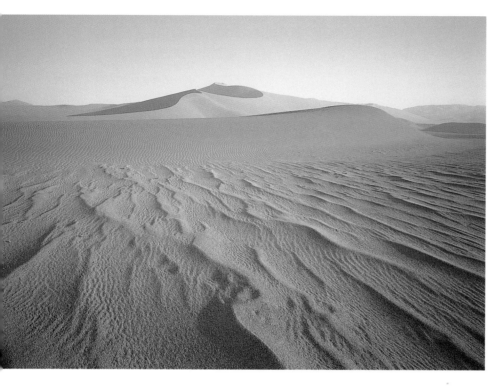

ABOVE: The impression of an empty landscape can be created with a telephoto lens. These isolated-looking rocks are actually part of a very busy bay!

ABOVE: The feeling of dunes stretching to infinity is enhanced by the low viewpoint and the ripples in the sand rushing away from the lens.

ABOVE: Sometimes only minimal detail is required, and subtle light forms the basis of the composition.

the frame, which is a common mistake. Even when faced with spectacular cloud formations, for example, don't be tempted to include too much, as it will lessen the impact of the land. By having just a little of the sky in frame, your photograph will still show the spectacular light, but will have more of a feeling of balance.

Taking the other extreme, you could find a spot which allows you to look down on the landscape unfolding in front of you. This will give an immense feeling of space and will allow you to include the many features – both natural and man-made – which are characteristic of the modern landscape.

Landscape styles

Aside from following the rule of thirds, there are numerous ways of making the composition of your landscape effective.

Empty landscapes

Although landscapes usually need to have a strong focal point, this is the perfect contradiction to that rule. A landscape which is almost entirely without stark features can have just as much effect as one where the viewer's eye is drawn straight to a particular object. You might concentrate on the textures of sand, for example, or the shape defined by a curving river with the sun glinting off it.

Both sunrise and sunset are wonderful times to photograph a featureless landscape, because the shapes and colours alone which are seen at these times of day can be enough to create a stunning photograph. It's also a composition which often works particularly well in the panorama format, as the eye is encouraged to sweep from left to right, almost "reading" the image in the way we would read a book.

LEFT: **A windy day need not spell doom for photography. Often the feeling of movement created by a long shutter speed will add to a composition. Do not be afraid to experiment.**

Movement

The stillest conditions often occur just as the sun rises. By 8 o'clock on a summer morning a breeze is usually blowing, putting paid to anything which requires a small aperture and slow film. For those souls who prefer a few extra hours in bed, do not be afraid to have a touch of movement in your pictures.

It pays, once again, to shoot plenty of film using a variety of longer shutter speeds so you can be sure of getting the best effect. If you find you are unable to get a sufficiently slow shutter-speed reading, even when you stop down to an aperture of, say, f/22, there are other ways of getting there. For a start, you could change the speed of film you are using. An ISO 400 film used in bright conditions is never going to give you a really slow shutter speed, no matter how hard you try. Load an ISO 100, ISO 50 or even ISO 25 film instead. Also, neutral-density filters can cut out up to four or five stops of light – depending on the strength of the filter – thus reducing your shutter speed dramatically (see Chapter 2, page 53).

If you want to convey the merest hint of a breeze in a golden cornfield, you'll need a slightly faster shutter speed than if you want to convey a gale rushing through the tree-tops. When it comes to water, however, it's a little more subjective. Some people prefer a very fast shutter speed which captures every last droplet of a crashing wave, while others prefer a shutter speed of half a second – or longer – which turns wild waves into nothing more than fluffy cotton wool. Who says the camera never lies!

Abstracts

There's no rulebook which states that a landscape photograph has to show a wide, open vista, with miles of countryside rolling off into the far horizon. A close-up can say just as much about our environment and can create a very

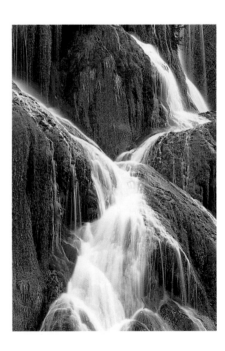

RIGHT: **Rushing water can sometimes be made to seem very peaceful, when a long shutter speed is used. Often, too, it is only on seeing the photograph that the route of a waterfall is revealed.**

ABOVE: **Always keep your eyes open for unusual compositions. Here, the strongly contrasting colours – and the fact that there are only two of them – emphasize the sharp, diagonal lines.**

Making a final check

Once you are happy with your composition, take a few moments to study the viewfinder. This could prove invaluable. It is at this point that you might notice the foil sweet wrapper which is perfectly placed for the sun to glint off it, or the unattractive dried-up grasses straying into the bottom of your frame.

The other extremely important thing to look at is your horizon. Is it completely straight? When taking pictures, many people concentrate so hard on what is in the foreground of the frame they completely forget to check the horizon, leaving it to appear as if it is sloping off to one side instead of being perfectly straight. If you find this is happening a lot in your pictures, it is worth investing in a small spirit level to ensure your camera is completely balanced. This final check does not take long, and it could save a lot of disappointment when you get your pictures back from the processing lab.

pleasing, almost abstract image of shape and texture. The natural geometry of leaves makes a perfect subject, as do icicles, grasses and, of course, flowers. Think carefully about the colour of your subject when shooting abstracts – one uniform colour can work just as well as an image which has a backdrop of colour and a focal point in a contrasting shade.

Framing

One of the most pleasing ways to lead your viewer into a landscape photograph is by framing a distant focal point with an object in the foreground. Boughs of trees do this perfectly, as do gateways, arches and other architectural features. They can also hide a multitude of sins, including dull, featureless skies or other objects which would otherwise be an unsightly intrusion into the frame. If you find a tree which provides a perfect frame to a feature, take care not to have just a few branches incongruously dangling into the top sliver of your frame. Instead, include the branches and, if possible, the curve of the trunk. It will bring the composition together a lot more coherently. A small aperture is vital in these circumstances so that your frame and your background are both sharp.

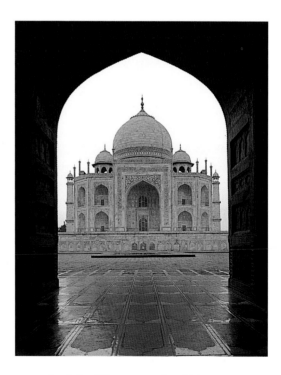

ABOVE: **Look for different ways in which to photograph well-known subjects. This composition works particularly effectively because the shape of the frame echoes the dome of the Taj Mahal beyond.**

A question of format

So far throughout this chapter we have assumed that all landscapes are shot on a 35mm-format negative or transparency. However, you do not have to look far to see that some of the best landscape photographers working today do not by any means always use a rectangular format. It is important to be aware that if you change format, you also have to alter the way you compose your picture.

6 x 6 cm

To many people, this is an unnatural format for landscape photography, as the square shape does not lend itself to the wide sweeping vistas we normally associate with the great outdoors. However, it is the chosen format for some renowned landscape photographers such as Charlie Waite. The rule of thirds was not written for this format, either, but when using a 6 x 6 cm format, you should look out for a strong, sizeable focal point, preferably towards the foreground of your picture. Avoid dividing the image precisely in half, especially if the sky is uninteresting, as this sort of symmetry works less well in the square format.

6 x 7 cm

Although there is only a centimetre's difference between this and a square format camera, they are worlds apart in terms of composition. This format is similar to the rectangular format that 35mm users are accustomed to, but allows the cropping out of too much bland sky or dull foreground. A format that works particularly well when the camera is turned on its side, it is an ideal route to a pleasing composition.

5 x 4 in.

This is the one format that sticks resolutely to the imperial measurement system! While the cameras are extremely heavy (you might want to hire a pack pony for particularly inaccessible locations), you may find that the huge leap in quality from 35mm makes the weight worthwhile. Compositionally, you would need to think in a similar way to when using 6 x 7 cm, but the main point in this format's favour is that the camera will considerably reduce the speed at which you work. That is because it is a fiddly camera to use, and the whole process is enjoyably laborious. However, so is landscape photography, so the two are perfectly suited!

6 x 12 cm and 6 x 17 cm

The panorama format is perfect for use in the landscape. It is a difficult format to master, as the long frame needs to be filled with visual interest across its whole area. However, the effort is worthwhile as the results often provide the most dramatic visions of space. The 6 x 17 cm format, in particular, is immensely tricky, as its letterbox format is a demanding one to work with, but it is worth it for the novelty of turning it on its side from time to time for an upright panorama picture.

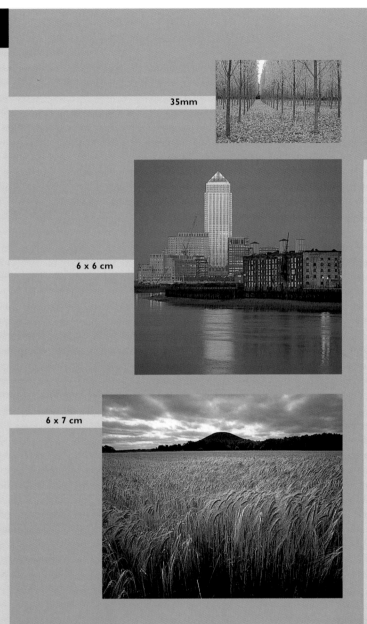

35mm

6 x 6 cm

6 x 7 cm

5 x 4 cm

6 x 12 cm

6 x 17 cm

Animals and nature

Composing nature photography is something you cannot rush. A photographer might wait an hour, a week or even a year for the right conditions in which to photograph a wildlife or botanical subject. But when the moment arrives, it does not tend to last long. Once you have the perfect conditions, they might last just a few minutes – for example, a bird of prey flying down to some bait which you have placed. Or they may last a few hours – such as a stage in the life-cycle of a butterfly. Some may last only a few days – for example, bluebells at their best. If you have patience on your side, the subject of nature and wildlife is an extremely satisfying – and vast – area of photography.

Start at home

You do not have to go on safari to Africa to get outstanding and characterful photographs of animals. If you have a pet – whether it's a humble hamster or an aristocratic afghan – home is often the best place to start. You know the behaviour of your pet, what it reacts to and any tricks it might perform for the camera.

If you don't keep pets, just head for your back garden. A wealth of wildlife photographic opportunities exist in even the smallest, simplest outdoor space: a dew-laden spider's web with a spider lurking in the centre, waiting for its next prey; a close-up of your prize roses, the red, velvety petals filling the frame – with or without a photogenic bumblebee gathering pollen; or simply a group of boisterous sparrows feeding from a bird tray. Slightly further afield, zoos, safari parks, wildfowl sanctuaries and rare-breed farms are just some of the places where opportunities for great animal photography exist.

Go down to their level

Whether you take most of your pictures through the bars of a rabbit hutch, or out in the Serengeti, the rules are fairly similar. First and foremost, the majority of the animals you will be photographing are likely to be much smaller than

ABOVE: **This characterful animal portrait works for several reasons: the cat has been placed slightly off-centre, its languid expression has been captured, and the backlighting draws attention to the texture of its fur.**

you, and you will not normally get a good picture by standing over the creature and photographing it from above. (The obvious exception to this is when you are in a helicopter hovering above the Florida Keys as several thousand pink flamingos take flight!) Therefore, you must be prepared to get dirty in your pursuit of the perfect picture, because when you photograph animals you will spend a great deal of your time either crouching down very low or even lying flat on your chest in the mud.

Ideally, you should shoot with your lens looking up at the animal's eyes, rather than down at them. Obviously, this is not always possible, but if you can manage it your pictures will have more impact as a result.

LEFT: The simplicity of a dew-laden web is best photographed with a shallow depth of field, so that the background is out of focus and does not distract from the composition.

ABOVE: By filling the frame with the poppy, the impression of size – and the petals continuing out beyond the edges of the picture – is created, while attention is drawn to the detail in the centre of the flower.

LEFT: Getting right down to eye level cannot be beaten with animal portraits: all the impact of this seal's doleful eyes would have been lost if the photographer had been standing up to take the picture.

Fill the frame

Whether closing in on a beautiful flower or a monkey at the zoo, if you frame your subject very tightly, the resulting picture will be far more dramatic than one which has a lot of extraneous background. Think of it as a classic animal portrait, where you want the viewer to concentrate on its features, the texture of its fur or feathers and to have eye-to-eye contact with it.

This is where a long telephoto lens will prove invaluable, and if animal photography is something you plan to do a lot of, it is worth the investment. Alternatively, teleconverters are of reasonable quality these days, and will provide more than satisfactory results. Using a longer lens will also throw the background out of focus, which helps to concentrate attention on the main subject and can help to disguise the fact that you photographed the animal at the zoo, and not in its natural environment.

ABOVE: **Close in on a subject to give your viewer a different perspective on a creature. Here, attention is drawn to the colour and texture of the fur of a Highland bullock.**

RIGHT: **Most people would be wary of a cayman, and their crocodilian relatives – and with good reason, as demonstrated when a telephoto lens is used to zoom in on a specimen's teeth.**

ABOVE: **Looking at these poppies from a low viewpoint gives the impression of the flowers growing up towards the deep blue sky.**

Give it some space

On the other hand, you could ignore all the advice about filling the frame. The result might turn out to be a photograph which is much more striking and dramatic than an ordinary animal portrait. Look at your subject's surroundings. If they would add to rather than detract from your final image, think about including them. Simple is still best, however, so try to isolate your subject against a plain background, whether or not you intend to include its surroundings.

Look at the shapes created by the animal's environment. The more stark and graphic the shapes are, the more they are likely to enhance the picture. For example, your result

BELOW: **This composition says something very different from the seal portrait on page 73. Here, its surroundings are emphasized, showing how the animal tones in with the colours, while its raised head echoes the shape of the rocks in the top half of the frame.**

ABOVE: **Quick focusing skills and a motor drive are helpful with any type of action photography. The duck's outstretched wings add dynamism to the composition.**

will be much more successful if you photograph a bird sitting in the branches of a dead tree, isolated against a plain blue sky, than if you photograph a creature which is partly camouflaged by its environment.

Animals in action

This is where the fun really begins. Animals are not instinctively inclined to remain in one place for any length of time (apart from sloths), so some stylish action shots are ready to be captured when your subject takes flight, takes to its heels or takes a dislike to you!

For a successful action shot you need to have your camera and lens braced firmly, with enough room to pan along with your subject as it moves (see "Perfect your panning technique" below). Experiment with shutter speeds either

to capture the animal completely crisply, or else to get an effective smidgeon of blur to convey the sense of movement. Bear in mind the advice on composition mentioned already – that is, you must decide whether to fill the frame with one animal – or, indeed, a group of animals – or to show the animal within its natural context.

Perfect your panning technique

Panning is a vital technique to learn if you want to take action shots of any subject. It involves releasing the shutter while you follow the animal or bird with your camera, which should be moving at the same speed as that of your subject. The subject will appear sharp or slightly blurred, depending on the shutter speed you choose. The slower your subject, the slower the shutter speed you can get away with. One of the advantages of panning is that it will blur the background, and intrusions which would otherwise have been a distraction are rendered as streaks of colour.

Keeping camouflaged

If you are serious about photographing wild animals in their natural habitat, be prepared to work hard for it. Perfect your skills on more common subjects which are easier to come across, so that when you are camouflaged up to the eyeballs in your hide at 5 o'clock in the morning, with nothing but a flask of coffee for company, the technique of photographing the animal you have been stalking for the past few weeks is second nature. The last thing you want to be worrying about when the badger, red squirrel or peregrine falcon finally arrives is whether you turn the aperture ring left or right in order to get f/5.6.

LEFT: A creature as timid as a badger can only be photographed from a hide, to which the animal must first become accustomed, and in which the photographer must be in place at least an hour before the animal ventures out to forage.

Hides

Portable hides are available nowadays at quite reasonable prices. Once you have found the spot where you will be working, set up the hide and leave it in place for a few days so that any animals or birds become accustomed to it. Although a hide is made from camouflage fabric, it will also pay to "decorate" it with foliage from surrounding trees. Learn the times at which your subject is in the vicinity, and arrive at the hide at least an hour beforehand, so that you are ready when the action takes place. Most important, wear plenty of layers to keep warm, and take food and drink with you.

Clothing

If you need to stalk your subject, you will need camouflage clothing to break up your outline and make you stand out less against the background. Coats, trousers and baseball caps are all available in camouflage prints, as are simple pieces of cloth, which can prove useful for covering long lenses. If you are stalking a particularly sensitive animal, do not wash this clothing after wearing it, because the creature will be able to smell the washing powder you use!

ABOVE: Natural colours and shapes, as well as foliage, help break up the outline of a hide or a lens, making it less noticeable.

The car

Believe it or not, this is one of the best forms of camouflage around! Many animals have become so accustomed to roads and vehicles that they now take no notice of them. So if you know that a particular animal hangs around the roadside, simply park your car and wait. Shoot by resting your lens on the top of the open window.

Portraiture

Theoretically, people should be one of the simplest subjects to photograph as they are by far the most prevalent. We are surrounded by them every day, we know how to interact with them and we can tell instinctively in a lot of cases what will annoy them and what will entertain them. Why, then, do so many portraits turn out differently from how we intended them to? Very often it is because the photographer is ill-prepared, with little idea of what he or she wants from the portrait session. Therefore, the answer is to make decisions and have everything in place well before bringing the subject into the equation. If the person is unaccustomed to being photographed, it is likely that they will be slightly nervous or feel awkward, so the last thing they need is to be made to hang around while the photographer fiddles with lights and backdrops, unable to decide where the person should sit, what they should wear and how they should pose.

A perfect starting point is to prepare by studying portrait photography in books and, in particular, magazines. There's no harm at all in trying to replicate pictures you like in order to learn about how people look and act in front of the camera. Then, once you have acquired the nec-

essary techniques, you can allow your imagination to run wild. However, do not be misled into thinking that portraiture has to involve a studio, with complex lighting arrangements and a professional model. Portraiture is just as much about real people in real surroundings as it is about a formal studio set-up. The main aim should be that you and your subject enjoy the session – at least that way they will be more likely to come back again another time!

Posing techniques

The secret of a successful portrait lies in the pose. If the person looks awkward and unhappy in front of the camera, it is probably because of the pose you have chosen for them. And unless the person you are photographing is a politician or a model, they will not be able simply to turn on the charm for your camera. They will need a bit of guidance. First, make them feel relaxed by chatting with them. As soon as they are talking about a subject that interests them, they will be less aware of the camera pointed at them. Some photographers suggest you should not even load a film for the first dozen or so shots, while your subject relaxes and learns to become accustomed to the camera.

BELOW: **If your subject stands straight on to the camera, it does not produce an interesting portrait. Slight changes in the angle at which this model faces the camera, as well as relaxed hands and arms, make all the difference, as this sequence shows.**

The face

A close-up of your sitter's face is a very strong form of portraiture. As there are no distractions from the backdrop, their expression is vital and will say a lot about the person.

A composition which shows them looking directly at the camera will have a great deal of impact, while one where they have turned their head very slightly one way or the other will send out an altogether different message. Experiment with high and low angles, but always concentrate on the eyes, making sure they are in pin-sharp focus – you will not get away with anything less when you crop as tightly as this. Cropping in this way will show up every flaw in a person's skin, so it is ideally suited to character portraits.

Head and shoulders

Because a head-and-shoulders portrait reveals more about the person and the backdrop, there are more factors to take into consideration. This includes what they are wearing and the position of their hands (see "You need hands", page 82). A good starting point is to angle your model's body and shoulders at 45° to the camera. This is more attractive and visually interesting than if they were square to the camera, and also allows you to try numerous different poses, simply by altering the position of their head and eyes. The rule of thirds also applies in portraiture, so you should frame your shot so that the person's eyes are in the top third of the picture. Experiment by tilting your camera at a slight angle, being aware that diagonals create a more dynamic composition than straight lines.

Full length

There's nothing more awkward-looking than a picture of a person standing ramrod straight, square on to the camera, in front of an irrelevant backdrop. If you want to take a full-length portrait of someone, there are numerous ways to go about achieving a successful picture. Should you want the person to be standing, then give them something to lean

ABOVE LEFT: Closing in on a person's face is a very effective way of making character portraits.

LEFT: Be aware of where your subjects' eyes are in the frame: notice here how both girls' eyes are almost on the same plane.

against. This might mean framing them in a doorway, or behind a gate, for example, so they can lean against it in a relaxed fashion.

The other option is to have them sitting at ease on a chair or some steps. Something for them to rest their elbows on would be helpful. Again, bear in mind the advice about the body being turned 45° to the camera, mentioned above, and shoot at around shoulder level to avoid any apparent distortion.

Posing more than one person

If you are faced with a group of people, the task of posing them becomes altogether more complicated. Try to position them so they fill your frame, and make sure they are all placed at different heights. This is most easily achieved by having at least one person sitting on the floor or ground, one on a chair or other object, and one standing. Vary the angles of their bodies to the camera, and keep arms and legs discreet so that they do not form a distraction. Try to

LEFT: **If the person feels awkward standing up, place them in a relaxed sitting pose instead – a full-length portrait does not have to mean the person stays on their feet.**

BELOW: **A photographer should always make sure that colours and textures complement one another. Simplicity is often the key to a successful portrait.**

Backgrounds

The backdrop you choose for a portrait is almost as important as the person you are photographing. Keep it simple, as anything too complex or colourful is going to be a distraction. Try to relate the backdrop to the subject and think about what you are trying to say about that person. For example, a character portrait of a manual worker, such as a miner, could look very striking set against a backdrop of the machinery operating the mine in which he works. However, equally effective could be a completely plain white background — this would draw attention entirely to his features and clothing, which would reflect his work.

Classic portraits can be complemented by fabric backdrops. A huge range of colours and patterns can be bought ready-made nowadays, a muted, mottled effect being the most versatile. But there is nothing wrong with using a wall or even the sky as a backdrop, if it relates to your subject and results in the kind of picture you are looking for. If you want the background to be as unobtrusive as possible, use a telephoto lens, which will throw it out of focus, or set your lens to its widest possible aperture.

LEFT: **The background of a wooden building suggests something about the accordion player's environment.**

LEFT: **A plain, uniform backdrop draws attention only to the subject, with no distractions.**

LEFT: **Do not underestimate the power of the sky above as a backdrop.**

You need hands

RIGHT: **A person's hands can say as much about them as their eyes or face, suggesting age, work and even personality.**

NEAR RIGHT: **A strong, firm position of the hands makes the subject appear confident.**

FAR RIGHT: **If your subject's hands seem awkward, ask them to do something which occupies their hands.**

You can tell a lot about a person by their hands, the saying goes. In a photograph, you can certainly tell how relaxed a person is by the position and tension in their fingers. The fingers should not be bent too tightly, and if your model is resting their chin on the hand, ask them not to lean too heavily on it. Avoid resting the chin on a fist as it is too similar a size to the face, and will be very distracting.

LEFT: The father and daughter facing each other makes a more intimate portrait than if they had been looking at the camera.

have some sort of interaction between the people, whether it involves linking arms, or resting a hand on the back of a chair. The most important thing is to make it appear as if they all belong in the photograph together, rather than each person being an individual standing next to another individual.

ABOVE: Make sure your subjects have fun when you photograph them!

Candid portraits

Spontaneous, candid portraits of people are one of the best ways of summing up a person's character. The only problem is, because of the nature of this kind of portrait, you might not make the most of the opportunity. Building up the nerve to approach someone and persuade them to pose for you can often mean that all thought of composition flies out of your head in your hurry to take the picture and allow the person to go on their way.

Avoid just 'snatching' a picture without asking first, as it will irritate them — at the very least! In these circumstances it is often a good idea to work backwards. First, find a spot which provides an interesting backdrop, then wait for someone to come along. If you ask politely — even if you do not speak the same language — more often than not the person will agree to being photographed. If you cannot quite work up the nerve, wait for a group of children to come along. They are usually more than willing to ham it up for your camera, and can be a relaxed and fun subject for a portrait.

Flattery will get you everywhere

Let's face it, none of us likes an unflattering photograph of ourselves, and you are more likely to please your model and make them willing to be photographed again if you take a few points into consideration. The first is your choice of lens. If using a 35mm camera, the classic portrait lens is the 105 mm. If you have a zoom lens, set it at around this focal length, or slightly longer. Bear in mind that the wider the lens you use, the more distorted your model's features will be.

A double chin can be minimized in a photograph if you ask your model to lift their chin very slightly and look up at the camera when shooting just their face, or head and shoulders. If your subject is sensitive about a bald patch, shoot at a slightly lower angle and have them looking down towards the camera. To avoid chunky upper arms, do not let your model squash them close to his or her body. Instead, keep a distance of a few inches between the arm and the side of the body.

Still life

If it is pouring with rain outside and there is no chance of taking any landscape pictures, or if you cannot find a subject willing to let you take their portrait, then take a look around you. Seemingly everyday objects can take on a whole new meaning when turned into a still-life photograph. It is a precise skill, which above all requires patience and experimentation.

Often it is the most ordinary subjects that can provide interest in a still-life composition, especially if several items are brought together which conjure up a mood or feeling.

ABOVE: As with many subjects, simplicity is often the key to a successful still life. Muted colours combine to reflect the different props, while the shape of the apple echoes that of the plate.

Even a simple flower or piece of fruit is a perfect subject for a subtly lit still life. It is also a photographic subject which is perfect for hoarders, as collections of old and bizarre objects gathered from junk shops and car boot sales are ideal items to bring together in a still-life picture. And now, if you discover a liking for still-life photography, you have an excuse for collecting even more!

ABOVE: **This is a particularly clever composition, as it suggests the chicken has left a feather as its calling card, instead of a sixth egg.**

BELOW: **Natural subjects also make good still-life compositions. In this case, the white space created in between the leaves' edges is as important and eye-catching as the leaves themselves.**

Keep it simple

Never has simplicity been more of a watchword than with still-life photography. Whatever you include in your composition, it has to have a reason for being there. A selection of random objects which bear no relation to each other will just look incoherent and confusing in the final picture.

Avoid cluttering the picture with too many objects as, again, this will simply become confusing. Instead, start with one object, adding another, then another, until you have a composition that works. Think about the shapes and colours created by the objects you have chosen, and try to make them work harmoniously with each other. For example, contrast curved edges with harder straight lines.

Backgrounds and textures

As with portraiture, the background used in a still-life composition is equally important as the objects you are photographing. It can complement or contrast, but again, you need to consider why you are using a certain type of background and what relevance it has to the photograph. Anything goes, whether it's a plain piece of white card to emphasize a black object, a strip of tin foil for a high-tech, futuristic appearance, or a piece of hessian sack for a rustic feel. It is also very easy to paint your own backdrops, but one of the best solutions is to raid your local toy shop for some Plasticine. It comes in a range of colours, you can mould it into any shape or texture, and when you've taken your shot, you can simply roll it into a ball and store it indefinitely — assuming your kids don't get hold of it first!

Think about the feeling you are trying to conjure up when you are composing a still life. If you have a pile of rusty nails, for example, they might work well against a backdrop of peeling paint, to emphasize the idea of decay. On the other hand, a completely plain, smooth background would draw your viewer's attention to the shape and texture of the nails themselves.

RIGHT: The stunning velvety texture and rich colours of the opium poppy are emphasized fully by the use of a plain, black background.

natural light

Understanding natural light

A successful photograph depends very much on the quality of light. And the quality of light is determined chiefly by four factors, all of which work in harmony (or otherwise) with each other to influence your resulting photograph.

Height

Early in the morning and late in the afternoon, when the sun is low in the sky, it produces long, raking shadows which are perfect for landscape photography. These shadows mould and shape the land, revealing textures and outlines within the scene. When the sun is at its peak – around midday – highlights tend to be washed out, while shadows are much darker, but it is a good time of day for the light to reveal bold, graphic shapes.

Direction

One of the earliest rules photographers learn is to keep the sun behind them when shooting. Although this is reasonable enough for basic photography, it is a theory that soon runs into problems. If you are shooting a portrait and your subject is facing the sun, they will squint – and

that is not too attractive. However, frontal lighting can be useful – if slightly bland – when you simply want to record detail, as the shadows will fall behind the subject. When the sun shines into your camera it can cause flare and – far more serious – damage your eyes. But it can also be a wonderful device for anything from dramatic silhouettes (see page 101) to subtly backlit flower pictures. If the light comes from the side to shine across your picture, the shadows formed help create depth.

ABOVE: **With the sun low in the sky, long, raking shadows are thrown.**

ABOVE: **Strong overhead lighting is unsuitable for many subjects, but in this case it emphasizes the whiteness of the statue and the Leaning Tower of Pisa beyond.**

LEFT: **A beautiful palette of intense colours can often be created at the end of the day – even if it is the result of pollution!**

Colour

The colour of light also changes throughout the day (see "Colour temperature", page 94). At the beginning and end of the day, light tends to be warmer because less white light can penetrate the thicker layer of the earth's atmosphere at these times. There can be variations even within this warmth, making them excellent times of day for photography. As the sun rises higher in the sky, more white light comes through and this makes the warmth of earlier in the day disappear.

Contrast

Intense sunlight produces the highest contrast between bright and shadow areas. While this is great for very bold, graphic images, photographers often make the mistake of assuming it is the best light to shoot in. However, highly contrasting scenes can be difficult to meter, and some of the detail usually has to be sacrificed because no camera film – despite the wonders of modern technology – can cope with a very extreme contrast range. If you find yourself in a situation where you can photograph a particular scene only in highly contrasting light, you must decide which part of your photograph is the most important, and meter for that.

LEFT: **Directional side-lighting reveals a strong contrast between highlight and shadow areas.**

The elements

It goes without saying that none of the factors which determines quality of light is a constant; each one is independent of the other, and can change many times throughout the day – sometimes very rapidly. This is due, in part, to the bugbear of all photographers – the weather. It can be our greatest ally or our worst enemy, and comes and goes as it pleases, often thwarting our best photographic intentions. But do not be put off. Good results can be had from most types of weather – you just have to be prepared.

Sunshine

Plain, blue skies do not make the most exciting complement to a landscape, nor is direct sunshine ideal for portraiture, so sunny conditions are often best for photography when combined with another element: shafts of sunlight breaking through a cloud, or backlighting a scene, for example.

Rain

This brings out the coward in the hardiest of us! But do not automatically abandon your camera if it is pouring. Rain is wonderful for cleansing the atmosphere and intensifying the colours of nature. It can also be fun to photograph people as they try to go about their everyday business while wielding umbrellas and fighting the elements. And it is hard to beat gathering stormclouds on the horizon, while sunlight bathes the foreground, for a dramatic backdrop. You might even be lucky enough to end up with a rainbow to add the finishing touch to your shot.

Wind

While perfectly still conditions are desirable for many types of photography – especially if you want to photograph anything involving reflections – the wind can add a dynamic twist to a picture. Use a range of long shutter speeds to capture its effect.

RIGHT: **Rain not only adds an extra dimension to many natural subjects, but also intensifies their colours. If no rain is forthcoming, cheat by using a plant spray!**

LEFT: **Rising mist early on a frosty winter's morning might mean dragging yourself out of bed before dawn – and enduring cold feet – but the results are worth it.**

ABOVE: **Clouds can form a fundamental part of a composition, particularly if they echo the main subject.**

Mist

Early-morning mist or fog is wonderfully atmospheric, and often has the added advantage of cutting out clutter or background detail which would spoil the photograph under clearer weather conditions. It is particularly photogenic when complemented by a rising sun to backlight the scene. Just be prepared to rise early to catch it!

Cloud

Cloud formations are often essential to a landscape photograph, since a plain, blue sky is rarely inspiring from a compositional viewpoint. Some landscape photographers are on a constant quest for the perfect cloud formation which echoes the shape of the land below. Do not underestimate the importance of bright cloud cover, either. It provides an immaculately even spread of light which cannot be beaten for portraits, or for lighting still-life compositions. And remember also that diffused light from a north-facing window can give just the even dispersal you need.

Frost

The sparkle of winter frost on leaves and grasses is a compelling reason for braving the cold, armed with your camera. Ordinary dried-up leaves take on a whole new appearance, and the best thing is that it can all be found in your own back garden!

The time of year

Not only does the quality of natural light vary throughout the day, it also varies throughout the year, so a picture taken in winter can look very different from one taken in spring – even after taking into account the

ABOVE: **A scene such as this would be quite ordinary without the crisp, sparkling frost that adorns the grasses in the foreground. A low, backlighting sun brings out the detail.**

seasonal changes in the environment. One of the advantages of shooting during the winter is that the sun is never directly overhead, unlike in the summer. Therefore, on a sunny winter's day, you do not have to get up quite so early as you would in the summer, because shadows stay long throughout the day, and the light is not as harsh as it can be during the summer months.

BELOW: **Some subjects look good throughout the seasons. To make a sequence such as this, you must mark exactly where the legs of your tripod were placed, and make a note of its height. Take the previous season's picture with you each time for reference.**

The time of day

As we have just seen, the time of day at which you choose to take your photograph is crucial to the result, since the quality of light varies enormously over the period between sunrise and sunset. In fact, it can even change quite profoundly within the space of a few minutes.

Plan ahead

Relying on natural light to give you the perfect result is, to say the least, a hit-and-miss affair. It can also be infuriatingly frustrating. However, there are certain plans you can make to ensure the time you spend taking a picture is worthwhile. First, you should make the most of the weather. You

This sequence shows how the colour of light changes in hue and intensity throughout the day, resulting in an entirely different picture each time.
TOP LEFT: **Before sunrise.**
TOP RIGHT: **Sunrise, 6.30 a.m.**
BOTTOM LEFT: **Midday.**
BOTTOM RIGHT: **Sunset.**

may have found the perfect location, and have set your alarm clock for 4 a.m. to be there in plenty of time for the first rays of light to be creeping over the horizon, only to wake up to a relentless drizzle. Unless you are sure it will be completely worthless to visit your location, resist the temptation to go back to sleep. You may find that the scene has benefited from the rainfall because its natural colours have become saturated as a result. Or you may arrive just as the first rays of sunlight break through the cloud. Or the rain may have created a subtle, ghostly mist which is floating over a pond.

Conversely, it would be disastrous to turn up at your location at sunrise, only to discover it has no light to speak of in the morning, but is absolutely glorious as the sun begins to set in the evening. When you find a place you know you want to revisit with your camera, use a compass to determine the direction of the light, and to work out what time of day will be best to bring out the qualities of that place. It may be that the scene – particularly if it is a wide, sweeping landscape – is photogenic both early and late in the day, but has very different qualities at both those times. For example, the view down onto a meandering river in a valley could look fantastic both lit from the front – when every detail in the landscape stands out – and when backlit at sunsets – with the river rendered as a silver strip flowing from a silhouette of hills beyond.

Colour temperature

This is one of those technical terms that tends to scare off photographers who are less keen on the scientific side of the craft. However, it is not something to be afraid of, and can be understood quite easily.

Imagine a piece of dull, black metal being heated in a furnace. As it warms, its colour will begin to glow a dark red.

RIGHT: Overcast, misty conditions bring down the colour temperature, resulting in a cooler image. This can often be atmospheric, but if you prefer to correct it, you can use a warm-up filter.

ABOVE: **A clear blue sky such as this can have a colour temperature of more than 10,000K.**

LEFT: **The warm, orange light which characterizes the end of the day is perfect for atmospheric and flattering portraits.**

After a longer period in the heat, it will go through a brighter red stage, then yellow, then white. The colour temperature scale works in the same way. Expressed as degrees Kelvin (K), colour temperature is based on the standard of midday sunlight, which is 5500K. The standard film used by photographers is daylight balanced, which means it is designed to reproduce colours completely accurately in this standard daylight of 5500K, or with flash. Anything cooler or warmer than this will produce a colour cast. Although colour casts can be filtered out at the printing stage if you are using colour-negative film, the only way round them when shooting on slide film is to correct the cast with filters. However, it should be remembered that sometimes the filter-free results can be very pleasing. It is unlikely, after all, that you would want to filter out the effects of a glorious sunset so it appeared less dramatic on film. You need to be aware none the less of the effect of colour temperature on your results.

Colour casts

Shooting on daylight film in light with a colour temperature below 5500K will result in a warm, orange colour cast, while a colder, blue cast is the result of shooting in conditions where the colour temperature is higher than 5500K. Rather than correcting these casts every time, you might prefer to leave them as they are, or even emphasize them further. This can be done by adding one of the blue 80 series filters to an already cold scene, or by using a warm-up 81 series filter on a warm, evening scene. But use them with restraint – you don't want to overdo it!

Outdoor temperature

Natural light is surprising in its wide range of colour temperatures. Early morning and evening light has a colour temperature of between 3000K and 4000K. Average noon daylight has the standard colour temperature of 5500K, but this figure alters according to the cloud cover – or lack of it – in the sky. It is a surprise to learn that skylight (which is blue) has a higher colour temperature than sunlight (which is white). The overwhelming strength of the sun is what brings the temperature down to 5500K, although a clear, cloudless sky can have a colour temperature of more than 10,000K.

Clouds also affect colour temperature drastically. A blue sky combined with a scattering of clouds will have a temperature of around 9000K, because the clouds can block the sun, so the blue sky dominates. It is for this reason that shadow areas on a bright day will often display a blue cast. An overcast sky actually combines skylight and sunlight more evenly, thus reducing the colour temperature to 7000K or thereabouts.

The chart below gives some general guidance on the types of filters to use for correcting excessive colour casts.

Light source	Colour temperature	Correction filter required
Clear blue sky	10,000–15,000K	Orange 85B
Open shade in summer sun	7500K	81B or 81C warm-up
Overcast sky	6500–7500K	81C warm-up
Noon sunlight	6500K	81C warm-up
Average noon daylight	5500K	none
Electronic flash	5500K	none
Early a.m./late p.m.	4000K	82C blue
One hour before sunset	3500K	80C blue
Sunset	3000K	80A blue
Tungsten photopearl	3400K	80B blue
Tungsten photoflood	3200K	80A blue
100W household lamp	2900K	80A + 82C blue
Candle flame	2000K	80A + 80C blue

Low-light photography

Just because the sun has set over the horizon, it does not mean you have to pack up your camera and head for home. The magical period of twilight – sometimes all too brief – between sunset and nightfall, when the sky is inky blue-black and street and house lights begin to shine, can provide some wonderful opportunities for truly creative photography. The resulting photographs, as the last fragments of light disappear over the sea, or as bright neon lights reflect in a puddle, can convey a tremendous sense of atmosphere. While low-light photography brings with it a certain number of specific considerations, once you have tried it a few times you might well find yourself hooked. For successful low-light photography, there are several factors you must take into account.

Subject

Without a doubt, cities and towns are the best subjects for low-light photography. The huge variety and quantity of artificial light sources which are found in the average town balance perfectly with the pinky-blue sky which is charac-

teristic of the hour before nightfall. Anything from a wide hilltop view looking down over a town, or a closer composition of a bridge over a river with reflections in the water and trails from car headlights (see page 186), to a close-up of a neon light will be a suitable subject for your camera. And do not be put off if the weather during the day has been dull or rainy. Even on the worst days, there is usually a hint of colour in the sky at twilight, and the reflections of streetlamps off rain-soaked pavings or in puddles can be very photogenic.

Although successful photographs can be made right into the darkness of night, the backdrop of a sky with a hint of colour in it is far more photogenic than large blacked-out areas of the sky after nightfall.

Give yourself time

The most important aspect of low-light photography is to get to your spot in plenty of time – certainly well before sunset. This will give you the chance to set up your camera and tripod properly, and to tweak your composition until it is just right. The longest you will ever get during twilight is about an hour, so the last thing you want to do is to turn up just after sunset and rush the job so that you only get a couple of decent shots – especially given that your pictures may run into exposures of several minutes, depending on the light levels and the speed of film you are using.

Exposure

With the huge variety of light sources and light levels you find in the average town, your camera's meter is likely to get a little confused. So don't place all your faith in your camera's automatic TTL meter. As with any metering you do, you need to decide what you would like to be the mid-tone and meter for that. If you can, take a meter reading from close up, then manually set your exposure on the camera and move back to your spot to take the picture. By taking a reading in this way and setting it manually, you will avoid the camera's meter being distracted by the large areas of dark sky and exposing for that, instead of the lights. The extreme brightness of some city lights means they will burn out during a long exposure, but most people can live with this as it often enhances the picture.

Film

Just because you are shooting in low light, do not assume you need a faster film in order to get a good result. In this case, in fact, the opposite is true. Low-light photographs taken on slow film of ISO 50 or 100 will display far more richness, saturation of colour and clarity than those taken using a faster film. Whatever speed of film you use, you will need to have your camera on a sturdy tripod anyway, so you might as well expose for a

ABOVE: **Reflections in rain-soaked pavements are clearer at the end of the day, during twilight.**

little longer and achieve the superior quality given by the slower films.

Bracketing

As the varying light sources at this time of day are so unpredictable, and because the natural light changes constantly and rapidly, it is essential to take meter readings as often as possible so you can alter your shutter speed or aperture accordingly. It also means sometimes that the only way to guarantee a satisfactory result is to bracket as much as possible. While bracketing is normally associated with both underexposing and overexposing around the recommended meter reading, in low-light

photography it is only necessary gradually to overexpose. Therefore, if your meter reading suggests f/11 and 15 seconds, you should expose for that reading, then take bracketed pictures. However, because of reciprocity law failure (explained below), it is advisable to bracket by opening the aperture, rather than lengthening the shutter speed. Try not to use a shutter speed of more than 30 seconds as anything longer than this will make your results more difficult to predict.

ABOVE: **The New York skyline is brought out to perfection just after sunset, when its sea of artificial lights balances with the colour of the sky.**

Reciprocity law failure

As we already know, the reciprocity law dictates that the exposure given by f/5.6 and 1/250 second is the same as f/8 and 1/125 second, which in turn is the same as f/16 and 1/60 second, and so forth. The majority of daylight-balanced colour films will not have any problem coping with shutter speeds of 1/1000 second down to one second. Beyond one second, however, this relationship between shutter speed and aperture becomes unreliable and can result in under-exposure. This is known as reciprocity law failure.

Film characteristics

The point at which an emulsion fails varies from one man-ufacturer to another, and from film to film. However, all manufacturers will be able to inform you of the character-istics of their films, and – best of all – new films are being launched onto the market all the time which are less sus-ceptible to reciprocity law failure. The best advice is to stick closely to the guidelines recommended by the manufactur-ers, but of course this is not always possible.

If you head into the realms of long shutter speeds, there-fore, be prepared to bracket extensively. But be aware that you cannot rely on this entirely. Because reciprocity law failure is associated with low light, that light will be fading even as your shutter is open, so you may get the chance for only three or four exposures at the most. Therefore, you need to be certain that your initial exposure is at least within acceptable bounds, otherwise you will just end up with a sequence of wrong, and wasted, exposures. But be bold. Do not bracket by a measly 10 seconds or so. If your indicated exposure is 30 seconds, and the manufacturer of the film you are using recommends compensating by one stop extra, bracket to include exposures of one minute, 90 seconds and even two minutes.

Bracketing with the aperture

The other problem is that extending the shutter speed results in further reciprocity law failure and therefore makes your results even more difficult to predict than they

ABOVE: **At the initial exposure setting of 1/8 second at f5.6, the depth of field was insufficient, so the photographer stopped down to f/32. According to the reciprocity law, this should have required a shutter speed of two seconds. However, as this law breaks down at shutter speeds longer than one second, compensation of one stop was required.**

already were! To be on the safe side, it is often a better idea to bracket by opening up the aperture, from f/11 to f/8, for example – if you can bear to sacrifice some of the depth of field, that is.

Bear in mind that it is not just in low light that reciproc-ity law failure can occur. If you are using very slow film, as well as a filter such as a neutral-density graduated filter – which can cut out several stops of light – and a small aper-ture to maximize your depth of field, your exposures will lengthen and reciprocity law failure will come into play. Once again, bracket accordingly to compensate for this.

One final point. Do not be too put off if your meter read-ing suggests an exposure far longer than that recommended by the film manufacturers. They are naturally cautious, despite the fact that most films tend to be slightly more robust than the published reciprocity characteristics might suggest.

Shooting into the light

Exploiting the qualities of frontal and side lighting are fundamental to good photography. We can see how light wraps around a subject to reveal its texture and enhance its shape so it stands out from the background in sharp relief. However, it is when we shoot into the sun that a whole new host of creative, yet controllable possibilities opens up to us. This is known as backlighting, and it can be exploited to produce just a subtle rim of light around a delicate flower, for example, right through to a bold, graphic silhouette of a building. The advantage of shooting into the light is that it is a technique you can use throughout the day, so you do not need to restrict yourself to the early morning or late afternoon light which is preferable for many other subjects.

Silhouettes

The best thing about silhouettes is that they are very straightforward to take. It is the one time you can set your camera to automatic exposure and rely on it to produce the result you foresaw when releasing the shutter. If you want to set it manually, simply take a meter reading from the sky, and set that.

RIGHT: Bold, graphic shapes work particularly well as silhouettes. Here, a meter reading from a bright area of the sky was taken, and set manually on the camera.

LEFT: A memorable picture does not always reveal every detail in a scene. In this photograph, low light and silhouetted figures create an atmosphere that is evocative of long summer days.

The best subjects for silhouettes are those with strong outlines since no other detail will be recorded on film. Hence the reason why so many silhouettes tend to be architectural subjects – especially older buildings, as these often have more elaborate features than those built more recently. When composing your picture, you should try to isolate your subject against the sky since every detail will record as a silhouette, and too much of it can become confusing. In the same way as you should avoid the proverbial tree trunk growing out of a person's head, you should watch out for branches sprouting from the top of your building. It is true that on the one hand they might enhance your composition, but on the other they might intrude, making it advisable to crop them out if at all possible. As with many photographic subjects, the best advice is to keep it simple.

Of course trees on their own often make excellent subjects for silhouettes, but you should bear in mind that it is best either to go for dead ones, or to photograph them in autumn or winter after their leaves have fallen. The sharp shapes of the branches and twigs provide more interest visually than the leaves.

Metering for backlighting

Backlighting – also known as contre-jour – does not only produce silhouettes. You can also control your use of it for a much more subtle result. If you want to retain detail in your subject, as well as backlighting it, you will need to take a spotmeter reading from an area outside of the backlit rim. For example, if you are taking a backlit portrait, you should take a meter reading close up from the person's face, and expose for that. Do not let the light shining into your camera fool you into underexposing their face. Backlighting is very flattering for portraits as it highlights the person's hair – especially if it is blonde – and softens their features, too. Don't worry too much if the

ABOVE: Frontal lighting would have failed to draw attention to the "furriness" of this plant's leaves and stem, while backlighting brings out its delicacy.

RIGHT: Blonde hair is perfectly suited to backlighting, giving it the effect of spun gold. In this case, a spot meter reading was taken from the young girl's face – which was in shadow – otherwise the camera's meter would have been fooled into underexposing.

ABOVE: **In this case, the flare is rather atmospheric, but there are ways of avoiding it if you want to.**

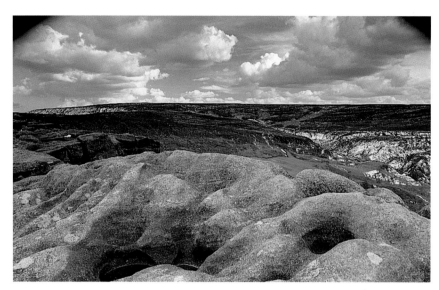

RIGHT: **Vignetting – the dark areas at the corners of the frame here – is a problem that occurs when the lens is too wide for the lens hood.**

backlit area burns out quite noticeably. As long as you have retained detail, it should not be too much of a distraction.

If you do not have a spotmeter facility, take a meter reading from the light shining into your camera and compensate by bracketing and opening up your aperture to at least two, if not three, stops more than the one your meter is indicating. The other options are to use a reflector (see page 105) or a burst of fill-in flash (see page 118).

Avoiding flare

One of the commonest flaws to occur when shooting into the light is flare. This is shown by translucent patterns appearing in the viewfinder as a result of stray light falling on the lens. Sometimes these patterns can enhance a picture, but these occasions are rare and it is something best avoided if at all possible. But how?

Use a lens hood

This helps to shield the front element from a certain amount of unwanted light. However, you will need to be on your guard to avoid vignetting – a darkening at the edges of the photograph caused by the lens hood encroaching into the frame. This is a particularly common problem when using wideangle lenses.

Position your subject

If your subject is movable, position it so that it is between your camera and the sun, blocking out the sun as much as possible. You will still have all the effect of backlighting, even if the subject stands directly in front of it.

Take an incident reading

A reading from a lightmeter will meter for the light falling on the subject, not the light reflected by that subject, so it is more accurate in the slightly unpredictable conditions caused by backlighting.

Cut the sun out of the frame

This can be done simply by shielding the top of your lens with a piece of card, altering your viewpoint or moving your subject.

Important note

When shooting into the sun, never look directly at it through your viewfinder. You could cause serious damage to your eyesight or even, in extreme circumstances, blind yourself.

Modifying natural light

ABOVE LEFT: **Natural light.**
ABOVE RIGHT: **A foil reflector bounces enough light back into the composition to make it a viable photograph.**

In our enthusiasm to take a picture, it is often all too easy to forget that a film emulsion is nowhere near as sensitive as the human eye. We can never assume that the camera film will record every minute detail we see through the viewfinder when we take the picture. It takes trial, error and a few wasted frames before we realize that the shady area in our frame is not going to display much detail if we have metered for the brightly sunlit area. But how can we get around this? There are a few options. We can take a meter reading for the brightest area, and another for the shadiest area, then set our exposure at a halfway point between the two; we can use a burst of fill-in flash (see page 118); or we can use a reflector.

ABOVE: **Without a reflector the shadows are slightly unflattering and there is no life to the model's eyes.**

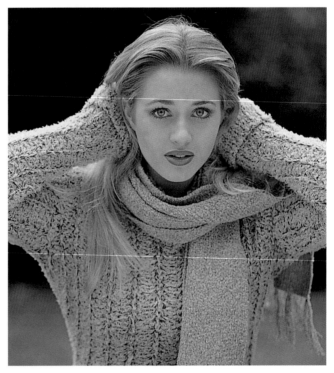

ABOVE: **A white reflector evens out the shadows, but gives a natural looking result.**

What is a reflector?

One of the most useful accessories in your photographic armoury, a reflector can be anything from a length of white fabric to a sheet of tin foil or a piece of gold card. Collapsible reflectors are stocked by most photographic retailers and – once you've got the hang of folding it up to go back into its case – these are well worth the investment. There is a huge range of sizes on the market, with the most common surfaces being white, silver or gold. Some reflectors have a different-coloured surface on either side for extra versatility, and there is also a choice between shiny and matt surfaces. A shinier reflector can sometimes bounce back as much as a whole stop more light than its matt counterpart.

White

This bounces a soft, subtle light into the shadow areas. It is a useful standard for a natural result.

Silver

A much harder, cooler light is reflected by a silver surface, and this is useful for both fashion and nature work.

Gold

This reflects a similar quality of light to a silver reflector, but the light has a distinctly warmer tone, and it can alter slightly the colour of your subject. It is particularly flattering for portraits.

Using reflectors

When you first buy or make a reflector, find a subject and experiment for a while. Notice how the quality of the reflected light alters according to the angle of the reflector and how close it is to your subject. Where you place a reflector depends on the direction of the light.

ABOVE: **A silver reflector bounces back a much harder light which, in this case, suits the model's pale skin tones less well.**

ABOVE: **A gold reflector significantly warms the model's skin tones and, as with the other reflectors, produces a catchlight in her eyes.**

Overhead light

If you are shooting a portrait and the sun is directly overhead, your subject will have harsh shadows under their nose and chin. Their eyes will probably also be in deep shadow. In these cases, you should hold the reflector flat, and as close to the person's face as possible – but take care

BELOW LEFT: **With the sun directly overhead, ugly shadows fall under the eye sockets and beneath the man's baseball cap.**
BELOW RIGHT: **Moving the couple slightly so that the sun is behind them, and using a white reflector, makes a huge difference to this portrait.**

that it doesn't creep into the frame! If you are shooting just a head-and-shoulders portrait, your subject can hold the reflector in their lap and adjust its height according to your instructions. Otherwise, you may find it useful to recruit a friend to assist you by holding the reflector and altering its position, while you concentrate on taking the photograph.

Side light

You will be able to get variable effects from your reflector when shooting a sidelit subject. Again, it is of most use when you need to balance a very contrasty scene, but it can also squeeze a bit more brightness out of overcast conditions. If you are shooting a sidelit still-life composition, you may need only a small reflector – a piece of silver foil wrapped around a piece of card could suffice. To obtain consistent results, you should clamp it in place so that you can go back to the set-up another day if necessary. If you

would like to retain a hint of the shadows being cast, place your reflector further away from the composition. If you want to get rid of the shadows as much as possible, then move it as close as you can.

Back light

As we saw on page 102, there will be some circumstances where you want to expose detail in the shadow area, while retaining the backlit effect. A reflector allows you to do this perfectly. The translucent petals of a flower will respond very well to the backlight and reflector treatment, as will a portrait – the latter will result in an attractive, reflector-shaped catch-light in the eyes. This combination is an ideal solution to the problem that arises when your subject faces the sun – that is, squinting eyes. It also means you will never have the problem of your own shadow encroaching into the photograph, which can happen if you keep the sun behind you all the time!

using flash

ABOVE: Obtaining photographs such as this requires an extremely specialized and sophisticated flash-lighting set-up in a controlled environment.

Flash Options

There are many situations where natural light is insufficient to take a picture – such as on very dull days, at night or, of course, indoors. The first and most obvious remedy is to open the camera's aperture or extend the shutter time, but this isn't always possible or desirable. Your camera may be set to the maximum aperture already, or perhaps you need the depth of field that a smaller aperture provides. A longer shutter speed may require a tripod and you may not have

switching to a faster one. This too brings its own complications. Uprating would adversely affect normally exposed frames which you've already taken, but removing it in favour of a faster film (assuming you have one on you) would be wasteful, especially if you only want to take a couple of shots rather than a whole roll.

This brings us to the third option: increasing the brightness level by introducing an artificial light source. Indoors this could in theory be the room lights or a table lamp, though in practice these are unlikely to be of sufficient power to raise the light level enough to take a picture. Outdoors not even these options are available, so there must be an alternative. Thankfully there is a quick, effective and powerful light source already at our fingertips, just waiting for us to switch it on – flash.

The invention of flash has revolutionized photography in low light. Beforehand, photographers risked life and limb with explosive powders, or cooked their subjects under hot floodlights in their quest for adequate lighting. The earliest types of flash were bulbs that could only be fired once before

ABOVE: **The world of flash photography can open up all sorts of creative possibilities. In this case, the photographer has made the most of the lovely ambient light and achieved an unusual result by using flash combined with a long exposure.**

one with you – and in any case, if your subject is a living one their movement during a long exposure would almost certainly render them a blur.

A second option is to increase the sensitivity of your film, either by uprating it (see Chapter 1, page 27) or by

being discarded. In fact, disposable flash cubes or bars are still available for the thousands of old instamatic cameras still in circulation. Today, however, most compact cameras and many SLRs include built-in flashguns, and there are dozens of accessory flashguns available, which can be fitted to the latter when extra power or features are required. Flash has some unique qualities – some advantageous, some not. It is important to know about them in order to obtain the best results.

The advantages of flash

- It is bright: because flashguns emit a lot of power for their size, you can use them with relatively fast shutter speeds and apertures.
- It is adjustable: its brightness level can be adjusted according to the distance of the subject and the lens aperture required.
- It is brief: a burst of flash lasts only a fraction of a second — in some cases less than 1/1000 second — so it can "freeze" the motion of fast-moving subjects.
- It is versatile: its qualities can be varied by changing its angle or position, or by bouncing it off a nearby surface.
- It is daylight balanced: flash produces a colour temperature similar to daylight, so with normal colour films you do not have to mess about with filters in order to avoid colour casts.
- It is portable: flashguns are small and can be carried in a pocket or a corner of your camera bag. The smallest models would fit inside a cigarette packet.

The disadvantages of flash

- It has a limited range: flash has a useful range of only a few metres. Its intensity diminishes as it travels, until it eventually peters out altogether. This effect is called "fall-off" and is bad news for the millions of people around the world who waste time and film taking flash pictures from the back rows of stadiums, concert halls and so forth. (The average flashgun would struggle to reach beyond about 10 metres.)

 The rate of fall-off is steep but linear, and can be calculated by using the inverse square law. In simple terms, this states that a single-point light source will, for every doubling of distance, diminish not by a half but by a factor of four. So, if a flash gives a working aperture of f/16 at two metres, at four metres it will be only a quarter as bright and will require an aperture of f/8 — two stops wider.
- It has limited coverage: while flash brightness diminishes as it travels forward, the same applies as it travels outwards, creating a circle of light which gradually fades to nothing. This angle of coverage is matched to that of a 35mm wideangle lens on an SLR or a compact camera. This means that if, for example, you tried to photograph a building at night using a lens wider than this, you would get a "hot spot" in the middle, while areas just a few feet on either side would remain unlit. However, some flashguns can adjust the breadth of coverage (see "Choosing a flashgun" on page 111).
- Its duration is short: because flash is so brief you cannot see the effect it is having until you get your pictures back. Potential problems such as reflections (from spectacles, for example) will not be spotted, so they must be anticipated. Its brief duration also limits the range of shutter speeds that you can use with it.
- Its battery consumption is heavy: flash exerts a considerable drain on your batteries, compared with other camera functions. If you use flash a lot it would be prudent to invest in a flashgun which can take rechargeable batteries or power packs.

Choosing a flashgun

No well-stocked camera bag is complete without a flash-gun, but choosing the right one for you from the hundreds on offer can be a daunting task. Here we will look at the main types of flashgun available and the most important features and specifications you need to consider.

Types of flashgun

Hot-shoe mounted flash

Most accessory flashguns are designed to be slotted into the camera's hot-shoe which, in most cases, is fitted to top of the prism. The hot-shoe is so called because it contains an electrical contact in the centre which triggers the flash-gun at the right moment. Some older cameras have a more

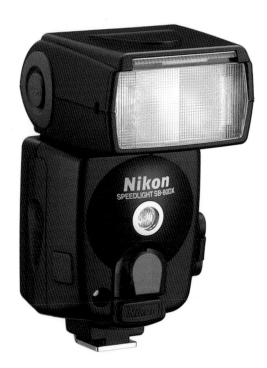

ABOVE: **An adjustable bounce flash head gives more flexibility than a flash gun with a fixed head.**

basic, contact-free shoe which simply holds the flashgun, and synchronization is achieved by plugging a short PC lead from the flash into a socket elsewhere on the camera. Few modern flashguns have a PC lead so, if you have such a camera, you will need to fit a hot-shoe adaptor between the shoe and the flashgun.

Bounce flash

Bouncing the flash off a nearby white surface produces softer, more natural-looking illumination than direct flash (see page 124). In order to do this, though, you must be able to tilt the flashgun's head upwards (to bounce off the ceiling) or rotate it sideways (for a wall). Most of the larger hot-shoe mounted flashguns can achieve at least the former.

Hammerhead flash

Hammerhead flashguns are designed for professional use and comprise a large head mounted on a long stem, which doubles as a handle. In general they are much more powerful than hot-shoe-mounted models, recycle faster and boast a wider range of accessories – especially when it comes to the choice of power sources. Many offer a choice between alkaline or rechargeable batteries (which fit either in the handle or in the head), or mains power. Some models can also be attached to shoulder-mounted battery packs for heavy usage on the move. Hammerheads are used mainly by press, PR, wedding and other branches of professional photography where portable flash is used. Like shoe-mounted models they offer varying degrees of sophistication and automation, depending on budget and needs.

Ringflash

These highly specialized flashguns are designed for macro photography. Their characteristic doughnut shape enables them to fit over the front of the camera lens, which

111

pokes through the hole in the middle. Because the light they produce comes from all sides of the lens axis rather than just one side, the resulting illumination is virtually shadowless and quite distinctive. Larger, mains-powered versions are available and are commonly used by fashion photographers.

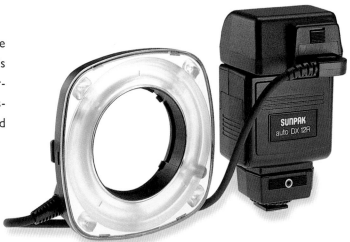

BELOW: **Ring flash creates a distinctive "halo" effect around the subject, with a circular catchlight in the eyes. It is also widely used in macro photography as it illuminates the subject completely evenly.**

BELOW: **A useful addition to any flash kit, a slave flash provides a touch of extra fill-in lighting.**

Slave flash

These, usually pocket-sized, devices are not attached to the camera at all. Instead they contain a sensor that triggers them when they see another flash – most likely the one on your camera. Consequently they are secondary flashguns, used to give the main one a helping hand (or produce a particular lighting effect). The idea is that you place one or more of these somewhere in front of you – either just out of shot or hidden within it. When you take a picture they all go off simultaneously. Slave flashes have no means of exposure control, but since they are intended only to provide fill-in and are not very powerful, this is rarely an issue.

Important features

Power

All other things being equal, the more powerful your flashgun, the better. With more power, your flash will have a longer range and, at a given subject distance, will allow you to select a smaller aperture than a less powerful gun would. Of course, all things are not equal, and there are a couple of reasons why you may opt for a less powerful model. The most obvious of these is cost: as a rule, extra power comes at a price. But there is also the portability factor to consider. The more powerful models tend to be physically larger and heavier, and if you use that extra power a lot you will find you also get through a lot more batteries. That said, if you have the budget and the space in your bag, a more powerful flashgun is a lot more versatile.

A flashgun's power is measured by its guide number. This figure is usually quoted in metres, based upon use with an ISO 100 film. The higher the guide number, the more powerful the flashgun.

Recycling time

This figure is the equivalent of the 0–60 time quoted for cars. It tells you how long it takes to recharge the flashgun once it has been fully discharged. When you want to take several flash pictures in relatively quick succession it can be frustrating having to wait for the flash to recharge. If this factor is particularly important to you, it may be advisable to buy one of the more expensive professional flashguns.

Coverage

Most flashguns are designed to cover an area equivalent to what you see through a 50mm or 35mm lens. If you are using a wider-angled lens than this you will get a hot-spot

in the middle and a dark vignette around the edges of the frame where the flash has not reached. Conversely, when you use a telephoto lens, some of the flash is wasted in lighting areas that are not in the shot. Some flashguns overcome the wideangle problem by including a plastic diffuser which you can clip over the front to widen the angle of coverage. The best answer to both problems is a flash with a zoom head. This features a fresnel lens in front of the tube, which, by moving back and forth, adjusts the angle of coverage to match the lens. Some expensive models do this automatically as you zoom the lens, others offer a push-pull mechanism which you adjust yourself.

Automation

With a straightforward, manual flashgun, you have to work out the required aperture by studying a chart on the back of the gun. To avoid the tedium of having to do this before every flash picture, it is worth investing in an automatic model. An auto flashgun measures the distance to the subject and cuts off the power when your film has had enough exposure. It does this after a brief exchange of information, whereby you tell the flashgun what film speed you are using and the gun tells you what aperture to set on the lens. As long as you stick to the same film and aperture, the flashgun will do the rest. Some more advanced models offer you a choice of apertures, and tell you the maximum range of the flash with each. Of course, if you forget to set the right aperture (or shutter speed) the flash has no way of knowing, and will carry on regardless. For a flashgun that does the thinking on your behalf, you need a dedicated model ...

Dedication

Dedicated flashguns automatically set your camera to the correct shutter speed, and adjust their output according to the aperture you are using, avoiding the need for your intervention. This is achieved by the inclusion of additional pins on the base of the flash-shoe which correspond to extra contacts on the camera's hot-shoe. Since each camera manufacturer uses a different array of contacts, the positioning of these pins varies. If you are buying a dedicated flashgun, make sure you get the correct mount for your camera.

Autofocus

If you have an autofocus camera, you may want a flashgun which will take over the focusing when the light is too low for your camera to do it. In order to do this it will need to have an AF illuminator (which looks like a dark-red translucent panel) on the front.

RIGHT: **Look out for a red panel on the front of your flash if you intend to use it in conjunction with an autofocus camera.**

Flash exposure

With modern, computer-controlled cameras and flashguns you could happily go through life with no understanding of flash exposure at all, because your equipment does all the calculating for you. But your resulting pictures are unlikely to rise above the merely adequate.

An understanding of flash exposure is a good grounding for a host of more creative techniques and will give you the confidence to experiment and perhaps even establish your

own visual style. Unfortunately, many photographers find the subject intimidating, so they never make the creative leap. Flash exposure is determined by factors governed by both the camera and the flashgun itself.

The camera
The sync speed

The first thing to know about using flash is that the camera's shutter speed has no influence on the flash exposure, only on the parts of the picture not lit by the flash. The speed of the flash burst itself is effectively the shutter speed and it is very brief – sometimes less than 1/1000 second. But that is not to say the shutter-speed dial is unimportant. Quite the reverse: with the focal-plane shutters used by most cameras, flash will work only at certain shutter speeds. This is because these shutters comprise two

LEFT: **Watch your shutter speed settings when using flash! If you set your camera to a shutter speed faster than your flash sync speed, not all of your frame will be exposed.**

"curtains", which travel horizontally or vertically across the film. The first one opens to begin the exposure, and the second follows behind to end it. At fast shutter speeds, the second curtain starts to close the shutter before the first has completed its journey across the frame, effectively forming a travelling slit. If the flash is fired at these higher speeds, only that narrow slit is exposed on film. So the fastest shutter speed at which flash can be used is the highest speed at which the whole frame is momentarily exposed. This is called the flash synchronization speed, and every 35mm SLR has one. The precise speed varies from model to model, but it is usually between 1/60 second and 1/250 second. (One or two recent cameras have managed to achieve much higher sync speeds when used with specially matched flashguns, but these are in a minority.) Most modern cameras automatically set the shutter to the flash sync speed as soon as a dedicated flashgun is attached and switched on, but by overriding this and choosing a slower speed more interesting pictures can often be achieved (see page 121).

The aperture

The brightness level of the flash in your pictures is determined by two variables: the intensity of light emitted by the flash itself, and the aperture selected on the lens. Exposure can be controlled either by keeping the flash output constant and varying the f-stop, or by choosing a particular aperture and adjusting the flash power to suit it. The former is achieved via the flashgun's manual mode, the latter by using the flash on automatic.

The major difference between these two methods is that, because the aperture controls all the light entering the lens, it affects the density of not only the flash-lit areas but also the surroundings – and of course it alters the depth of field. So if you take a lot of flash pictures you will produce more consistent results if you adjust the flash output rather than the f-stop between shots. Whichever method you choose, though, your working aperture is determined to a great extent by the power of the flashgun. The lower the

power, the wider the aperture will have to be. Your working distance is also a factor – the closer your subject, the smaller the aperture you are able to use.

The flashgun
Autoflash

Automatic flashguns work by measuring – via a sensor on the front of the gun – the amount of light hitting your subject, then cutting off the flash when the on-board computer has decided the subject has had enough. The further away the subject, the more flash will be needed to reach this point. In order for the auto mode to work, you must tell the flash what aperture you have set, or use one suggested by the flashgun itself.

While these methods work well most of the time, there are exceptions. All exposure-measuring systems, including those found in flashguns, assume the subject is of average density, so when you are shooting very light or very dark subjects, the exposure-measuring system is likely to get things wrong. This applies also with subjects photographed against very dark or light backgrounds, since these can influence the reading. (That is why the faces in portraits taken at night or in dimly lit venues are often very washed-out – the dark background has caused the flash to overexpose the subject.) With experience you will come to recognize situations which may cause the flash exposure to err and you can compensate accordingly. In the auto mode this is easy – simply use a larger or smaller aperture than that suggested on the back of the gun. (If it tells you to use f/8, for example, you can set f/5.6 on the lens to effectively double the flash power, or f/11 to halve it.)

Dedicated flash

The exposure sensors in dedicated flashguns follow broadly the same principles as auto models, but measure the light coming through the lens (TTL), which is more accurate. Because dedicated flashguns know which aperture you're using, they reduce the risk of error caused by the photographer forgetting to set the lens to the right f-

stop. They simply adjust their output to match the aperture you're using – as long as it is within the maximum range.

Like auto models, dedicated flashguns can be fooled by dark or light subjects or backgrounds, but overcoming this is less straightforward. Altering the lens aperture won't work because the flash will simply adjust its power to compensate. More sophisticated flashguns feature a flash-exposure-compensation button which allows you to increase or reduce the metered flash exposure by up to three stops in either direction. In the absence of this feature you'll have to resort to deception to fool the flash into doing what you want it to. The easiest way is to override your camera's DX film-speed sensor and set a higher or lower ISO than the film you are actually using. If you are using ISO 100 film, setting the ISO to 50 will delude the flash into thinking your film is slower than it really is, so it will give one stop more power. At ISO 200 it will do the opposite.

Manual flash and the guide number

The manual mode is the best one to use when you are shooting multiple photographs at a fixed distance and you want your exposures to be consistent. This is because manual flash emits a fixed and constant output, irrespective of any changes in ambient-light level or subject distance. With some more sophisticated units, this output can be adjusted from full power to a half, a quarter and in some cases down to 1/64 power.

Exposure must be calculated manually, too. Some flashguns provide a table on the back which tells you what aperture to set for a given film speed and subject distance. Others use a sliding scale to achieve the same result. Another method is to use the flashgun's guide number (GN).

The GN is a useful method of comparing the relative power of different models when you are shopping for a new flashgun, but it is also the best way to calculate the correct flash exposure when in manual mode. You can use it in one of two ways: either to determine what aperture you should set for a particular subject distance, or to calculate how far away your subject should be for a given aperture. Dividing the GN by the distance between you and your subject will tell you what aperture you need to set. Therefore, if your subject is 5 metres away and your guide number is 40, your correct aperture is f/8. However, if you would prefer to be using f/11 in this situation, then you would divide the GN by the aperture you want to use. This will then tell you what distance your subject must be in order to expose it correctly at that aperture. In this case it would be 3.6 metres: 40 (the guide number) divided by 11 (the aperture).

Using flash in daylight

The idea of using flash outdoors on a sunny day, when there is more than enough natural light to take a picture without it, may seem rather strange. The purpose of flash, surely, is to enable photography in conditions which would otherwise be too dark.

This may be true, but in photography it is not just the quantity of light that is important – the quality of the light is also crucial. Light quality is determined by several key factors: direction, height, contrast and colour being the most significant. There is no set right or wrong combination of these qualities, it all depends on what you are photographing and the effect you want. But if you find that the light quality is wrong for your particular subject at the time and place you want to photograph it, then at times like this your flashgun can be a great ally.

Flash in bright sun

The most common example is outdoor portraiture in bright sun. The high sun of a summer's day produces ugly shadows under the subject's nose and chin, and even their eye sockets can take on a panda-like appearance. Turning the subject to face away from the sun may help, but then they will be in shadow. A correct exposure for the face will overexpose the more brightly lit background. It is a conundrum best solved by using a small amount of flash. (A white reflector could also be used, but is less versatile in use and more cumbersome to carry around.) A controlled burst of flash can reduce or even eliminate these unwanted shadows, but it has to be the right amount. Too little flash will be ineffectual. Too much will look obtrusive and, with print films, cause the background to darken. Signposting your use of flash in this way distracts the viewer, drawing their attention to your technique rather than the subject matter of the picture.

There are exceptions of course, and in some quarters a few fashionable photographers have made a trademark out of heavily flashed "in-your-face" outdoor portraits, which

work especially well with wideangle lenses. As a norm, though, it is generally accepted that the sun, rather than the flashgun, should be the main light source. The aim of the flash is to "fill in" (hence the name) shadows cast by the sun and it should therefore appear no brighter than the natural light in the final image.

One of the most effective ways to use fill-in flash is to shoot into the light, with the sun behind your subject, then use flash to light the face. This not only produces an attractive rim-light around the subject but also reduces the risk of them squinting. A subtle blip of fill-in flash can even be used in dull weather when there are no shadows at all, to brighten the face slightly and put a flattering catchlight in the eyes. Of course, the technique is suitable for more than just portraiture. It can also be used with animals, flowers and other non-human subjects, and exactly the same principles apply.

Balancing the exposure

Achieving a harmonious flash balance requires careful calculation – unless you are lucky enough to have a modern dedicated flashgun which does the maths for you. But even these are not always ideal, because they are programmed to provide flash of equal brightness to the ambient light – what is known as a 1:1 lighting ratio. This produces brash results in which it is still fairly apparent that flash has been used. A more subtle, natural-looking effect can be achieved by halving the flash power so that its output is one stop less bright than the prevailing conditions (a 1:2 ratio) or even quartering it so that it is two stops less (a 1:4 ratio).

Some sophisticated flashguns feature a "flash ratio" or "flash-exposure-compensation" control which lets you alter the daylight to flash ratio as required. Simply key in "minus two stops" or whatever ratio you require and the flashgun's on-board computer will do the rest (as long as you are in range). The camera will play its part, too,

keeping the shutter set to the sync speed (although, as far as the flash exposure is concerned, it does not matter what shutter speed you use as long as it is no higher than the sync speed).

Non-dedicated fill-in flash

With non-dedicated automatic guns there are a few more steps. If your flashgun offers a choice of shooting apertures, select one and set this on your lens. Next, take an ambient-light reading of the scene (or from your subject's highlight) to determine the shutter speed which will provide the right general exposure at this aperture. Setting this shutter speed (as long as it is no higher than the sync speed) will, in theory, provide a 1:1 fill-in. In practice, however, your subject will be slightly overexposed because the ambient meter reading did not take account of the flash. The result will be a harshly lit subject. A more natural look would be achie ved by using a 1:2 ratio. To do this, the lens aperture should be one stop smaller than the one indicated on

BELOW: **A variety of effects can be achieved by altering the output of a flashgun. On the far left, use of flash is obvious, while the result on the far right is less so, and creates only a subtle catchlight in the model's eyes.**

1:1

1:2

1:4

1:8

the flashgun. For a 1:4 ratio it should be two stops smaller. In order to maintain the correct ambient exposure, any decrease in the aperture should be matched by a corresponding slowing in shutter speed. If your auto gun offers only one aperture, you will have to work around this one and hope that the shutter speed is within range.

Manual flashguns work in a similar way: your aperture will be determined by your subject distance (unless you have a variable-power model) and this should be your starting point. From here, simply follow the same steps as for auto flash.

TOP LEFT: **Flash output is too low, resulting in underexposure.**
CENTRE LEFT: **Correct flash output.**
BOTTOM LEFT: **Flash output is too high, resulting in overexposure and washed-out features.**

Example of fill-in flash with non-TTL flashgun

Let's imagine that you want to use fill-in flash for an outdoor portrait. Your flashgun tells you that, with the ISO 100 film you are using, and the subject at a distance of 3 metres, you must set an aperture of f/5.6. An ambient reading from the subject's face tells you that, at f/5.6, you need to set a shutter speed of 1/125 second for a correct exposure. Your flash sync speed is 1/250 second so this is all right. However, you do not want a 1:1 flash ratio, and decide to plump for a more subtle 1:2. The flash power must be decreased by one stop. Setting the lens to f/8 will underexpose the flash by the required stop, but will also underexpose the ambient light. This is corrected by reducing the shutter speed to 1/60 second. This will not affect the flash exposure but it will increase the ambient exposure by one stop, back to what it was before you changed the aperture.

Slow-sync flash

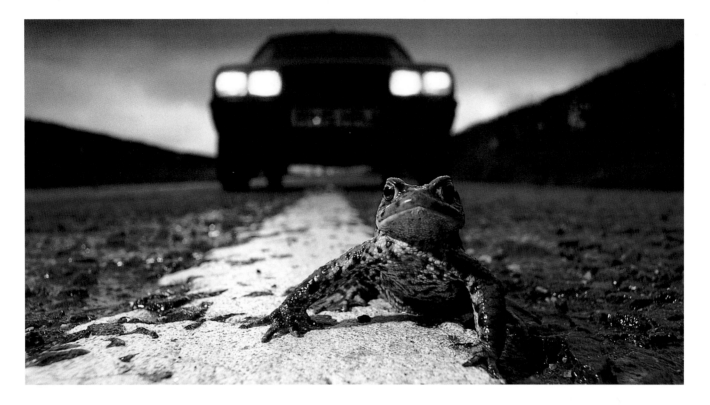

ABOVE: **By balancing flash output with ambient light, detail is retained in the background, while the foreground is correctly exposed.**

The majority of flash pictures are shot in low light, mostly indoors. The typical result is stark, white faces set against a virtually black background. Any natural atmosphere that existed at the time is lost in the gloom. While pictures like this provide a useful record of the moment, artistically they leave a lot to be desired.

There are numerous situations when you might want to record not only the moment, but the ambience of your surroundings. Perhaps you're gathered round the Christmas tree, which is festooned with fairy lights; or you're in a cosy, candlelit restaurant; or you find yourself amid the bright lights of Piccadilly Circus at night. With your camera and flash set to automatic, you are unlikely to capture any of the atmosphere which made you want to take the photograph in the first place. This is because the flash sync speed which most cameras select with flash is usually between 1/60 second and 1/250 second, and these speeds are much too brief

to record any of the dimly lit background. The simplest way to rectify this problem is to use a much slower shutter speed. Most modern compact cameras recognize the demand for atmospheric flash pictures by offering a slow-sync mode, which combines flash with a much lower shutter speed. With SLR cameras you can easily do this yourself. You will have to check with your instruction manual to discover which modes you can do this in. Some, such as program, usually insist that you stick to the sync speed. Shutter priority or manual are generally the best modes to use.

The ideal shutter speed

There's no lower limit on the shutter speed you can set. Indeed, it could be for minutes or even hours, but obviously you would not be able to hand-hold the camera at these speeds without causing camera shake – though in most cases this would only really affect the background, as the subject would be frozen by the flash. The ideal setting depends on how dim the ambient illumination is, whether there is any movement and whether or not you are using a tripod. If your aim is to expose the surroundings perfectly, you will have to take an ambient exposure reading, then set an aperture and shutter speed combination which offers the best compromise between depth of field and exposure time. If perfect background exposure is less important than simply recording the atmosphere of the occasion, a speed of around 1/15 second is a good place to start. You can hand-hold at this speed and it will still give four stops more background exposure than a 1/250 second sync speed would. While a tripod is undoubtedly useful in these circumstances, it is not essential. You will find that, as long as you steady yourself against a pillar or wall or rest on a table, you can take a reasonably sharp, if not crisp, slow-sync picture at quite slow speeds.

Timed exposures with flash

When your shutter speed drops into multiple seconds a tripod – or at least a solid wall, bench or other support – becomes a necessity. Flashlit pictures at these speeds are only really necessary for times when you want to record a person outside at night with, say, a building behind, or perhaps in a very dimly lit interior. As long as the subject is standing next to, rather than in front of the background subject (and has an area of deep black behind them) they could actually leave the scene once the flash has gone off and the viewer of the picture would be none the wiser.

Recording movement

Flash really comes into its own when you want to record movement. The briefness of flash allows for visual effects that would be impossible without it. Depending on the technique you use, flash can either freeze fast action or produce a blurred, impressionistic interpretation.

The freezing option really works, artistically, only with living or fluid subjects where their position in time would not be possible without movement. It might be an athlete with flailing arms or legs in mid-leap, or a splash of liquid with droplets poised in mid-air. A subject such as a moving car would simply look as though it was stationary. With ultra-fast subjects, such as speeding bullets or the flapping of a hummingbird's wings, even a normal flash is too slow to stop the movement, and specialized high-speed flash must be used.

Although the phrase "slow-sync flash" applies to any flashlit picture taken at a slow shutter speed, it has come to be particularly associated with moving subjects, and with good reason. More often than not, the best way to convey movement is to use a slower shutter speed so that, while the flash records a frozen moment of action, the longer shutter speed records the continuing motion as a blur around it. This technique is more accurately referred to in some quarters as "flash-blur" and is often more effective than just a slow shutter speed alone, where only the blur is registered on the film. Again, the choice of shutter speed for this technique depends on the speed of the movement and the degree of blur you want, but experiment by starting at 1/60 second and working your way down through the speeds to see exactly the sort of effect it has.

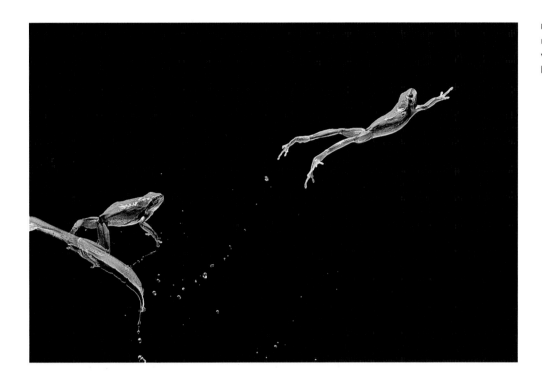

LEFT: **High-speed flash can record movement in a way which the human eye would be unable to arrest.**

Second-curtain sync

Flashguns are synchronized to fire at the beginning of an exposure, rather than the end. At the sync speed the time difference is only a fraction of a second, but with slow-sync flash it can be a significant period of time. Some flashguns (and a few SLRs with built-in flash) allow you to choose to trigger the flash at the end, rather than the beginning, of the exposure. This feature is called second-curtain or rear-curtain sync, and can have a marked effect on pictures of movement during long exposures, when you get a frozen flash image accompanied by a streak of motion blur.

Say you are photographing someone running, or perhaps swinging a tennis racket. Our minds expect the streaks of movement to follow behind the action, thus indicating its forward motion. This effect requires the flash exposure to be at the most forward point in the direction of travel – in other words, at the end of the exposure. In the standard flash mode, the flash image is recorded at the beginning of the travel, and the motion streaks follow afterwards. In the final photograph the blur will appear to precede the action – giving the impression that the subject is moving backwards.

LEFT: **The blur created by second-curtain sync "follows" the action, making it appear more natural than if it was to precede the movement of a subject.**

LEFT: **Using a longer shutter speed creates a "ghosting" effect, which can be very atmospheric.**

Bounce flash

One of the drawbacks of using a flashgun is its harshness. As a small high-contrast light source it produces illumination which, while better than nothing, can be very unflattering. Faces often look stark and ghostly (often with red eyes) and ugly shadows are cast on nearby backgrounds. Even mildly shiny objects such as polished wood are frequently scarred by large glaring reflections, or "hot-spots". There are several possible ways to combat this problem, but all have the same aim: to make the light from the flashgun appear softer and spread over a larger area.

How to use bounce flash

With a suitable flashgun, the easiest way to achieve this is to bounce the light off a wall or ceiling. In doing so, this surface effectively becomes the new light source. Bounce flash can have a marked and dramatic effect on the quality of the light from a flashgun. As well as producing softer, more flattering illumination on faces, it also solves the problem of red-eye, and greatly reduces the density of background shadows. There are a few conditions which must be met, however.

TOP RIGHT: **Direct flash produces a slightly unflattering, washed-out result.**
CENTRE RIGHT: **Bounce flash with a diffuser attached is far more flattering and natural.**
BOTTOM RIGHT: **Bounce flash on its own is also more desirable for portraiture than direct flash.**

The flashgun

You need a flashgun with a head which can tilt upwards and/or rotate to the sides. Ideally it should do both, so if you want to bounce light off the ceiling, for example, you can do so whether the camera is held vertically or horizontally.

The wall/ceiling

Your chosen surface should be white, or off-white. If it is coloured it will turn the bounced light, and therefore the subject, whatever colour the surface is. Ceilings tend to be favoured over walls for this technique – not only are they more likely to be white but, because they are above the subject, the resulting illumination more closely resembles the light from the sky so it looks more natural.

The distance

Bounced flash has to travel much further, so your surface must be quite close to the subject. Whatever the maximum range of your flashgun with your chosen film/aperture combination, it must be greater than the total distance from the flash to the surface, and from the surface to the subject. And, since no wall or ceiling reflects all the light that hits it, allowance must be made for the light which it absorbs. Also, some of the bounced flash is scattered elsewhere, and the type of room you are in will influence how much of that stray light gets back to the subject (not much if you are in a capacious ballroom, more if you are in your living room).

The angle

Like a snooker ball, flash will bounce off your surface at the same angle at which it struck the surface. If you are bouncing off the ceiling for example, and you point the flash straight upwards, the light will bounce right back over your own head, or just in front of you. And if the flash strikes directly above the subject's head, the bounced light will fall at too steep an angle, resulting in ugly shadows under the nose and chin and in the eye sockets. The same applies when using walls. If the flash is aimed too close to the subject, the side of the face away from the wall will remain unlit. For optimum results, aim the flash-head to hit the surface roughly midway between you and the subject, or at least a metre in front of them.

Calculating exposure with bounce flash

You can see how power hungry bounce flash can be, so it is no surprise that the biggest problem associated with it is underexposure. With a TTL flashgun you have little to fear, because it knows how much of the flash has reached the film, although you do need to keep an eye on the underexposure indicator to make sure the subject was within range. Automatic non-TTL flashguns should also be able to give a fair indication of whether or not your flash exposure was correct, as long as the sensor on the flash remains pointing at your subject when you turn the flash-head.

With a manual flashgun, your calculation should be based on the total distance the flash has travelled (including to and from the bounce surface). Whatever aperture you have arrived at (whether through your own maths or by reading off the table on the back of the flashgun) you should set the lens to at least a stop wider to allow for this absorption and scatter.

Reflector cards

The concept of bounce flash is so sound that photographers have found a way to use it even when there is no nearby surface to bounce it off. They do this by tilting the flash upwards and fitting a piece of white card to the back of it. You can make these cards yourself, or buy one of the numerous manufactured ones. The cards, which vary in size and shape (some are formed into a scoop), can be attached with Velcro, sticky tape or elastic bands, and are small enough to fit into a pocket or camera bag. One of their advantages is that the light does not have to travel so far before it is bounced, so flash power is not as dramatically curtailed as when using a wall or ceiling – although because

they are smaller, their degree of diffusion is not as great. When using reflector cards, the precise position of the flash-head will depend on the shape and angle of the card. It should be pointing slightly downwards, but not too far – unless your intention is to light your subject's knees! This is something you should be able to judge by eye.

Diffusers

Diffusers are an alternative to reflector cards. Like reflectors, they fit on the flashgun and soften the light, but there are differences between the two. First, since you do not

have to angle the flash there is no dispute about where to point the head – and of course diffusers will work on flashguns with non-moving heads. The resulting illumination is more direct and generally less soft, depending on the model used. The smallest diffusers are made of frosted plastic and fit directly over the flash-head. The largest are miniature versions of studio softboxes and have to be assembled before use. There are even inflatable models. You can, of course, make your own – for example, from an old margarine tub, slide-box lid or plastic bag – but remember that the larger the diffuser, and the less transparent the diffusing material, the less light it will transmit.

Exposure measurement is more tricky than with bounce flash. With manual guns you will have to perform some tests to determine how many stops you lose. With auto models, just make sure the diffuser does not obscure the sensor on the flashgun. If it does, you will have to resort to using it in the manual mode, if it has one. TTL flashguns should do the work for you, but bear in mind that if the diffuser covers the AF illuminator you may have difficulty focusing in very low light.

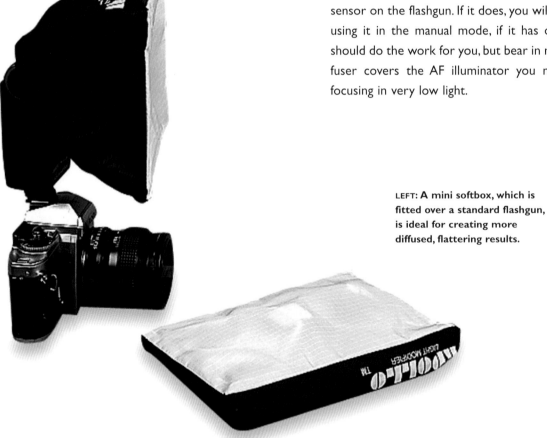

LEFT: **A mini softbox, which is fitted over a standard flashgun, is ideal for creating more diffused, flattering results.**

Using your camera's built-in flash

Most modern SLRs and virtually all compact cameras include a small built-in flashgun. On the face of it these diminutive devices may seem like an afterthought – fine for "happy snaps" or emergencies but of no use in "serious" photography. They do, after all, share several unpromising qualities: they have a very short range; you cannot move them, bounce them or diffuse them; and they offer little control to the photographer – often, the only variables possible are "off" and "on". However, while a built-in flash is no substitute for a decent accessory flashgun, there are many circumstances when it is all you need.

Fill-in flash

Few casual photographers ever consider using their flash until the natural light fails, but arguably the most useful application of a built-in flashgun is when the ambient light is at its very brightest – to fill in the harsh shadows produced by bright sunshine. The fact that it is not very powerful is not really a problem. Fill-in flash is meant to be subtle and the aim is only to lighten, not eliminate, the shadows. As long as your subject is within the flash range it will have some effect. A modest contre-jour effect should even be possible.

Only the most sophisticated cameras will switch the flash on automatically in these conditions, so you must activate it manually. This is usually done by sliding a switch, pressing a button or, with some SLRs, physically raising the pop-up flash. Once activated, it may fire only at full power, but don't worry; in bright sun it's unlikely to overwhelm the ambient light (unless you are at very close range).

Adding catchlights

A positive side effect of fill-in flash, whether you are in bright sun or not, is the catchlight it puts into your subject's eyes. Without a catchlight, eyes can look dull and lifeless. Adding catchlights gives them a very flattering sparkle which somehow brightens the subject's expression and makes them look more attractive. For this reason, many photographers use a very small burst of fill-in flash for all outdoor shots of people – whether in bright sun or not.

BELOW LEFT: **Ambient light can be a little dull.**
BELOW RIGHT: **Using built-in flash to provide fill-in gives the eyes more sparkle and reveals extra detail in the child's jacket. The reds are more saturated.**

Warming up a portrait

Flash tends to be cooler in tone than sunshine, but it can be warmer than the natural light on a dull, miserable day. In the latter conditions faces often take on an unflattering bluish tinge, which can make them appear slightly unhealthy. A small amount of flash can give faces a lift and help make people stand out from the background. This also applies to indoor shots under fluorescent lighting, where the greenish cast can give faces an even more sickly appearance. While this is also a fill-in flash technique, its purpose is different from that of the more traditional, shadow-filling application.

Brightening colours

Brightly coloured objects can be made to appear even more saturated by exposing them to a burst of flash at close range. For proof of this effect look no further than the work of the acclaimed photojournalist Martin Parr, who has used this technique to emphasize the gaudiness and vulgarity of modern life. In his pictures, food, packaging and bric-a-brac are brought vividly to life using direct flash close-up.

Freezing movement

As long as your subject is within range, even a small built-in flash can freeze the movement of a running dog or a child on a swing. Without flash, moving subjects can sometimes be rendered a messy blur. Flash will allow you to record the subject in sharp relief, even if it is against a motion-blurred background. This is especially useful with compact cameras, where you have no idea of, or control over, the shutter speed.

Indoor and low-light portraits

This is the obvious application for a built-in flashgun. Parties, family snaps, special occasions – these are all subjects of photographs which tend to be lit by flash. If you are an SLR user it is worth remembering that without a built-in flashgun pictures like these are a lot more trouble. Fiddling about trying to find, set up, charge, then use, your high-tech accessory flashgun (assuming you have one) may cause you to miss the crucial moment. And in these situations any picture is better than none.

RIGHT: **Renowned Magnum photo agency photographer Martin Parr deliberately uses direct flash in close-up to reveal all the garishness of his subjects.**

The disadvantages of built-in flash

Short range

With average-speed film, built-in flashguns have a useful range of only 3 or 4 metres. For subjects further away than this they cannot be relied upon to make a significant contribution to the overall lighting.

Lack of control

As mentioned earlier, most built-in flashguns can only be switched on or off. There is no ratio control to fine-tune the output, and no means of bouncing or diffusing it to soften the light it produces.

Harsh lighting

A general principle of light is that the smaller the source the harsher the illumination will be. Built-in flash tends to produce very deep, unflattering shadows when it is the main light source. These are particularly prominent around the nose and neck of the subject, and on the background behind them. Also, because the light hits the subject almost head on, built-in flash produces no natural modelling (the soft shadows that reveal shape and form) and can give the subject a startled, "rabbit-in-the-headlights" appearance.

Red-eye

Red-eye is arguably the most unpleasant side effect of built-in flash. It gives subjects a demonic appearance which can completely ruin a picture. The worst news is that, despite the manufacturers' best efforts (with various "reduction" devices), there is no sure-fire way of avoiding it without recourse to a separate flashgun. Red-eye is caused by flash illuminating the blood-vessels in the back of the eye and bouncing back into the lens, and usually occurs in low light when the subject's pupils are open wide. The best cure is to move the flash further away from the lens so that these reflections bounce away from the optical axis, but of course you cannot do this with a built-in flash. If you cannot switch to a separate flashgun — preferably on a bracket and diffused — the only option open to you is to try to increase the room lighting to shrink the subject's pupils.

Battery usage

A final, financial, consideration is that flash is a very power-hungry feature, and frequent use will quickly eat into the battery's life. If your camera takes the more expensive lithium-type batteries this is something to be aware of.

When not to use flash

Flash is a very useful tool to have at your disposal, but it is by no means the best way to cope with every low-light situation. There are times when flash is inappropriate and other techniques would serve you better.

When flash is forbidden
"No Flash Photography" – this sign is a common sight in museums, galleries, stately homes, theme parks, cinemas and other public places. Sometimes this rule is intended to protect and conserve, say, a valuable art work from light degradation, but often the reason is commercial – your hosts would much rather you spent your money buying their postcards instead. If you know about this rule in advance, the best plan is to load up with fast film beforehand, then shoot in available light if you can. If you are forced into long exposures, brace yourself against a wall or other rigid surface to minimize the risk of camera shake.

With glass or reflective surfaces
Taking a photograph through a window is obviously not appropriate when it comes to flash, as the light will simply bounce off the glass, leaving you with a picture showing just a giant out-of-focus reflection. Likewise, if your subject is standing in front of a pane of glass, or a mirror, or even a shiny metal surface, the flash can reflect back into the camera to such an extent that the flare may overwhelm the subject itself. If you must use flash, and you cannot move the subject elsewhere, the best approach is to shoot at an angle to the offending surface to minimize the risk of flash bouncing back. Better still, resort to the flash-free, hand-held method.

When the subject is out of range
There is no point in wasting battery power trying to light a subject which is beyond the reach of your flashgun – especially since the maximum range quoted by the manufacturer is usually rather optimistic in the first place. Move closer to the subject if you can.

When it would distract the subject
When your subject is engaged in an activity that requires their full attention – knife juggling, for example – taking a flash photo of them is probably not the most considerate thing to do. Instead, load up with fast, grainy film to enhance the atmosphere.

When it would ruin the atmosphere
Many people, on finding themselves somewhere with a pleasant ambience – say, a candle-lit restaurant or a lit-up December street – decide to record the moment for posterity. On comes the flash – and out goes the atmosphere. In any situation where someone has taken the trouble to set the mood, the flashgun is best left in the off position. This is also true during laser shows, light shows and firework displays, where of course you won't see any of these lovely effects if you use flash. The best technique in these situations is to rest the camera on something solid (a table, say), select the flash-off mode, activate the self-timer and keep still during the long exposure (assuming you want to be in the shot). Alternatively, the fast-film, hand-holding option is always worth a try.

FACING PAGE: **Both of these images, although very different, would have been spoiled if flash had been used. In their different ways, each is atmospheric thanks to the lighting conditions which already exist. In the top picture, flash would have frozen the subject's hands, reducing the feel of concentration and movement, while in the bottom picture the balance between natural and ambient light creates a lovely palette of colours, which would have been neutralized by flash.**

Studio flash

Many photographers are drawn to working in a studio-based environment. The discipline is in a different realm from most outdoor photography. Studio photographs are, by and large, constructed rather than found images. They are the product of the photographer's (or someone else's) imagination, rather than observations or snatched moments in time. Studios provide photographers with a technically controlled environment in which to work, and in which they can influence virtually every aspect of the picture – the props, the styling, the composition, the pose (if a portrait) and the background.

In a studio you are not at the mercy of the weather: the lighting can be as bright and contrasty or as soft and subtle as you like, whatever is going on in the climate outside. You can work at your own pace, as slowly and methodically as you wish, and with still life you can even leave it unfinished and come back to it another day. You can leave it set up until you have processed the films, just in case. Then there are all the comforts of being indoors, in the warmth, with a kettle and a comfortable chair nearby.

What is a studio?

A studio does not have to be a purpose-built room, it can be almost anywhere: a spare bedroom, a loft or basement, the garage – even the corner of your living room. You do not have to use flash, you can use daylight or tungsten-balanced light if you prefer, but if you do decide to use flash you will find that your portable flashgun has several drawbacks. The most significant of these is that you cannot see what effect the light is having on your subject until you develop the film. You cannot see where the shadows are falling, or detect any unwanted reflections. You cannot easily mould the light into the shape and style you require. This is where studio flash comes into its own. If, having dabbled in studio-based photography, you find yourself developing a serious interest in it then it will almost certainly be worth making the investment in a basic set-up.

Basic equipment for studio flash

Studio flash-heads are very different from portable flashguns. For a start, they are much bigger. They run off the mains, so they are a lot more powerful and recharge more quickly between flashes. Most important, they incorporate a tungsten or halogen "modelling" lamp so you can see approximately how the flash will look – and they allow the attachment of a huge range of modifying accessories to radically alter the lighting effect.

Studio flash systems fall into two main categories: those with integral heads (called monoblocs) which are fully self-contained, requiring only a stand and a mains lead to be attached to them; and those based on power packs. With the latter, the heads contain only the modelling lamps and flash-tubes, and all the power-generating components (the capacitors, etc.) are contained in a separate floor-standing unit to which the heads are attached. These are generally more powerful and more expensive and are really only necessary for serious, heavy-duty professional work. For most enthusiasts, monoblocs are the answer.

Anatomy of a monobloc flash-head
Power

Studio flash systems do not use guide numbers to indicate their power, since this figure would depend entirely on what accessory was attached. Instead, their power is judged by their electrical input, which is measured in joules, or watt-seconds. The entry-level, lowest-powered monoblocs are usually rated at about 200–250 joules, with mid-range models at around 400–500J. Power-pack models tend to start at about 1000J. The relationship is simple to calculate: a doubling of the joules figure is a doubling of power (or an increase of one whole stop).

Obviously, the higher-powered models are more versatile: you can shoot at smaller apertures, light subjects fur-

ther away, attach larger softboxes and so forth, but they can be a disadvantage when you need only a small amount of power – perhaps because you want to shoot at a wide aperture. Although the output can almost always be adjusted, some units will only go as low as a quarter – or even half – power, which may not be low enough. Some can be adjusted only in increments of a whole or a half stop; others can be steplessly varied.

Modelling light

The modelling light is usually a photoflood or halogen bulb, which is situated next to the flash-tube. Its purpose is to provide continuous illumination to give you a rough idea of the effect you will get from the flash. It should be possible to adjust the power of the modelling light in proportion to the flash. This is especially important when you are using more than one light. That way, if you reduce one of the flash-heads to half power, the modelling light will reduce its output so you can see the relative difference in brightness between them. Most makes of flash include this feature, but

there are exceptions. Other useful modelling light features include an ability to switch it off altogether and the option to link it with the recharge circuit, so that the modelling light goes off when the flash is fired and only comes back on when fully charged. This latter feature is particularly useful in portraiture, when you're more likely to want to shoot pictures in quick succession.

Slave

Your camera is connected to the flash unit via a cable, which triggers the flash as the shutter is opened. If you are using more than one flash-head, though, you will need some means of firing the second one at the same time. This device is a light-sensitive cell called a "slave" and is built in to most modern units. Ideally, slaves should be positioned so that they will see the flash from the other unit wherever it is positioned. On some (usually older) models, the slave is a separate accessory which must be plugged into a socket on the flash-head and rotated to face the correct angle.

BELOW: **A monobloc flash-head is operated entirely from a panel on the back of the unit.**

Common accessories

Most studio flash-heads need some sort of modifying accessory attached to them to channel the flash and prevent it from going where it is not wanted. The type of accessory you fit, however, depends entirely on what effect you want. With the right modifier you can create high-contrast or low-contrast light, a wide spread or a narrow beam. The following items are the most popular attachments.

Softbox

A softbox is exactly that: a box-like structure with a white translucent front which produces soft light. It is designed to replicate the effect of indirect sunlight coming through a window. Softboxes come in various sizes, from under a metre square to several metres across, and the larger the softbox, the more diffused the light will be at a given subject distance (all other things being equal). The drawback is that a larger softbox requires more power to produce the same light output as a smaller one would. The degree of softness they produce can also be controlled by their distance from the subject. The closer they are, the larger they appear and therefore the softer the light they produce. Some softboxes are of rigid construction, others are made of fabric – like tents – and can be dismantled for transportation. Softboxes are popular where reflections of the light source are likely, as a square of light is less obtrusive than most other forms of reflection. Some photographers stick strips of black card on the front of them so the reflection looks like a window.

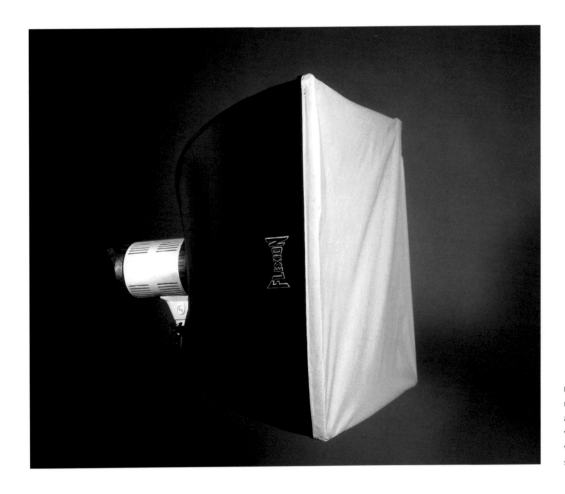

LEFT: **A softbox is the most common flash accessory, providing a wide, even spread of light which is particularly suited to portraiture.**

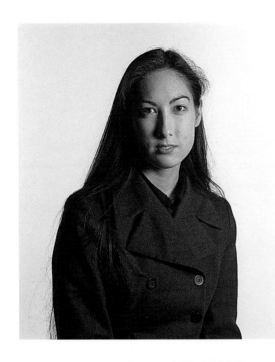

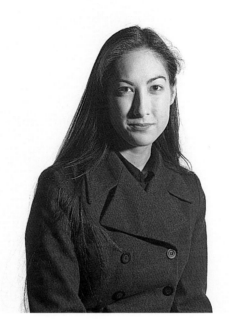

LEFT: **This sequence reveals the wide range of effects which can be created by using just one flash-head and varying its attachment. These portraits used (from top left to bottom right) an umbrella, a softbox, a dish reflector and a snoot.**

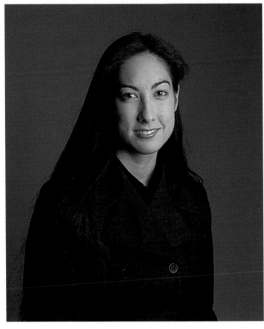

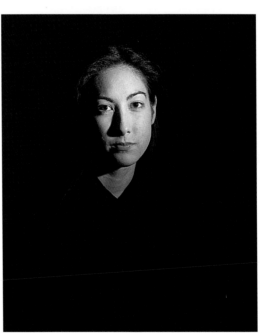

Umbrella

Brollies come in various sizes and surfaces. With most types, the flash-head is turned to face away from the subject and the light is bounced back onto it from the brolly. Most umbrellas are comprised of white, silver or gold material, while some are reversible with white on one side and a metallic surface on the other. Some are made of translucent fabric and are designed to fire

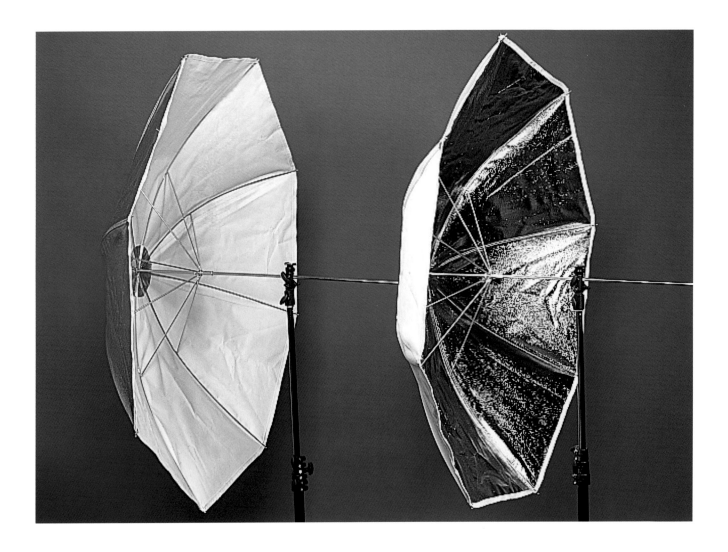

ABOVE: **Umbrellas, also used mainly for portraiture, come in a variety of surfaces, each giving a slightly different quality of light.**

the flash through rather than bounce it off. Metallic brollies produce a harder, more directional light than white ones, with the gold obviously fulfilling a secondary warming-up role. Brollies are among the most popular of modifiers because they are relatively inexpensive, fold up quickly to a small size and are quite versatile – especially the reversible versions.

Dish reflector

These are bottomless metal bowls which attach to the front of the flash-head to produce a fairly hard, directional light. Again, they come in a wide range of shapes and sizes: the tiny "spill-kill" is designed to stop light from escaping around the sides when an umbrella is fitted; deeper, narrower dishes produce a relatively small circle of hard light; wide, shallow ones result in a larger circle of softer light. Some of these wider types incorporate a cap in the centre which covers the flash tube and prevents any direct light from reaching the subject. Dish reflectors are not as easily portable as brollies or collapsible softboxes,

edged circle. They are commonly used with gobos – patterns such as venetian blinds, keyholes and so on, cut out of sheets of metal or etched on glass. These are then focused onto the subject or background to create special lighting effects. This is a fairly expensive and specialized accessory, though still cheaper than the few stand-alone focusing spotlights.

BELOW: **A conical snoot focuses the beam of light on to a very small area.**

Stand

Since you cannot attach a studio flash-head to the top of your camera (not that you would want to), you need to attach it to a stand. These are usually three-legged devices, with height-adjustable stems. Some are on wheels to facilitate easy movement, others feature hydraulic damping so that when you undo one of the height locks the head glides gently downwards rather than dropping abruptly – thus reducing the risk of damaging the fragile flash-tube. When choosing stands, it is best to avoid the thin, flimsy ones as they tend to sway when a heavy flash-head is attached to them.

and their high-contrast light requires more skill to control properly.

Snoot

Snoots produce a very narrow beam of light, and are commonly used in a secondary role – to light hair or throw a spotlight on the background, for example. Used as a main or "key" light, the result would be very hard illumination with dense black shadows. There are two main types: conical snoots through which an ever-decreasing diameter narrows the flash spread; and honeycomb snoots which use a honeycomb grid to prevent the light from spreading outwards.

ABOVE: **A focusing spot is useful for creating special effects, when used in conjunction with patterned gobos.**

Focusing spot

Some flash-heads allow the attachment of a spotlight which can be focused, via a fresnel lens, down to a small, sharp-

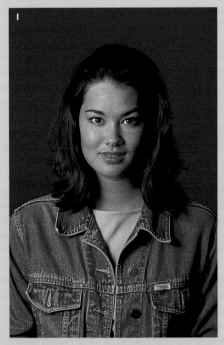

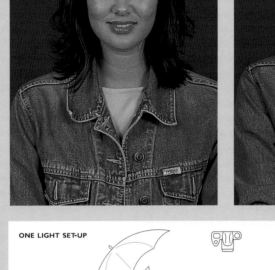

Picture 1 uses just one studio flash-head with an umbrella, which throws one side of the model's face into shadow. While the result is satisfactory, the shadow created by her nose is not ideal.

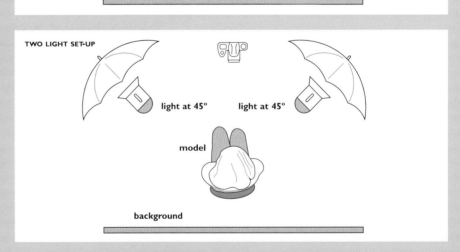

ONE LIGHT SET-UP

light at 45°

model

background

Pictures 2, 3 and 4 use two studio flash-heads, each placed at a 45° angle to the model.

Picture 2 has both lights set at full power, which illuminates the model's face completely evenly.

In picture 3, the output of the right-hand unit has been reduced to half power. The resulting subtle shadow on the left-hand side of the model's face creates a little more depth.

In picture 4, the output of the flash has been reduced to quarter power, making the shadow more pronounced. In each case, the left-hand flash unit has stayed at full power.

TWO LIGHT SET-UP

light at 45° light at 45°

model

background

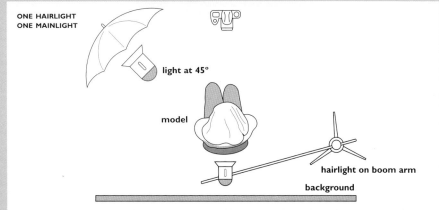

ONE HAIRLIGHT
ONE MAINLIGHT

light at 45°

model

hairlight on boom arm

background

In picture 5, the photographer has kept the main flash unit at full power, but this time has added a light with dish reflector pointing down towards the back of the model's head. This adds a highlight to the model's hair — as suggested by the term "hairlight" — making the photograph appear more three-dimensional.

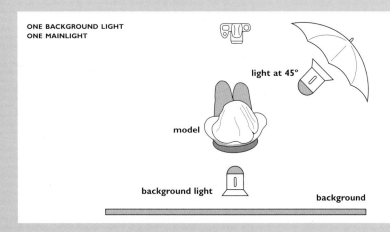

ONE BACKGROUND LIGHT
ONE MAINLIGHT

light at 45°

model

background light

background

Picture 6 uses the main flash at full power once more. However, for this image, a flash unit with dish reflector was placed behind the model, pointing towards the background. This makes a pleasing "glow" behind the model, and creates the effect of a graduated backdrop, even though it is actually one uniform colour. The output of the background light can be altered from full, to half, quarter, eighth or even sixteenth power, which effectively gives you five backdrops for the price of one!

Buying a basic kit

RIGHT: **A huge variety of studio lighting effects can be achieved with two flash units and a few accessories. Many manufacturers sell studio starter kits that provide everything you need.**

Although quite a lot can be achieved using a single flash-head with a few accessories, most studio photographers use two or more lights, as this provides significantly more versatility. In use, one of these will be the main or "key" light. This will provide the shape and modelling on the subject. A second, less powerful light may be used as a fill-in, to reduce the density of the shadows cast by the key light. The second light (or a third one) could also be used to light the background, perhaps to cast a circle of illumination behind the subject to help make it stand out more. If the subject is a portrait, a light may be used to light the hair and give it a sheen. Of course reflector boards could be substituted for lights in some of these situations, but it is useful to have at least a couple of lights at your disposal.

If you are starting out it is usually cheaper to buy one of the ready-made two-light kits than to buy lights separately. These kits may comprise two identical lights or one which is more powerful than the other. Generally, the kit will include a couple of stands, and either two brollies or a brolly and softbox. A sync lead will also be provided.

The only additional purchase necessary is a flash meter, and some kits even include these. Because studio flash units are not automatic and have no guide numbers, you need a flash meter to measure the aperture reading with your particular unit/distance/modifier combination. An ordinary ambient-light meter is not suitable for this purpose. Flash meters vary in specification, but a basic model is adequate for most needs. More complex models offer features such as multiple flash measurement, remote (cable-free) flash measurement, and selective reflective flash measurement, which you may or may not use.

close-up and macro photography

An introduction to close-up work

LEFT: **Close-up and macro photography reveals a world not normally visible to the naked eye.**

ABOVE: **Texture, shape and form, while fundamental to all photography, take on a whole new meaning when studied through a macro lens, as demonstrated by the smoothness of these tulip petals.**

What makes a good macro subject?

Almost anything can be a suitable subject for a close-up or macro image. Collectors of stamps, coins and other small objects can record and catalogue their examples; electronics students can photograph circuit boards and so forth for later study; but overwhelmingly the most popular subject for close-up treatment is nature, in its myriad forms. Perhaps it is because the flora and fauna of our world are so endlessly fascinating, or because there is such a tremendous variety of accessible subjects to choose from.

Going in close, however, presents numerous technical and aesthetic challenges, and the closer you get, the greater they become. These potential pitfalls must be understood and mastered if the photographer is consistently to produce good close-range images. Perhaps the first step in the process is to decide how close you want to get to your subject. The answer to this question will determine the equipment you need in order to do so.

ABOVE: **Macro photography is not limited to reproducing a subject at life size – it can go even closer to make it appear larger than life!**

Definitions

Close-up photography

There is no technical definition of what constitutes a close-up. It is basically just a more intimate than average view of a subject. You do not need any special equipment to shoot close-ups; your existing lens at or near its minimum focus point will do fine. All you need is an eye for detail.

Macro photography

The term "macro" is possibly the most misused word in photography. For years, lens manufacturers have been using it to describe any lens that focuses slightly closer than average. In fact, what they refer to as macro should, more accurately, be called close-up. Technically speaking, a photograph cannot be considered a true macro shot until the subject is reproduced on the film at life size (1:1) or greater, although the definition has stretched with misuse to include ratios of 1:2 and even 1:4. Macro photography extends beyond life size to ratios of about 4:1. At these magnifications you will

LEFT:
Photomacrography goes in even closer, magnifying cells and suchlike to a degree which shows us their make-up.

need a small amount of specialized equipment, but the good news is that it is not expensive. The full technical term for macro photography is, in fact, photomacrography. Macro suits us fine!

Microphotography

This is not about photographing very small objects close up, but is in fact the process of making tiny photographic images, such as on the microfilm so beloved of James Bond and other spies.

Photomacrography

If you want to, you can photograph subjects too small to be seen with the naked eye; this is done by attaching your camera to the top of a microscope and shooting through it.

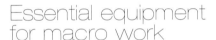

The camera

Although you can shoot close-ups with any camera, at high magnifications an SLR is virtually essential. This is for several reasons. First, at close distances, compacts and other non-SLR cameras suffer most markedly from parallax error – the difference between what the lens sees and what you are looking at through the viewfinder. The few centimetres in distance between the lens and the viewfinder may cause you inadvertently to crop part of the subject out of the picture, or even to miss it altogether. Secondly, non-SLRs will not be able to focus close enough for high-magnification work, and in most cases their fixed lenses rule out the use of supplementary macro accessories. There are other reasons, too, but these are enough to underline the importance of using a reflex camera.

The SLR you use should also have certain features. First, a depth-of-field preview facility is needed, both to check which parts of the subject are in sharp focus and to see what effect changing the aperture has. A mirror lock-up, while not essential, is a highly desirable addition as it reduces camera vibration when the shutter is released. If your camera is an autofocus model, you will need some means of switching off the AF and, for larger than life work, you will need either a stopped-down metering mode or manual exposure. This is because you may need to fit an accessory between the camera and the lens. This would sever the electronic link which automatically closes down the lens to the chosen aperture when you depress the shutter button.

The lens

Macro photography is a great test of optical quality. Because there is usually so much detail, any lens which is less than crisp from edge to edge will quickly be found out. If you are serious about macro photography, get the very best lens you can afford. Prime lenses are generally more suitable than zooms. Not only are they likely to be sharper but their wider maximum apertures make critical focusing easier, especially if you have to fit additional light-reducing accessories.

Consider also the focal length of the lens. With a short lens, such as a standard 50mm, you may find you are so close to your subject that you are casting a shadow over it and blocking out the light. If it is a living subject, you also run the risk of frightening it away. A short telephoto can be a boon with certain subjects and when using ambient light. A lens with internal focusing is an advantage. These maintain a constant length irrespective of the focus point. Ordinary lenses increase in length as the focal point gets closer, and you run the (albeit small) risk of poking your subject with the front element if you are not careful.

A tripod

This is an essential accessory, especially when you are working near or at true macro. This is partly because high magnifications also magnify camera movement and therefore increase the risk of camera shake, but also because depth of field is so shallow that your plane of sharpness is likely to drift off the subject if you try to hand-hold the camera.

Reproduction ratios

The relative magnification of a close-up subject is usually indicated by its reproduction ratio (sometimes called a magnification ratio). When a subject is recorded on film at half its real size (e.g. when a 20mm long object measures 10mm long on the film) it is said to have a ratio of 1:2. When it is a fifth of its actual size it has a ratio of 1:5. At life size it is 1:1 and if it was three times larger on the film than in reality it would be 3:1.

Note that these ratios apply only to film and not prints. It is easy to make a subject appear life size or bigger on a print simply by making an enlargement. You can only make a subject appear larger on the film by getting closer to it or by using a lens of greater magnification. This is when it falls into the realm of close-up photography.

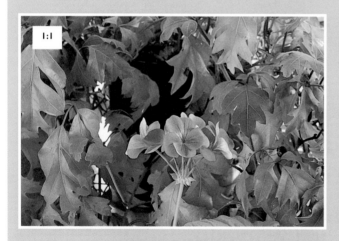

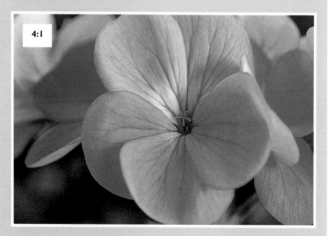

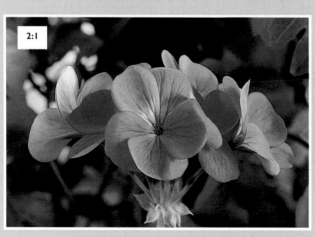

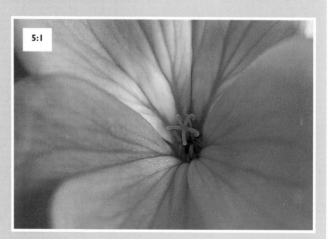

Accessories for macro

When you have racked your lens to its minimum focus point and you still cannot get close enough, you need to adopt another strategy. This will probably involve interfering with the lens in some way – usually by attaching something to the front or back of it. Depending on how close you want to get, here are the options:

Close-up dioptre lenses

These are often incorrectly referred to as filters, because they screw onto the front of your lens just as a filter would. Close-up lenses represent the simplest, cheapest way to get closer to your subject. They are generally available in three strengths: +1, +2 and +3 dioptres, with the higher number indicating greater magnification (though stronger ones are available, and they can also be used either singly or in any combination). Close-up lenses work by bending the light rays passing through them so that they focus at a nearer point than they would otherwise.

BELOW: Extension tubes are fitted between the lens and the camera body. This increase in distance between lens and film plane allows you to get in closer than if you were using the lens on its own.

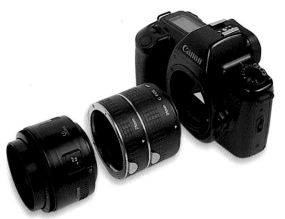

Pros and cons

The main benefits of this type of lens are cost (under £20 in most cases) and the fact that, since they do not reduce the amount of light entering the lens, no exposure compensation is required. Their main drawbacks are that, because you are placing another optical element in the light path, they do impair image quality to some extent. Also, magnification potential is limited unless you combine them, but then the quality deteriorates markedly.

Extension tubes

Increasing the distance between the lens and the film plane allows you to focus in on subjects more closely, and the greater the distance, the greater the image magnification possible. Extension tubes are a set of hollow rings which fit between the lens and camera body to act as spacers. They are usually sold in sets of three rings of different depths and, like close-up lenses, can be used either singly or together in any combination.

Pros and cons

Because they contain no glass, only air, extension tubes do not degrade image sharpness at all. They do, however, reduce the amount of light reaching the film, so longer exposures, wider apertures or faster film will have to be used. With most (though not all) tubes you retain the aperture coupling so you do not have to stop down manually, and TTL metering is still possible. You may, however, lose the autofocus function, though AF is of limited use in macro work anyway.

One of the big disadvantages of tubes is that you have to keep dismantling your set-up to add or subtract tubes and, because they are of set sizes, fine adjustments to magnification are not possible, as the required extension may be between ring sizes. Extension tubes are, however, relatively inexpensive for the degree of magnification you can achieve.

BELOW: **Bellows provide more flexibility than extension tubes, as magnification can be increased or decreased by extending or retracting them.**

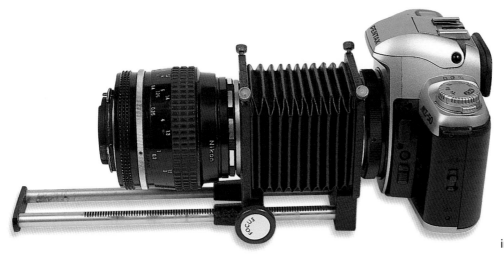

BELOW: **Bellows provide more flexibility than extension tubes, as magnification can be increased or decreased by extending or retracting them.**

up to four times life size with a suitable lens attached. On the minus side, they are bulkier to store and use and, in most cases, you will lose the automatic diaphragm function. This means you will have to stop the lens down manually before exposing and, depending on your camera, metering may be problematic. Also, at longer extensions, a greater amount of light is lost in reaching the film than with tubes, so even longer exposure times will be needed. Finally, they can be quite expensive (two or three times more so than tubes) so they are only really suitable for serious macro users.

Bellows

Bellows also fit between body and lens and work in the same way as extension tubes. They are comprised of a length of light-proof, flexible bellows mounted on a metal rail. One end of the bellows attaches to the camera's lens mount, and the other houses another mount for the attachment of a lens (which may be a standard or wide-angle optic or, if preferred, an enlarger lens). The bellows extension is usually adjusted by means of a lockable rack-and-pinion device on the base, so magnification can be increased or reduced at the turn of a knob.

Pros and cons

Bellows are much more versatile than tubes. Unlike tubes, which can only extend in stages, and must be dismantled to do so, bellows can go from minimum to maximum extension steplessly and without necessitating the removal of the lens or body. Their ultimate length is longer, too, so much greater magnifications are possible –

Macro lenses

Macro lenses look pretty much like normal lenses, except they can focus much more closely. True macro lenses can focus straight from infinity down to 1:1 life size in one rotation of the focusing ring, while others go down to 1:2 and must be used with a matched extension tube for the final adjustment to life size. Macro lenses are commonly available in two focal-length ranges: the standard lens (50mm–60mm) and the short telephoto (90mm–105mm), though there are one or two 200mm macro lenses. Basically, the longer the focal length of the lens, the less close you have to get to your subject to obtain a given magnification. This is handy if your subject is dangerous or likely to scare easily, but also means you are not in your own light, casting a shadow on your subject.

Pros and cons

With macro lenses it is mostly pros. Optically they are far superior to ordinary lenses, particularly at high magnifications where normal lenses may not always be up to scratch. Since they focus to infinity you can also use them as regular lenses. For macro work they are simplicity itself to use: nothing needs to be added or removed and full metering, focusing and stopped-down features are retained. There is only one real drawback – the cost. But if you buy a used lens or one of the handful of excellent independent brands they can be surprisingly affordable.

Teleconverters

Teleconverters are generally used to extend the effective focal length of your lens to make it more telephoto, but they also enable greater magnifications to be achieved at close range. They are usually available in two strengths, 1.4x or 2x, and effectively magnify the subject size by these amounts even at the minimum focus distance, which usually remains unchanged. They can also be used in conjunction with extension tubes or bellows.

Pros and cons

Teleconverters are similar in price to extension tubes, but their magnification potential is not as great. They are useful,

therefore, if you already own one for telephoto work, but not worth buying specifically for macro work. Also, since they contain lens elements, there is some effect on image quality.

Reversing rings

These are thin metal rings incorporating a filter thread on one side and a lens mount on the other, and are designed to allow you to fit your lens on backwards. This may seem like

BELOW: The reversing ring is shown here between the camera body and the reversed lens.

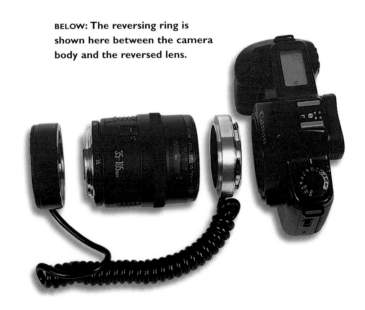

a strange thing to want to do, but in fact there is sound logic behind it. At high magnifications, most lenses provide better optical quality when they are reversed. This is because of the way they are constructed. A lens can be reversed when it is used in conjunction with extension tubes or bellows for beyond life-size magnifications, but the simplest and cheapest method is to attach it directly to the camera body.

Pros and cons

Reversing rings are a fairly inexpensive way to obtain macro images, and with a typical standard lens you can obtain near 1:1 magnification. The quality is high, too. The drawbacks are that you lose all coupling with the lens – including aperture stop-down and metering. The magnification you get is non-adjustable and the focus range limited. Also, they do not work so well with lenses whose aperture diaphragms are at the back of the lens, because when they are reversed the diaphragm will be at the front, causing diffraction and, therefore, some loss of image quality.

Stacking rings

These are similar in appearance to reversing rings, except that, rather than a lens mount on one side, they have a filter thread on both sides. This allows one lens to be fitted, in reverse, on to the front of another. The reversed lens becomes, in effect, an elaborate close-up dioptre lens, but offering better optical quality and much greater magnifications. Ideally, the reversed lens should be between 24mm and 50mm, and the camera-mounted lens should be a telephoto of at least 100mm. The magnification achieved by the combination is calculated by dividing the attached lens by the reversed one (so with a 50mm lens reversed on to a 100mm lens the magnification is 2x life size). For best results the tele lens should be used at minimum aperture to reduce the risk of vignetting caused by the reversed one.

Pros and cons

Very high magnifications are possible at very low cost, assuming you have the lenses already. Even if you do not, second-hand ones of any make (you do not use the lens mount) can be bought quite cheaply and used to stick on the front of your existing lens. All the functions of your taking lens (stopped-down aperture, TTL metering, etc.) are retained. The only drawback is that the magnification cannot be varied without using a different combination of lenses.

LEFT: **Stacking rings are screwed on to a conventionally fitted lens, while a reversed lens is fitted onto the other side.**

149

Getting started

Many of the so-called rules that we have come to take for granted in our "normal" photography no longer apply when we move into the world of macro. Going in close to your subject presents several technical challenges, and these tend to magnify in size along with your subject. Here are the main ones:

Depth of field

The more you magnify your subject, whether by moving in close or using a telephoto lens, the less depth of field you have. Even at small apertures, where the depth of field is greatest, it may still be only a few millimetres deep once you approach, or exceed, life size. This is not a big problem

BELOW: This lack of depth of field, although highly photogenic, requires extremely precise focusing skills. Even the tiniest imprecision could spoil an otherwise stunning shot. In this case, perfect focusing on the centre of the flower blurs everything beyond the plane of focus.

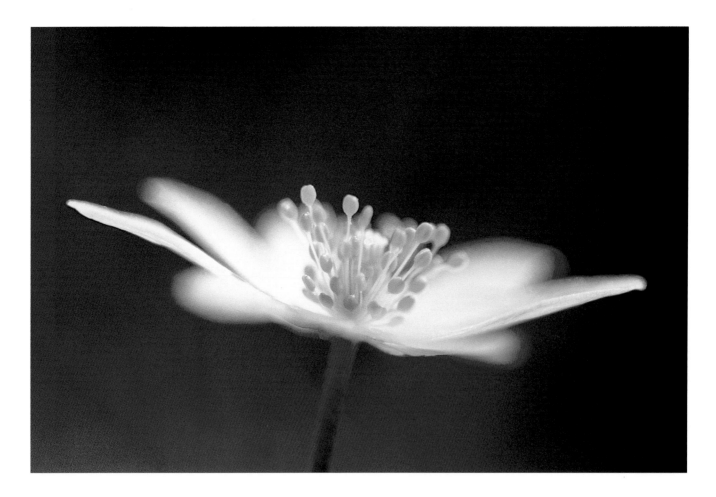

ABOVE: The extremely shallow depth of field afforded by macro photography is not always a hindrance – sometimes it adds to the apparent mystique of the subject being photographed.

with a flat, two-dimensional subject such as a stamp (as long as you are perfectly square on to it), but with a three-dimensional subject you are likely to find that you are unable to get the entire subject in focus at once. If you are able, one solution is to rotate the subject until it is presenting its shallowest profile to the lens – or move the camera position to achieve the same effect. If you cannot do either of these things, or if you have already done so but you still do not have enough depth of field, then you have to decide which part of the subject to render in sharp focus and which parts to blur.

Movement

This limited depth of field makes it almost impossible to photograph moving subjects, as even a fractional shift in subject position may take them out of the zone of sharp focus. This applies whether the subject is a living creature attempting to escape your scrutiny or an inanimate twig blowing in the wind. And it is not just subject movement you need to be concerned with. Your own movement, no matter how steady you think you are, can cause your plane of focus to drift off the subject. Even a fractional shift in position is enough to render your subject completely out

of focus. At small apertures you will probably find yourself using slow shutter speeds, too, so the potential for problems caused by movement are magnified. You can also see why hand-holding the camera is out of the question.

Light level

This is linked to the last two problems in that the necessity to use a small aperture will, unless the ambient light level is high, also force you to select a very slow shutter speed. If the subject is, say, a flower in the garden, even a gentle breeze may cause enough movement to produce blur. This problem is exacerbated if, in your quest for maximum image quality, you have chosen a slow speed film. Boosting the light level with the aid of flash brings problems of its own, not only in controlling the visual effect but also in calculating flash exposure when you are faced with the fourth problem …

Loss of camera functions

As we have already seen, once you start fitting supplementary accessories between the camera and the lens, you can no longer rely on your camera to do all the work for you. Not only will you lose the autofocus option (which is of little use in macro anyway), but the resulting loss of coupling between the lens and the body may, depending on the particular camera, cause the loss of your TTL metering, dedicated flash exposure and auto diaphragm linkage. This slows down the whole procedure of taking a photograph, which in many ways is no bad thing. It also means you may have to resort to a pencil and scrap of paper to work out what exposure you need to give.

Taking the first steps

So you have your camera loaded and ready to go, and you have your tripod and close-up accessory. You are keen to photograph something, but what? A good place to start is your own garden. Not only is this a handy location if you have to go back indoors for extra bits and pieces, but it is a safe environment where you can leave your camera and

LEFT: **Insects become like characters from 1950s B-movies when placed under the scrutiny of a macro lens!**

Choosing a subject

Macro photography allows us to isolate a single aspect of a subject and emphasize it. This could be its colour or texture, its shape or form. It could also be its beauty or sheer ugliness! Strong colours can be found not only in flowers but in the deep green of a leaf or the vivid red of a ladybird. They could be the artificial colours of man-made objects such as children's toys, ceramic pots, or your collection of garden gnomes. Textures can be found in the hairs on the wings of a butterfly, the aged wood of a fence post, the gnarled bark of a tree, the rusting metal of an old shovel, the peeling paint of the potting shed. Shapes? How about the concentric lines of a snail shell, or the graceful pose of a fuchsia? Perhaps it could be a shape made by the play of light and shadow cast by an ornament.

Thinking about the composition

There are two basic choices in the composition of macro photographs. Do you crop in tightly, isolating the subject from the environment and emphasizing the quality which attracted you to it (its texture, for example)? Or do you step back slightly and show the subject in the context of its

work in a methodical, unhurried manner, experimenting with different techniques. The natural light of the outdoors will also eliminate the added complication of having to introduce your own lighting – which you would probably have to do if you stayed in the house. Best of all, the average garden offers a potential feast of subject matter, from flowers, plants, bugs and insects, to wood, stone, metal and plastic.

RIGHT: **A dew-laden spider's web is photographed at an oblique angle to highlight its abstract quality.**

LEFT: How many people would normally take the time to study the feathery and maze-like underside of a mushroom?

RIGHT: Butterflies and moths are classic macro subjects.

RIGHT: **As with any photographic subject, consider the contrast between colours within a composition, and frame it with as few distractions as possible in the background.**

surroundings? There is no right or wrong choice – it is a purely subjective decision, but the course you choose will determine the techniques you need to apply.

Going in close magnifies the problems in depth of field and other areas, but the results can have more instant impact. On the other hand, the wider view presents a more natural result which is less alien to our normal field of vision. If you decide upon this latter option you should also consider your choice of lens. Wideangle lenses, for example, can be extremely effective in showing off the subject in its surroundings. At close range, very wideangle lenses produce a strong, "in-your-face" result in which the subject is disproportionally large and appears to be bursting out of the frame, while the entire garden and beyond stretches out to infinity in the background.

Another compositional choice facing you is whether to use the camera vertically ("portrait" format) or horizontally ("landscape" format). A tall flower may seem like an obvious case for a portrait picture but you may find that a landscape shot is more interesting, especially if you place the subject off-centre on one of the thirds and there are some good tones and colours in the background.

Symmetrical subjects, such as butterflies and some plants and flowers, often look good when you abandon the rule of thirds altogether and place them in the dead centre of the frame. This emphasizes their symmetrical shape: if the picture was cut down the middle, one half would be a mirror image of the other.

When deciding on a viewpoint, study the subject first to decide on the most interesting angle. Move around the subject but also remember to look from above and below. If the subject is a flower, say, try to find a perfect example. Examine the aspect presented to you and if there are flaws, such as localized damage, blight or decay, choose an angle which hides it or find another example – unless of course the imperfection is visually interesting and enhances the subject's appearance.

The background

With macro, as in all photography, it is easy to get so absorbed in the subject that you do not notice the intrusive telegraph pole in the background. Do check carefully to ensure there is nothing in the background which would distract from the subject. This is especially important if you

are showing the subject in the context of its environment. Look through the viewfinder with the depth-of-field preview activated to see what the picture would look like at the aperture you plan to use, since things which are blurred beyond recognition when viewing (which is usually performed with the lens wide open) may become sharp enough to annoy once the aperture is closed. With very wideangle lenses you will have a much larger area of background to police in this way.

If you are going in close, you still need to examine any areas of background that are visible in the picture. How do they look with the lens stopped down? If they are far enough away they will be just a blur, but consider the colour and tone of that blur. Would the subject look better against a light or dark background? Look at the relative lighting on the subject and background. If the subject is in sunlight and the background in shadow, the latter will come out dark whatever its intrinsic tonal value. Very dark backgrounds rarely flatter, even with light subjects – they tend to look like cut-outs, pasted on.

Dark subjects on dark backgrounds? Well it doesn't sound promising, does it? (Though there are bound to be exceptions.) If the natural background is not suitable, it is easy to create your own with a sheet of coloured cardboard placed behind the subject (on a clamp or stand) just beyond the range of focus. You can use any colour you like, but if you want a natural-looking picture it is best to use a green or a light brown (the colours of flora) or blue (to simulate a blue sky). Beware, though, that

ABOVE: Sometimes even the shallow depth of field associated with close-up photography is not shallow enough, and the background becomes distracting.

ABOVE: There is a simple solution. Take an out-of-focus photograph of some green foliage, make a matt-surface enlargement and place it at a distance behind the subject (this will throw it out of focus even further). No one will ever be any the wiser.

ABOVE: Detail in the background should be carefully considered. In this example, the blurred flowers are successfully incorporated into the composition, as they suggest a profusion of flowers which continue beyond the confines of the frame.

LEFT: **While a completely dark background is usually inadvisable for macro subjects, in this case the strong sidelighting makes it a suitable option.**

unless they are used correctly, card backgrounds will look like exactly that. Keep them well out of focus, and if you can get some dappled light on them to break up their uniformity, all the better.

Supports and other aids

The use of a clamp, tripod, lighting stand or some other means of support has already been mentioned with regard to holding a card background but, like an ailing football team, the subject itself can often benefit from some additional support. With subjects like flowers and plants, which tend to wave gently in the wind, getting them to hold still for the duration of the exposure can be a frustrating experience. You can reduce the problem by using a stick, cane or rod as a splint, and bag ties or string to gently fix the stem of the subject to the support. Care should be taken to ensure that the subject is not damaged while doing this, and that the support does not appear in the shot. An alternative is to use a sheet or stiff board as a windshield, deflecting the breeze around the subject; you need

to be careful that this does not cast a shadow (unless you want one – but that is another story). With either technique, you still need the wind to die down as much as possible before taking the picture, because these tricks are only an aid, not a cure.

The indoor option

If you would rather stay indoors – perhaps because it is raining outside – you can still take macro pictures. Indeed, many photographers prefer to do this for the control it gives them. There is no wind to worry about and, since it does not take up much space, you can leave a macro set-up in the corner of a room indefinitely and come back to it whenever you like. Subjects can be brought in from your own garden or elsewhere (though do think twice before picking wildflowers or removing wildlife from its home), or you can find plenty of objects in your home to photograph: houseplants, ornaments, fabrics, coins, food from the fridge, etc. Lighting can be a problem, since the illumination in your home is likely to be lower than that outside, but you can either shoot near a window or use artificial light.

Lighting and exposure

As with all types of photography, the success or failure of a macro image can hinge on the lighting. Macro photographers have more options open to them in this regard than those in other specialisms. As always, there is natural daylight in all its forms. This can be modified as required by the use of reflectors or flash. If you decide on the latter, there is a further decision to make: on or off camera flash, ringflash or macroflash? And would you like diffusion with that, sir? Moving indoors, your horizons broaden further. You can still use natural light, either from a window or in a conservatory, and this can be supplemented with the same flash options. Alternatively, you can block out the daylight and just use flash. No flash gear? Tungsten lighting will do fine. If your subject is static, even an anglepoise lamp will do the job.

Outside

In the great outdoors daylight is the natural choice, but not just any old daylight. Direct sunlight is in most cases a poor choice because the hard shadows it casts make it generally unsuited to revealing the fine detail in tiny, delicate subjects.

There are exceptions, though. Some subjects – translucent ones, for example – may be enhanced by being photographed *contre-jour*. This would make colours sing out and reveal delicate internal structures. Opaque subjects can be revealed in silhouette or with rim-lit edges.

On the whole, though, hazy, diffused light is best. This type of illumination is of lower contrast, so highlights will be less burnt out and darker areas will still carry detail. In diffused sunshine, when the sun is behind clouds, the light still has some directional quality, so you get attractive soft shadows. On sunless, grey days the light tends to be rather flat and virtually shadowless, but colour saturation can be quite intense, especially after rain.

BELOW: You need to decide whether to shoot in natural light, or with flash. In this comparison, the naturally lit flowers (BELOW LEFT) are revealed in more detail than the flash-lit version (BELOW RIGHT). Although the colours in the flash-lit image are more saturated, the flash has cast harsh shadows – similar to those that would be cast by harsh sunlight.

ABOVE: **Even flash lighting in this example has created the surreal impression that the flower is suspended in mid-air.**

If the natural light is not quite right for your needs — perhaps it is too directional or too flat — it can easily be modified to your requirements by the use of a few simple accessories. One of the most useful of these is a pocket reflector. This may be one of the elaborate folding fabric types or a simple sheet of card. A reflector can perform several useful functions. On a bright, sunny day it can fill in areas of shadow, reducing image contrast, or it can be used to light the front of backlit subjects. It can also be used as a shield to screen the subject from direct sunlight. On a dull day it can be placed near the subject and used to provide some direction to the lighting. Reflectors come in different surfaces — usually white, silver or gold — to produce

different effects. A piece of translucent fabric such as muslin can perform a similar light-softening function in bright light, by allowing sunlight to filter through it. Another, more radical option is to carry a small mirror or piece of silver foil to introduce a hard, targeted highlight to a specific area. You can, of course, also use fill-in flash instead of a reflector.

Indoors

Creating an indoor macro studio is relatively simple, and provides more lighting versatility than outdoor photographers are accustomed to. If you set up in a conservatory you may find the ambient light almost as bright as it is outside, and by selectively closing certain blinds or curtains or pinning up a white sheet the light can be modified to your needs. If you do not have a conservatory, a large window can be useful, though this will be less bright and, since the light is coming from only one direction, you will have to turn the subject to control the way the light falls on it. Again, this light can be diffused with a bed sheet.

An alternative to daylight is tungsten light. Your ceiling light is not a good option here because you cannot move or control it easily, but an anglepoise type of lamp is fine. The main drawbacks are that this light is not very bright, and the colour is very orange, but these problems can both be cured quite easily. If you are using print film the cast can be corrected at the printing stage. With slide film you can either use a blue 80A filter over the lens or switch to a tungsten-balanced film. If you use tungsten lighting, you should make sure you block out all daylight otherwise your subject will be lit by both types of light. This will make it impossible to achieve neutral colour, since correcting for one cast will make the other worse. Getting the right amount of brightness is less of a problem indoors since you can use very long exposures (minutes, if necessary) without worrying about the wind blowing your subject and causing it to move.

Domestic tungsten lighting is usually quite harsh, because most types consist of a bare bulb in a metal

reflector. This will be less noticeable with tiny subjects, but if you wish, the harshness can be diluted either by using several lights (to build up the brightness level in the shadow areas) or by shining the light through a sheet of white cloth, tracing paper, bubble wrap or any other diffusing material.

Another drawback of tungsten light is the heat it generates. If the light is too close to the subject, or left on for too long, the heat may wither or even burn it. It is also crucial to avoid placing any diffusers too close to the light source, because if they get hot they will become a fire hazard.

If you become serious about indoor macro photography, and wish to use artificial light, you can buy tungsten-balanced studio lights, which are brighter than ordinary domestic lights and can be modified with a range of accessories. Alternatively, you could use flash …

Using flash in macro photography

As artificial light goes, flash is by far and away the most versatile. You can use it indoors or out, move it to any position you like, modify it by a surprising degree, and since it runs on batteries, you do not need to be near a power source. At close range, even relatively small flashguns are large in comparison with the subject, so cumbersome diffusion devices are less essential. The main drawback is that you cannot see the effect flash produces until you get the film processed, so you will have to rely on experience to visualize it. In fact, it is best to find a set-up which works for you, perform a few tests, then stay with it.

Flash on camera

A standard hot-shoe-mounted flashgun is not ideal for macro work. At close range, the angle between the flash

ABOVE: The even, diffused light of an overcast day is perfect for photographing macro subjects, both indoors and out.

tube (several inches above the top of the camera) and the subject is quite steep. Unless you can angle the flash downwards, most of the light will miss the subject anyway, and that which does reach the subject may produce long shadows underneath. A built-in flash is even less useful. A long lens (or extended lens) is liable to cast a shadow over the subject so none of the flash will reach it. There are several alternative options.

Off-camera flash

By using a suitable cord you can take the flash off the hot-shoe and attach it to a bracket or stand. This will allow you to position it wherever you like – perhaps closer to the lens axis or looking down on the subject from above, to simulate light from the sky. Diffusers and reflectors can, if desired, be used to modify the flash. The main drawback of off-camera flash is the cost of the cords, especially for dedicated units. The alternative is to use a PC cord instead, but you will lose your TTL flash metering. If your flash and camera do not have the necessary connections you can buy inexpensive adapters.

A macroflash set-up

A macroflash is a purpose-designed unit composed of two flash tubes, one on either side of the lens. Some are physically attached to the lens, others are supported on adjustable stalks or brackets like antennae. With some models you can control each flash independently, adjusting

RIGHT: **A macroflash unit – although appearing slightly cumbersome – is a versatile and portable way to light your macro subjects.**

the output of each or even switching one of them off if required. With fixed-output, manual models you can control the ratio between the tubes by fitting a neutral density filter over one of the heads. There are several models of macroflash on the market but you may find it worthwhile, financially, to make your own. This can be done quite easily. The advantage of macroflash is that it produces relatively even lighting which still has some direction and modelling. It can also be adjusted to suit your tastes and the subject. Because it is attached to the camera, a macroflash rig is easily portable.

Ringflash

These are discussed in greater detail in the section on flash (page 111). They are basically doughnut-shaped flashtubes which fit around the lens. They are similar in appearance to some macroflash units but, because the tube wraps all the way around the lens, the light they produce is virtually shadowless. Many macro photographers find ringflash too flat for their taste and prefer the greater control and more natural modelling of a macroflash.

Studio flash

For indoor macro photographers who already own studio flash equipment this is an option, but it is not worth buying specially. Because studio flash units tend to be quite large, their illumination is always likely to be fairly uniform when used on tiny subjects, and even with a dish reflector fitted.

LEFT: **A ringflash is a circular flash tube which wraps around the camera's lens, producing a completely even light.**

Calculating exposure

Ambient light

Thankfully, most modern cameras offer TTL metering and this is retained with many supplementary accessories. The only thing to be aware of is particularly light or dark subjects and backgrounds fooling the meter reading, and for this some adjustment should be made. If you do not have the benefit of TTL metering, you will need to take a separate hand-held reading from the subject and then adjust this exposure to allow for the greater magnification. Luckily there is a simple formula to calculate the required compensation:

At half life size add one extra stop over the meter, at life size add two stops, and so forth.

You can make this adjustment by opening the aperture, but it is usually better to reduce the shutter speed so you retain your depth of field.

Flash exposure

This is more tricky. With TTL flash you should have few problems, but you may find your TTL system less accurate at close range. Perform some tests to find out. In any event, you will still need to compensate for unduly bright or dark areas in the picture. When dedication is lost, you will need to shoot a test roll of film to determine the required aperture. There are a few points to bear in mind when performing these tests.

First, remember that the decrease in light is quite rapid at close range. Every doubling of flash distance causes a light loss of two stops, and at macro distances this may be just a few inches. Because of this fall-off, you may find that the flash produces an unnaturally dark background. This can be cured to a great extent by positioning the flash much further from the subject so that fall-off is less pronounced. The resulting increase in contrast by moving the light further away (it

now appears smaller from the subject's position) can be offset by diffusion. You will, however, need a more powerful flash if you want to use it further away. An alternative solution to the fall-off problem is to try to balance the flash with the ambient exposure so that the fall-off is less visible (see "Non-dedicated fill-in flash", page 119).

Remember also that whatever exposure setting you arrive at will apply only at a specific magnification range. Adding extra extension tubes or other lens extensions will cut out more light and necessitate further testing.

the black and
white darkroom

Equipment

Developing films: what you need

Although it is not necessary to develop your own films – you can simply take them to a lab and ask for developing only – it is a good idea to learn how to do this if you would like to have maximum control over your final image.

Developing tank

This is a small, lightproof plastic barrel in which the developing process takes place. It is usually designed to develop two 35mm rolls of film, or one 120 roll – although you can buy tanks with a capacity of four 35mm rolls.

Reels

The unprocessed film is threaded onto a reel to form a spiral so that none of the film emulsion touches itself. If the emulsion touches, the developer cannot get in between to form an image on the film.

Developer

There are several types of black and white film developer on the market, each with its own qualities. Some are designed to give optimum results with a particular film, some are formulated especially to produce fine grain, while others will give a grainier result. So much of black and white developing and printing is down to personal preference, it is best to try a few different developers and then stick to the one which gives the most pleasing results for you.

Fix

This is a chemical that clears the developed film, leaving you with a black and white negative. After the film is fixed, it is safe to look at it in daylight without risk of fogging.

Measuring cylinders

Developing a film is a precise art, so an accurate measuring cylinder is essential. Invest in two, and label one for developer and one for fix. That way, you lessen the risk of contamination between the two chemicals.

Thermometer

Developer has to be mixed at a particular temperature for the best results (usually around 20°C). The water to rinse the film after developing and fixing also has to be around the same temperature, otherwise you risk reticulation. This is when the film emulsion breaks down because of extremes of temperature, which will produce a speckled effect on your prints.

RIGHT: **Precise measuring of chemicals is fundamental to accurate black and white processing and printing results.**

Drying line

While a drying cabinet provides the best conditions in which to dry your developed print, a line rigged up in a dry, dust-free (or as near as possible) room will suffice for most users.

Printing: what you need

This is the biggest outlay you will need to make but, once purchased, the equipment should last many years. Make sure you know exactly what you want from your darkroom before parting with your hard-earned cash, as you could end up making false economies.

Enlarger

If you are serious about black and white printing, you should give as much thought to the enlarger you buy as you would to a new camera. There are two main types of enlarger – diffuser and condenser. For general use, the diffuser type is recommended, as condenser enlargers produce a harder, more contrasty light, and will show up every last speck of dust on your negative.

If you plan to print exclusively in black and white using variable-contrast papers, you can choose between an enlarger which allows you to dial in the grade of print you require, or one used in conjunction with variable-contrast filters. The filters slot in either above or below the enlarger lens, depending on the model of enlarger.

Another alternative is an enlarger with a colour head. Although these can be used for variable-contrast black and white printing, you can run into problems with exposure times once you start dialling in different filtrations. Invest in one of these only if you plan to experiment with colour printing, or if you do not mind abandoning the colour filtration head and using it in conjunction with a range of variable-contrast filters instead.

Also bear in mind the size of negative you will be printing with. If you shoot a lot of photographs on medium format, there is obviously little point in buying an enlarger suitable only for printing 35mm negatives. Size also matters when it comes to prints. If you know you are unlikely to want to print bigger than 10 x 8 in., then this is as big as you need your enlarger to go. However, you

may find this limiting in the long term, so it could be better to choose a model which allows you to go up to 12 x 16 in. or even 20 x 24 in. if you plan to print up your own exhibition one day!

Enlarging lens

In the same way as a camera lens dictates the quality of your photograph, an enlarging lens influences the quality of your black and white print, particularly when you start to make prints larger than 10 x 8 in. If you will be printing solely from 35mm negatives, you need only buy a 55mm lens. However, if you will also be printing from medium format negatives, you will need to invest in an 80mm enlarging lens as well.

Filters

These are essential if you do not have a head on your enlarger which allows you to dial in the contrast. Variable-contrast filters are plastic squares which slot into a tray either below or above the enlarger lens, and which allow you to control the contrast of your print in graded increments between one and five (one giving the least contrast, and five producing the greatest contrast between highlight and shadow areas).

Easel

As well as securing your printing paper and holding it flat, an easel provides the easiest way to make borders on your black and white prints. Again, buy one which can accommodate up to the largest size of paper you are likely to want to use. Unfortunately, these are expensive accessories, and you would be better off buying a more substan-

tial second-hand piece, than skimping and going for a cheaper new version.

Timer

For consistent, repeatable results, the only solution is an enlarger timer. Keeping an eye on the second hand on your watch is a very poor substitute! You need not invest in a sophisticated model, just a sturdy, reliable and accurate one.

Focus finder

In the low light of the darkroom, you cannot always rely on the naked eye to tell you whether or not your print is in focus. A focus finder does the job for you. It can take a little getting used to, but will prove invaluable once you do.

ABOVE: **A standard two-blade easel.**

ABOVE: **A digital timer is more accurate than counting "elephants". Make sure you keep a note of exposure times for your prints, so they are straightforward to repeat.**

LEFT: **A focus finder ensures a sharp print. Other versions of this accessory resemble miniature microscopes.**

LEFT: **A safelight will allow you to see what you are doing, without risk of fogging your paper.**

Safelight

Luckily the developing process does not have to take place in pitch black. You are permitted the glow of the red safelight, which you can use without fogging your paper. Different paper manufacturers recommend different types of safelight for use with their products, but do not be fooled into thinking they are simply trying to sell you their own model. The quality of your print can be marred if the wrong safelight is used, so adhere to the recommendations on the printing paper box.

Developing trays

As with the easel, even if you plan to print only on 10 x 8 in. paper, it's worth investing in a set of three trays of 12 x 16 in., because it would be frustrating to limit yourself in the event of wanting to produce larger prints. Obviously, though, the larger the trays, the greater amount of chemicals you will require. Some printers invest in a separate set of trays for toning their prints, to avoid cross-contamination.

Measuring cylinders

As with film developer, print developer has to be measured accurately, to ensure repeatable results.

Developer

There are many different types of developer on the market, each with its own characteristics. Some enhance grain, while others make it appear finer. Some are designed to boost contrast, others to lessen it, while yet more produce prints which display cold, neutral or warm tones. To further complicate matters, the length of time a print is allowed to develop and the concentration and temperature of the developer can also affect the outcome of a black and white print. Your printing will show more consistency if you stick to one developer to start with and learn about its characteristics, keeping to the dilutions and developing times recommended by the manufacturer. If your printing is likely to be mainly on variable-contrast paper, there are developers specifically for these. Since it goes off quickly, it is false economy to buy and mix up large quantities of developer. After making several prints, the developer starts to become exhausted, taking longer to bring about the image on the paper. Once this happens it should be poured away and replaced.

ABOVE: Upright print developers and washers are ideal for darkrooms with limited space.

LEFT: **Wearing soft gloves while handling your processed negatives reduces the risk of scratching them or covering them with fingerprints.**

BELOW: **Use tongs so that your hands do not come into contact with the chemicals.**

Spot bath

Some printers simply use a bath of water to arrest the printing process before placing the print in the fix. However, for optimum control, a stop bath is vital because it halts the developing process immediately.

Fix

This makes your image permanent and allows you to look at it in daylight without risk of fogging.

Other accessories

Print tongs are essential for moving prints from one tray to the other, but they must be used carefully to avoid creasing or tearing the paper. For those who are only happy if their hands are in the developer, plastic or latex gloves are essential. Some people go for years happily immersing their hands in various chemicals, only to develop allergies very suddenly, after which it can be very hard to print without irritation, even when wearing gloves.

Choosing your paper

Selecting a black and white paper on which to print is not a straightforward task. Do you want to use graded or variable-contrast paper? And should that be fibre-based or resin-coated? Then there's the finish to consider. Will your print look best on matt, glossy or something in between, like pearl? Only you can decide.

Resin-coated paper

There is still a certain snobbery attached to resin-coated paper, many believing it delivers an inferior result to that of its fibre-based counterpart. It certainly feels very different, with almost a plastic quality. However, as your printing skills develop, there is no reason at all why you should not produce equally as good a print on resin-coated paper as you would on fibre-based. Its advantages are that it is much quicker to wash, therefore less wasteful of water, and also that it doesn't buckle, so can be mounted extremely easily when dry.

Fibre-based paper

Those who still adhere to the snobbery mentioned above would argue that fibre-based paper has a certain depth and a wider range of tones than resin-coated. In the end, printers should use whatever they feel produces the best results for them. Because the chemicals soak through the emulsion layer of fibre-based paper into its base paper, fibre-based paper needs to be washed for a very long time – around 45 minutes to one hour in slow-running water. It also buckles while drying, making dry mounting necessary before it can be framed properly.

Fixed-graded paper

These are papers which are available in packs of one grade only, from 0 to 5. Economically, they make less sense, as you have to buy six boxes of paper in order to give yourself the full choice, while one box of variable-contrast paper can provide the same range – in fact, even wider, because variable-contrast paper gives you the grades in between, too. The uses of these papers are more limited nowadays, as the quality of variable-contrast papers has improved considerably.

Variable-contrast paper

The huge advantage of variable-contrast paper is that you can utilize the entire range of grades within one print. As already mentioned, their quality nowadays is easily comparable with their fixed-grade counterparts, making them the most versatile and economical option for any printer.

Paper tones

Once you have decided upon resin-coated or fibre-based, variable-contrast or fixed-grade, you then have to choose the tone of your paper. Warm-toned papers are now commonplace, giving a result which appears to have been very slightly sepia-toned. Neutral papers, on the other hand, produce much colder greys. In the end, your choice should come down to the sort of mood you would like your print to evoke.

Paper finishes

Gloss is far and away the most popular finish for a paper, appearing to give a crispness and density which seem to be lacking from matt, semi-matt or pearl finishes. It is also possible to buy papers which have textured surfaces – anything from a stippled effect to those which appear to be more like watercolour paper than something intended for photographic use.

Lightproofing a room

Whether your darkroom is in the attic, the basement, the bathroom or the cupboard under the stairs, it must be completely lightproof to prevent fogging either of the film as you load it on to the spiral before placing it in the developing tank, or of paper when you remove it from its light-tight box and place it under the enlarger.

The main area where light can encroach into a darkroom is around the door frame. This can be rectified quite easily by using black tape or paper around the edges, or rigging up a blind or curtain made from heavy black fabric. Although most darkrooms are painted black, don't assume you have to paint your bathroom this colour if that's what you use as your darkroom! White is just as suitable. It is also extremely important that your darkroom has adequate ventilation.

Contact prints and test strips

The process of making a contact print and test strip, although laborious, is the only way of telling which negatives are most suitable for printing, and what the best exposure is going to be for that particular negative. Making a contact print also allows you to consider potential crops as you can draw on it with permanent felt-tipped pens, and these prints are also invaluable for filing purposes.

The contact print

The variations in exposure you may have used while shooting a roll of black and white film mean that sometimes not every negative will appear identically exposed on the contact print. This means that either you will need to make a couple of contact prints, giving each a different exposure time under the enlarger, or else you will need to burn in those negatives which need extra exposure.

Although you can buy specially made contact frames in photographic retailers, these are not vital to making a good contact print. The only essential piece of equipment you need is a sheet of glass large enough to cover the rows of negatives as they are placed on the piece of printing paper. Since most contact prints are made on 10 x 8 in. paper, a sheet of glass measuring 12 x 10 in. should suffice. It is essential that this is kept as clean as possible, as you do not want any grit to scratch your negatives before you have

even had the chance to see which ones you want to print!

The height of your enlarger should be adjusted so that the coverage of light is slightly bigger than the paper. You might like to make a note of this height, as it will help keep future contact prints consistent. Since grade 2 paper is considered to be the ideal average, it is a good idea to make all your contact prints on this grade of paper.

First, you will need to make a test contact sheet by moving a piece of black card across the sheet of negatives at equal intervals. For a contact sheet, you can get away with five-second intervals, as exposure is less critical than when you are making a test strip from one negative. Select which of the exposures gives the best average results (for example, 10 seconds) and make a full contact sheet by exposing the whole set of negatives at that time. If some of your negatives are too dense to have exposed enough on the paper, but you can see they have enough detail still to have potential as a print, make another test to determine an adequate exposure. Then you can make a second contact print, burning in the appropriate negatives (see page 175) and retaining the original exposure for the remainder of the negatives, so they are all correctly exposed on one sheet. You should write the exposure times on the back of the contact sheet, in the event that you need to make another copy in the future.

LEFT: A contact print is essential to any filing system, and allows you to select which negative you want to make an enlargement from.

The test strip

Once you have made your contact print and decided which of the negatives you want to enlarge, the next step is to make a test strip. This is a procedure that is often taught incorrectly, and in a way which can result in far more work and wastage of printing paper than is necessary.

As with the contact print, test strips should be made on grade 2 paper (either fixed-grade, or variable-contrast paper with a grade 2 filtration).

The first step is to adjust the enlarger to the correct height for the size of paper you will be using. As exposure times vary depending on the distance between the enlarger head and the paper, there is little point in carefully determining your exposure, only to alter the height of the enlarger when you decide you want a 12 x 16 in. print instead of a 10 x 8 in.

The next step is where people often go wrong, placing a sheet of paper on the baseboard and exposing the entire sheet in intervals. This makes no allowance for which part of your negative you consider to be the most important, and where it falls in your composition. Therefore

you need to decide which part of the negative forms your main subject, tear your paper into five or six strips of about 1–2 in. wide, and expose each strip in the same place on the baseboard. These strips do not have to be laid vertically. If the most important part of your negative sits horizontally or diagonally in the frame, you should place each strip accordingly.

There is little point in varying your exposure in large intervals, as the test strips with very long exposures are almost guaranteed to be far too dark. Instead, try exposing at five-second intervals so that you end up with five test strips, say, exposed at 5, 10, 15, 20 and 25 seconds. Put all the test strips into the developer at the same time, and do not be tempted to remove any until the full developing time recommended by the manufacturer is complete. They should be transferred to the stop bath, then washed in fix and dried in the same way as you would a print. Finally, they will be ready to examine under normal lighting conditions – either a well-lit room or, preferably and if printing during daylight hours, in natural light.

BELOW: **By making a test strip from an identical area of the negative, you are better able to select the correct exposure for your enlargement than if you were to expose the whole negative at equal intervals across the paper. In this case, eight seconds was selected as the correct exposure.**

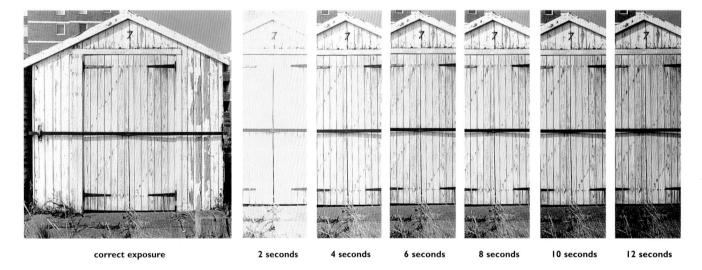

correct exposure 2 seconds 4 seconds 6 seconds 8 seconds 10 seconds 12 seconds

If none of the test strips appears to give quite the right exposure, decide which two are the closest, and make another test strip with an exposure halfway between them. For example, if 5 seconds is slightly too light, and 10 seconds is slightly too dark, make a test strip exposed at 7.5 seconds.

Testing for the correct grade

Now that you have your correct exposure, it is time to decide which grade of paper is best for the enlargement you want to make. You might decide that the grade 2 paper on which you have made your test strips is correct for the negative you are enlarging. However, as you become more accustomed to printing and assessing your negatives, you will begin to see how a different atmosphere or feeling can be injected into your prints when you increase or decrease the contrast between highlight and shadow areas.

The method of determining the correct grade is identical to that of making a test strip, except that this time you alter the grade you are using. If you are using graded paper, the exposure time will be the same across all the grades, assuming you are using paper by the same manufacturer. If you are using filters or dialling filtration into the enlarger head, however, you should double the exposure for grades 4 and 5. Therefore, taking our above example, you would expose grades 0 to 3 at 7.5 seconds, but grades 4 and 5 at 15 seconds.

Again, these strips should all be developed at the same time, then fixed, dried and examined under good lighting. Only then will you be able to decide properly which is the correct grade of paper or filtration for that particular negative.

RIGHT: Selecting a grade is often down to the printer's personal taste and desire to bring out extremes of contrast, or every possible tone of grey. Neither is right or wrong. The printer here decided that a filtration of grade 2 provided the desired result.

grade 0

grade 1

grade 2

grade 3

grade 4

grade 5

Making a print

LEFT: **A filtration of grade 4 ensures that the mountains appear in silhouette, while the clouds in the mackerel sky are bright white.**

LEFT: **The wide range of tones and textures in this detail in a ground-level shot is revealed by printing at grade 2.**

Now that you have gone through the process of making your contact print and testing both for correct exposure and the correct grade, you are finally in a position to make an enlargement from your negative.

The initial enlargement

The first step is to make a print exposing the whole sheet of paper at the time and grade indicated by your tests. Before you expose the paper, you will need to check your focus, using the focus finder (mentioned above). It would be frustrating and wasteful of paper if you were to make an enlargement, only to find the focus had slipped since you made your test strips. After exposing the paper, quickly slide it face up into the developer, and ensure an even dispersal of developer across the paper by rocking the developing tray gently. Do not be tempted to prod the paper into the developer using your tongs, as this will more often than not result in the print scratching or the paper creasing.

Develop the print for exactly the same length of time as you did with your test strips, then remove it carefully, using the tongs to hold the edge of the print. Slide it into the stop bath and then the fix. Make sure it is fixed properly, and do not be tempted to remove the print early in your haste and excitement to see the final result. Once it is washed and dried, as before, take it into a decent light source to study it.

The next step

In an ideal world, your first print would be perfect, displaying exactly the ideal range of tones and contrast to convey the feeling you had intended. However, as we all know, the world is not perfect! You might find that one part of your print is too dark at the given exposure, becoming muddy and reducing detail you wanted to include. Another area might be too bleached out, creating a highlight which detracts the viewer's attention from your main subject area. Or you might feel that a completely straight print, with equal exposure throughout, is simply too bland, and an

altogether more dramatic print could be created with just a few alterations.

Now is the time to make a second print, this time altering the exposure according to the changes you want to make. This is usually done by a process known as dodging and burning.

Dodging and burning

First study your print and decide which areas need to be altered. You might decide that a person's eyes are too dark, and need to be lighter in order to draw attention to them. This would require dodging to hold back the eyes, thus giving them less exposure. You might then decide that a highlight in the background is too distracting, drawing attention away from the main subject. This part of the print would therefore have to be burned in to reduce the highlight, or even get rid of it altogether.

The tools to perform the tasks of dodging and burning cannot be bought, one of the reasons being that your hands are often the most versatile tool you can use. However, where your hands cannot perform the task, a piece of card cut to shape, or a length of thin but sturdy wire with a roughly cut piece of card or a blob of Plasticine on the end

RIGHT: The area in shadow in the straight-printed negative (top) still showed detail in the negative, so a mask was cut and the area held back for part of the exposure.

ABOVE LEFT: **Although the grade of paper was correct for what the printer wanted, a straight print meant that the right-hand side of the subject's face was too dark.**
ABOVE RIGHT: **To bring out the detail in his eye, cheek and ear, this area was dodged (or held back) during exposure.**

will do the job to perfection. The shape and size of the dodging or burning tool will vary according to the alterations you need to make to your print.

Making the changes

There are many different ways of solving printing problems through dodging and burning, so it is up to you to find those which suit you best. However, those described here are some of the common printing issues which can arise, along with some suggestions of how to deal with them.

Eyes too dark

Assess how much lighter than the rest of the print the eyes need to be (e.g. 30% lighter or 50% lighter). Use two small pieces of Plasticine, each on the end of a piece of wire (one for each eye) as a dodging tool, and set your enlarger timer to a time appropriate to how long you want to hold back the eyes. For example, if your basic exposure is 12 seconds and

you have decided the eyes need 30% less exposure, set your timer to 4 seconds. Holding the dodging tools close to the enlarger lens to avoid obvious signs of dodging, make the exposure while moving the wires very slightly to blur the lines between dodged and undodged areas. After this, set the timer to the remainder of the exposure time – in this case, 8 seconds – and expose the whole sheet of printing paper as normal.

No detail in the sky

You have shot a wonderful landscape composition with a dramatic sky, and can see the sky detail on your negative, but it has not reproduced on your print. This is a common problem as the contrast between the sky and the land below it is often very high. You need first to determine the correct exposure for your foreground, then to make another set of tests for the sky. If your picture has a relatively straight horizon, the procedure is quite straightforward. Say your tests have shown the sky needs 20 seconds exposure, while the land needs only 10. Set the enlarger timer to 10 seconds, and hold your hand close to the enlarger lens, placing it across the picture so it covers the land. Make sure there are no chinks between your fingers which could allow light from the enlarger through. Expose the paper for 10 seconds, moving your hand very slightly up and down. After this, expose the whole sheet for the remaining 10 seconds. Alternatively, you could cut a mask from a piece of card, and burn in the sky this way. With both methods, the most important thing to avoid is a "halo" around the area which has been held back. While this can occasionally be used to artistic effect, more often than not it forms a distraction and simply looks like a bad printing technique.

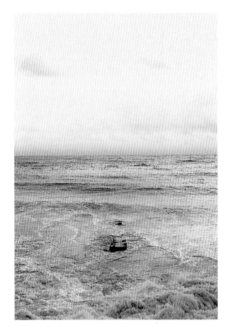
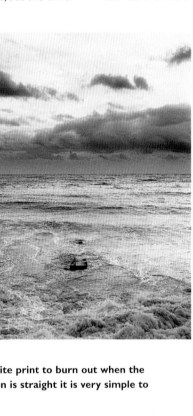

ABOVE: **It is common for the sky in a black and white print to burn out when the foreground is correctly exposed. When the horizon is straight it is very simple to burn in the sky to the desired level.**

BELOW: **A card mask can be cut to hold back an area of the print, but be wary of overlapping into the burnt-in area, which creates a "halo" (centre).**

BELOW: **While the old man's face was correctly exposed, the background needed to be darker, so the print was burnt in around the edges to create a more even spread of tone.**

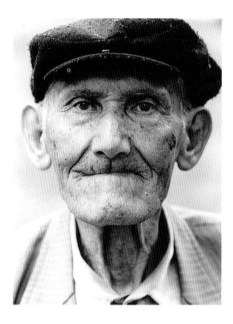

Burning a small area

This is more straightforward than it sounds. If, for example, one side of the face is bathed in bright light while the other is in dark shadow, you could simply change to a lower grade to reduce the contrast between the two. However, if you prefer the higher contrast but simply want a little more detail in the bright area, you cup your hands beneath the enlarger lens, leaving a hole of the appropriate size between the edges of your palms. During the extra exposure required you gently move your hands to burn in the area. Alternatively, you could make a small hole in a piece of card using a ballpoint pen, and hold the card over the paper, only allowing light through the hole to burn in the required area.

An object encroaching into the horizon

You may have a lack of detail in the sky but with the complication of something – whether a person's head, a building or a flower – which crosses the boundary between the horizon and the sky, and in which you want to retain detail. If the shape is very uniform – a straight-sided, rectangular building, for example – the solution is easy. Simply cut a card mask to the shape of the horizon and the building, and burn in the sky while holding the mask over the area to be held back. If the shape is less regular, things become a little more tricky. However, your hands and fingers are probably the best option again. For example, you could use your left hand to cover the main area of the print, then hold your other hand over the top so that a finger (or fingers) or thumb covers the detail which encroaches into the horizon.

Keeping it consistent

Once you have made a perfect print, you will not want to go through the process of testing every area all over again if you return to make further prints at a later date. Therefore, it is essential to keep a record of the procedure. The method most favoured by printers is to lay a sheet of tracing paper over the print, and draw around the areas which have been changed – using a felt-tipped pen – then writing within that space the alterations you made. For example, if your basic overall exposure was 15 seconds at grade 3, you would mark all the areas on the print which adhered to this exposure. If another part of the print required an extra 5 seconds, you would mark this as such, while yet another area might have been held back for 7 seconds and, again, you would indicate this on the tracing paper.

Creative printing techniques

Once you have mastered the making of a good print, the world of black and white printing is your oyster, and you can let rip on the numerous creative printing techniques possible even with the most basic of darkrooms. However, as we saw earlier in the book, simplicity is, nine times out of ten, the key to a successful photograph. Going over the top on technique could detract from what would be a very successful image if it was left to speak for itself. And, as we have also said, you cannot mask a bad photograph with the use of techniques. Learn how to be more creative, but also learn the best time to use these techniques. If you are unsure, it's advisable to leave well alone.

Borders

The borders of a black and white photograph are not strictly a technique, as their inclusion or exclusion, and the type of border you decide to use, should be considered an intrinsic part of the final print. However, since they can be so varied, it is worth looking at them here. These are some of the effects which can be achieved.

No border

You may feel that your black and white image requires no border at all, simply the even white surround created by using an easel, which can vary in width and can be deeper at the bottom to provide an improved sense of balance.

Black keyline on white border

This is the most common border seen on black and white prints, and is usually the most effective as it is subtle, neat and suits a wide variety of subjects and styles. It is created by using a negative carrier which is slightly larger than the negative itself, thus revealing part of the film's rebate. The easel is then adjusted according to how thick you would like your black border to be. This border particularly suits pictures which have a great deal of white surrounding the main subject – a high-key portrait, for example.

White keyline on black border

This is achieved by making a normal print, then placing a piece of black card – which has been cut to a size slightly larger than that of the image, and according to the size of the white keyline you prefer – over the print and exposing the edges for long enough to give a full black. Obviously you will need to do some tests first to determine how long you need to expose the paper in order to achieve this black. This border tends to suit more formal, darker prints.

LEFT: **Sometimes a frame can appear confining, so some photographs are better with none at all.**

RIGHT: **A black border can be created by filing down the edges of a neg carrier in order to create a bigger aperture.**

LEFT: **A white key line surrounded by a wide black border is extremely eye-catching when used in conjunction with a dark image.**

Showing sprocket holes

This has to be used quite carefully, because the sight of the sprocket holes of the negative can draw attention to the technique you have used, instead of the image itself. It simply requires a negative carrier too big for your negative (e.g. using a 6 x 7 cm negative carrier to print a 35mm negative).

Ragged edges

Used in conjunction with the right style of image, this can look very effective. Simply cut a 35mm-sized aperture out of a piece of card, making a point of distressing the edges with a scalpel. Slot the card into the negative carrier along with your negative and print as normal.

ABOVE LEFT: **Showing the rebate of the film can also be effective.**
ABOVE CENTRE: **The sprocket holes of a negative are a good complement to some subjects, but should be used carefully as they are sometimes a distraction.**
ABOVE RIGHT: **These ragged edges are particularly suited to the diffused print.**

Toning

Like so much of black and white printing – indeed of photography as a whole – the decision as to whether to tone a black and white print is a purely subjective one. And, once again, it can either enhance a print beautifully or it simply may not work for that particular style of image. Most toners can be bought "ready-made" from photographic retailers, although some printers still prefer to buy the chemicals themselves and mix their own combinations. Books that give the chemical formulae are quite readily available, and the chemicals can be purchased from specialist suppliers.

Toners which are designed to add colour to a black and white print are usually a two-bath process, requiring a bleach bath, then a toning bath. It is essential that the print is washed thoroughly after being fixed, after it has been bleached and again after it has been toned.

Toning can be done in normal light, but must always be carried out in a well-ventilated area. If you are intending to tone a print, you should print it slightly darker than normal, as the bleaching process can make the highlights too bright, and therefore a distraction. Also, toners can react slightly differently to different types of paper, so it is worth conducting some tests of your own to have the utmost control over your final result. The three main types of toner are explained here, but there is no reason why you should not experiment with gold toner, copper toner, or even tea or coffee!

Selenium toning

While it can add a purplish tinge to a print and increase slightly the density of the blacks – depending on the dilution used and the length of time the print is allowed to remain in the toner – the principal purpose of selenium toning is to prolong the life of the print. For this reason, it

Untoned

Sepia toned

Blue toned

is used by many professional and "fine-art" printers who wish to produce archival quality prints. Selenium can be highly dangerous, and must, without fail, only be used in a well-ventilated area and while wearing gloves and using tongs. It is a one-bath process.

Sepia toning

This is a two-bath toner, the first stage being to place the print in a solution of potassium ferricyanide – or bleach. The bleach works on the highlight areas of the print first, and the darker areas last. The satisfying aspect of sepia toning is that it is very controllable, and can be used to either very subtle or very obvious effect. It is common to allow the bleach to work on the print only for a brief period, to keep depth in the darker areas of the print and show only a hint of the warm, brown tone. It can even be painted on to very specific areas of the print, using a paintbrush or cotton bud. Alternatively, the print can be kept in the bleach until the entire image has disappeared, before being removed and washed thoroughly until the yellow staining has disappeared. When placed in the sepia toner, it will then completely take on the brown tone, resulting in a print that suggests it was shot decades earlier than it actually was. Sepia toning, like selenium, is an archival process which prolongs the life of a print.

Blue toning

This is another two-bath process and, like sepia, its intensity of colour can be controlled carefully. Only rarely will a vivid blue suit an image, so it is better to remove the print from the bleach bath fairly quickly, wash it, then place it in the blue toner until a cool, steely colour is achieved. Where blue toner really comes into its own is when a print is first sepia toned, then blue toned afterwards.

Copper toned

Intensified blue

Split toning: blue and sepia

Hand colouring

Hand colouring a black and white image requires a steady hand, a fair bit of practice, and a touch of restraint. The final point is important, as it defines the amount of colouring or tinting a print may require. Sometimes only partial colouring of a print can be very effective – for example, painting

BELOW: **Hand colouring conjures up an atmosphere of times gone by, and suits a rustic subject such as this still-life composition.**

in a single flower on a model's dress, leaving the remainder of the picture in monochrome. Or you could paint completely a still life of a basket of flowers, say, giving it an olde worlde feel. Hand tinting also works well when applied on top of a print which has been toned, and some practitioners believe it works best on fibre-based papers.

Various hand-colouring kits are available, in the form of oils or dyes. They should be applied using the best paintbrushes you can afford.

Diffusing

A diffused print has an ethereal quality which can enhance and romanticize a black and white picture very effectively. It is also an extremely simple technique to master. The difference between diffusing at the shooting stage as opposed

to the printing stage is that soft-focus filters on a lens bleed the highlights into the shadow areas, while in the printing process the darker areas blend into the highlights. The technique suits all manner of portraits, as well as landscapes and still-life images.

In the same way that soft-focus effects can be achieved in camera, the stocking-over-the-lens or the Vaseline-smeared skylight filter approaches work just as well in the darkroom. However, for the most consistent, repeatable results, it is worth investing in a diffusing filter. Although they come in varying strengths, there is little point in pur-

BELOW: The old cliché of Vaseline on a skylight filter – held under the enlarger lens during exposure – creates the perfect romantic atmosphere for a print such as this.

ABOVE: **Undiffused print.**

chasing every strength available, as the level of diffusion can be controlled very easily. All you have to do is make a series of test strips, each one slightly more diffused than the next. For example, if your print requires an exposure of 20 seconds, make one test strip which diffuses the light for the entire time, then reduce the diffusion by 5 seconds for each subsequent test strip (in this example, 15 seconds with diffusion, 5 without; 10 seconds with diffusion, 10 without, and so on). Then simply make the print in the normal way, using the quantity of diffusion you feel will suit the image best.

ABOVE: **Print diffused for half the exposure time.**

ABOVE: **Print diffused for the whole exposure time.**

creative
techniques

Experimenting

Once you've become more confident with your basic camera and exposure technique, it's a good time to start experimenting to gain more exciting results. How many times have you been sent to sleep by other people's unadventurous holiday snapshots? As a more creative photographer, you owe it to your friends and family to arm yourself with a few clever tricks and techniques – and don't worry about making mistakes: it's only by risking the odd frame of film and trying out new ideas that you can really reap the artistic rewards.

Long exposures and the 'B' setting

When taking pictures at night or in dark conditions where flash would spoil the mood and overpower more subtle ambient lighting effects, it's useful to set the camera on a tripod or other steady surface and turn the shutter-speed dial to "B". This allows you to extend exposure times beyond the camera's own automatic shutter-speed settings (usually ranging from around 1/2000 second to 2 seconds) and time them manually instead, measuring the length of the exposure by counting out the seconds in "elephants" or using the second hand of your wrist watch. (At night it helps to have a wrist watch with an illuminated dial, or to use a small pocket torch to help see the time.)

Traffic trails

One of the easiest ways to practise making long exposures is to fix your camera to a tripod and find yourself a safe, pedestrianized bridge overlooking a busy motorway. At dusk, when there's still some purple-blue ambient light in the sky, you can capture the streaking trails of white and red head and tail lights as the cars speed along – though the car silhouettes themselves will magically disappear because they're moving too fast to record on film.

To capture this effect, just load up with a slow-speed film of ISO 100, set the shutter-speed dial to its "B" setting and use a remote release to start the exposure to avoid jogging the camera. Set the aperture to f/2.8 and take a meter reading. For greater depth of field, you'll need to work backwards from the reading for f/2.8 to calculate the correct length of the exposure for a smaller aperture setting

ABOVE: **A busy street with floodlit buildings provides the perfect opportunity to perfect your "traffic trail" technique. Note the photographer stood at a junction to obtain curved trails as well as straight ones. The trail going through the middle of the frame was created by a double-decker bus.**

such as f/16 or f/22. (For instance, if the reading you get for f/2.8 is 1/2 second at ISO 100, you'll be able to calculate that for f/16 your "B" setting exposure must last approximately 16 seconds, timed manually on your wristwatch.)

With long exposures, it's always wise to bracket, making the exposure longer in regular increments. So if you take your first exposure at f/16 and 16 seconds, next try f/16 and 20 seconds, then 30 seconds, then one minute, adding the recommended extra exposure to counter reciprocity law failure (see page 100).

When studying your initial results you'll notice how the longer your exposure, the brighter your pictures become, and that as the night darkens, the composition loses sky-colour interest. Next time, try creating variations in different traffic conditions such as nose–to–tail rush-hour traffic jams and at traffic lights.

BELOW: **Try to photograph the fun of the fair against a twilit sky to balance the artificial and natural light sources.**

LEFT: **Arrive at the site of a firework display in plenty of time to get a prime position. Either close in on the action to fill the frame with colour, or use a wideangle lens and include some silhouetted figures in the foreground to give a sense of scale.**

Fairgrounds

Swirling colour, movement and light are favourites for creative night-time photography, and there are rich pickings of all three at the fairground. With such a wide variety of illuminated rides to choose from you're spoilt for choice, but photographers' favourites include big-dipper-style roller-coasters and giant rotating ferris wheels – basically, any ride which can be shot with a long exposure to blur the moving coloured lights against a dusky-coloured sky.

Again, long exposures are required if you want to include dramatic movement in your pictures, and the best approach is to slip the camera on a tripod to avoid camera shake spoiling your results, and then set the shutter-speed dial to "B". To work out your exposure, take a meter reading at maximum aperture (usually f/2.8) to gauge the available light, then work back from this reading to a smaller aperture setting such as f/16 or f/22, to gain greater depth of field. Bracket the exposure, making it longer in set increments, to guard against reciprocity law failure.

So that you don't have to worry about leaving your camera bag unattended while you line up your compositions, one option is to travel light, with just a camera and standard zoom and monopod, or else team up with a friend who can keep an eye on your gear.

Fireworks

Choreographed firework displays always provide opportunities for great pictures – the difficulty comes in making sure the camera is pointed at the right stretch of night sky at the right time! Using a wide-angle lens gives you less scope for error, but a telephoto or zoom lens will help you fill the frame with the action. Use the first firework as a guide for cropping.

Making the exposure is the easy bit: just let the fireworks do it for you, by building up a composite image filled with colourful explosions as they happen. This technique involves finding an unobstructed vantage point over the crowds and setting the camera on a steady surface such as a tripod. Select f/16 as your working aperture and switch the shutter-speed dial to "B". Now line up the camera lens with the first firework as the display starts and release the shutter to start the exposure, holding a sheet of black card over the lens in between firework explosions and keeping the shutter open, manually, until you've caught about four or five explosions on film.

As the night sky is pitch black, there's little risk of overexposure unless you have a street lamp or some other unwanted light source sneaking into frame. Check all four corners of your viewfinder carefully.

Cross-processing

Usually when you send a colour film off for development, the processing lab will follow strict manufacturers' guidelines as to the correct chemical baths to use and for how long, their correct temperature and sequence – the aim being to achieve consistency and critical accuracy in reproducing image colours, density and contrast, time after time.

However, in recent years the rise of DIY home-processing kits and adventurous professional labs have made it possible to explore what happens when you fail to follow these stringent guidelines. For instance, in the early 1980s it was discovered that a whole range of weird and wonderful colour results are possible when you deliberately (or even accidentally!) flout film-processing rules in the name of art. It was found that surreal colour shifts and increased image contrast could be achieved by processing colour negative film in the chemicals designed for colour transparency film, and vice versa.

ABOVE: **Choose brightly coloured subjects if you plan to cross-process a film, as the shifts in cast will become more apparent. Do not forget that different types of film produce different results, so experiment with a variety of speeds and brands.**

Colour shifts

The normal processing sequence for most colour slide films involves using E6 chemistry to create a positive transparency image with a clear film base. Developing baths must be used in a strict sequence to gain acceptable results: the first bath develops the film to form a black and white negative, the second is a reversal bath which chemically fogs the remaining silver halide, and the third bath acts as a colour developer, producing colour dyes to form a colour image.

However, when you subject an exposed colour negative film to this processing sequence, the E6 chemistry cannot take account of the film's built-in orange mask (which is designed to help keep the negative's colours pure during enlargement). As a result, a colour negative cross-processed in E6 yields all manner of wayward colour shifts in a palette that ranges from warm bluey-purples to deeply saturated cyan and rich navy black, depending on the film brand and any filtration used during picture taking.

Another important factor when cross-processing a negative film in E6 chemistry is the ISO speed at which you choose to rate the film. For example, if you deliberately overexpose the film a couple of stops when taking your pictures, or push–process it in the E6 chemistry, results tend to look brighter and cleaner, with more boisterous contrast and dramatic, burnt–out highlights. From these positive images created on negative film, you can make prints and manipulate the colour even more, via an internegative or by making an R–type print.

Making negatives with slide film

Conversely, by processing a colour slide film in the C41 chemistry normally reserved for developing colour negative films, you can make colour negatives with a clear film base. This time, because slide film lacks the orange negative mask mentioned before, the processed film comprises extremely high-contrast, high-key negatives with rich colour saturation. Again, the unnatural colour palette can be enhanced by selective filtration at the printing stage: it's best to start off at your normal enlarger settings, then play around for special effects.

If you don't have processing or printing facilities at home, contact your local professional lab – they are used to cross-processing films on customers' behalf.

Polaroid transfers and emulsion lifts

Polaroid instant films offer a range of creative opportunities for special-effects photography, and are well-suited to experimentation. For one thing, the image can be seen quickly enough to assess and amend any mistakes before the end of a shoot. For another, the prints are robust enough to withstand manipulation, and on certain types of Polacolor film the emulsion layer is sticky and mobile before it dries, which means, for example, that you can manipulate its gooey surface with a cocktail stick to distort picture shapes and create patterns.

Though the film packs aren't cheap, playing around with Polaroid images nearly always pays off, especially when tackling emulsion transfers and emulsion lifts. For both techniques, look out for "ER" designated Polacolor films, which have the special gluey emulsion; in 6 x 6 cm format look for Type 669; in 5 x 5 in. sheet films, Type 59; in 5 x 4 in. pack films, Type 559; and in 10 x 8 in. sheets, Type 809.

Fortunately for 35mm SLR users, you don't need to splash out on a Polaroid camera or special medium-format instant-film back to secure an image on Polaroid film. The company produces a special instant-image transfer unit called the Daylab Jr. Slide Printer, which allows you to project mounted 35mm slides direct on to Polaroid pack film, simply and quickly at the press of a button.

Polaroid image transfers

Once your image is captured on the correct type of Polacolor film, you can transfer it on to any other dampened, absorbent surface, such as textured watercolour

paper or even damp cotton fabric or canvas, to give your images greater texture for a more painterly look.

To transfer the image, you need to separate the negative from its Polacolor paper prematurely – that is, before the print has finished self-development. Just peel away the protective paper and discard the under-developed print, flipping the negative face down squarely on to your clean, damp sheet of watercolour paper. Apply pressure to the back of the negative with a rubber ink roller to ensure complete contact between the still-developing negative and the receptor paper. It's best to use a protective layer of fabric or paper in between image and roller to avoid damaging the end-result. The finished image transfer can now be dried and sprayed with a clear UV protective coat to seal the image. As variations, Polaroid suggest you might like to try cloth, wood and even unglazed clay surfaces.

Polaroid emulsion lifts

Although transferring the emulsion like this is huge fun, actually lifting the emulsion off the Polacolor print is far more challenging and the results every bit as rewarding.

This time, the exposed Polaroid image is allowed full development, and instead of being prematurely rollered on to a sheet of paper, the print is peeled away from its black paper sheath and plunged into a tray filled with hot water (80°C/180°F). After about five minutes, the gluey Polacolor emulsion begins to loosen and lift away from its backing paper, allowing you to – very, very gently – remove the translucent image with a blunt implement such as a pair of

rubber tongs (or a soft bristle brush, or your finger inside rubber gloves, to avoid scalding yourself). This procedure can be extremely tricky and delicate, and opinion varies as to whether it's any easier to work with a larger format 10 x 8 in. Polaroid than with fiddly 6 x 6 cm. In either case, it takes a lot of time and practice to keep the image intact without any tears or rips.

Once the emulsion is free, the aim is to slide this flimsy, floating image off its original backing paper and on to a sheet of more attractive watercolour paper or other textured surface – in one piece. It's easiest to lie the watercolour paper flat inside the tray, alongside the Polaroid image, so the paper gets wet

ABOVE: **The painterly, watercolour effect of the image transfer means it works particularly well on watercolour paper, which can be bought cheaply at art shops.**

RIGHT: **Do not attempt to lay an emulsion lift completely flat – the creases, and even the slight tears which can occur, are all part of the charm of this technique.**

and the emulsion doesn't have so far to travel. After drying, fix the image in place using a clear UV lacquer spray.

If you find the hot water causes the emulsion to bubble and split, an alternative is to lift the emulsion by soaking the Polacolor print for 15 minutes in cold water. In this case the emulsion will not lift and float free, but will need persuasion with a rigid smooth scraper such as a credit card.

Multiple exposures

The ME function on most modern SLR cameras has made the art of multiple exposure photography a relatively quick, simple and painless affair. Just take a picture, press the ME button and take a second one – both exposures will appear on the same frame as a composite image when you get the film back from the processing lab.

Most cameras will even halve each exposure automatically for you too – the reason being that if you were to make a double exposure on the same frame without compensating for the fact that the film is receiving twice the amount of light, you'd overexpose the composite image. In the same way, with more ambitious multiple exposures combining three or four separate images, you'd need to cut the exposure accordingly: just reduce the length of the exposure by the number of images you intend to combine on the same frame of film. For instance, with a three-part multiple exposure metered at f/8 and 1/60 second on ISO

100 film, you need to knock the exposure length down two stops to 1/15 second.

The object of most multiple-exposure photography is to show things in the same image area that would not be possible in real life. For instance, with ME photography you can take a picture showing you with your "twin", or make a time-lapse type image, showing the growth pattern of a plant or a flower coming into bud. You can even move mountains or, if you really want to, put your house on the moon!

However, setting up a surreal image requires careful thought and planning. Bear in mind that dark parts of a scene shot on slide film will allow pale parts of the next exposure to show through. So, if you want to mask

LEFT & ABOVE: **A multiple exposure does not always have to combine two separate images. An effective, soft-focus result can be achieved by shooting a composition in sharp focus, then de-focusing the camera and making a multiple exposure to achieve this dream-like image. You could even try three multiple exposures – one sharp, one slightly out of focus, and one completely out of focus.**

out particular areas, just cover them with a sheet of black light-absorbing velvet.

It is important to keep an eye on the composition: draw it on paper before you start and work out exactly where each part of the multiple exposure will appear in the composite. The value of keeping things simple will quickly become apparent!

Slide sandwiching

One of the quickest routes to an eye-catching image is to take two separate photographs on slide film and combine them in the same slide mount. This so-called sandwiching technique is useful when you want to create a surreal or abstract image, introduce mood through colour, or give an image a more painterly finish by adding pattern or texture to a scene. The best results are planned carefully in advance, shooting both images specifically with the intention of making a sandwich, although the technique can be used to enhance existing "dud" images which lacked colour or interest at the taking stage and would otherwise be consigned to the wastebin.

BELOW: **It would be impossible to achieve such a perfectly exposed image by conventional means – there's nothing wrong with a bit of cheating!**

Shoot the moon

Multiple-exposure technique really comes into its own when you want to photograph a moody, moonlit landscape. Ordinarily, with a landscape scene at night, the moon appears so small in frame as to be insignificant, and thanks to the long nocturnal exposures required, you risk including unwanted subject blur from the moon's movement across the sky.

The best bet is to shoot the moon and the landscape separately as a multiple exposure, with the camera on a tripod. First shoot the moon so it appears in the top right-hand corner of the film frame, using a telephoto lens to make it appear a little larger. Because it's bright against the dark sky, you won't need a very long exposure and won't risk subject movement. Next press the ME button (or disengage the film wind-on lever if using an older SLR camera) and change lenses to a shorter focal length. Re-compose the scene so the landscape occupies the bottom and left-hand side of the picture area, carefully cropping the moon out of frame this time, so it doesn't appear twice. This exposure will be longer, to record detail in the moonlight, but without subject movement from the moon. To make sure you've got a good exposure on film, try shooting several bracketed variations of the same scene, remembering to change lenses each time.

Alternatively, carefully load and shoot a whole roll of film showing just the moon in the top left-hand corner of the image area. As you load the film, take care to mark the leader with a chinagraph pencil to show exactly where it was positioned – this will help you reload and align the film later. After your moon exposures, finish the film and rewind it manually, leaving some of the film tongue hanging out of the cassette. When you're ready to shoot the landscapes, reload the film, making sure to align the film leader in the correct position.

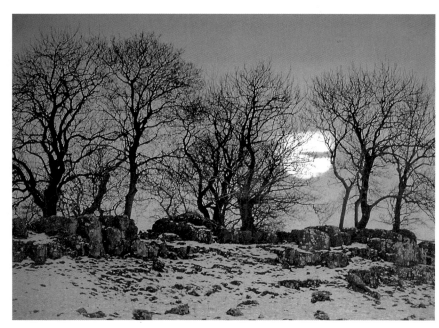

ABOVE: **These two photographs on their own are nothing special. However, once brought together to form a single picture, they produce a very pleasing result.**

Some of the most successful slide sandwiches are those where a texture has been introduced to an atmospheric landscape, giving it a painted look and softening the sharp edges. This can be done by shooting and slightly overexposing either a sheet of stippled glass or a length of backlit muslin with a macro lens to gain a light pattern of highlight and shadow that evokes paint texture or canvas. Next shoot your land-scape – again slightly overexposing the scene to lose highlight detail and make the image more ethereal. After processing, pair both transparencies togeth er in the same slide mount and see how the overlaid texture image introduces a subtle hint of surface detail to the landscape.

If you're shooting for a sandwich, try to slightly over-expose both images so they come out paler on slide film than usual. This means that highlights in one image (such as a sunlit sky area) may be so bleached out that important shadow detail in the other shot shows through.

Just hold the images up to a window to check whether the sandwich idea will work.

With more complex slide-sandwich projects – for instance, where large- and small-scale images are combined in the same surreal scene – one of the most difficult aspects to get right is making sure the image details fit alongside each other in frame without one obscuring the other. For this reason it helps if you can draft out a quick diagram as an aide memoire, illustrating where each part of the scene will fall in frame, then bring it along with you when shooting both scenes.

Though the joy of this technique lies in its simplicity, for more professional, permanent results, you can copy the slide sandwich pair together on to another film. You do this by inserting both slides into a zoom slide copier (approxi-mately £50 second-hand) fitted onto your camera and use a flashgun to light the proceedings. It is best to stick to the manufacturer's recommended flash-to-copier distance, copy-film speed and aperture settings.

Digital
Photography

digital versus traditional photography

The camera

Look at most modern digital cameras and you will see little difference from their film-based counterparts. Sure, most models have a tell-tale small viewing screen on the back of the body but, apart from this, most look and feel very familiar. If you describe a camera in its simplest terms it is a box with a lens, viewfinder, shutter, aperture and a place to hold the film.

All cameras, no matter how basic or sophisticated, follow this simple design. The photographer frames the image using the viewfinder. When the composition is judged to be just right, the shutter is released. Light passes through the lens and the aperture and is focused on to the film. The shutter is closed at the point when enough light has reached the film to form an image.

The digital camera adheres to this basic design in most ways except that the image is recorded onto a digital

sensor rather than film. All the other elements of the camera work in much the same fashion for both traditional and digital image capture. If you are proficient with your film camera then you will be able to transfer a lot of your skills to new digital equipment.

The basics

Lens

The function of the lens is to focus the image in front of the camera onto the film or sensor. Lenses for digital cameras are essentially the same as those for film-based cameras. In fact with some professional-level cameras the same lenses can be used on both film and digital camera backs.

Viewfinder

The viewfinder is the photographer's frame around the world. It is here that the image is composed and a moment selected for the shutter to be released. Most digital cameras have a viewfinder that is separate from the lens as well as a small colour screen that, in some modes, can act as a preview of what you are photographing.

Shutter

The shutter helps controls the amount of light falling on the film or sensor. In film-based cameras the shutter is

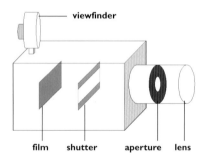

ABOVE: **All cameras are basically a light-tight box with a lens, viewfinder, shutter, aperture and a place to put the film.**

RIGHT: **Digital cameras are very similar to film cameras in most areas except that the film is replaced with an electronic sensor.**

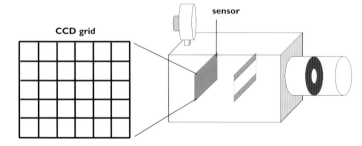

usually a thin metal curtain that is raised to allow light into the camera for a specific amount of time and then lowered. Some digital cameras work in a similar manner, but others just turn the sensor on and then off again.

Aperture

The aperture is the second mechanism that controls the amount of light entering the camera. It works in a similar way to the irises in our eyes. When light levels are high the hole is made small to restrict the amount of light hitting the film. When levels are low the diameter is increased to allow more light to enter the camera.

The film

Instead of the traditional film, the digital camera captures its images using a sensor. Areas of light and dark together with information about the colour of the scene are all recorded within a fraction of a second. Most digital sensors are smaller than the 35mm film frame.

BELOW: **The new Canon digital SLR camera uses a non CCD sensor to capture images.**

Digital film

The heart of a digital camera is the sensor. This usually takes the form of a grid of Charge Coupled Devices, or CCDs, each designed to measure the amount of light hitting it. When coloured filters are placed over the top of each CCD, each sensor can determine the colour of the light as well as the quantity. The filters are set in a pattern across the grid alternating between red (R), green (G) and blue (B). Using just these three colours it is possible to make up the majority of the hues present in a typical scene.

Colour film and filtered sensors

The idea that all the colours that we see can be made up of three basic or primary colours might seem a little strange, but this system has been used in colour photography from the time that it was first invented. In fact the modern colour film has more in common with its digital sensor counterpart than you might first realize.

About 80 years ago it was discovered that you could capture the colour detail of a scene by shooting it on black-and-white film through red, blue and green filters. If these images were then projected together through the same filters, the colour scene could be recreated. Since those early days colour film has developed in sophistication but this basic separation idea remains the same – the colours of a

scene are separated and recorded individually and then recombined as a print or transparency.

Once it was found that CCDs could only record black and white (the brightness of a scene), it was a comparatively small jump to impose a similar separation idea onto a grid of CCDs. The result is that the majority of sensors in cameras now use this system. The files they produce are called RGB as they contain the colour information for the

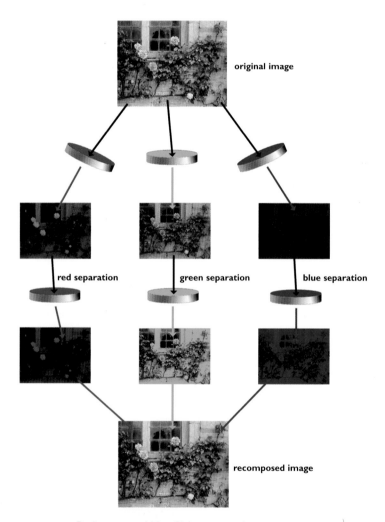

ABOVE: Red, green and blue filters are used to separate the colours of a typical scene into three greyscale images. These pictures are then tinted and recombined to form a colour version of the original scene.

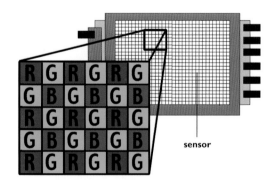

ABOVE: A pattern of filters on a grid or matrix of CCD cells forms the heart of most digital cameras.

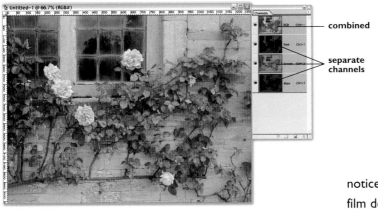

combined

separate
channels

LEFT: Colour digital files are made up of red, green and blue channels which are stored separately and are then recombined when printed or viewed on screen.

scene in three separate black-and-white channels relating to each colour, red, green and blue. When we view the file on screen or print it the three separations are recombined to form a full-colour image.

The new grain

With traditional film the details of a scene are recorded via an intricate structure of light-sensitive grains. Each grain changes in response to the light that hits it. These grains can be visible on the final print or transparency, most noticeably in large prints, or if you have been using a fast film designed for low-light photography.

The digital equivalent of grain is a picture element, or pixel as it is usually called. Your digital photograph is made up of a grid of pixels. When seen at a distance these rectangles of colour blend together to give the appearance of a continuous tone photograph. Each pixel is the result of a CCD sensor recording the colour and brightness of a part of a scene. The more sensors you have on your camera chip the more pixels will result in your digital file. Just as the grain from traditional negatives is more noticeable as you make larger prints, pixels also become more apparent as you make bigger pictures.

RIGHT: Pixel grids seen from a distance appear as though they are a continuous tone photograph.

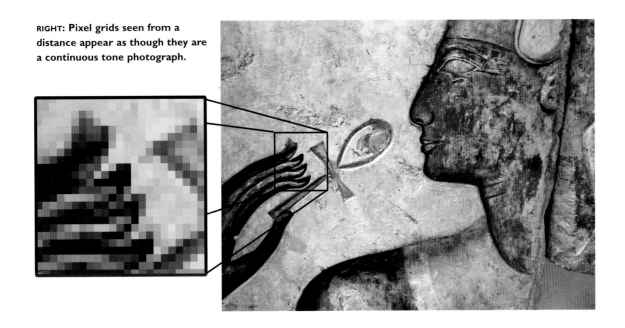

The digital process

The process used for capturing images the traditional way is so familiar for most of us that it is almost second nature. Shoot your images onto film, have the film processed and your negatives enlarged and then sit back and enjoy your images. When it comes to the digital equivalent it can be a little more confusing.

Essentially we still have three main stages – a shooting (capturing) phase, a processing (manipulation) phase, and a printing (outputting) phase. However, what happens in each stage is a little different.

Capturing

1. The image is composed and focused and the shutter is released. Here the concerns are the same whether you are shooting on film or with a digital camera.
2. Light hits the sensors. Varying amounts of light are reflected from the scene focused by the lens onto the sensor. Each sensor receives a slightly different amount of light.
3. In response to the light, each CCD cell produces an electrical charge. The more light, the greater the charge. Keep in mind that each sensor is filtered red, green or blue so the charge reflects the colour of the light as well as the amount.
4. All the electrical pulses are collated, converted to digital information and stored according to their

ABOVE: The traditional photographic production cycle with its three basic stages.

shooting processing printing

capturing manipulation outputting

ABOVE: The digital production cycle still has three distinct phases but after the familiar shooting phase the way the content is processed is quite different.

position within the CCD grid or matrix. This process is sometimes called quantization and uses a special chip called an analog to digital converter or ADC.

5. The digital information is stored in the camera as picture files. The information which now represents a single digital image made up of pixels, each of which has a position within the grid, a colour and a brightness, is saved to memory within the camera. The camera is now ready to take another shot.

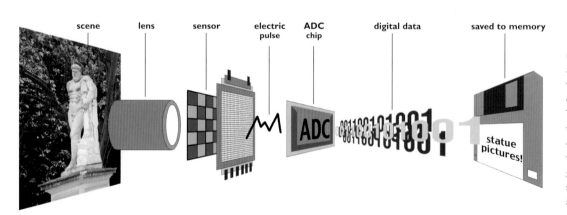

scene lens sensor electric pulse **ADC chip** digital data saved to memory

LEFT: Shooting skills are very similar with film and digital cameras. The difference is that the digital camera captures the image using a grid of electronic sensors rather than a piece of film.

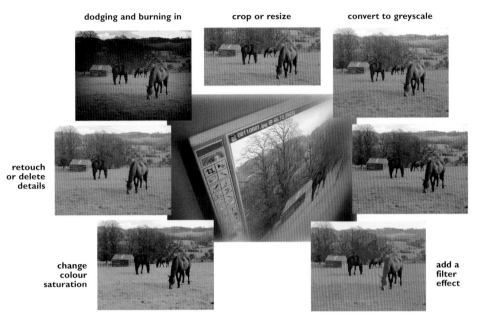

dodging and burning in crop or resize convert to greyscale

retouch or delete details

change colour saturation

adjust contrast and brightness

add a filter effect

LEFT: It is during the manipulation stage of the process that we can see the power of digital photography. Here images are enhanced or changed according to the photographer's design or fancy.

Manipulation

6. The digital files are transferred to a computer. The space within the camera is limited so at some stage it is necessary to download or transfer the image files. This is usually achieved by connecting a cable from the camera to a PC.

7. Once the image is on the computer an editing program like Photoshop can be used to enhance the image.

8. The enhanced picture is saved in the computer, usually on the hard disk.

Outputting

9. At this point the image is ready for outputting. Most times this means making a print using an inkjet or similar colour printer, but the digital file can also be used for web publishing or even printed (written) back to film as a slide or negative.

CD

BELOW: When negatives are printed we are limited to one outcome – the print. The digital photograph has a broader range of possibilities.

PHOTO*college*.co.uk

web

print

film

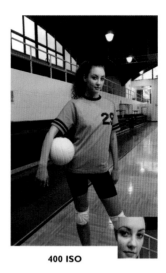
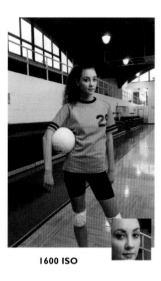
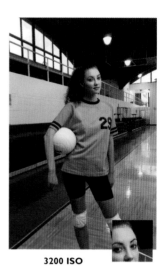

| 400 ISO | 1600 ISO | 3200 ISO | 6400 ISO |

ABOVE: Unlike other cameras before it, the **DCS620x** and **DCS720x** use cyan, magenta and yellow filters to separate scenes into three greyscale channels. In doing so it has gained a full stop more sensitivity.

Exceptions to the rules
Non RGB filtered cameras

In 2001 Kodak released the latest version of its digital professional press camera. The DCS720x is a major step over previous models. Instead of using a CCD matrix that is filtered red, green and blue, Kodak has changed the separation filters of the sensor to cyan (C), magenta (M), and yellow (Y).

In doing this Kodak have gained an extra stop of usable sensitivity as the new filters allow more light to pass to the sensor than before. This means that the camera can be used with an ISO film sensitivity setting equivalent to 6400.

For anyone familiar with colour printing techniques the step probably appears to be a fairly simple one. For years we have known that CMY colours work in a balancing act with their opposite RGB colours to form white light. So it seems completely logical to swap separation filters and gain the advantage of more light hitting the sensor.

standard **RGB** filter pattern

LEFT & RIGHT: The new **CCD** chip Kodak uses in its **DCS620x** and **DCS720x** is based on cyan, magenta, yellow separation of the light rather than red, green, blue.

new **CMYK** filter pattern

ABOVE: **The colour diamond familiar to colour printers clearly shows the relationship between the two separation systems.**

Non CCD sensors cameras

While CCDs are the main image sensor technology in town, some manufacturers are successfully pioneering image capture using other techniques. Early in 2002, Canon introduced a six-megapixel digital SLR camera based on the highly acclaimed EOS 1-N film camera. The camera makes use of a CMOS chip rather than the usual CCD matrix.

Canon has used CMOS sensors in some of its desktop scanners for a few years and in this camera has managed to overcome some of the engineering obstacles that stopped large sensor production in the past. The chip, measuring 22.7 x 15.1mm, consumes less power than the same size CCD and is able to be integrated more easily into image-processing circuits. Such advantages may see this type of chip assume dominance of the camera market in the future.

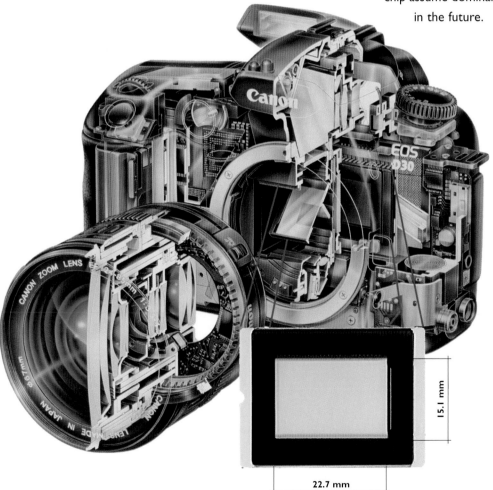

LEFT: **Canon has successfully enlarged the CMOS sensor technology that it has been using in its scanner products to suit capture in the new camera.**

More sensors = higher resolution = better quality pictures

In traditional photography, the film is separate from the camera so it is possible for a photographer to select the film that is suitable for a particular job. If you are shooting sport under floodlights at night you can use a fast film that is particularly sensitive to low light. If, on the other hand, you are shooting under controlled lighting conditions within a studio, you can use a slow film with fine grain and saturated colours.

The digital photographer doesn't have the luxury of being able to swap recording stock. The sensitivity and "grain" or resolution of the sensor is fixed. For this reason manufacturers continue to try to develop digital cameras with higher resolution chips that can handle a greater range of lighting conditions.

Over the last few years we have seen digital camera resolution increase from the early days where it was measured in hundreds of thousands of pixels to today when chips are capable of upwards of 6 million pixels. Some specialist studio models are capable of 16 million pixel images but these are not your average point-and-shoot cameras. To put these figures into perspective the average 100 ISO film is estimated to have 60 million light sensitive grains within one 35mm frame. This means that the best digital SLR camera's sensors are still only capable of recording about 10% of the detail possible using film.

In terms of sensitivity, five years ago the average digital camera chip had an equivalent ISO rating of between 100 and 200. Now professional-level press models like the Kodak 720x can shoot up to a sensitivity of 6400 ISO. This effectively enables the digital press photographer the opportunity to shoot under a much wider range of lighting conditions than ever before.

ABOVE: The Kodak DCS720x is capable of shooting under a much wider range of lighting conditions than ever before.

How is a sensor's resolution measured anyway?

A digital image is measured not in inches or centimetres but in pixels. Each pixel relates to a sample that was taken by a CCD sensor during the capturing process. Digital cameras have a set number of sensors and so the resultant file's pixel dimensions can be directly related to the chip it was made with.

The sensor's resolution is measured by quoting the number of pixels widthways by the number in height. A typical resolution might be 1200 x 1600 pixels. When these dimensions are multiplied you will have a sensor with approximately 2 million pixels. This is called a two-megapixel sensor.

When digital pictures are printed the pixels are spread over the paper at a specific rate per inch (or centimetre). This gives us the printing term dots per inch (DPI).

capturing the image

Starting to shoot

Making images is the main job of the photographer and the technology, be it traditional or digital, should play a supporting rather than leading role in this task. Knowing your medium is a sure way to guarantee good results, but never lose sight of the technology's role in your photographic life: it is there to underpin your image-making, not overtake it.

The same imaging principles used by traditional film photographers also apply to digital photography and are covered comprehensively in the first part of this book. When it gets right down to it, there are really only three things you need to understand to make great images: composition, focus and exposure.

Composition

When you look through the viewfinder of a camera, you are framing the world. You choose what is in the frame and how the elements fit together. Some of the best images are ones that present a single idea or subject. Move objects, change backgrounds and remove distractions from the frame. Remember that although you can concentrate your vision on a particular object so that other things in your peripheral view almost don't exist, the camera is not as clever and not nearly as selective.

Focus

The majority of digital cameras are supplied with an autofocus (AF) lens system. In the viewfinder you will see one or more focusing areas. For the camera to focus, the subject must be in this area. In most cameras the focus area is positioned in the centre of the frame but in professional models you will find multiple focusing areas. With the aid of a dial or thumb toggle, the photographer can choose which area will be used for primary focus.

In AF terms, two modes determine the way in which the autofocus system works. In single mode, when the button is held halfway the lens focuses on the main subject. If you wish to change the point of focus, you need to remove your finger, move the camera and then re-press the button. The constant or continuous focusing mode focuses on the subject when the shutter button is half pressed but adjusts the focusing when the subject moves. This is sometimes called focus tracking. Some AF SLR systems have "pre-emptive focusing" that not only tracks the subject but analyzes its movement across the frame and tries to predict where it will move. This is particularly useful in sports photography.

Experienced film-based photographers are able to control not only where their images are focused but also how

ABOVE: **Keeping the composition simple gives you a greater chance of ending up with a balanced image.**

ABOVE: **Search the viewfinder to find objects that distract from the main idea of your image. Change position or angle to eliminate these things from your picture.**

ABOVE: **Digital sports photography requires an approach in which the action point is anticipated and captured rather than seen. By the time you see the action, it will be too late to press the button.**

large the depth-of-field effect is within their images. Digital shooters can use similar techniques, but the small size of most sensors means that the majority of digital images will contain large depth-of-field characteristics. This said, careful control of aperture, focal length and subject distance can all be used to make images with a variety of sharpness ranges.

Exposure

Contrary to popular belief, good exposure is just as critical in digital photography as in traditional shooting. Bad exposure cannot be "fixed in Photoshop". Under- or overexposure of the sensor leads to images in which the critical picture detail is lost forever. The creation of good-quality images always starts with the capture of as much of the image detail as possible, and the capturing process is governed by good exposure.

The theory is simple. To capture good images you must adjust the amount of light entering the camera so that it suits the sensitivity of the sensor. All digital cameras contain a metering system designed to measure the amount of light entering the camera. In most cases the meter is linked with an auto-exposure mechanism that alters the aperture and shutter to suit the light that is available.

In most scenarios the auto-exposure system works well, but in about 5–10% of all shooting occasions the meter in the camera can be fooled. For these occasions you will need to intervene in the exposure process. You can do this in one of three ways: by manually overriding the automatic settings if your camera allows; by pointing the camera at a part of the image that most reflects the exposure needed for the photograph, then half pressing the shutter button to lock the exposure before recomposing the image; or by purposely over or underexposing the image. Use a hand-held meter if you want to double-check the exact amount of light falling on your subject.

Digital lenses

The first-generation digital cameras had either fixed focal length lenses or very short zooms. More and more of the newer models are being released with long zooms that are at least the 35mm equivalent of 28–105mm.

However, an important factor to bear in mind when buying digital lenses is that most digital sensors are smaller than the 35mm film frame. This difference affects the perspective of different lens lengths. The way we classify lenses as wide, standard or long is related to the frame size, so a "standard" digital lens is likely to have a focal length of only 10mm. To give you some reference point, always look for the 35mm equivalent lens length. This will help guide your lens choice.

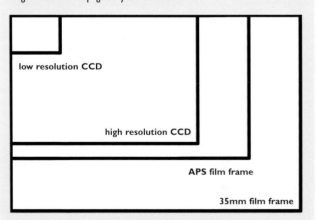

ABOVE: **Despite the increase in sensor size and resolution, the majority of digital cameras still have a capture area less than that of a 35mm frame.**

Camera types and models

Digital cameras come in all shapes, sizes and price ranges. What you choose to purchase will depend on how you intend to use the images and the type of pictures you want to take. Essentially all cameras can be separated into three different groups:

Consumer

This group contains entry-level cameras. These are designed for the budget-conscious user who wants to start in digital photography but has a limited amount of money to spend. The film camera equivalent is definitely the point-and-shoot variety.

Most consumer cameras have base level features, 2.0–3.0 megapixel sensors and fixed focal length lenses. These cameras use technology that we all thought was terrific a few years ago but which has been overtaken by new advances.

Prices start from as little as £100/US$140 for a very basic model and rise with functionality to about £300/US$450. The products here provide a good starting point for new digital users and for those photographers who need a simple camera with modest image-output quality.

Prosumer

This group contains the types of cameras designed for the serious amateur or the professional with limited needs. Here you will find advanced design and technology, high-resolution sensors and good-quality optical zoom lenses.

You will pay more for the units in this group, £300–1,000 (US$450–1,400), but what you are buying is extra levels of control for both the photographic and digital parts of the camera. Image quality in a lot of these units rivals that of the more expensive pro models.

The down side is that the designs are still proprietary, which means there is little chance of changing lenses or adding accessories already purchased for a separate film-based system. The cameras here are more than capable of producing professional photographic-quality results with technology that is definitely cutting-edge.

Pro cameras

These cameras are generally designed on the film-based bodies of either Nikon or Canon cameras. This means you can use the same lenses as you would on the traditional models. The target market is definitely the professional

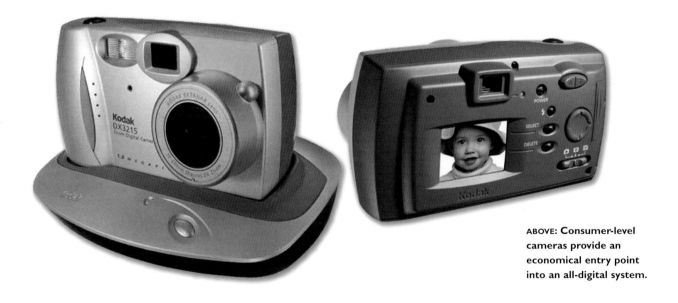

ABOVE: Consumer-level cameras provide an economical entry point into an all-digital system.

RIGHT: **Prosumer-level cameras often provide the image resolution of the high-end SLR units without the expense.**

photographer and with prices that range up to £8,000 (US$11,000) you would have to be a very wealthy, or very serious, amateur to be able to afford one. Designed to look and feel as much as possible like their film counterparts, the prosumer cameras are at the very forefront of digital-imaging technology. All the major companies like Kodak, Nikon, Canon and Fuji have a presence in this area of the market and, given the level of financial commitment involved in their development, this is a situation that will continue into the future.

Buying your first digital camera

With so many cameras on the market, it is important to compare features when deciding which unit to buy. Purely photographic variables like zoom length and maximum aperture are probably more familiar to you, but the digital options often cause new users more difficulties.

Below is a list of what may be said to be the most important digital features. When looking at cameras, take notes on their specifications in these areas. It will then be possible for you to compare "apples with apples" when it comes to the final choice.

Price

As a general rule of thumb, the more expensive cameras have greater resolution and a larger range of features, both manual and automatic. This said, price can be a major deciding factor and it is important that you balance what you can afford with the limitations that come with each price bracket.

Resolution

The best cameras have chip resolution approaching 6.0 mega-pixels, and as you now know, the more pixels you have, the better quality the final prints will be. This said, cameras with fewer pixels still are capable of producing photographic prints of smaller sizes. The table below gives you an idea about what print sizes are possible with each resolution level.

Focus control

Fixed-focus cameras have lenses with large depths of field but no ability to focus on particular objects. These cameras are suitable only for general-purpose photography. Auto-focus cameras have lenses that can focus on separate parts of the image. The number of AF stops determines how accurate the focusing will be.

Optical zoom range

Be sure to check that any information quoted on the zoom range of the camera is based on the optics of the lens rather than a digital enlargement of the picture. Enlarging the image is not a true zoom function and only serves to pixelate the image.

Aperture range

Small aperture numbers such as F2.8 mean that the camera can be used in lower light scenarios. If you regularly shoot in low-light conditions, look for a camera with a lens which includes a range of aperture settings.

ISO equivalent range

Being able to vary the sensitivity of the chip is an advantage. You won't achieve the same quality results at higher ISO values as the base sensitivity, but having the option to shoot without a flash in low light gives you more flexibility.

Delay between shots

Cameras need time to process and store the shots you take. The size of the memory buffer will determine how much delay there will be between shots.

Resolution

Chip pixel dimensions	Chip resolution	Maximum photographic image size at 200dpi
640 x 480	0.30 million	3.2 x 2.4 in. (81 x 61mm)
1440 x 960	1.38 million	7.4 x 4.8 in. (188 x 122mm)
1600 x 1200	1.90 million	8 x 6 in. (203 x 152mm)
1920 x 1600	3.00 million	9 x 8 in. (229 x 203mm)
2304 x 1536	3.40 million	11.5 x 7.5 in. (292 x 190mm)
2272 x 1704	4.0 million	11.4 x 8.5 in. (289.5 x 215.9mm)
2560 x 1920	4.9 million	12.8 x 9.6 in. (325 x 243.8mm)
3008 x 2000	6.1 million	15.04 x 10 in. (382 x 250.4mm)

Flash type and functions

Most digital cameras have a built-in flash system. Check the power of the flash, which is usually quoted as a guide number. The higher the number, the more powerful the flash. Also take notice of the flash modes present in the camera. Options like red-eye reduction, fill flash and slow shutter flash sync are always useful.

Download options

Getting your images into your computer should be as easy as possible. If the camera uses a particular cable connection (USB, SCSI, serial, firewire and USB2.0) make sure your computer has the same option.

RIGHT: **Professional-level cameras are designed to fit into already existing film-based systems.**

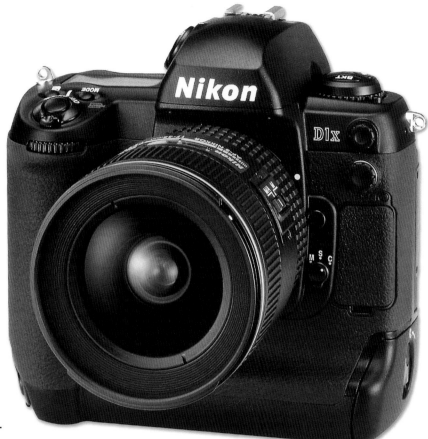

Storage capacity

The film used by digital cameras comes in the form of flash memory cards. The storage capacity of the card is measured in megabytes. The larger the card supplied with your camera, the more images can be stored before being downloaded to the computer.

Camera size and weight

The size and weight of a camera can determine how comfortable it is to use. Make sure you handle any prospective purchase before making your final decision.

Manual features

The ability to manually override or set auto functions can be a really useful, if not essential, addition to a camera's functionality. Auto everything point-and-shoot units are designed for general shooting scenarios, trying to make images outside of these typical conditions can only be achieved with a little more user control.

How sensitive is my chip?

The sensitivity of film to light is expressed as an ISO number. Films with a low number like 50 need a lot of light to make an exposure. Higher numbered films require less light and are usually used for night shooting or taking pictures under artificial light.

Chips don't have ISO ratings. Instead manufacturers allocate "ISO equivalent" ratings so that we all have a reference point to compare the performance of sensors and their film counterparts.

Unlike film, most chips are capable of being used with a range of ISO settings. The smallest number usually produces the best-quality image. At higher settings the resultant images are usually a little more noisy and not quite as sharp.

The black art of scanning

It was not too long ago that an activity like scanning was the sole responsibility of the repro house. The photographer's job was finished the moment the images were placed on the art director's desk. But as we all know, the digital revolution has changed things, and scanning is one area which will never be the same.

Desktop scanners that are capable of high-resolution colour output are now so cheap that some companies will throw them in as freebies when you purchase a complete computer system. The proliferation of these devices has led to a large proportion of the photographic community now having the means to change their prints, negatives or slides into digital files. This provides a hybrid pathway for film-based photographers to generate digital files. But as all photographers know, having the equipment is only the first step to making good images.

The following steps will help you get the best out of the machinery you have to hand.

Set up

Without realizing it, when we pick up a camera, load a film and take a photograph we have made a range of decisions that will effect the quality of the final print.

By selecting the format – 35mm, 120 or 5 x 4 in. – we are deciding the degree that we can enlarge the image before we start to lose sharpness and see grain. The same can be said about our choice of film's sensitivity. Generally, low ISO stock will give you sharper and more grainless results than a faster emulsion. These things go almost without saying.

In a similar way, when we start to work digitally we have to be conscious of quality choices right from the beginning of the process. Essentially we are faced with two decisions when scanning – what resolution and what colour depth to scan with.

Resolution

Scanning resolution, as opposed to image or printing resolution, is determined by the number of times per inch that the scanner will sample your image. This figure will effect both the enlargement potential of the final scan and its file size. The general rule is, the higher the resolution, the bigger the file and the bigger the printed size possible before seeing pixel blocks, or digital grain.

For this reason, it is important to set your scanning resolution keeping in mind your required output size. Some scanning software will give an indication of resolution, file size and print size as part of the dialogue panel but for those of you without this facility, here is a rough guide:

Resolution

Scanning resolution	Image size to be scanned	Output size @ 300dpi	File size
4000	35mm (24mm x36mm)	20 x 13.33 in. (508 x 330mm) 6000 x 4000 pixels	22.7 mb
2438	35mm	11.5 x 7.67 in. (292 x 195mm) 3452 x 2301 pixels	22.7 mb
1219	35mm	5.74 x 3.82 in. (146 x 97mm) 1724 x 1148 pixels	5.68 mb
610	35mm	2.87 x 1.91in. (73 x 49mm) 862 x 574 pixels	1.42 mb
305	35mm	1.43 x 0.95 in. (36 x 24mm) 431 x 287 pixels	0.36 mb

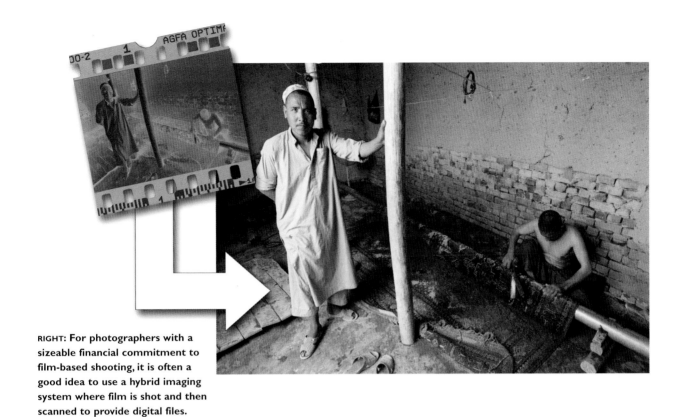

RIGHT: For photographers with a sizeable financial commitment to film-based shooting, it is often a good idea to use a hybrid imaging system where film is shot and then scanned to provide digital files.

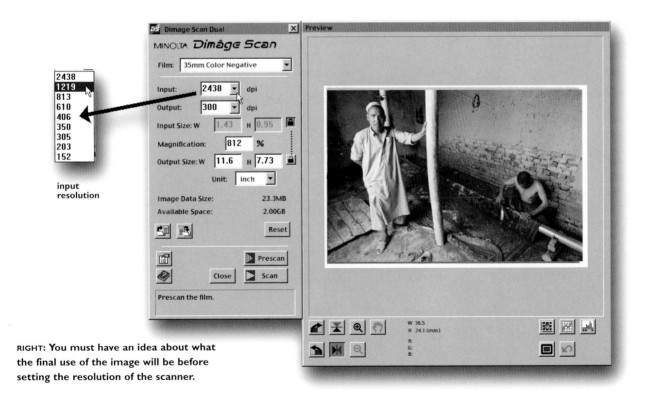

input resolution

RIGHT: You must have an idea about what the final use of the image will be before setting the resolution of the scanner.

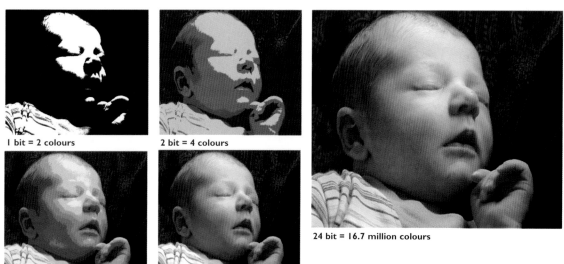

1 bit = 2 colours

2 bit = 4 colours

4 bit = 16 colours

8 bit = 256 colours

24 bit = 16.7 million colours

ABOVE: The colour depth of a file determines the numbers of colours possible in the image.

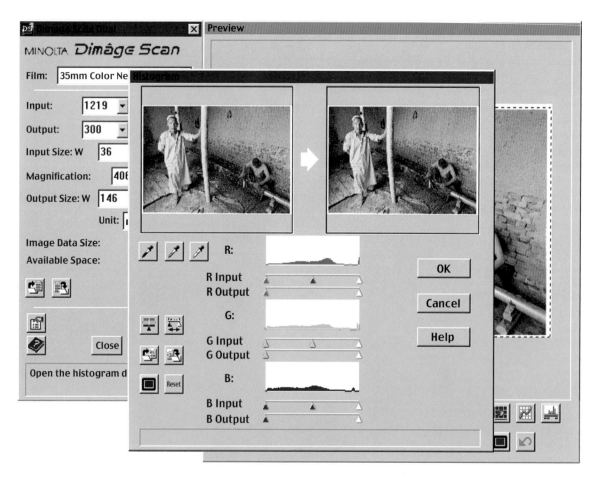

ABOVE: Good control of exposure during the scanning stage will result in a file that contains as much of the information that was in the negative as possible.

Colour depth

Colour depth refers to the numbers of possible colours that make up the digital file upon the completion of scanning. This is not as much of an issue as it used to be. Generally most modern computer systems can handle photographic quality colour, sometimes called 24 bit, where the image is made up of a possible 16.7 million colours. So here the decision is basically whether you want to scan in colour or greyscale (8 bit or 256 levels of grey). Be aware, though, that colour files are generally three times bigger than their greyscale equivalents. Some higher cost models have the option of working with 16 bits per colour giving a total of over 65,000 levels of grey for a monochrome image and billions of colours for RGB files.

Capture controls

With resolution and colour depth set we can now scan the image – well almost! Just as exposure is critical to making a good photograph, careful exposure is extremely important for achieving a good scan.

All but the most basic scanners allow some adjustment in this respect. Preview images are supplied to help judge exposure and contrast, but be wary of making all your decisions based a visual assessment of these often small and pixelated images. If you inadvertently make an image too contrasty, you will loose shadow and highlight detail as a result. Similarly, a scan that proves to be too light or dark will have failed to capture important information from your print or film original.

It is much better to adjust the contrast, sometimes called "gamma", and exposure settings of your scan based on more objective information. For this reason, a lot of desktop scanner companies also provide a method of assessing the darkest and lightest parts of the image to be scanned. With this information you can set the black and white points of the image to ensure that no details are lost in the scanning process.

For those readers whose scanning software doesn't contain this option, try to keep in mind that it is better to make a slightly flat scan than risk losing detail by adjusting the set-

Computers can only work with digital information, so the scanning process is designed to convert continuous tone pictures such as photographs, transparencies or negatives into digital representations of these images. The machinery samples a section of the picture and attributes to it a set of numerical values. These indicate the brightness and colour of that part of the image and its position in a grid of all the other samples taken from the photograph. In this way a digital version of the image is constructed, which can then be edited in programs like Photoshop or Paint Shop Pro.

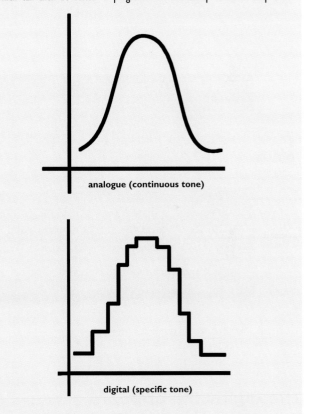

analogue (continuous tone)

digital (specific tone)

ABOVE: **Scanners sample continuous tone originals at regular intervals, attributing specific numerical values for brightness, colour and position.**

tings so that the results are too contrasty. The contrast can then be altered later in your image-editing package.

With all the pre-scan decisions made you can now capture your image.

Common scanning problems and solutions

The image is too bright

The image has been scanned with settings that have resulted in an overexposed file. Highlight detail is lost and midtone areas are too light. In the histogram the bulk of the pixels are at the right-hand end of the graph. Rescan with a lower exposure setting.

pixels pushed right

ABOVE: **A scan that is too bright will have limited separation in highlight details.**

pixels bunched to the left

ABOVE: **A dark scan will lose shadow details.**

The digital file shows no shadow detail

No matter what changes are made in your image-editing package, these details will not return. The histogram shows a bunching of pixels at the shadow end of the graph. Rescan the image, changing either the shadow or exposure setting so that it gives these areas more exposure.

The digital file appears flat and lacking in a good spread of tones

The histogram shows a bunching of the pixels in the centre of the graph. Either rescan with a higher contrast setting or use the Contrast or Levels features in your image-editing package to spread the tones across the graph.

pixels grouped in the centre

ABOVE: **A flat scan compresses all the image tones in the centre of the graph.**

Tricks of the trade: scanner as camera

Tim Daly, UK-based illustrative photographer and author of countless digital imaging articles, users his scanner as a large camera to produce hauntingly beautiful images of everyday objects.

He says, "There is no reason why we shouldn't use all imaging devices at our disposal as ways of making great pictures. The scanner is, in effect, a large camera capable of capturing images with extremely fine detail in high resolution. The only drawback to scanner-based images is that it is not possible to 'shoot' moving objects."

Tim's technique for making cameraless pictures:

1. Prepare your scanner. This may mean that you need to construct a small cardboard box, painted white on the inside, which fits neatly over the glass surface.
2. Select the objects you wish to include in the montage using clipping paths to keep the edges sharp.
3. Scan each of the objects in turn creating separate image files for each.
4. Open files in Photoshop and proceed to place them into the one image as separate layers.
5. Adjust the size, colour, position and contrast /brightness of each layer to suit the other components in the image.
6. Selectively burn and dodge areas of the image to add shadows to objects and direct the viewer's attention by making some parts more apparent, others less noticeable.

ABOVE: It is possible to use your scanner as a high-quality digital camera.

ABOVE: Tim's process involves the scanning of separate objects and their combining in Photoshop.

Other sources of digital files

During recent years, other options for obtaining digital versions of your silver-based images have started to be provided by high-street photo labs. It is now possible to drop your film off at the local processing business and have the negatives processed, printed, scanned and saved to CD-rom as part of the service. The quality and resolution of the scans vary from one provider to the next, so ask to see examples before committing yourself.

Putting images on CD was a process pioneered by Kodak in the mid nineties with its ProCD product. This system still provides some of the best digital conversions of your images available. Files are saved in a variety of file sizes and resolutions, giving the user the ability to choose the level most suitable for the job at hand.

For those readers who don't want to invest in a scanner or who want file sizes greater than those available from the average desktop unit, third party scans may be the answer.

Types of scanners

There are essentially two different types of scanners: those suitable for scanning prints and those used for negatives and transparencies. Both types sample the image at regular intervals to determine colour and brightness, but the flatbed or print scanner bounces light off the object onto the sensor, whereas film versions scan the image via light travelling through the film.

Companies like Microtek have been able to combine both methods into their range of hybrid scanners. With these units, the user can select reflective- or transmission-based scanning, depending on the original image type.

ABOVE, LEFT & BELOW: Print scanners are a very economical way to start making digital images from your film originals.

ABOVE: Film scanners are usually more expensive than their flatbed counterparts and are capable of scanning negatives as well as slides.

manipulating

Image editing software

The main tool that photographers use when working with digital photographs is an image editing program. This piece of software enables the digital worker to creatively control and selectively change the images he or she has captured.

There is a range of different packages on the market. They fall roughly into three categories: entry, intermediate and professional level. Of all the groups Adobe's Photoshop is the clear leader. Despite it being a piece of software designed specifically for the professional market it has gained wide acceptance with all levels of users irrespective of their experience level. The rest of the packages have places in the market defined not so much by their cost but by how simple they are to use.

of certain parts of the program. Over the last few years though these entry level packages have made major progress in terms of features and functions.

ABOVE: **Digital imaging software packages come in three different levels determined by their ease of use and sophistication more than by their price.**

Entry level

These packages are the easiest pieces of software to use. They offer simple approaches to common tasks and an interface that is uncomplicated and well laid out. Often they are designed so that children and new image workers can easily transfer images from camera or scanner, make a few changes and then print them out. Some even contain special "wizards" or automated step-by-step instructions for creating greeting or post cards, posters and stickers. With the upsurge of interest in the web more and more of these programs also include features that ease the process of publishing your images online.

As a first outing these products are well worth trying, especially because you will find them very competitively priced or even better, bundled free with your camera or scanner. There are, however, two sides to the simplicity coin – the very approach that makes these products easy to use also means that they can be quite limiting.

Such limitations are not obvious when you restrict yourself to activities for which the program was designed. But when you try to be a little more creative you might find yourself frustrated by not being able to change the settings

Intermediate level

The programs in this group give you more features and tools and in so doing allow you to be more creative. It's here that you will find the biggest growth area of the image editing market. Often programs that start their life with entry level features develop with maturity and sophistication to a level that meets the needs of the intermediate user. The software companies know that most digital workers want the power and the flexibility of the professional packages, but at budget prices.

To a large extent the software in this group provides what the imaging public wants. The products here contain most of the features and flexibility of the professional packages with less of the limitations of the entry level options. Of course there are differences. You would expect there to be when you can pay up to five times more for Photoshop than you do for Paint Shop Pro. The feature

sets of the intermediate packages can be smaller, the level of user interaction not as great, but on the whole these pieces of kit do a great job.

When you find that you are being limited by the program that came with your scanner these packages would be your next step.

Professional

This category contains the cream of editing software. It is here that you will find packages that are packed to the brim with features, functions and filters. The sheer range of options can often make these programs difficult to learn and even more difficult to master. These programs are used daily by professionals in a range of areas. The flexibility and sheer number of image editing tools means that medical, press, portrait and commercial photographers can all find a modus operandi with these packages that suits them.

Photoshop has always been a major player in this part of the market, but in recent years it has dominated the area, providing the model that all other packages are trying to emulate. There is no disputing that Photoshop is already a feature rich mature package. When you couple this with the fact that Adobe releases a new version of its flagship software every 12 months or so, you can see why the others are finding it hard to play catch-up. The way that Photoshop links with professional level desktop and web publishing software means that it's not just photographers who are singing the program's praises.

If you are planning to use images you create professionally then skip the first two categories and dive straight into a professional package. The learning curve will be steep to start with, but you will be rewarded with a much more powerful and comprehensive image editing environment.

The window to a new world

The interface is the way that the software package communicates with the user. Each program has its own style but the majority contain a work space, a set of tools laid out in a tool bar and some menus. You might also encounter some other smaller windows around the edge of the screen. Commonly called dialogue boxes and palettes, these windows give you extra details and controls for tools that you are using.

Programs have become very complex; sometimes there are so many different boxes menus and tools on screen that it is difficult to see your picture. Photographers solve this problem by treating themselves to bigger screens or by using two linked screens – one for tools and dialogues and one for images. Most of us don't have this luxury so it's important that right from the start you arrange the parts of the screen in a way that provides you with the best view of what is important – your image. Get into the habit of being tidy.

ABOVE: **Most packages have a method of setting up the screen work space that is similar.**

Know your tools

Over the years the tools in most image editing packages have distilled to a common set of similar icons that perform in very similar ways. The tools themselves can be divided up into several groups depending on their general function.

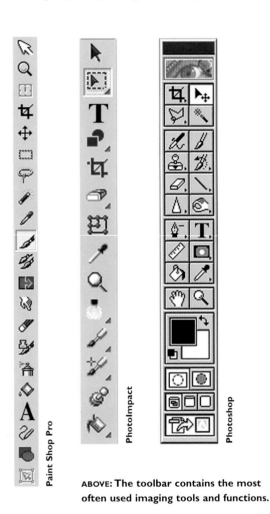

Paint Shop Pro

PhotoImpact

Photoshop

ABOVE: The toolbar contains the most often used imaging tools and functions.

Drawing tools

Designed to allow the user to draw lines or areas of colour onto the screen, these tools are mostly used by the digital photographer to add to existing images. Those readers who are more artistically gifted will be able to use this group to generate masterpieces in their own right from blank screens.

rubberstamp

air brush

eraser

paint bucket

brush

pen/line

ABOVE: Drawing tools allow you to change and add to the pixels that make up your digital photograph.

Most software packages include basic brush, eraser, pen, and line, spray-paint and paint bucket tools. The tool draws with colours selected as and categorised as either foreground or background.

Selecting tools

When starting out most new users apply functions like filters and contrast control to the whole of the image area. By using one, or more, of the selection tools, it is also possible to isolate part of the image and restrict the effect of such changes to this area only.

Used in this way the three major selection tools – lasso, magic wand and marque – are some of the most important tools in any program. Good control of the various selection

magic wand

BELOW: Selection tools enable the user to isolate a group of pixels to work on.

lasso/polygon

marque/elliptical/cropping

ABOVE: **Adding text or type to your images is a comparatively simple process with most packages.**

ABOVE: **Most packages contain a host of other tools and some even allow the user to customize the toolbar with those most used.**

methods in a program is the basis for a lot of digital photography production techniques.

Text tools

Adding and controlling the look of text within an image is becoming more important than ever. The text handling within all the major software packages has become increasingly sophisticated with each new release of the product. Effects that were only possible in text layout programs are now integral parts of the best packages.

Viewing tools

This group includes the now infamous magnifying glass for zooming in and out of an image and the move tool used for shifting the view of an enlarged picture.

Others

There remains a small group of specialist tools that don't fit into the categories above. Most of them are specifically related to digital photography. In packages like Hotshots they include a "Red Eye Remover" tool specially designed

ABOVE: **Viewing tools help you to navigate, and zoom in and out of, your images.**

to eliminate those evil-eyed images that plague compact camera users. Photoshop on the other hand supplies both "Dodging", and "Burning-In Tool" tools.

Software – what are some of the choices?

To give you some idea of what is available the following is a summary of seven of the leading software packages on the market. Each program has its own strengths and weaknesses, and it wouldn't be possible to select any one product that would be suitable for all photographic jobs and users. When making your choice consider

• the type of activities you want to undertake
• your current level of experience
• the type of activities you want to undertake in the future.

To give you a good idea about what each level of software is capable of, the techniques described in the following chapters will demonstrate how to use three different software packages to achieve similar effects. As the techniques become more complex you will notice that the simpler packages might not have the features needed to complete the task, but on the whole the differences of approach and flexibility will become obvious.

For entry level Ulead PhotoImpact software will be chosen. From the intermediate group the much-famed Paint Shop Pro has been selected, and for the professionals Photoshop will be used.

Also included are Macintosh and Windows shortcuts for software that is available on both platforms.

Roxio PhotoSuite 4 Platinum
Level: Entry/intermediate

Over the past few years Roxio, previously MGI Software, has sold more than 26 million units of its top three software packages – PhotoSuite, VideoWave and Live Picture. The latest release of PhotoSuite confirms Roxio's commitment to the area and introduces a new range of functions and added features for users. Straddling the entry and intermediate levels, this package caters for most digital photographic needs.

Summary

PhotoSuite 4 Platinum Edition is the latest version of Roxio's web and PC photo software. The new version adds more power to its photo-enhancement tools, e-sharing capabilities, and extends the boundaries of imaging beyond the desktop to the Internet with new web features that allow home and business users to create personal websites in minutes.

Features
General

PhotoSuite has a clean "look and feel" and includes thorough step-by-step guides that allow users of all experience levels to employ a vast lineup of features available

LEFT: **PhotoSuite is a feature full editing package that boasts a user base in the millions worldwide.**

for getting, preparing, composing, organizing, sharing and printing photos.

Image editing and enhancement tools

Manipulation controls include cut, clone, crop, adjust colours and resize your photos. You can also remove red eye, wrinkles and blemishes or restore old, torn and faded pictures. You can choose from many special effects including warp, ripple, splatter, mirage, sepia, moonlight and more.

Image organization tools

Other features allow users to organize, store and retrieve photos in customized electronic albums. Fast, powerful keyword search makes it easy to find what you want. PhotoSuite comes with more than 1,500 professionally designed templates for home and business.

Recognizing that sometimes users simply want to view a photo rather than edit it, PhotoSuite 4 comes with a separate image viewer that provides users with a means of quickly viewing or browsing image content.

Best uses
- Home office
- School projects
- Family photos
- Image preparation for web
- Very good general-purpose image-editing program

Extra functions
Enhanced PhotoTapestry

A favourite among users, PhotoTapestry replicates a photo by filing up to 2,000 thumbnail photos in the form of the original. In this version of the program users now have the ability to create their own thumbnail collections, in addition to using any of the 30,000 thumbnails included.

LEFT: **PhotoSuite uses a simple task orientated screen to guide users through common editing activities.**

frames of an animated GIF. You have complete control over playback options, frame duration, and can even add transitions between frames.

Panoramas

The inclusion of an enhanced stitch engine gives digital image makers the ability to stitch together as many as 48 photos, and create 360° interactive web panoramas that a web-page visitor can navigate.

Screen saver creator

Also new to PhotoSuite 4 is support for MP3 files, as well as a sophisticated screen saver creator, which includes the ability to use scrolling panoramas.

Personal web page creation and publishing

PhotoSuite 4 includes a complete set of tools for the creation and publishing of websites. Users can select one of the pre-designed web templates included and simply add image content, or they can take complete control over design and layout. With a few simple clicks of the mouse, users can add image content, text with animation, hyperlinks, and incorporate borders and drop shadows.

Support for web-based email

The package supports sending photos directly through popular web-based email services such as Hotmail and AOL Mail. Users are able to reduce and optimize file size before sending photos and can even send multiple photos as an executable file that launches a special slideshow viewer.

Web animations

PhotoSuite 4 includes a GIF (Graphics Interchange Format) file editor. This features allows users to turn photos into

Roxio PhotoSuite 4 Platinum

Hardware requirements:	Microsoft Windows 95, 98, ME, NT 4.0 (SP3 or higher), Windows 2000 or XP. Internet Explorer 5 is required and included. The recommended system required is a Pentium II – 266MHz, 32 MB of RAM recommended, SVGA Video Card, 800 x 600 screen area, 24-bit True Color 2 MB Video RAM, 200 MB Hard Drive space plus 65MB space for IE and DirectX.
Current version:	Photosuite 4 Platinum
Platform:	PC
Price:	US$49.99
Download trials:	No
Web link:	www.mgisoft.com www.photosuite.com

Microsoft Picture It! Photo Studio 2002
Level: Entry

Picture It! Photo Studio is exactly what you would you expect from the biggest software publishing company in the world. With a new web-styled start-up screen, automated correction tools, and step-by-step guided projects, it's easy for users to complete most photo-editing tasks. You can access your photos from almost any source, fix common photo problems and then share your images with everyone you know – in print or online.

Also worth noting is a publishing version of the product that combines the photo-editing features of Picture It! with an easy-to-use desktop publishing package. Microsoft has obviously taken note of public cries for a piece of software that can go from digital camera to finished publication in the one program.

LEFT: **Picture it! is Microsoft's entry into the imaging market. The package provides easy-to-use functions for most home imaging needs.**

Summary

You can access your photos from a digital camera, scanner, or the Internet. The editing tools included allow you to automatically correct brightness, contrast, sharpness, and tint or colour cast. You can also fix photo problems such as red eye, remove blemishes and wrinkles from faces and use cutting-edge photo effects like emphasise and fade.

Users can then print at home with most photo and specialty papers.

Features
General

Digital camera-friendly Mini Lab works with multiple photos at the same time.

Image editing and enhancement tools

Text effects include photo, fill, bend shadow, highlight, 3D, floral, stained glass, quilt, wave, swirl, satin, and chrome. Sizing and positioning tools allow you to crop, rotate, flip, skew, align, match colour; other tools include alignment guides, rulers, edge finder, and shapes. Touch up your images with tools like brightness and contrast, tint, red eye, dust, blemish, scratch, black and white, old to new, and scratch and wrinkle removal.

Add special effects such as shadow, transparency, blur, sharpen, distort, 3D effects, fade and clone. Illusions filters include chalk, crayon, ink, marker, pencil, sketch, watercolor, emboss, glass, glow, mosaic, metal, sepia, impressionist, sponge, fingerpaint, and burlap. A range of paint and colour effects include freehand, photo stroke, art stroke, gradient fill, and stamping. Frames include highlighted, soft, stamped, cool, photo stroke and art stroke.

Image organization tools

Catalogue photos and find them easily with the Gallery feature. Search your catalogued items by name, date, or event to find your photos quickly and easily. Make use of multiple save options, such as save for the web, save as wallpaper, send by email, save to Kodak PhotoNet online.

Print features include wallet-size photo templates, spe-

LEFT: **Picture It! uses a clear and simple design to help ease new users into image editing activities.**

cialty paper templates, print multiple, index print and print online at fujifilm.net and at Kodak PhotoNet.

Best uses

- Home office
- School projects
- Family photos
- Very good general-purpose image-editing program
- Simple web page creation

Extra functions

Web

The software allows you to create and post personal web pages, albums, and slide shows with guided set of project tools.

Email

You can also email your photos to friends and family and receive true photographic prints in the mail when you send your projects to fujifilm.net or Kodak PhotoNet online print service.

Microsoft Picture It! Photo Studio 2002

Hardware requirements:	A multimedia PC with Pentium 166-MHz or higher processor.
	The Microsoft Windows® 95 or 98, Windows ME, Windows NT, or Windows 2000 or XP operating system.
	For Windows 95 or Windows 98: 64 MB of RAM
	For Windows ME or Windows 2000: 64 MB of RAM
	245 MB of available hard disk space
	Microsoft Internet Explorer 5.5 software
	Quad-speed CD ROM drive or higher.
	Super VGA monitor (1 MB of VRAM).
	Microsoft mouse or compatible pointing device.
Current version:	Picture It! Photo Studio 2002
	Also available: Picture It! Publishing Gold Edition
Platform:	PC
Price:	US$54.95
Download trials:	No
Web link:	www.microsoft.com

PhotoImpact

Level: Entry/Intermediate

PhotoImpact 8 is an image editor that addresses both the image editing and web page creation needs of the average digital photographer. You can manipulate your images and lay out web graphics and then optimize and output them as complete web pages.

Summary

Ulead's imaging program gives the user a range of tools, and a changing interface that is designed to support both simple and complex manipulation tasks. You can edit images and create web pages using functions such as:

- A full array of imaging & painting tools
- Vector 2D and 3D graphics
- Over 60 exclusive special effects & filters
- Visual web page layout & one-click HTML output

Features

Image editing and enhancement tools

PhotoImpact includes an extensive set of creativity tools for creating and editing photographic content. Imaging Tools include:

- Special Effects
- Path Drawing Tools
- Text Tools & Effects
- Wrap & Bend
- Masking

Painting features

- 12 Paint brushes including Paintbrush, Airbrush, Crayon, Chalk
- 9 Clone brushes like Bristle, Oil Paint, Marker.
- 14 Retouch brushes such as Dodge, Burn, Smudge. Cursor shows true brush shape
- Paint and clone using object mode for improved layer control

- Paint with textures
- New Colorize Pen retouch tool

Special effects

Lighting: Create still and animated effects using Lightning, Bulb light, Fireworks, Meteor, Comet, Halo, Spotlight, Lens flare, Laser and Flashlight

Type: Add gradient, transparency, hole, glass, metal, emboss, emboss-outline, emboss-texture, sand, concrete, lighting, fire, snow, neon and seal effects to text, selections and objects

Transform: Create still and animated effects with smudge, pinch, punch, ripple, stone, mirror, horizontal and vertical mirror, whirlpool, diffuse and horizontal squeeze

Particle: Add element-based fire, rain, clouds, snow, smoke, bubbles, fireflies and stars

Artistic textures: Create unlimited still or animated textures using palette ramps, hue shifts and colouring control

Warping: Distort images & objects using various effects

ABOVE: PhotoImpact is a very capable entry-level package that has enough functions and features to be considered as a semi-intermediate candidate.

Image organization tools

The program features a customizable interface, visual "Pick-and-Apply" galleries, providing the user with simple but effective tools for editing and enhancing their images. Features include:

- EasyPalette
- Quick Command Panel
- Album Management
- Screen Capture
- Digital Watermarking

Best uses

- Home office
- School projects
- Family photos
- Image preparation for web

Extra functions

Web toolkit

PhotoImpact 6 delivers the tools needed to create web graphics and complete HTML pages. Features include:

- Save as web page
- Component Designer
- HTML Text
- Interactive Rollovers & Buttons
- Image Optimization
- GIF Animation
- Image Slicing

Ulead PhotoImpact

Hardware requirements:	Intel Pentium or above compatible system. Microsoft Windows 95/98/NT4.0 SPE (or above) or Windows 2000 64MB of RAM or Windows XP. 240 MB of available hard disk space. CD-ROM Drive. True Color or High Color display and monitor. Mouse or WinTab Compatible pressure-sensitive graphics tablet (optional).
Current version:	PhotoImpact 8
Platform:	PC
Price:	US$89.95 boxed version
	US$79.95 download version
Download trials:	Yes — 30 day from www.ulead.com
Web link:	www.ulead.com

Adobe Photoshop Elements

Level: Entry/Intermediate

Adobe has finally heard the cries of the mortals and has produced an image manipulation package that has the strength of Photoshop 7.0 with a price tag more equal to most budgets. Adobe's new package gives desktop image makers top-quality image-editing tools that can be used for preparing pictures for desktop printing, or web work. Features like the panoramic stitching option, called Photomerge, and the File Browser palette are sure to become favourites.

Thankfully the colour management and vector text and shape tools are the same robust technology that drives Photoshop itself, but Adobe has cleverly simplified the learning process by providing step-by-step interactive "How Tos" or recipes for common image manipulation tasks. These coupled with new features like Fill Flash, Adjust Backlighting and the Red Eye Brush tool make the package a digital photographer's delight.

ABOVE: **Photoshop Elements is Adobe's entry level product and is squarely aimed at the home market.**

Summary

You can use guided activities to bring your photos into the computer organize photos, touch up, enhance, and modify images, and share your images in print, via email, or on the web.

Features

Organization

- Import photos from a scanner, digital camera, floppy disk, Kodak Picture CD, or the Internet.
- Store, manage, and locate photos with the built-in File Browser, which lets you create customized albums.

Editing and enhancement

- Touch up or repair photos.
- Improve brightness, contrast, and colour with the Quick Fix dialogue
- Apply dozens of special effects.
- Ensure that the colours you print match the colours on-screen with built-in colour management software.

Creativity

- Use styles to quickly add drama and pizzazz to the way that your images look
- Create personalized PDF slideshows.
- Use Photomerge to create a panorama from multiple images.

Best uses

- Home office
- School projects
- Family photos
- Image preparation for web

LEFT: **A simple icon driven approach to editing activities means that this package is easy to use for all levels of users.**

Extra functions

- Create personalized wallpaper for your PhotoDeluxe screen background.
- Assemble a multimedia presentation complete with captions, music, and animations with PhotoParade

E-sharing

Post photos and photo projects directly to your personal web community on ActiveShare.com. Email photos and slide-shows from directly within PhotoDeluxe.

Adobe Photoshop Elements

Hardware requirements			Colour monitor with 800x600 resolution and thousands of colours
Mac:	PowerPC® processor		CD-ROM drive
	Mac OS 9.1, 9.2.x, or Mac OS X v.10.1.3-10.1.5		32-bit TWAIN data source or Adobe Photoshop
	128MB of RAM with virtual memory on 350MB of		compatible plug-in
	available hard-disk space		Internet Explorer 5.0, 5.5 or 6.
	Colour monitor capable of displaying thousands of		
	colours at a resolution of 800x600 or greater	Current version:	2.0 (Windows)
	CD-ROM drive		2.0 (Macintosh)
PC:	Intel Pentium processor	Platform:	PC, Mac
	Microsoft Windows 95, Windows 98, Windows NT 4.0	Price:	US$99.00 (either platform)
	with Service Pack 5 or Windows XP	Download trials:	Yes
	128 MB of available RAM	Web link:	www.adobe.com
	150 MB of available hard-disk space		www. ActiveShare.com

Corel Photo-Paint 10
Level: Intermediate/Professional

ABOVE: Photo-Paint is an editing and image-creation product designed with the professional image maker in mind.

With its eyes firmly set on the professional market Corel over the last few years has been busy developing a substantial image editing and creating package. Photo-Paint was originally conceived as a bitmap editing add-on to Corel's now famous vector drawing package – Corel Draw. Now in version 10 this product has certainly matured way beyond these unassuming roots.

Unfortunately for much of this program's life it has lived in the shadow of Adobe's Photoshop and this has meant that a lot of photographers are still unaware of the vast array of image creation and editing features that Corel has managed to squeeze into their product.

In some ways it is a little unfair to make direct comparisons with other editing packages. Even though Photo Paint does contain an extensive range of editing tools this is only half the story. Much of the product's power is in the way that it integrates image-creation features with the enhancement tools. This shouldn't be surprising giving Corel's history with vector drawing packages.

Summary

Touted as the imaging tool to use for everything from "precision editing" to "original painting", Corel Photo-Paint is certainly a product that is worth looking at if your day-to-day work requires image creation as well as enhancement. Along with Photo-Paint's substantial image editing and creation tool set comes a range of add on technologies that will help streamline your imaging activities. These include

- Media asset management via the inclusion of Canto Cumulus Desktop
- Bitstream Font Navigator for font management
- Corel TEXTURE – realistic natural textures
- Corel CAPTURE – application window screen captures
- Corel SCRIPT Editor – scripting application
- Digimarc Digital Watermarking
- Human Software Squizz! To help create distortion effects. 800 TrueType and Type 1 fonts

Features

Image editing and enhancement tools

Choose from over 15 Artistic Media brush types featuring hundreds of options or create your own brush types. Over 100 Effects filters, including new artistic, texture-based and creative effects. Multiple onscreen colour palettes. Extensive Undo and Redo features. Support for pressure-sensitive graphics tablets.

Experiment using Live Effects, with interactive tools including Perspective Drop Shadow, Watercolour Effect, Plastic Effect, Fill, Blend, and Transparency. Apply non-destructive visual effects to any image with over 20 different lenses.

Image organization tools

Use the Ixla digital camera interface for easy download of

images from over 120 camera models. Enhanced printing features – imposition layout, preflight warnings, miniature preview to verify changes and downsampling of bitmaps. Easy import and export of images with embedded ICC standard profiles – CPT, CDR, TIFF and EPS. Import, edit and export multi-layered Adobe Photoshop PSD files, Adobe Illustrator AI and EPS files, and MetaCreations Painter RIFF files

Best uses

- Professional level photographic enhancement and editing
- Professional level bitmap image creation
- Home office
- Image preparation for web and print publishing

Extra functions
Web

Integrated web design features, including animated GIF, QuickTime(tm) VR, AVI and MPG creation, and support for GIF 89a, PNG, TGA, PCX and JPG with onscreen preview.

Corel Photo-Paint 10

Hardware requirements	
PC :	Windows 95, Windows 98 or Windows NT 4 or XP
	32 MB RAM (64 MB recommended)
	Pentium R 133
	2X CD-ROM drive
	Mouse or tablet
	SVGA monitor
	100 MB hard disk space
Mac:	Power Macintosh Power Macintosh G3
	Mac OS 7.6.1 Mac OS 8.1, OSX or higher
	32 MB RAM with Virtual Memory enabled
	64 MB RAM or greater
	CD-ROM drive
Current version:	PC – 10
	Mac – 10
Platform:	PC, Mac
Price:	US$249.00
Download trials:	No
Web link:	www.corel.com

Jasc Paint Shop Pro
Level: Intermediate

Jasc has cleverly positioned its product between the template driven entry level packages and comparatively expensive professional ones. Providing much of the feature set of the big products and more flexibility than the smaller ones Paint Shop Pro has always had a huge user base the world over. Now in its seventh version, this is a mature package that provides what most serious photographers demand from their editing program.

Summary

Start to use this package and you will discover what 20 million users already know – Paint Shop Pro offers the easiest, most affordable way to achieve professional image-editing results.

ABOVE: **Paint Shop Pro started as a highly regarded shareware product. Now in its seventh version this is an intermediate-level product with a small price and its eyes set firmly on making some inroads into the pro market.**

Paint Shop Pro enables users to:

* Retouch, repair, and edit photos with high-quality, automatic photo enhancement features
* Create and optimize web graphics with built-in web tools and artistic drawing and text tools
* Design animations with Animation Shop 3 included free
* Save time with productivity tools: grids, guides, alignment, and grouping
* Expand your creativity with over 75 special effects
* Share photos electronically via email, websites, and photo-sharing sites

Features
Image editing and enhancement tools

Tools for Painting, Drawing, Text, Image Editing, Layers and Layer Blend Modes. Screen Capture features and Digimarc Watermarks. Special Effects Filters, Picture Tubes and Picture Frame Functions.

Automatically adjust colour balance, enhance brightness, saturation, and hue. Remove red-eye, automatically. Restore damaged photos with Scratch Removal Tool. Adjustable Histogram enhances details without loss of information. Instantly remove noise, scratches, dust, or specks and improve crispness and impact. Repeat last command feature.

Image organization tools

Direct Digital Camera Support, Photo Enhancement Filters, Colour Adjustments and Adjustment Layers. Visual Browser, Multiple-level Undo/ Redo, Multiple Image Printing and Batch File Format Conversion features. Enhanced Support for nearly 50 file formats, which is more than any other product on the market.

Best uses

- Professional and intermediate level editing
- Home office
- School projects
- Family photos
- Image preparation for web

Extra functions

Web development tools

Create professional-quality GIF animations with Animation Shop 3. Speed-up downloading of web graphics with Image Slicing. Automatically create "hotspots" and embed URL links with new Image Mapping features. Create visual mouse-overs with Image Rollover effects. Preview graphics in various web file formats in up to 3 browsers. Enhanced Optimize graphics for high web performance with JPG/GIF/PNG Optimizer.

ABOVE: **Using the familiar menu and toolbar combination, there are more than a few similarities with the other major products in the professional and intermediate areas.**

Jasc Paint Shop Pro

Hardware requirements:	500 MHz or better processor
	128 MB of RAM
	32 bit color display adapter at
	1024 x 768 resolution
Current version:	7
Platform:	PC
Price:	US$99.00 USD download
	US$109.00 USD boxed
Download trials:	Yes — www.jasc.com
Web link:	www.jasc.com

Adobe Photoshop
Level: Professional

ABOVE: Adobe's Photoshop is the premier editing product in the market today. Its feature and tool range coupled with its robustness has made it the industry favourite for several years now.

Now in its seventh version, Photoshop is definitely the tall poppy of the image-editing market. Millions of professional users the world over have made this package the industry standard. With each new version of the product Adobe has cemented its position as the undisputed front runner.

Adobe Photoshop 7.0 software introduces the next generation of image editing with the broadest and most productive tool set available. With strong links to major web and desktop publishing packages Photoshop enables the professional user to achieve the highest-quality results across all media.

Summary

Adobe Photoshop 7.0 software maximizes creative possibilities with a wealth of innovative new tools. For web designers, the combination of new vector drawing tools with powerful rollover styles allows for quick creation of buttons and other web graphics. And now users can easily create sophisticated, multi-state JavaScript rollovers by saving custom button shapes in libraries then selecting rollover styles in ImageReady 7.0 to automatically slice the buttons and apply a variety of new layer effects.

Features
Image editing and enhancement tools

Photoshop includes the most flexible toolset on the market. The combination of selection, painting and enhancement tools

LEFT: Photoshop is the package that pioneered the menu/toolbar interface that a lot of the other packages now emulate.

RIGHT: **Adobe is also marketing a cut down version of its frontline product under the LE or limited edition tag. Containing the most used basic tools and functions of the fully fledged program the competitive pricing of this product does make it a viable entry into Adobe's world.**

has set the industry standard that the other programs follow. In addition to those tools we already know version 6 includes vector shape drawing with resolution-independent output and on-canvas text entry and advanced formatting.

Image organization tools

Including a collection of automated tools like the much used "Contact Sheet", Photoshop provides basic robust organization tools designed for the professional user.

Best uses

- Professional level photographic enhancement and editing
- Home office
- Image preparation for web and print publishing
- Extensive linking with professional publishing packages for web and print.

Extra functions
PDF support

Extensive PDF workflow including shared PDF annotations.

Web

Streamlined web workflow with Adobe GoLive and Image Ready 7.

Print

Streamlined web workflow with Adobe Illustrator and InDesign.

Adope Photoshop

Hardware requirements		
PC:	Pentium-class processor	64 MB of available RAM (with virtual memory on)
	Microsoft Windows 98, Windows Millennium, Windows 2000, Windows NT 4.0 or XP	125 MB of available hard-disk space
	64 MB of available RAM	Color monitor with 256-color (8-bit) or greater video card
	125 MB of available hard-disk space	Monitor resolution of 800x600 or greater
	Color monitor with 256-color (8-bit) or greater video card	CD-ROM drive
	Monitor resolution of 800x600 or greater	
	CD-ROM drive	Current version: 6
Mac:	PowerPC-based Macintosh computer	Platform: PC, Mac
	Mac OS Software version 8.5, 8.6, 9.0, or OSX	Price: US$609 for all platforms
		Download trials: Yes — www.adobe.com
		Web link: www.adobe.com/products/photoshop

Digital darkroom

In this new photography the computer is a major part of your digital darkroom. This machine is the pivot point for image acquisition, manipulation and output. For this reason it is important to be clear about what equipment is really needed for the job.

The metal box that sits on the computer desk before you contains a variety of components that together give you access to your images. Each component plays a part in the image production cycle.

Processor (CPU)

It seems that every 6 months or so the major chip manufactures produce a new version of their frontline processors. These chips are the engine of your computer and as such determine how quickly your machine will complete most tasks.

ABOVE: **The CPU is both the brains and the brawn of your desktop computer.**

The processors are categorized in terms of their cycle speed and generally speaking, the higher the number, the faster the chip. At present the best chips have a speed of about 2200mhz. Compared to the 12mhz "Turbo" chip that drove some computers in 1989 these new processors just fly. But as soon as the chip makers develop faster models, software manufacturers and creative users dream of even more complex tasks to give them. The result is no matter what speed the machine is, they never seem fast enough for the job at hand.

CPU purchase tip: The fastest and latest are also the most expensive. Buying a machine with a slightly slower chip (the fastest and latest two months ago) will provide a more economical, albeit a little slower, entry machine.

Memory (RAM)

RAM memory is where your editing program and image is kept when you are working on it. It is different to the memory of your hard drive or zip disk, as the information is lost when your computer is switched off. The amount of RAM your computer has is just as important as processor speed for graphics work. Photoshop recommend five times the amount of RAM as the biggest image you will be working on. If you work with 20 megabyte files regularly then your computer should have at least 128 mb of RAM memory.

RAM purchase tip: Buy as much memory as you can afford. The amount usually supplied with off-the-shelf systems is sufficient for most word processing and spreadsheet tasks but is usually not enough for good-quality digital imaging.

Screen

The screen is the visual link to your digital file. It follows then that money spent on a good quality screen will help with the whole cycle of production. Screen size is impor-

tant, as you need to have enough working space to layout tool bars, dialogue boxes and images. Screens are catagorized in terms of a diagonal measurement from corner to corner. 15- or 17-in. models are now the standard with 19 or 20 in. being the choice of imaging professionals. Look for a screen with a low dot pitch number (0.28 or less) as this helps to indicate how sharp images will appear.

Screen purchase tip: Make sure that you "test view" a known image on a screen before purchasing as there can be a great difference between units of similar specifications.

Video card

The video card is the most important part of the pathway between computer and screen. This component determines not only the number of colours and the resolution that your screen will display, but also the speed at which images will be drawn. Pick a card with a fast processor and as much memory as you can afford.

Video card purchase tip: Read a few tests from the big computer magazines before deciding on a card. Don't assume that good 3-D performance will also be reflected in the area of 2-D graphics. Check to see that the amount of memory you have on the card enables you to view your desktop at higher resolutions in full 24-bit colour.

Mouse or graphics tablet

Much of the time spent working on digital images will be via the mouse or graphics tablet stylus. These devices are electronic extensions of your hand allowing you to manipulate your images in virtual space. The question of whether to use a mouse or stylus is a personal one. The stylus does provide pressure sensitive options not available with a mouse only system. Wacom, the company foremost in the production of graphics tablets for digital imaging use, has recently produced a cordless mouse and stylus combination that allows the user to select either pointer device at will.

ABOVE: The tools and menus of your program are accessed by using either a mouse or stylus. Wacom produces a cordless combination package that provides the option of either system.

Mouse or graphics tablet purchase tip: Try before you buy. The mouse, or stylus, needs to be comfortable to use and should fit your hand in a way so that your fingers are not straining to reach the buttons.

Storage

The sad fact is that digital imaging files take up a lot of space. Even in these days where standard hard disks are measured in terms of gigabytes the dedicated digital darkroom worker will have little trouble filling up the space. It won't be long before the average user will need to consider expansion options. For more details about the alternatives see Part Two, Chapter Seven.

Storage purchase tip: A CD writer provides the most economical way of storing large image files.

Tidy screen tips

No matter what size screen you have it always seems that there is never enough space to arrange the various palettes and images needed for editing work. Here are a few tips that will help you make the most out of the "screen property" that you do have.

Docking

Docking is a feature that allows several palates or dialogue boxes to be positioned together in the one space. Each palette is then accessed by clicking on the appropriate tab at the top of the box.

Rollups

Most editing packages allow for large palettes to be rolled up so that the details of the box are hidden behind a thinner heading bar. The full box is rolled out only when needed.

Resizing the work window

If you have a small screen then it is still possible to work on fine detail within an image by zooming in to the precise area that you wish to work. For this reason it is worth learning the keyboard short cuts for "zooming in" and "out". This function is a little like viewing your enlargement under a focus scope.

Hide all the palettes

Once you have selected a tool, it is possible with some editing programs, to hide all the palettes and dialogues to give you more room to manoeuvre. In Photoshop this is achieved by hitting the TAB key.

LEFT & BELOW: Some of the frustrations that come from having limited screen space can be alleviated by employing some basic "tidy screen" tips.

docking

rollups

screen resize

manipulation techniques

part two / chapter four

The basics

Opening your images

With your images transferred from the camera or scanner, it's a simple job to open them into your image-editing package. Most programs provide you with the opportunity to view small thumbnails of each image before opening it fully.

PhotoImpact

1. Select File>Visual Open from the menu bar.
2. Find the drive and folder that contains your image.
3. Double click the thumbnail to open your image.

Paint Shop Pro

1. Select File>Open from the menu bar.
2. Browse the disk and folders to select your image.
3. Check Preview of image.
4. Click Open button.

Photoshop

1. Select File>Open from the menu bar.
2. Browse the disk and folders to select your image.
3. Check Preview of image.
4. Click Open button.

Changing brightness

One of the first things you learn when printing traditional photographic images is how to control the exposure of the print. Too much and the image is dark, not enough and the image is too light. The digital equivalent of this is the brightness control. Usually in the form of a slider, this feature allows you to increase or decrease incrementally the brightness of your images.

Make sure that when you are making your adjustments you don't lose any picture detail. Too much lightening and delicate highlights will be converted to white and lost for-

ABOVE: **You start the manipulation phase of the digital-imaging process by opening your saved images from disk.**

BELOW: **Changing brightness is one of the first tasks to undertake with a new image.**

RIGHT: Sometimes confused with brightness, contrast controls the spread of tones within your image.

ever. Conversely if you radically decrease the brightness of your photograph much of the shadow detail will be converted to black.

PhotoImpact

1. Select Format>Brightness and Contrast from the menu bar.
2. Change the brightness level using the slider, or
3. Select the thumbnail that looks like the best spread of tones.
4. Click Preview to confirm your changes.
5. Click OK to finish or Continue to make more changes.

Paint Shop Pro

1. Select Colours>Adjust>Brightness/Contrast from the menus.
2. Adjust Brightness slider.
3. Check preview for changes.
4. Click OK button when finished.

What if I make a mistake?

First of all, don't worry! Select the Undo option from the edit menu of any of the programs. This will undo the last step that you completed. In this case it would restore your image to the original brightness before your alteration. Remember, though, Undo can only erase the last step.

Photoshop

1. Select Image> Adjustments > Brightness /Contrast from the menus.
2. Adjust Brightness slider.
3. Check Preview for changes.
4. Click OK button when finished.

Adjusting contrast

Contrast can be easily confused with brightness, but rather than being concerned with making the image lighter or darker, this function controls the spread of image tones.

If an image is high in contrast it will typically contain bright highlights and dark shadows. Both of these areas will contain little or no detail. These images are usually taken on sunny days. Low contrast pictures are typically captured on overcast days where the difference between highlights and shadows is less extreme.

All image-editing software packages provide the user with the ability to alter the contrast of their images.

PhotoImpact

1. Select Format>Brightness and Contrast from the menu bar.
2. Change contrast level using the slider, or
3. Select the thumbnail that looks like the best spread of tones.
4. Click Preview to confirm your changes.
5. Click OK to finish or Continue to make more changes.

LEFT: **Removing colour casts from images is definitely a photographic job that is more easily accomplished digitally than traditionally.**

Paint Shop Pro

1. Select Colours>Adjust>Brightness/Contrast from the menus.
2. Adjust Contrast slider.
3. Check preview for changes.
4. Click OK button when finished.

Photoshop

1. Select Image >Adjustment>Brightness/Contrast from the menus.
2. Adjust Contrast slider.
3. Check Preview for changes.
4. Click OK button when finished.

Automatic corrections

Most software packages also include ways of applying contrast and brightness automatically. These features are based on the computer assessing the image and spreading the tones according to what it perceives as being normal. In most instances, using these features results in clearer images with better overall contrast and brightness, but I would always suggest that you make the changes manually when you are manipulating important or complex pictures. Manual correction allows much finer control of the shadow and highlight areas.

PhotoImpact users can use the Auto-Process >Contrast option found under the Format menu to automatically correct contrast and brightness. Photoshop provides and Auto Levels and Auto Contrast that allows users to correct automatically and distribute their image's tones.

Getting rid of colour casts

Working in colour brings with it both pleasure and pain. Sometimes what our eyes see at the time of shooting is quite different to what appears on the computer screen. Skin tones appear green, white shirts have a blue tinge or that beautiful red carnation ends up a muddy scarlet hue – whatever the circumstances, sometimes the colour in pictures seems to go astray.

In the old days, if you didn't have your own colour printing set-up you would have had to live with these problems. Now, with the flexibility of modern image-editing programs, ridding your favourite picture of an annoying cast is easily achieved.

PhotoImpact

1. Select Format>Colour Balance from the menu bar.
2. Select the thumbnail that looks like the best colour correction.
3. Click Preview to confirm your changes.
4. Click OK to finish or Continue to make more changes.

NB: You can change the amount of difference in the colour cast of the thumbnails by altering the Thumbnail Variation slider.

Paint Shop Pro

1. Select Colours>Adjust>Red/Green/Blue from the menus.
2. Adjust the individual colour sliders.
3. Check proof for changes.
4. Click OK button when finished.

Where do my casts come from?

Our eyes are very accommodating devices. Not only do they allow us to see objects and colours, but they also help interpret what is around us. For instance, if we view a white piece of paper under a fluorescent light, a household bulb or in the shadow of a building, it will always appear white to us. If we photographed the same sheet under similar lighting conditions the results would be quite different.

Under the fluorescent tube the paper would appear to have a green tinge, lit by the household bulb it would look yellow and in the shadow the sheet would look blue. Each light source has a slightly different colour. The professionals refer to these differences as changes in the colour temperature of the light. The sensor, or film, in our cameras records these differences as colour casts in our pictures.

Most modern digital camera have an automatic "white-balance" facility that helps the sensor record the image as if it were shot under white light. Similarly, a lot of the camera-based software programs available contain a function that accounts for different lighting conditions.

auto white balance

fluorescent lighting

LEFT: **Automatic white balance functions on modern digital cameras help to alleviate mixed lighting problems that still plague film users.**

Photoshop

1. Select Image>Adjustments>Variations from the menus.
2. Adjust Fine-Coarse slider.
3. Select the version of your picture that is cast free.
4. Check Current Pick for changes.
5. Click OK button when finished.

Adding casts to an image

Although it might feel like a strange thing to do at first, there will be times when you want to add a cast or a dominant colour to your pictures. A good example of this is adding a tint to a black-and-white image to produce effects similar to sepia or blue-toned prints.

LEFT: **Toning of a black-and-white image can be achieved digitally by intentionally adding a cast to your image.**

To add colour to a black-and-white or greyscale image you will need to save the image as an RGB file even though it only contains black, white and grey information. Most programs allow you to do this by changing the colour mode of the image to RGB. You will not notice any immediate difference but the file will now be able to accept colour information.

Photoshop users can then add tints to their image by selecting the Hue/Saturation option from the Image menu. Ensure that the Colorize option is checked, then change the colour of the tint via the Hue slider control and the strength by adjusting the Saturation slider.

If you use Paint Shop Pro then you can achieve similar results by using the Colorize option from the Colours menu. Again moving the settings of both the saturation and hue controls will change the strength and colour of the tint.

Cropping your photograph

The framing of images is one skill that easily transfers between traditional and digital photography. By the careful positioning of the four edges of the image you can add impact and drama as well as improving the composition of your images.

Tricks of the trade: tinting at work

Israel Rivera, a landscape and documentary photographer, loves the look and feel of moodily printed and toned photographs. His latest project involved careful shooting and long hours of darkroom printing to achieve the emotion he desired in his prints.

Late in the project, Israel realized that the techniques he was using in the darkroom could be easily duplicated digitally. Cautiously at first, he started making pixel-based versions of his emotive prints. He says, "Initially I felt that the digital images might look a little gimmicky, but once I saw the results, there was no turning back. The pictures are great and the image quality speaks for itself."

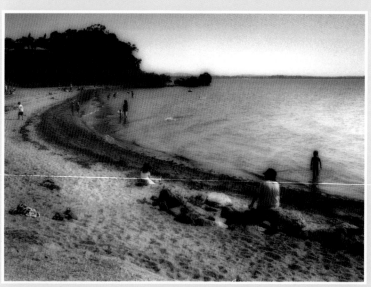

ABOVE: Israel Rivera makes good use of the enhancement features of Photoshop in his moody images.

LEFT: Brightness, texture and colour are all manipulated digitally during production.

ABOVE: **Cropping your images can help to concentrate the viewer's attention on the most important aspects of your shot.**

For most of us, framing or cropping occurs twice during the image-making process – once when we compose the picture within the viewfinder and a second time when we make final adjustments before printing.

Digital cropping is a simple matter of drawing a rectangular border around the area of your photograph that you wish to keep. What is inside this selection will remain, what is outside will be discarded. Often it is what you choose to throw away that makes an image strong. So, before making that final decision, be sure that the cropped image is more dynamic and balanced than the original. Remember, if you don't like the results of your crop, you can always Undo and start again.

PhotoImpact

1. Pick the Standard Selection tool from the toolbar.
2. Click and drag a selection around the part of the image you want to keep.
3. Select Edit>Crop from the menu bar to discard the parts of the image outside the selection.

Paint Shop Pro

1. Select the Cropping tool from the toolbar.

2. Draw a rectangle around the section of the image you wish to keep.
3. Adjust the selection using the "handles" in the four corners of the rectangle.
4. Double-click in the centre of the rectangle to complete the crop.

Note: If the toolbar is not visible, select the Toolbar option from the View>Toolbars menu.

Photoshop

1. Select the Cropping tool from the toolbar.
2. Draw a rectangle around the section of the image you wish to keep.
3. Adjust the selection by clicking on the edge or corner "handles" of the rectangle and moving them to a new position.
4. Double-click in the centre of the rectangle to complete the crop.

Note: If the toolbar is not visible, select the Toolbar option from the Windows>Tools menu. If the cropping tool is not visible, click and hold the marque tool. This will produce a "tool rollout" which will contain the cropping tool as one option.

Retouching

All of us are struggling to capture the perfect picture, the one image where everything comes together – composition, focus, lighting and exposure – to make a photograph that is both memorable and dramatic. How often you capture such an image depends on your experience and skills, but for every one image that you feel makes the grade, there are many that come really close. With a little digital help, these images can also become success stories.

Traditionally, retouching was the sole domain of the photographic professionals. Using fine brushes and special paints, these artists would put the finishing touches onto photographic prints. The simplest changes would involve the removal of dust and scratch marks from the print. More complex jobs could require a total fabrication or reconstruction of destroyed or unwanted parts of an image.

The advent of digital techniques has changed the retouching world forever. The professionals have traded in their paints and brushes for graphics tablets and big screens and more and more amateurs are carrying out convincing spotting jobs at home.

There are many methods for retouching images, here we will concentrate on the most basic techniques that are used for removing from your photographs marks that are usually the result of dust on the negatives during scanning. Most of the programs use a cloning or rubber stamp type tool to copy a clean part of the image over the offending dust mark. The best results are achieved by careful use of the retouching tools on enlarged sections of the image.

PhotoImpact

1. Select the Remove Scratch tool from the toolbar.
NB: If the tool isn't visible you can display all the retouching tools by making the Retouch Tool Panel visible by selecting View>Toolbars and Panels>Retouch Tool Panel from the menu bar.
2. Adjust the size, edge softness and shape of the brush using the Attribute toolbar.
3. Adjust the level of the effect.
4. Position the mouse pointer over the scratch and click to retouch.

ABOVE: Once the domain of back-room artisans, high-quality photographic retouching is within easy reach of most digital workers.

ABOVE: Most of the entry-level packages have a "Red Eye Reduction" feature that rids your images of the effect that seem to plague compact camera users.

Paint Shop Pro

1. Select the Clone Brush from the toolbar.
2. Select a brush size and type.
3. Move the pointer over the part of the image that you want to copy over the dust mark.
4. Hold the Shift key down and click over the area to be copied. This specifies the copy point.
5. Move the cursor to the dust mark and click and hold to start over-painting with the copied area.

Photoshop

1. Select the Rubber Stamp tool from the toolbox.
2. Select a brush size and type.
3. Move the pointer over the part of the image that you want to copy over the dust mark.
4. Hold the Alt key for Windows and Option key for Macintosh and click over the area to be copied. This specifies the copy point.
5. Move the cursor to the dust mark and click and hold to start over-painting with the copied area.

Top tips for cloning

1. Carefully select the area to copy. This is the biggest factor in how successful your retouching will be.
2. Adjust the your brush size to suit the size of the dust mark.
3. Use a brush style that has a soft edge, this way the copied area will be less noticeable against its new background.
4. Sometimes adjusting the transparency (opacity) of the cloning brush will helps make your changes less noticeable. This will mean that you have to apply the tool several times to the dust mark to ensure coverage.

Tricks of the trade: better retouching techniques

Although the techniques above are more than up to the task of smartening up your images, the professionals often have their own pet methods for tweaking their photographs. Commercial photographer Florian Groehn uses a combination of Photoshop's Dust and Scratches filter and the History brush.

He says that if you use the filter by itself your whole image become soft and unsharp. "It is much better to apply the filter only in the area of the dust problems. Combining the filter and the history brush allows this." Follow the steps below to use Florian's technique.

1. Open your image into Photoshop.
2. Select the Dust and Scratches filter from the Filter>Noise menu.
3. Highlight a typical dust mark in the preview area of the filter dialogue.
4. Adjust the Radius slider until the mark disappears. Notice that the image becomes soft and areas of colour become flat and textureless.
5. By adjusting the Threshold slider you can now reintroduce some texture (grain) back into image. High values here will bring the dust mark back so aim for a balance between texture and the elimination of marks.
6. When you are satisfied with the preview select OK to filter the image.
7. Select the step before the filter in the History palette.
8. Select the History Brush from the toolbox.
9. Change the mode for the brush to darken for light marks on a dark background and lighten for dark marks on a light background.
10. Apply the brush to the marks.

ABOVE: **First, apply the dust and scratches filter to your image. Adjust the settings so that you eliminate dust but still retain texture.**

ABOVE: **Next, use the History palette to select the step before the filter was applied.**

LEFT: **Finally, retouch the white dust spots using the History brush set to darken.**

Adding borders

There is no doubt that the quality of the image is everything. A good picture needs no tricks or frills to help make an impression. As if to prove this point, some photographers go as far as to refrain from any form of post-shooting "embellishment". They regard even the addition of borders to an image as sheer gimmickry.

This attitude ignores the fact that the edges of an image have always been important to photographers. Some shooters always include the black frame of the negative's edge as part of their image. The border does three things –

Simple black frame border

Select a suitable image to which to apply your border. Keep in mind that traditionally this type of edge treatment was reserved for photographers who wanted their audience to know that the image was shot full-frame. It was a way to show off the in-camera compositional skill of the photographer. When you saw the black edges of a print, you knew that the image had not been subjected to any cropping during the enlarging process – you were seeing exactly what the photographer saw.

ABOVE: **A simple black border added to your image can help to contain the viewer's eye.**

contains the picture elements of the photograph, visually separates the image from its surroundings, and passes on to the viewer the composition that the photographer intended.

What is even more significant is that borders have been a part of print-making tradition for years. Whether it is the black edges of the negative's frame or the chemical over-spill of a Polaroid print, many photographers have found that the edge of the image helps to define the photograph.

The world of digital imaging means that print borders in all manner of shape, size and style are readily available. Any image, no matter its origin, can be surrounded by a border easily. This technique section will show you how to make two of the most popular border types – black edge and drop shadow.

To some extent this assumption is still made with black frames, but don't let this stop you experimenting. Remember that, once you have mastered the basic steps of this technique, there is no reason why you can't use a range of other border colours.

Photoshop has a function called Stroke which forms the basis of one technique used to make black borders around images. This command can be used to draw a line that follows the edge of a selection. In this example we simply select the whole image and stroke the selection with a line of a given colour and pixel width.

Paint Shop Pro, on the other hand, has a specialist Add Borders command that allows the user to place a

ABOVE: **Most image-editing software has facilities
for adding a white border with a drop shadow.**

coloured line around the whole image quickly and simply.
No selection step is needed, and the lines at different edges
can be of different thicknesses.

Paint Shop Pro

1. Ensure the background colour is black.
2. Select Image>Add Borders.
3. Adjust the size of each border.

Photoshop

1. Select>All.
2. Ensure that foreground colour is black.
3. Select Edit>Stroke (Width = 16 pixels,
 Location = Inside).

Shadowed print edge

As in a lot of areas of our life, fashion exists within the
realms of digital imaging. The drop shadow – a subtle blurry
shadow that gives the illusion that the text or image is sit-
ting out from the page – is one "look" that has been very
popular over the last couple of years. Such is the extent of
its usage that most image-editing software, including
Photoshop and Paint Shop Pro, now has automated
processes for creating this effect.

The example below adds a white border to the image
first before increasing canvas size and finally adding
shadow.

Paint Shop Pro

To make the white border:

1. Ensure the background colour is white
2. Select Image>Add Borders.
3. Adjust the size of each border.

To make canvas big enough for the drop shadow:

4. Select>All.
5. Select Edit>Cut.
6. Select Image>Canvas Size (adjust the size to account
 for the shadow).
7. Edit>Paste>as a new selection.
8. Click to stamp down when positioned
 (keep selected).

To make the shadow

9. Select Image>Effects>Drop Shadow.
10. Adjust sliders to change the style of the shadow.

Photoshop

To make the white border:

1. Select>All.
2. Ensure that foreground colour is black.
3. Edit>Stroke (Width = 16 pixels,
 Location = Inside).

To make canvas big enough for the drop shadow:

4. Select>All.
5. Ensure background colour is white.
6. Select Edit>Cut.
7. Select Image>Canvas Size.
8. Adjust the size to account for the shadow.
9. Edit>Paste.

To make the shadow:

10. Select Layer>Layer Styles>Drop Shadow.
 Adjust sliders to change style of shadow.

LEFT: **Specialist frame or edge software can provide almost infinite variations to the surrounds of your image.**

Specialist border and edge effects software

Some software companies have devised specialist packages to help make border and edge effects on digital images. One such company is Extensis Software whose Photoframe product is now in its second version. A downloadable demo version is available from www.extensis.com.

The product installs easily into Photoshop and is accessible through the Filters menu. It is very simple to use. After opening your image go to Filter> Extensis>PhotoFrame. A specialized dialogue box appears which then allows you to select, add and adjust borders and edge effects from a range supplied with the software. The manufacturer claims that well over one thousand different frames are possible.

The real power of the product is apparent when you see the extent to which you can control the application of the effects. With the image previewed it is possible to use the controls to change size, softness, opacity, colour, and width of the border. In addition, you can use the mouse pointer to change the size, shape, and position of the frame.

When you are happy with the results of your adjustments, click the apply button and you are returned to the Photoshop interface with the finalized version of your image.

A recent addition to the Extensis product group is an online version of Photoframe. Users can now create a variety of frame and edge effects for their images directly within their web browser, without the need to install desktop software. Photoframe Online is available free to Creativepro.com members at www.creativepro.com/photoframe/welcome.

ABOVE: **Extensis' Photoframe product automates the frame-making process via a Photoshop plug in.**

Other border types

Sometimes a slick straight-edged neat and tidy border is not what you want for a particular image. Providing an edge that is more rough and ready photographically would mean printing through a glass carrier, or using a roughly cut mask sandwiched with the negative at the time of printing. These techniques do, however, provide borders with a unique look and feel.

Digitally speaking, it is possible to achieve a similar effect by combining a ready made "rough frame" file with your image file. Putting both images together requires a bit of forethought though. Make sure that the images are a similar size and orientation. Check the colour mode of each file. If you want a coloured final image then both files need to be in a colour mode before you start – this applies even if the border is just black and white.

The process is fairly simple – select the frame, copy it to memory and then paste it over the image. The tricky bit is resizing the pasted frame so that it fits the dimensions and shape of the picture. To achieve this, Photoshop workers will need to practise manipulating the image using the Free Transformation command. Those readers who prefer Paint Shop Pro will need to become familiar with the Deformation tool.

Paint Shop Pro

To select frame:

1. Open Frame and Image files
2. Ensure that the image file has enough white surround to accommodate a frame.
3. Select the white areas of the frame picture using the Magic Wand
4. Click on Selections>Invert to select actual frame
5. Select Edit>Copy.

To paste the frame onto the image:

6. Switch to the image file.
7. Edit>Paste>as a new layer (to paste frame onto image file).

To adjust the frame to fit the image:

8. Select the Deformation tool from the toolbar.
9. Move the corner and side nodes to re-size the frame to fit.

Photoshop

To select frame:

1. Open frame and image files.
2. Ensure that the image file has enough white surround to accommodate the frame.
3. Select the white areas of the frame picture using the Magic Wand.
4. Select>Inverse (to select the actual frame).
5. Edit>Copy.

To paste the frame onto the image:

6. Switch to the image file.
7. Edit>Paste (to paste frame onto image file).

To paste the frame onto the image:

8. Select Edit>Free Transform.
9. Move the corner and side nodes to re-size the frame to fit.

Making your own border files

The border used with the image above was made by scanning the edge of a black-and-white photograph printed with a glass carrier. Once converted to a digital file you can then select the image area and cut it away. The resulting border file can then be used with any other image file.

Try making your own files by scanning old prints or the edges of ones made specially for the purpose.

LEFT: You can make and apply your own borders by scanning the edges of a pre-existing print or one specially made for the purpose.

Using filters

As much as anything, the filter's decline in use can be attributed to changes in visual fashion and the filter effects of the seventies have made a comeback, thanks to digital. This time they don't adorn the end of our lenses but are hidden from the unsuspecting user, sometimes in their hundreds, underneath the Filter Menu of their favourite image-editing program.

Artistic filters

coloured pencil

cutout

fresco

paint dabs

plastic wrap

rough pastel

The association with days past and images best forgotten has caused most of us to overlook, no, let's be honest, run away from, using any of the myriad of filters that are available. These memories, coupled with a host of garish and look-at-this-effect-type examples in computing magazines, have overshadowed the creative options available to any image-maker with the careful use of the digital filter.

To encourage you to get started, I have included a few examples of the multitude of filters that come free with most imaging packages. I have not covered Gaussian blur or any of the sharpening filters as most people seem to have overcome their filter phobia and made use of these to enhance their imagery, but I have tried to sample a variety that you might consider using.

If you are unimpressed with the results of your first digital filter foray, try changing some of the variables. An effect that might seem outlandish at first glance could become useable after some simple adjustments using the sliders contained in most filter dialogue boxes.

The filter examples are grouped according to their type. For ease of comparison, each of the filters have been tested using a common image.

Artistic filters

Coloured pencil: Sketchy pencil outlines on a variable paper background.
Variables: Pencil Width, Stroke Pressure, Paper Brightness.

Cutout: Graded colours reduced to flat areas much like a screen print.
Variables: Number of Levels, Edge Simplicity, Edge Fidelity.

Fresco: Black-edged painterly effect using splotches of colour.
Variables: Brush Size, Brush Detail, Texture.

Brush stroke filters

accented edges

cross hatch

ink outlines

sumi-e

Paint dabs: Edges and tones defined with daubs of paint-like colour.
Variables: Brush Size, Sharpness, Brush Type.

Plastic wrap: Plastic-like wrap applied to the surface of the image area.
Variables: Highlight Strength, Detail, Smoothness.

Rough pastel: Coarsely applied strokes of pastel-like colour.
Variables: Stroke Length, Stroke Detail, Texture, Scaling, Relief, Light Direction, Invert.

Brush stroke filters

Accented edges: Image element edges are highlighted until they appear to glow.
Variables: Edge Width, Edge Brightness, Smoothness.

Crosshatch: Coloured sharp-ended pencil-like crosshatching to indicate edges and tones.
Variables: Stroke Length, Sharpness, Strength.

Ink outlines: Black ink outlines and some surface texture laid over the top of the original tone and colour.
Variables: Stroke Length, Dark Intensity, Light Intensity.

Sumi-e: Black outlines with subtle changes to image tone.
Variables: Stroke Width, Stroke Pressure, Contrast.

Distort filters

Pinch: Image is squeezed in or out as if it is being stretched on a rubber surface.
Variable: Amount.

Distort filters

pinch

shear

twirl

wave

Pixelate filters

colour halftone

mezzotint

mosaic

pointillize

Shear: Image is distorted in the middle in one direction whilst the edges remain fixed.
Variable: Undefined areas.

Twirl: Image is spun and stretched to look as if it is being sucked down a drain hole.
Variable: Angle.

Wave: Image is rippled in a wave-like motion.
Variables: Number of Generators, Type, Wavelength, Amplitude, Scale, Undefined Areas, Randomize.

Pixelate filters

Colour halftone: Creates an effect similar to a close-up of a printed colour magazine image.
Variables: Maximum Radius, Screen Angles for channels one to four.

Mezzotint: Adjustable stroke types give tone to the image.
Variables: Type.

Mosaic: The image is broken into pixel-like blocks of flat colour
Variable: Cell Size.

Pointillize: Random irregular dot shapes filled with colours drawn from the original image.
Variable: Cell Size.

The ten commandments for filter usage

1. Subtlety is everything. The effect should support your image not overpower it.
2. Try one filter at a time. Applying multiple filters to an image can be confusing.
3. View at full size. Make sure that you view the effect at full size when deciding on filter settings.
4. Filter a channel. For a change, try applying a filter to one channel only – red, green or blue.
5. Print to check effect. If the image is to be viewed as a print, double-check the effect when printed before making any final decisions about filter variables.
6. Fade strong effects. If the effect is too strong, try fading it. Use the Fade selection under the Filter menu.
7. Experiment. Try a range of settings before making your final selection.
8. Mask then filter. Apply a gradient mask to an image and then use the filter. In this way you can control which parts of the image are affected.
9. Different effects on different layers. If you want to combine the effects of different filters, try copying the base image to different layers and applying a different filter to each. Combine effects by adjusting the opacity of each layer.
10. Did I say that subtlety is everything?

Sketch filters

bas relief

chalk and charcoal

graphic pen

stamp

Sketch filters

Bas relief: Image colour is reduced with cross lighting that gives the appearance of a relief sculpture.
Variables: Detail, Smoothness, Light direction.

Chalk and charcoal: A black-and-white version of the original colour image made with a charcoal-like texture.
Variable: Charcoal Area, Chalk Area, Stroke Pressure.

Graphic pen: Stylish black-and-white effect made with sharp-edged pen strokes.
Variables: Stroke length, Light/dark balance, Stroke direction.

Stamp: Broad flat areas of black and white.
Variables: Light/Dark Balance, Smoothness.

craquelure

Texture filters

stained glass

Texture filters

Craquelure: Cracks imposed on the surface of the original image.

Variable: Crack Spacing, Crack Depth, Crack Brightness.

Stained glass: Image is broken up into areas of colour which are then bordered by a black line to give an effect similar to stained glass.

Variables: Cell Size, Border Thickness, Light Intensity.

Filter DIY

Can't find exactly what you are looking for in the hundreds of filters that are supplied with your editing package or available to download from the Net? IPhotoshop provides the opportunity to create your own filtration effects by using its Filter>Other>Custom option.

By adding a sequence of positive/negative numbers into the twenty-five variable boxes provided, you can construct your own filter effect. Added to this are the options of playing with the scale and offset of the results. Best of all, your labours can be saved to use again when your specialist customized touch is needed.

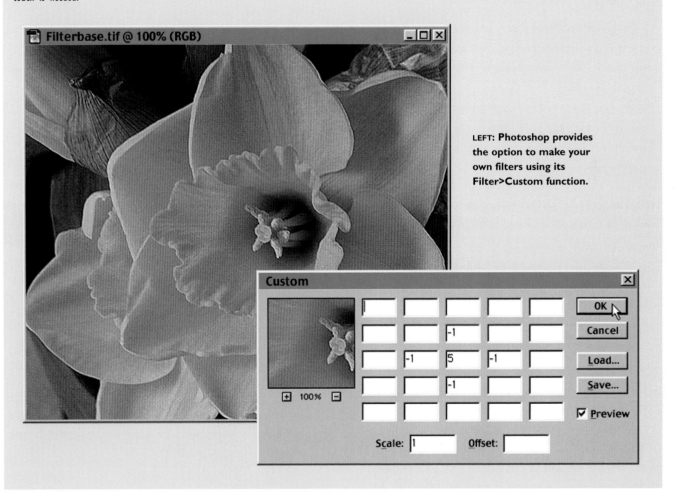

LEFT: **Photoshop provides the option to make your own filters using its Filter>Custom function.**

Changing sharpness

Sharpness has always been an image characteristic for which photographers have striven. Shooters spend a lot of time and money on purchasing equipment and developing techniques that help ensure that their images are always pin sharp. Strangely, in recent years and in direct contrast to these ideas, just as much care and attention has been paid to intentionally blurring parts of the photograph.

A predominant picture style in the late nineties and into the new millennium has been the photograph with an ultra-small depth of field. Used to great effect in glossy food magazines, these images contain large areas that are purposely shot out of focus to contrast with a small section of the picture that is kept very sharp.

Traditional techniques for capturing these images involve the use of good-quality lenses, judicious selection of f-stop settings and, in some cases, a studio camera that is capable of changing the plane of focus. Apart from these manual techniques, a certain amount of control over sharpness is also possible within the digital field. In this section we will look at two methods that can help change the appearance of sharpness in your images.

Increasing sharpness

It should be emphasized that an image that is taken out of focus can never be made sharp. Good focusing is the key to sharp images, and this fact is not altered by using digital techniques. The sharpening options offered by most software programs can only enhance the appearance of sharpness in an image, not make bad focusing good.

Entry level software usually offers at least one method for sharpening images. The more sophisticated image-editing programs offer a range of sharpening choices. Most of these have fixed parameters that cannot be changed or altered by the user. Some programs provide another choice – unsharp masking. This feature has a greater degree of flexibility and can be customized in order to get the best out of your images. The unsharp mask filter gives the user the most

choice over his or her sharpening activities and should be used for all but the most simplistic sharpening needs.

PhotoImpact

Basic sharpening:

1. Select Format>Focus from the menu bar.
2. Pick the thumbnail that represents the best sharpening effect, or
3. Click the Options button.
4. Adjust Sharpen/Blur slider and Levels settings.
5. Click OK to finish.

Unsharp masking:

1. Select Effect>Blur and Sharpen>Unsharp Mask from the menu bar.
2. Pick the thumbnail that represents the best sharpening effect, or
3. Click the Options button.
4. Adjust Sharpen Factor and Aperture Radius sliders.
5. Click OK to finish.

What is unsharp masking?

Those of you who have a history in photography will recognize the term "unsharp masking" as a traditional film compositing technique used to sharpen the edges of an image. The sharpened edges, when seen at a distance, give the appearance of increased sharpness to the whole image. A different technique, which had the same type of results, involved developing black-and-white film in a high "Acutance" developer like Agfa's Rodinal. The developer produced an increase in the contrast between edges, giving an appearance of increased sharpness.

Photoshop and the other software programs combine the spirit of both these techniques in their Unsharp Masking filters. When the filter is applied to an edge, the contrast between two different tones is increased. This gives the appearance of increased sharpness at the edge.

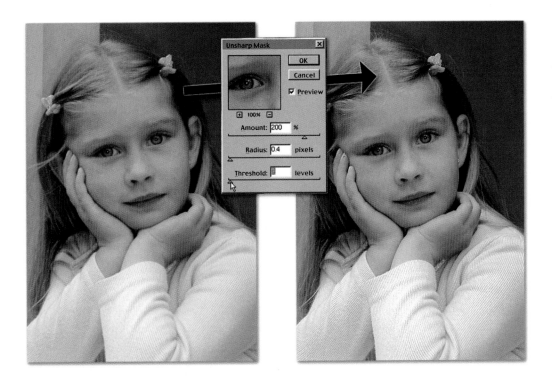

Unsharp Mask
OK
Cancel
Preview
100%
Amount: 200 %
Radius: 0.4 pixels
Threshold: levels

LEFT: **Unsharp masking provides the ability to control the sharpening of the image via three slider settings. In Photoshop these are called amount, radius and threshold.**

Paint Shop Pro

Basic Sharpening:

1. Select Image>Filter>Sharpen or Sharpen More from the menu bar.

Unsharp Masking:

1. Select Image>Filter>Unsharp Mask from the menu bar.
2. Adjust Radius, Strength and Clipping settings. Click OK to finish.

Photoshop

Basic Sharpening:

1. Select Filter>Sharpen>Sharpen, Sharpen Edges or Sharpen More from the menu bar.

Unsharp Masking:

1. Select Filter>Sharpen>Unsharp Mask from the menu bar.
2. Adjust Amount, Radius and Threshold settings.
3. Click OK to finish.

Controlling your unsharp mask effects

In Photoshop the user can control the effects of the filter in three ways, via the slider controls in the dialogue box (other programs use similar controls with varying names):

Amount

Ranges from 0% to 500% and determines the degree to which the effect is applied to the image. Start at a value of about 150%.

Pro's sharpening tip

Convert your image to LAB mode and apply the sharpening to the L channel only. As all the colour information is held in the other two channels, the sharpening will only affect the detail of the image, not the colour.

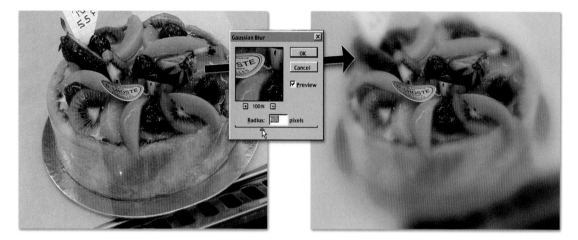

LEFT: Intentional blurring, or defocusing as some photographers prefer to call it, is a technique that is widely used in glossy food photography. A similar effect can be obtained by careful use of the Gaussian blur filter.

Radius

Controls the number of pixels surrounding the edge pixels that are affected by the sharpening. To start with, try setting the radius at the resolution of your image divided by 200. For example if the resolution is 600 dpi then the radius should be set at three (600/200 = 3).

Threshold

This setting determines how different in brightness pixels need to be before the sharpening filter is applied. Although much under-used, this filter is essential for controlling which parts of your image will be affected by the sharpening. When you apply sharpening to flat areas of tone, like sky or flesh, they become very "noisy". By adjusting the threshold value you can stop the sharpening of these areas whilst maintaining sharpening every-where else. A value of zero sharpens all the pixels in the image.

Intentionally blurring your images

Although the notion of artificially introducing blur into your carefully focused images might seem a little sacrilegious, this digital technique is an important one to learn. Most pho-tographers know that a blurred background will help to direct the viewer's eyes towards the main subject in your image. The blur functions contained within modern image-editing packages enable you to change the areas of focus within

your picture and control the viewer's gaze more easily than ever before.

Again the more sophisticated software programs provide the greatest number of blur functions, Photoshop and Paint Shop Pro giving six possibilities, but most packages include at least one blur filter. Just like the unsharp mask function, the Gaussian blur filter gives the user more control over the amount of blur applied to an image.

PhotoImpact

1. Select Effect>Blur and Sharpen>Blur, or
2. Select Effect>Blur and Sharpen>Gaussian Blur from the menu bar.
3. Pick the thumbnail that represents the best blurring effect, or
4. Click the Options button.
5. Adjust Variance sliders.
6. Click OK to finish.

Paint Shop Pro

1. Select Image>Blur>Blur or Soften filters from the menu bar or, for more control,
2. Select Image>Blur>Gaussian Blur.
3. Adjust Radius slider to the desired setting.
4. Click OK to finish.

Photoshop

1. Select Filter>Blur>Blur or Blur More from the menu bar or, for more variations and control,

2. Select Filter>Blur>Gaussian Blur, Motion Blur, Radial Blur or Smart Blur.

3. Adjust the sliders to the desired settings.

4. Click OK to finish.

Advanced tonal control

The tones within a typical digital image are divided into 256 levels of red, green and blue. Each part of the image is uniquely described according to its colour, brightness and position within the grid that makes up the whole image. Apart from viewing the file as a picture, there are several other ways that the pixels can be displayed.

The histogram and levels function

The histogram is a basic graph of the spread of pixel tones from black to white. High points in the graph indicate that there are a lot of pixels grouped around these specific tonal values. Conversely, low points mean that comparatively few parts of the image are of this brightness value. In simple terms, this graph maps the amount of pixels in the highlight, midtone and shadow areas of the image.

The histogram becomes particularly handy when used in the context of Photoshop's Levels function. Here the user can control the spread of the image tones. This means that flat or compressed tone images can be expanded to allow the display of a full range of brightnesses from black to white.

Paint Shop Pro implements a similar histogram-based feature with Equalize and Stretch settings found under the Colours>Histogram Functions selection on the menu bar.

Paint Shop Pro

1. Select Colours>Adjust>Histogram Functions> Equalize or Stretch from the menu bar.

Photoshop

1. Select Image>Adjustments>Levels from the menu bar.

2. Adjust the white and black points of the graph by either dragging the left and right triangles until they meet the first pixels, or by

3. Sampling the brightest and darkest parts of the image using the eyedroppers.

4. Midtones can be adjusted by moving the middle triangle beneath the graph.

5. Click OK to finish.

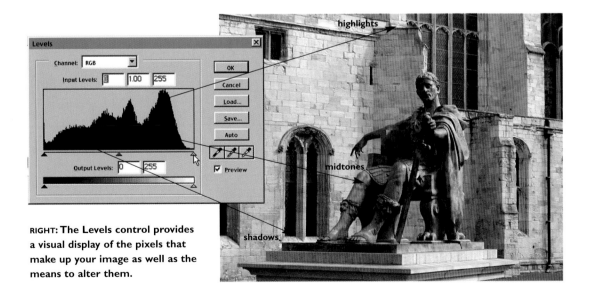

RIGHT: **The Levels control provides a visual display of the pixels that make up your image as well as the means to alter them.**

The curves function

Characteristic curves have long been used by photographers to describe the specific idiosyncrasies of the way that different films and papers respond to light. In both Photoshop and Paint Shop Pro the curve has been used as a way of displaying and modifying an image's tonal areas.

When a user opens the curves dialogue box in Photoshop he or she is confronted with a straight-line graph at 45 degrees. The horizontal axis represents the current brightness of the pixels in your image, or input levels, the vertical axis represents the changed values, or output levels.

The diagonal straight line that appears by default when opening the curves dialogue box indicates that input and output levels are the same.

Changes are made to the image by moving the position of parts of the curve. When the pointer is clicked on the curve an "adjustment point" appears. When this point is clicked and dragged the pixels associated with that value will be lightened or darkened. Because the point is just part of a curve values on either side of the adjustment will also be affected. Many adjustment points can be added to the curve to anchor or change a set of pixels.

In Paint Shop Pro the curve idea is used to represent image tones in the Gamma Correction function. Red, green and blue channels can be adjusted together or independently. Unlike Adobe's product, making changes in Paint Shop Pro will only alter the midtones of the image. Black-and-white points are effectively fixed and are best altered through the contrast and brightness controls.

Paint Shop Pro

1. Select Colours>Adjust>Gamma Correction from the menu bar.
2. Move the sliders to the left or right to change the values of the midtone areas of your image.
3. Deselect the Link option to allow independent alteration of red, green or blue channels.
4. Click OK to finish.

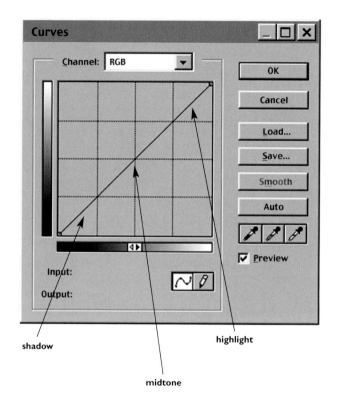

shadow

highlight

midtone

ABOVE: **The Curves function provides a way to visualize and control the tones in your image. It does this in a way that echoes the ideas used for years by photographers to illustrate how film and paper respond to light and development.**

Photoshop

1. Select Image>Adjustments>Curves from the menu bar.
2. Using the mouse, move parts of the curve to adjust shadow and midtone and to highlight areas of your image.
3. Click OK to finish.

Finer curve control using Photoshop

By clicking on a section of your image you can easily locate the value of that pixel and its position on the curve. This method was used to identify a specific group of highlight pixels in the Memorial Cross image. This image is made up mainly of light tones, with a small amount of shadow detail contained in the

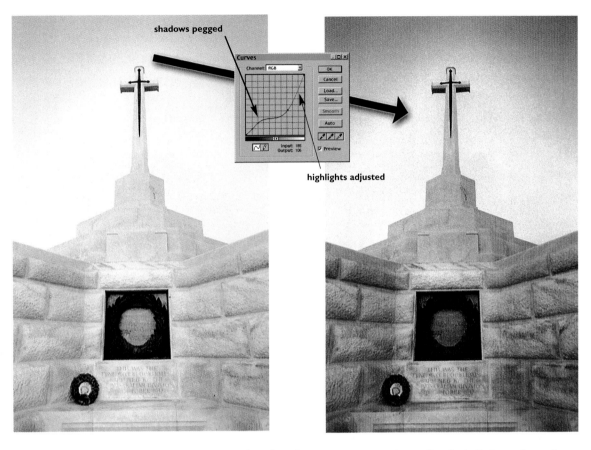

shadows pegged

highlights adjusted

ABOVE: Pegging parts of the curve before alteration gives the user more control over the pixels that are changed.

wreaths. To add some drama to the image, the shadow details were located and their position pegged on the curve. Then highlight detail was adjusted, safe in the knowledge that the shadows would remain largely unchanged. It is easy to see the changes to the resultant image, as the lighter tones have been modified to included more midtone area.

Handy hints for Photoshop curve changers

Changes can be subtle or dramatic depending on the amount that the curve is altered from its original state. To help you with your first set of adjustments, here are a couple of helpful hints:

- Moving an adjustment point to the left will result in a lightening of these pixels,
- Conversely, a movement to the right will darken the pixels,

- A steepening of a section of the curve will result in higher contrast of the values selected, and
- A flattening of the curve will result in a lower contrast image.

If selecting and moving points is not precise enough for your needs, then you can change to the pen mode and freehand draw your own curve directly onto the graph. Those working with precise changes can note input and output value adjustments as they appear at the bottom of the box.

Using channels and curves together

At the top of the curves dialogue box is a selectable drop-down menu that allows the user to select "combined" or "individual" channels. This feature provides the user with the ability to modify each individual channel that makes up your image. In the case of the Lemons image, which is an RGB file, it is possible to select and adjust one channel at a time. To demonstrate this the blue channel was selected, making the mid and shadow tone areas lighter. This adjustment makes the blue background more vibrant without affecting other areas of the image.

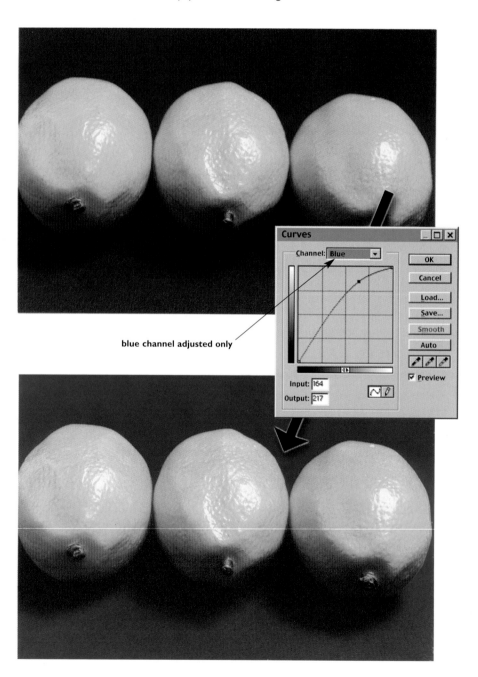

blue channel adjusted only

RIGHT: The curve of individual channels can be altered independently allowing for manipulation of just one colour at a time.

Selecting areas to work on

New and experienced users alike agree that being able to select specific areas of an image to work on is one of the most basic, but essential, skills of the digital darkroom worker. Sure, it is possible to make broad and general adjustments to pictures without such skills, but it's not too long before you will find yourself wanting to be a little more particular about which parts of the image you want to change.

With selection being such an important part of modern image-editing techniques, it is no surprise that all the main software products have a variety of methods that can be used to isolate wanted pixels.

The majority of these tools can be grouped into three major techniques:

1. Lasso- and pen-type tools that are used to draw around objects,

2. Marquee tools that, again, draw around objects, but in predefined shapes such as rectangles or ellipses, and

3. Colour selection tools, such as the magic wand, that define selection areas based on the colour of the pixels.

Added to these are selection tools designed specifically for isolating foreground objects from their digital backgrounds. The Extract function from Adobe's Photoshop and the Mask Pro plug-in from Extensis are two such products.

The basic tools

Not all tools are suitable for all jobs. For this reason the software companies generally provide several different selection tools that can either work in isolation or together.

Marquee

Out of all the standard offerings, the marquee tool is the most simple. The user has a choice of a rectangular or elliptical marquees, providing the ability to make square and rectangular selections along with circular and oval shaped ones. This is appropriate for selecting regular hard-edged objects in an image and is often used in conjunction with other tools.

Photoshop

1. Select marquee tool.

NB: Remember, to change tools you select and hold down the mouse button until the other options become available.

2. Locate the starting point of the rectangle, or ellipse. This is usually the upper right or left of the image. Click and drag the mouse to draw the selection.

Marquee tool

Magic wand tool

Magic wand

The magic wand makes its selections based on pixel colour, not drawn area. If the part of the image you want to select has a dominant colour that is in contrast to others within the picture, then the magic wand is a good choice.

The precision of the colour selection can be adjusted using the Tolerance setting found in the wand's palette. The higher the number, the less fussy the tool will be about its precise selection. To get the tolerance level just right, you might need to deselect and reselect several times. If you are lucky enough to have a clean and colour-consistent object or background, this is the tool for you.

Photoshop

1. Select the magic wand tool.
2. Click on the dominant colour in the background of your image.
3. Check the resultant selection to see that all

background pixels have been encompassed by the marching ants.

4. If the selection isn't quite right, deselect (ctrl+d or Select>Deselect), adjust the tolerance of the wand (double click the magic wand in the tool box to reveal the palette), and select again.

Lasso

Using the lasso tool or, for even more accuracy, the magnetic lasso which sticks to edges, the user can draw around irregular-shaped objects. An alternative to this approach is to select the parts of the image that you don't want changed and then invert the selection. Inverting swaps the selection from object to background and vice versa.

Photoshop

1. Select the lasso tool.
2. Carefully outline the objects that you want selected, or

Lasso tool

Pen tool

3. Draw around the objects you don't want in the selection, and
4. Inverse the selection (Select>Inverse).

Pen tool

The pen tool, like the lasso, is essentially used to draw the outline of the objects to be selected. Again, with this tool you have the option of a magnetic version, which aids in drawing by sticking to the edges of objects. The pen draws a path rather than a selection. Once drawn, it has to be converted to a selection before use.

Photoshop

1. Select the pen tool.
2. Carefully outline the objects that you want selected.
3. Once completed, show paths palette (View>Show Path).

4. Convert path to a selection (in the paths palette select Make Selection).
5. Delete path and leave selection (in the paths palette select Delete Path)

Adding to and subtracting from selections

You can add to a selection using any of the standard tools by holding down the shift key and then reusing the selection tool. You can also subtract from a selection by using the tool whilst depressing the Control key for PCs or Option key for Mac. In this way you can progressively build a complex selection that encompasses many irregular shapes, tones and colours.

Adding text

Adding text to your images is an important next step towards digital proficiency. Traditional photographic techniques rarely gave the opportunity for shooters to add easily a few well-chosen words to their images. This is not the case with digital image-making. All of the major image-editing software packages have a range of text features. All have functions that allow the selection of font size and type and positioning within the picture. The most sophisticated packages also provide extra enhancements for the text, such as automatic "drop shadows" or "outer glows".

PhotoImpact

1. Pick the Text tool from the toolbar.
2. Position the cursor, now a text icon, in the image and click.
3. Use the Text Entry Box to enter text.
4. Use the settings to adjust font size, type and colour.
5. Click OK to finish.

Paint Shop Pro

1. Pick the Text tool from the toolbar.
2. Position the cursor, now a text icon, in the image and click.
3. Use the Text Entry dialogue box to enter text.
4. Use the settings to adjust font size, type and colour.
5. Click OK to finish.

Photoshop

1. Pick one of the Text tools from the toolbar.
2. Position the cursor, now a text icon, in the image and click.
3. Use the Type Tool dialogue box to enter text.
4. Use the settings to adjust font size, type and colour.
5. Click OK to finish.

Text tool

theory into practice

part two / chapter five

Restoring a black-and-white photograph

Difficulty level: 1
Programs: PhotoImpact, Paint Shop Pro, Photoshop

Restoring an old photograph is typical of the type of jobs that the digital photographer is presented with on a regular basis. The type of skills needed to make repairs to damaged or faded images makes picture restoration a good exercise for new users.

Capturing your image

Most restoration tasks start with the carefully scanning of the original image. It is this process that captures all the information you will be working with, so be sure to adjust the contrast and brightness controls within the scanner plug-in to guarantee that you don't loose delicate highlight or shadow detail.

In some cases, where the original has been torn to pieces, it is worth spending a little time making sure all the

relevant sections are located and scanned. Repositioning and stitching the offending pieces together is a lot easier than trying to create complex bits of an image anew.

Even if the original is a black-and-white print, you can still scan it as a colour original. This way you can capture the tint of the emulsion or toner that was used to produce the print originally. It also means that stains on the print surface can be isolated more easily (using Select >Colour Range in Photoshop) and removed.

Contrast and brightness control

Once the image is captured, the first step is to adjust the contrast and brightness. This can be undertaken using the automatic controls contained within your imaging package or by manually pegging the white and black points of the

ABOVE: **More than just the start of the restoration process, scanning captures the information that will be the basis of your completed image. Lack of care here will lose important information that is vital to the process.**

ABOVE: **Adjust the spread of the tones in your image by altering its contrast and brightness.**

Steps for shadow enhancement

PhotoImpact

1. Select Format>Tone Map from the menu bar.
2. Click on Highlight Midtone Shadow Tab at the top of the dialogue.
3. Move the Midtone slider to the right add or increase the values to lighten shadows.

BELOW: **A little adjustment to the shadow area of your image will help, as it's this detail that is often lost in the printing process.**

Paint Shop Pro

1. Select Colours>Adjustments>Gamma Correction from the menu bar.
2. Make sure that the Red, Green and Blue sliders are linked.
3. Move the sliders right to lighten shadow detail.

Photoshop

1. Select Image>Adjustment>Curves from the menu bar.
2. Carefully push the shadow area of the curve upwards so that the section from the black to this point is steeper than before.

PhotoImpact

Paint Shop Pro

Photoshop

image. Apart from these general changes, you can make small adjustments to the brightness of the shadow areas, so that subtle details, which tend to get lost at the printing stage, are more apparent.

Removing dust and scratches

Dust and scratches are a fact of life for most of us who scan our own negatives and prints. Sure, careful cleaning of the original will produce a file with fewer of these problems, but, despite my best efforts, some marks always seem to remain. All imaging packages contain good tools for removing these annoying spots. Most are based on either blending the mark with the surrounding pixels or stamping a piece of background over the area. Time spent on this helps ensure a professional result.

Repairing damaged areas

Reconstructing damaged or missing areas of an image is the most skillful part of the restoration process. Most tears and major scratches can be fixed by using the Rubber Stamp tool in Photoshop, PhotoImpact's Clone-Paintbrush or the Clone Brush in Paint Shop Pro. Search the picture for areas of the image that are of similar tone and texture to the damaged area to sample. The quality of your selection will determine how imperceptible the repair will be.

Large areas can be constructed quickly by selecting, copying and pasting whole chunks of the background onto vacant or missing parts of the image. Feathering the edges of the selection will make the copied areas less apparent when they are pasted. Remember, credibility is the aim in all your reconstruction efforts.

ABOVE: To disguise the smoothing that is associated with some restoration steps, add a little texture to the image. Try to match the size and type of grain structure with that of the original.

Putting texture back

Often one of the telltale signs of extensive reconstruction work is a smoothing of the retouched areas. Even though

cloning samples texture as well as colour and tone, continual stamping tends to blend the textures, producing a smoother appearance. To help unify the new area and disguise this problem, a little texture should be applied to the whole image.

This can be achieved by adding "noise" to the image. This option is situated under the Filter menu in Photoshop, the Image menu in Paint Shop Pro and the Effects menu of PhotoImpact. In an enlarged view of your image (at least 1:1 or 100%) gradually adjust the noise effect until the picture has a uniform texture across the both new and old areas.

Adding colour

A lot of historical images are toned so that they are brown-and-white rather than just black, white and grey. A similar, sepia-like effect can be created digitally using the colourize options of Photoshop (Image> Adjustment> Hue/ Saturation), PhotoImpact (Format> Hue/Saturation), and Paint Shop Pro (Colours> Colourize). With the colourize box ticked, you can make changes to the tint of the image by sliding the Hue selector.

BELOW: Restoration is a common job for digital photographers and one that hones important imaging skills and techniques.

ABOVE: Adjusting the Hue/Saturation control is an easy way to add a digital tone to your print.

Getting rid of backgrounds
Difficulty level: 1
Programs: Photoshop, Mask Pro

ABOVE: **Deep etching is a frequently used preliminary step to adding multiple images together in a montage.**

In the old days, placing an object against a clean, white background was achieved by a process called "deep etching". This technique required a graphic designer or photographer to cut away background information by carefully slicing the image with a scalpel. Today, the job is completed in a less dramatic and more effective manner using a blunt mouse instead of a sharp knife.

Achieving this deep-etched look digitally requires the careful selection of objects and the deletion of their backgrounds. As an example, an illustration is chosen containing a sign in the background, so as to extract the sign from the image and combine this image with a second picture (see above). Usually one of the Photoshop's in-built tools would be used to complete this task, and, as we have already seen, there is a variety of ways to reach the same goal.

Lasso tool
Using the Lasso tool, or for even more accuracy, the Magnetic Lasso, you can draw round the whole sign, being careful to pick out the edges.

Any overlaps can be tidied up using the eraser. You could then inverse the selection (Select>Inverse) and delete the background (Edit>Cut).

ABOVE: **The Lasso is a selection tool that is based on an area drawn by the user.**

ABOVE: **The Marquee tool** also bases its selection on a drawn area.

ABOVE: **The Magic Wand** selects objects based on their colour.

Marquee tool

The Marquee tool is not really an option here as the shape of the object to be selected is not regular. A rectangular marquee would leave a lot of the background area still to be erased.

Magic wand

The Magic Wand tool makes its selections based on colour not a drawn area. For this example, it would be best to select the background colour and then adjust the tolerance

(found in the Magic Wand palette) to try to encompass all the required pixels. It would then be a simple matter to delete the unwanted pixels.

Colour range

In a similar way, the Colour Range tool, which is found nestled under the Selection menu in Photoshop, can allow you to select interactively the background or foreground colours, from which a selection or mask can then be made.

RIGHT: **Colour Range** is a refined colour selection tool that allows the user to adjust and add to the colours that are selected.

Why the need for more?

With such a variety of ways to achieve that all-important selection, there would seem to be little or no need for another group of tools in this area. As the software versions of each of the leading packages have developed, so too has the sophistication of their selection tools. What more could specialist selection or masking products give the user that would warrant their use?

The short answer is that, despite the strengths of these standard tools, for most jobs, specialist software can provide a greater level of flexibility and adjustment.

The Mask Pro way

Extensis has obviously designed their Mask Pro plug-in around the tasks that digital workers find themselves doing most often, and has been careful to provide a range of options that, although similar to Photoshop in flavour, provide an extension to Adobe's tool set.

When you select Mask Pro from the Extensis heading under the Photoshop Filter menu, you are presented with a new working window containing the image, four palettes and the toolbox. Standard and Extensis versions of traditional tools like the Brush, Paint Bucket,

ABOVE: **Mask Pro is a dedicated selection system designed to make the job of cutting objects from their backgrounds easier and faster than ever before.**

keep

magic brush

magic fill

magic wand

magic pen

hand

erase

drop

brush

bucket fill

airbrush

pen

zoom

ABOVE: The tools in **Mask Pro** are customized versions of the ones available in Photoshop.

keep palette

colours to keep

drop palette

colours to drop

new set new colour bin colour

ABOVE: The Keep and Drop palettes determine what parts of the image are saved or deleted from the image.

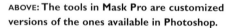

ABOVE: Brushing around an object in the Mask Pro window automatically drops unwanted pixels from the image.

Mask Pro usage summary

1. Crop the image if necessary.
2. Open the Mask Pro plug-in by selecting the desired mode from the Extensis selection underneath the Filters menu in Photoshop:
 Filters > Extensis > Mask > Select or
 Filters > Extensis > Mask > Composite.
3. Use the eye droppers to select the colours you wish to keep or drop from the image.
4. Select the areas to mask away using one of the painting or drawing tools like the Magic Wand or Magic Brush.
5. Search for the any holes and complete the mask using the Bucket Fill and Magic Fill tools.
6. Save the mask and return to Photoshop satisfied with a job well done!

Optional: Before returning to Photoshop you can apply other Mask Pro options such as:
- Using the Make Work Path to create a clipping path, or
- Using Edgeblender to reduce or eliminate halo effects

Those of you who are Net connected can download trial versions of all the Extensis software from Error! Reference source not found.

Magic Wand and the Pen are provided. Use the Keep and Drop eye droppers to select the colours within the image to be saved or discarded. These colours will now form the basis of the selection made with any of the specialized tools.

Next, drag the Magic Wand or Magic Brush tool along the outside edge of the image that you want to isolate from the background. Mask Pro will mask the area based on the Keep and Drop colours you have selected. Once completed, the image can be returned to Photoshop with the foreground figure now free of its background.

Once the sign is isolated, it is a comparatively simple job to drag it from its original window to that of the new background. If, like me, you need some white space to the side of the background image, change the size of the canvas before combining the images.

Adobe's extract tool

Hidden away under the Image menu in Photoshop is Adobe's specialist selection tool. Revised and updated for Version 6, the concept is simple – draw around the outside of the object you want to select, making sure that the highlighter overlaps the edge between background and foreground, and then fill in the middle. The program then analyses the edge section of the object using some clever fuzzy logic to determine what should be kept and what should be discarded, and Hey Presto! the background disappears.

The tool is faster than lasso or pen tools as you don't need to be as accurate with your edge drawing, and it definitely handles wispy hair with greater finesse than most manual methods I have seen. There are several ways to

LEFT: Adobe's answer to advanced selection tools like Mask Pro is the Extract function.

refine the accuracy of the extraction process that are handy for those areas where the computer has difficulty deciding what to leave and what to throw away.

Extract usage summary

1. Select the layer you wish to extract.
2. Chose Image>Extract from the Photoshop menus.
3. Using the Edge Highlighter tool, draw around the edges of the object you wish to extract.
4. Select the Fill tool and click inside the object to fill its interior.
5. Click Preview to check the extraction.
6. Click OK to apply the final extraction.

Extraction tips

- Make sure that the highlight slightly overlaps the object edges and its background.
- For items such as hair use a larger brush.
- Make sure that the highlight forms a complete and closed line around the object.

ABOVE: **The first step in the extract process is to highlight the edges of the object to be extracted.**

ABOVE: **Once completed, the highlighted object can be filled.**

ABOVE: **Photoshop processes the command to extract by determining which part of the object is to be kept and which is to be dropped. The result is the selected object with its background deleted.**

Digital depth of field

Difficulty level: 2
Programs: Photoshop

Photographers have long considered control over the amount of sharpness in their images a sign of their skill and expertise. Almost all shooters display their depth of field agility regularly, whether it's by creating landscape images that are sharp from the very foreground objects through to the distant hills or the selective focus style so popular in food and catalogue shots. Everyone from the famed Ansel Adams to today's top fashion and commercial photographers makes use of changes in areas of focus to add drama and atmosphere to their images.

In the digital age, the photographer can add a new technique to the traditional camera-based ones used to control depth of field in images. Unlike silver-based imaging, where once the frame is exposed, the depth of sharpness is fixed, pixel-based imaging allows the selection of focused and defocused areas after the shooting stage. In short, a little Photoshop trickery can change an image which is sharp from the foreground to the background to one that displays all the characteristics normally associated with a shallow depth of field.

Basic defocusing of the pixels – step by step

1. Choose an image that has a large depth of field. This way you will have more choice when selecting which parts of the image to keep sharp and which parts to defocus. The example I have used has a large depth of field in its original form; it's sharp from the holy man in the foreground to the temple walls at the back of the frame. The picture demonstrates all the characteristics of an image made with a small aperture, such as f/16 or f/22. If I had shot this image with a larger aperture (f/2.8 or f/2), the holy man in the mid-ground would be sharp, while the foreground and background would be defocused.

2. Use one of Photoshop's selection tools to isolate the part of the image you want to remain sharp. Having selected the whole figure of the holy man, inverse the selection (Selection>Inverse). In the example, the new selection included both the background and foreground information.

3. Add some feathering to the edge of the selection so that the transition points between focused and defocused picture elements is more gradual. This step can be omitted if you want sharp-edged focal points that contrasted against a blurry background.

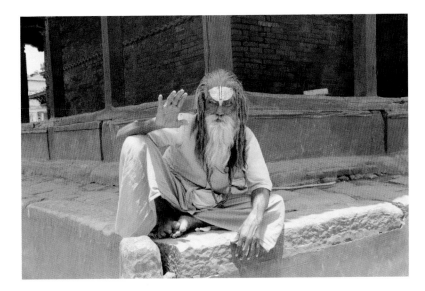

LEFT: **A large depth-of-field example made with a wide-angle lens and a large f-stop number.**

4. Filter the selected area using the Gaussian Blur filter (Filter>Blur>Gaussian) set at a low setting to start with. Make sure the Preview option is selected, this way you can get an immediate idea of the strength of the effect.

5. Hide the "marching ants" that define the selection area so you can assess the defocusing effect. Use the magnifying tool to examine the transition points between sharp and blurred areas. Re-filter the selection if the effect is not obvious enough.

This technique provides a simple in-focus or out-of-focus effect. It reflects, in a basic way, a camera-based shallow depth of field effect and draws our attention to the holy man. However, it is not totally convincing. To achieve a result that is more realistic, the technique needs to be extended.

Producing a more realistic depth-of-field blur

If realism is our goal, it is necessary to look a little closer at how camera-based depth of field works and, more importantly, how it appears in our images.

Imagine an image shot with a long lens using a large aperture. The main subject, situated midway into the image, is pin sharp, but the depth of field is small, so other objects in the image are out of focus. Upon examination, it is possible to see that those picture elements closest to the main subject are not as blurred as those further away. The greater the distance from the point of focus, the more blurry the picture elements become. The same effect can be seen in images with large depths of field, through the depth of sharpness is greater.

This fact, simple though it is, is the key to a more realistic digital depth of field effect. The application of a simple one-step blurring process does not reflect what happens with traditional camera-based techniques.

More realism – step by step

1. Using your raw scan image, repeat the first few steps of the basic defocusing process using Gaussian Blur filter settings that produce only a slight effect. A pixel radius of one is a good start. In my example, the holy man and the portion of the step beneath him was kept sharp, the rest of the image was slightly blurred.

2. Now change the selection so that those parts of the image that are just in front of the subject or just behind are not included. Apply another Gaussian Blur filter. This time, increase the pixel radius to two. In the example image more of the step in front and behind the main subject was excluded from this second application of the filter.

3. Change the selection again removing the image parts that are next furthest away from the main subject. Reapply the Gaussian Blur filter with a setting of four. Part of the temple behind the subject in the example

ABOVE: **If believability is the aim, the blurring effect needs to be applied gradually across the image.**

was now removed from the selection which was then blurred again.

4. This step can be repeated as many times as is needed to give a more realistic appearance to the effect. Each time, the selection is changed to exclude picture parts that are progressively further away from the subject, and each time the filter setting is doubled. In my example below, four different selections were used to produce a more realistic depth of field effect (see below).

If the simply created depth of field in the first example is compared with the more refined version in the second image, it is possible to see how an authentic feeling can be created by gradually increasing the amount of blur within the image.

Taking the story further

Using the techniques above, it is possible to replicate the depth-of-field effects that

are obtainable through traditional means. However, if the idea is taken further, the clever digital photographer can produce images that achieve a quality and style that exceeds what is possible with camera-based manipulations.

Depth of field is based on a single plane of focus that runs through your subject. When using fixed-backed cameras, such as 35mm or medium format, the focus plane is parallel to the back of the camera or film plane. The depth of sharpness in the image then extends in front of and behind this plane. Aperture selection, lens length and subject distance all control the extent to which this sharpness extends into your picture.

Even with moving-back cameras, such as a monorail or 4 x 5 in. format, depth-of-field control is restricted, pivoting around a single plane, though that plane can be tilted away from the parallel.

Digital depth of field frees the image-maker from all these focus plane constraints. Areas of sharpness are controlled by the section of the image that is selected in your editing package, not by where the focus plane was at the time of shooting. Using this idea, it is possible to have areas of sharpness in the foreground and background of an image at the same time. This would not be possible using traditional means.

RIGHT: **A series of four selections was used to produce an image with a more realistic shallow depth-of-field effect.**

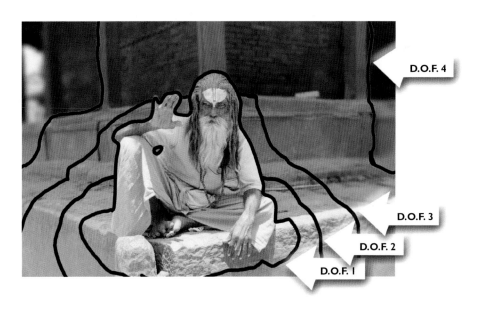

D.O.F. 4

D.O.F. 3

D.O.F. 2

D.O.F. 1

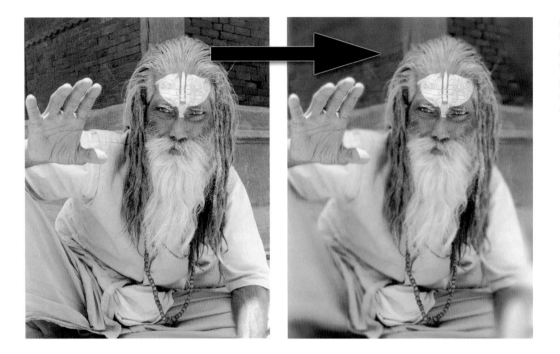

LEFT: **An extension to the basic technique gives the user the chance to go beyond pure replication of camera-based depth-of-field effects.**

How to produce non-focal plane constrained depth of field

To explain this idea I have selected another image of the holy man, this time shot a little closer in. The traditional depth of field displayed in the straight version of the image shows the main subject as sharp with a small amount of softness in the wall behind. As expected, the areas of sharpness revolve around a single plane that is parallel to the camera back and runs vertically through the subject (see above).

A digitally manipulated version of the same image exhibits a range of focus points that are not necessarily in the same plane. In the example the face, the hand and the beads were kept sharp whilst applying a blur filter to the rest of the image. The final image shows depth-of-field effects that can not be achieved traditionally as the three sharp elements are not in the same plane (see right).

This final technique, though not possible using camera and film, draws on a long and rich heritage of sharpness manipulation and will surely open up a new vista of visual possibilities for the digitally creative.

Selected focus points

ABOVE: **Several points within the image, not all on one plane, were chosen to remain sharp. It would not have been possible to produce this effect by traditional means.**

Digital lith printing

Difficulty level: 2
Programs: PhotoImpact, Paint Shop Pro, Photoshop

The craft printing revival of the nineties introduced a new generation of monochrome enthusiasts to a range of printing techniques, both old and new, that transform the mundane to the magnificent. Lith printing is one such technique. For the uninitiated, the process involves the massive over-exposure of chloro-bromide-based papers coupled with development in a weak solution of lith chemistry. The resultant images are distinctly textured and richly coloured and their origins are unmistakable.

The process, full of quirky variables like the age and strength of the developer and the amount of over-exposure received by the paper, was unpredictable and almost impossible to repeat. In this regard at least, printers found this technique both fascinating and infuriating. This said, it's almost a decade since lith printing started to become more commonplace and there is no sign of people's interest declining.

"Long live lith," I hear you say, "but I don't have a darkroom." Well, there's no need. The digital worker, with basic skills, a good bitmap imaging program, and a reasonable colour printer, can reproduce the characteristics of lith printing without the smelly hands or the dank darkroom of the traditional technique.

Step 1: Decide what makes a lith print

If you ask photographers what makes a lith print special, the majority of them will tell you it's the amazing grain and the rich colours. Most lith prints have strong, distinctive and quite atmospheric grain that is a direct result of the way in which the image is processed. This is coupled with colours that are seldom seen in a black-and-white print. They range from a deep chocolate, through warm browns, to oranges and sometimes even pink tones. If our digital version is

to seem convincing, the final print will need to contain all of these elements.

Step 2: Get yourself an image

Whether you source your image from a camera or a scanner, make sure that the subject matter is conducive to a lith-type print. The composition should be strong and the image should contain a full range of tones, especially in the highlights and shadows. Good contrast will also help make a more striking print.

Step 3: Lose the colour

Unless you are scanning from a monochrome original, you will need to change the mode of your digital file from either RGB or CMYK colour to greyscale. Even though lith prints do have a distinct colour, they all start life as a standard black-and-white image.

To change colour to greyscale:

PhotoImpact – Format>Data Type>Greyscale
Paint Shop Pro – Colours>Grey Scale
Photoshop – Image>Mode>Greyscale

ABOVE: **If you are starting the digital lith-printing process with a colour image, your first step is to convert the image to greyscale.**

Step 4: Adjust contrast and brightness

Sometimes when a colour image is changed to greyscale there is a noticeable flattening of the tones – the image looks low in contrast. Using the tools in your editing program, adjust the contrast and brightness of the image to make up for any loss of contrast. Make sure that all the tones are well spread and that the image contains a good black and white as well as textured shadows and highlights.

To adjust brightness:

PhotoImpact – Format>Brightness/Contrast

Paint Shop Pro – Colours>Adjust>Brightness/Contrast

Photoshop – Image>Adjust>Brightness/Contrast.

Step 5: Add texture

There are a couple of ways to simulate the texture of the lith print. You can filter the whole image using a film grain filter. Most of these types of filter have slider controls that adjust the size of the grain and how it is applied to the highlights of your image. I prefer to use a Noise filter as it gives an all-over textured feel that is more suited to the lith print look. Again, variations of the intensity of the effect can be made via the filter's dialogue box.

To add texture:

PhotoImpact – Effect>Noise>Add Noise.

Paint Shop Pro – Image>Noise>Add.

Photoshop – Filter>Artistic>Film Grain or Filter>Noise>Add Noise.

Step 6: Add colour

The simplest and most effective way to add lith-like colours to your image is to make another change to its colour mode. For Photoshop users, instead of reverting back to a RGB, change to a duotone mode. This special colour mode is designed to allow a greyscale image to be printed with the addition of another user-selected colour. In effect, we can select whether the digital lith print will have a chocolate brown or pink colour by selecting the second colour that will mix with the grey tones of the monochrome print.

LEFT: **After desaturation, images tend to be a little flat. This can be rectified with a small adjustment of the Contrast and/or Brightness sliders.**

ABOVE: **Grainy texture is one of the most recognizable characteristics of
lith prints; adding it to our digital image is critical if the effect is to be reproduced.**

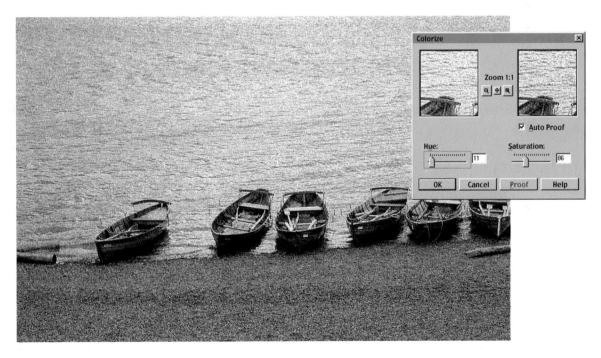

ABOVE: **Lith-like colours can be added to the black-and-white image using the Hue/Saturation controls.**

Paint Shop Pro and PhotoImpact devotees will need to colourize a RGB file that has been reconstituted from the greyscale, and then create the lith colour by adjusting the Hue and Saturation sliders.

To add colour:

PhotoImpact – Format>Data Type> RGB True Colour.

Format>Hue Saturation.

Check Colourize option and adjust Saturation and then Hue sliders to add colour to the greyscale.

Paint Shop Pro – Colours>Channel Combining> Combine From RGB.

Select the greyscale image for each channel source, then Colours>Colourize.

Adjust Saturation and then Hue sliders to add colour to the greyscale.

Photoshop – Image>Mode>Duotone.

Change type from monochrome to duotone.

Double click the colour space in ink 2.

Select a colour from the colour swatch.

Step 7: Print your results

Printing, the final step of the process, shouldn't be underrated. Be sure to use the best quality settings for your printer. This means selecting the highest resolution possible and making sure that check boxes like Finest Detail are always ticked. Finally, use good-quality heavyweight photo paper. Remember, most photographic paper is about 225gsm so if you want the same feel as a photograph, make sure you use a similar weighted stock to print on.

Action stations

The macro language that allows users of Photoshop 4 or greater to record a series of actions and apply them, at a later date, to another image is a facility perfect for creating lith effect.

Simply activate the recording button, proceed through the steps of making a colour image into a lith one, and save the action for later use. Then, when the action is started, the steps are carried out one by one as if you are pressing the buttons. Not only can you apply the effect to another image with just one button click, you can also change a whole folder, or directory, of candidate images by using the associated batch function. You now possess a whole series of self-recorded actions that carry out a range of routine tasks.

RIGHT: The steps of the digital lith process can be recorded as a Photoshop action, making the whole process a one-button-push affair.

before

after

Tricks of the trade: Stephen McAlpine's textured montage technique

Difficulty level: 2
Programs: PhotoImpact, Paintshop Pro, Photoshop

Stephen McAlpine is a professional portrait and wedding photographer who spent the first ten years of his career creating beautiful hand-crafted black-and-white images for his clients. Long hours were spent in the darkroom moulding and shaping a visual style that is both distinctive and emotive.

The approach was a success with his clients but his best work took many hours to complete. When he started to play with digital techniques, he realized he could provide the same style of work within a time frame that suited his bottom line.

"Digital is an extension of what I was already doing in the darkroom." McAlpine explains. "The new technology provides me with a way of working that is both creatively satisfying and efficient. I can now offer clients a fully customized service that would have been prohibitively expensive if produced traditionally. What's more, with current digital RA4 printing [photographic colour printing] the image looks and feels no different than what I would have produced if I had spent hours in the darkroom."

The following is a summary of the steps that McAlpine uses to create his beautiful images.

1. Scan the various image parts from black-and-white original negatives.
2. Adjust the contrast and brightness of the individual parts so that they have a uniform look. Double-check that the light direction and quality is consistent with all parts.
3. Drag all components onto separate layers of one image. Resize and adjust edge areas to fit the parts together.
4. Introduce uniform grain (or noise) across all components to give the appearance that they were all sourced from one negative.
5. Add drama to the image by selectively darkening and lightening areas using the Dodging and Burning-in tools. Artificially create drop shadows for foreground objects to give the appearance that they were shot in situ.
6. Use the Variations filter (or Hue/Saturation control) to add toning colours to the black-and-white images.
7. Output proofs to a desktop inkjet and final client images to a digital RA4 colour printer.

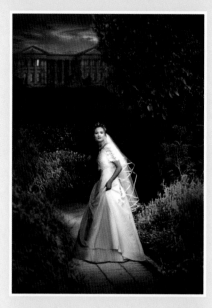

LEFT: Stephen McAlpine's imagery was initially produced in a darkroom-only process. Now he makes use of digital techniques to create images that are both stunningly beautiful and highly emotive.

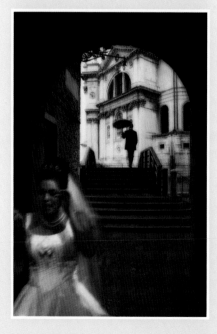

LEFT: The steps used by McAlpine to create his photographs are designed to unify separate image components.

Diffusion printing
Difficulty level: 2
Programs: Paint Shop Pro, Photoshop

These days the photographic world is full of diffused images. From the food colour supplements in our weekend papers to the latest in portraiture or wedding photography, subtle use of diffusion is a regular feature of contemporary images.

Traditionally, adding such an effect meant placing a "mist" or "fog" filter in front of the camera lens at the time of shooting. More recently, in an attempt to gain a little more control over the process, photographers have been placing the same filters below their enlarging lenses for part of the print's exposure time. This process gave a combination effect where sharpness and controlled blur happily coexisted in the final print.

The digital version of these techniques allows much more creativity and variation of the process and relies mainly on the use of layers and the Gaussian Blur filter. Both Photoshop and Paint Shop Pro have these facilities, coupled with simple interfaces that allow the user to control the application and control of the blur.

The basics of digital diffusion

The Gaussian Blur filter, which can be found in most image-editing packages, effectively softens the sharp elements of an image when it is applied. Used by itself, this results in an image that is quite blurry and, let's be frank, not that attractive. However, when this image is carefully combined with the original sharp picture, we achieve results that contain sharpness and diffusion at the same time, and are somewhat more desirable.

Essentially we are talking about a technique that contains three distinct steps:

Firstly, make a copy of your image and place it on a second layer that sits above the original. Rename this layer "blurred layer".

With this layer selected, apply the Gaussian Blur filter. You should then have a diffused or blurred layer sitting above the sharp original. (Photoshop users who don't like the look of the Gaussian diffusion, can choose to use the

before

after

LEFT: **Digital diffusion printing provides the user with more controllable options than are traditionally available.**

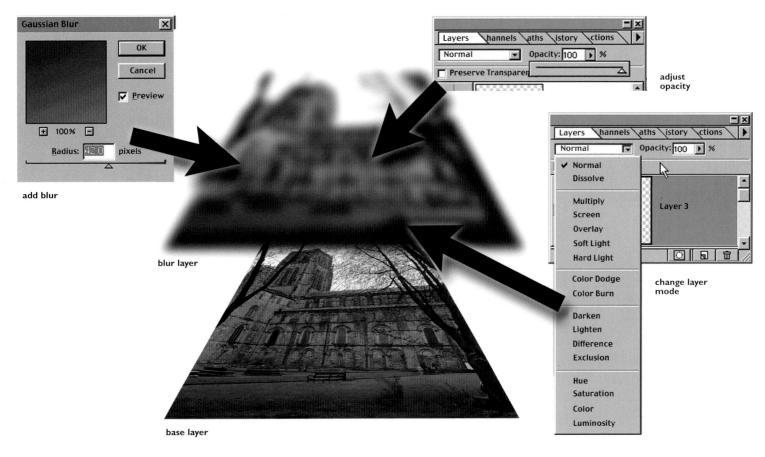

add blur

blur layer

base layer

adjust opacity

change layer mode

ABOVE: **A Gaussian-Blurred layer placed above the sharp original is the basis of the diffusion technique.**

Diffuse filter instead. This filter is not as controllable but does achieve a different effect.)

Finally, change the layer blending mode and/or the opacity of the blurred layer to adjust the way in which the two layers interact as well as how much of the sharp layer shows through.

Photoshop contains 14, and Paint Shop Pro 17, different blending modes that allow the user control over how any layer interacts with any other. The modes used for the example image were normal, soft light, multiply and luminosity. Of course, other modes might work better on your images so make sure you experiment.

Adjusting the blurred layer's opacity changes the transparency of this image. This, in turn, determines how much

of the layer below can be seen. More opacity means less of the sharp layer characteristics are obvious.

By carefully combining the choice of blending mode and the amount of opacity, the user can create infinite adjustments to a diffusion effect.

Paint Shop Pro

1. File>Open – Select image.
2. Layers>Duplicate.
3. Rename new layer "blurred layer"
4. Make sure this layer is selected.
5. Image>Blur>Gaussian Blur.
6. Adjust blending mode and opacity in layers dialogue.

Photoshop

1. File>Open – Select image.
2. Layer>Duplicate Layer.
3. Rename new layer "blurred layer".
4. Make sure this layer is selected.
5. Filter>Blur>Gaussian Blur or Filter>Stylize>Diffuse.
6. Adjust blending mode and opacity in layers dialogue.

One step further: graduated diffusion

In some instances, it might be preferable to keep one section of the image totally free of blur. If you use Photoshop this can be achieved by applying the Gaussian filter to your original image via a selection.

For example, the gradient tool could be selected, making sure that the options were set to "foreground to transparent" and "radial gradient". Then switch to "quick mask" mode and make a mask from the centre of the image to the outer right-hand edge of the image. When switching back to the selection mode, you would now have a graded circular selection through which you could apply the blurring filter.

If this extra step is applied to a duplicate of the original image on a separate layer, it will still be possible to use blending modes and opacity to further refine the image.

Photoshop

1. File>Open – Select image.
2. Layer>Duplicate Layer.
3. Rename new layer "blurred layer".
4. Make sure this layer is selected.
5. Ensure that the gradient blur tool is set to "foreground to transparent" and "radial".
6. Switch to "quick mask" mode.
7. Draw gradient.
8. Switch back to selection mode.
9. Filter>Blur>Gaussian Blur or Filter> Stylize>Diffuse.
10. Adjust blending mode and opacity in layers dialogue.

Even more control: erased back diffusion technique

You can refine your control over the diffusion process even more by using the Eraser tool to selectively remove sections of the blurred layer. At its simplest, this will result in

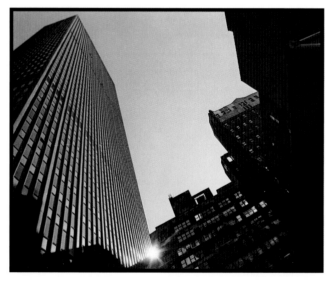

before

after

ABOVE: The erase back diffusion technique provides the user with control over which areas of the image remain sharp and which are blurred.

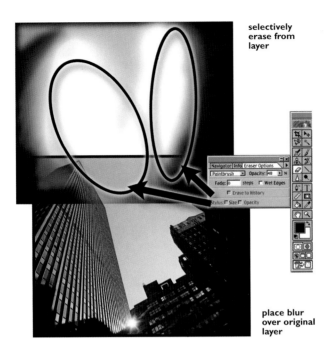

selectively
erase from
layer

place blur
over original
layer

ABOVE: **The Eraser tool is used to delete sections of the upper blurred layer to reveal the sharp image below.**

areas of blur contrasted against areas of sharpness. However, if you vary the opacity of the Eraser, you can carefully feather the transition points.

The addition of the erasing step allows much more control over the resultant image. It is possible to select and highlight the focal points of the photograph without losing the overall softness of the image.

Paint Shop Pro
1. File>Open – Select image.
2. Layers>Duplicate.
3. Rename new layer "blurred layer".
4. Make sure this layer is selected.
5. Select Eraser tool.
6. Adjust opacity of the tool.
7. Erase unwanted sections of the blurred layer.
8. Image>Blur>Gaussian Blur.
9. Adjust blending mode and opacity in layers dialogue.

Photoshop
1. File>Open – Select image.
2. Layer>Duplicate Layer.
3. Rename new layer "blurred layer".
4. Make sure this layer is selected.
5. Filter>Blur>Gaussian Blur or Filter>Stylize>Diffuse.
6. Select Eraser tool.
7. Adjust opacity of tool.
8. Erase unwanted sections of blurred layer.
9. Adjust blending mode and opacity in layers dialogue.

Layer blending modes

These modes determine how layers interact together. The following modes work best with the diffusion technique examples described here and are common to both Photoshop and Paint Shop Pro, but don't limit your experimentation. Try other modes, the effect they give might be more appropriate for the images you use.

Normal
This is the default mode of any new layer and works as if you are viewing from above the group of layers. In this mode, a layer that is only partially opaque (that is, partly transparent) will allow part of the layer beneath to show through. As the opacity level drops, the layer concerned becomes more transparent.

Multiply
Multiplies the top layer colour with that of the layer directly beneath it. This always results in a darker colour.

Soft light
Darkens or lightens the bottom layer colours, depending on the top layer colour. If the top colour is lighter than 50% grey, the image is lightened, as if it were dodged. If the top colour is darker than 50% grey, the image is darkened, as if it were burned in.

Luminosity
Creates a result colour with the hue and saturation of the bottom layer colour and the luminance of the top layer colour.

Panoramic imaging

Difficulty level: 1

Programs: Spin Panorama, PhotoImpact, Photosuite

There is just something special about a panoramic photograph but a camera capable of capturing such images can be prohibitively expensive.

A more economical approach

Spin Panorama is a piece of bonus software that comes free with some Epson printers. Since it's designed to generate impressive virtual reality tours from a series of individual shots, you might think that it would be of little use to someone interested in print-based images. You would be wrong.

In the process of stitching together a series of images, the program allows the user to save the final scene as a JPEG file. As most photographers interested in digital-imaging know, this is an eminently useful format.

How to use spin panorama

Shoot your images making sure that you have an overlap between successive images of between 20 and 40%. Hold the camera steady and before you start to take the photographs pan through the vista to check to see if your view point, exposure, height and position are the best for the location. For the most accurate results you should pan "around the camera" keeping it as the centre of your pivot.

Start the Panorama Maker program choosing which format image you wish to create – Horizontal, Vertical, 360 degree or mosaic Tile. If you know the focal length of the lens used to shoot the source images you can input that value in the Camera Lens section of the dialogue. If you are unsure then use the Automatic option.

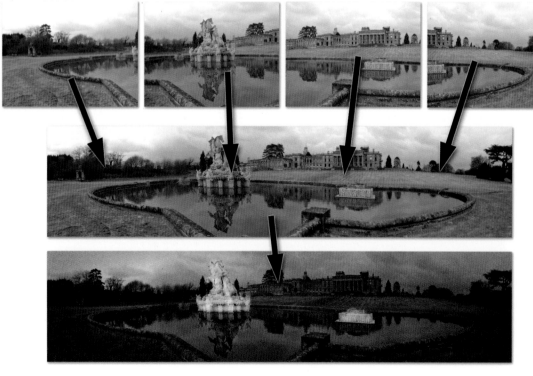

LEFT: **It is possible to produce digital panoramic images using several standard images stitched together at the edges.**

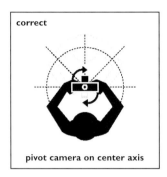

correct

pivot camera on center axis

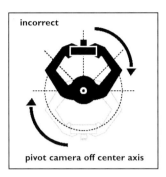

incorrect

pivot camera off center axis

ABOVE: **Shooting around the axis of the lens will provide images that are more easily stitched.**

Select the output size you require and make sure that the Automatic Exposure Correction feature is checked. Click Next.

Create a new Album using the New option from the drop-down menu. Add the source images from either your camera or computer to the album preview area. Drag the images from here to the story board section at the bottom of the screen. Change the order of the pictures by clicking and dragging to a new position. Alter orientation, contrast or brightness of any picture by double clicking on the thumbnail to take you to the Edit Screen. Click Next.

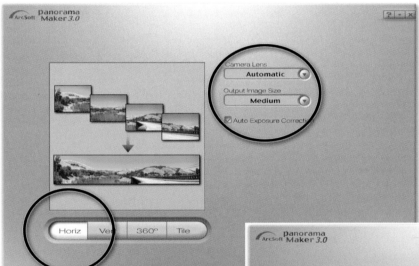

LEFT: **After starting the Panorama Maker program choose the style of image, focal length of lens and size of final result.**

RIGHT: **Add the source images to the album section of the screen and then drag them to the storyboard.**

The program produces an automatically stitched image. Use the magnify options to check the stitch points of overlapping picture edges. To increase the accuracy of difficult areas you can adjust the stitch points for each overlap manually by clicking on the Fine Tune button. This screen allows you to manually drag the matching stitching points for two consecutive images. Match image parts from both pictures. Sometimes it is necessary to try a range of stitching points before achieving a convincing result. Click OK and then Finish to complete the panorama.

Output the final panorama. The final step in the process allows you to save the completed panorama as a picture in a variety of formats (Save button), a QuickTime movie file (Export button) or to print the wide vista photograph (Print button).

BELOW: You can manually place the stitching points using the Fine Tuning screen if the automatic process does not produce good results.

crop lines

BELOW: With the stitch complete you can choose between three types of output – image file, QuickTime movie or print.

Software details

Spin Panorama is produced by Picture Works Technology, Inc. The program is available as part of the bonus software pack with new Epson printers.

PhotoImpact, Photoshop Elements and Photosuite also have dedicated stitching functions that you can use to create panoramic images.

Recapturing the drama of your images

Difficulty level: 3
Programs: Photoshop

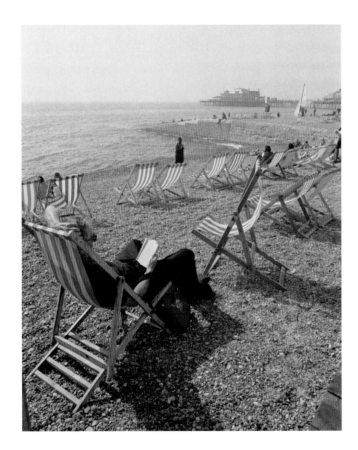

ABOVE: Sometimes shots have the potential to be a lot more dramatic than they first appear. There are several characteristics in this image that can be improved via a little digital enhancement.

At times it's hard to make decisions about which images to print and which to file. Many photographers find it difficult to judge their own work and are often disappointed with the results. The images don't reflect the atmosphere each saw and felt at the time of shooting. In years past, one could seek to recapture this atmosphere through the use of sophisticated darkroom techniques. More recently, however, digital manipulation provides a range of options, some not even possible in the darkroom, that help bring the drama back to original images. The following process combines a series of basic techniques that together will help transform your images.

As examples, a couple of images are shown here that failed to reproduce the atmosphere that was evident on the day. The first is a typical beach scene, complete with deck chairs, gravel (alas, no sand) and the obligatory old pier in the background. The second is a portrait of a stylish young gent intent on "tanning his tatts". Both images seemed stronger in the viewfinder than the straight prints indicate, and are good candidates to demonstrate the techniques that can be used to enhance the theatrical nature of these images.

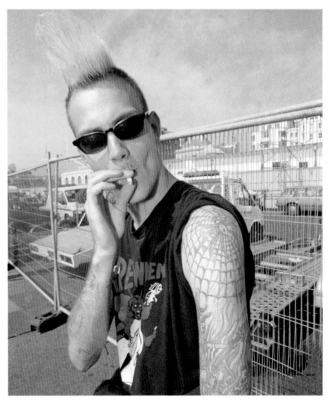

ABOVE: This portrait image, though already striking, can be improved by some drama-enhancing digital techniques.

RIGHT: Defocusing
parts of the
image can help
direct the eyes of
your audience
towards the
focal points
you choose.

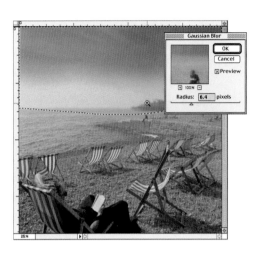

RIGHT: Defocusing parts of the image can help direct the eyes of your audience towards the focal points you choose.

Step 1: Defocusing, or depth of field

Photographers have long used depth of field to control what is sharp within their images. We all know that shallow depth of field, produced by a long lens or a small aperture number (or both), isolates the focused object against a blurred background. This technique has more recently been called "defocusing", indicating that the photographer has made a definite decision about the sharpness of all elements in the image and that it didn't just happen by accident.

This term is handy to use for the digital version of the technique as it describes the process of blurring that occurs. Background objects, like the fence in the punk portrait, can be selected using one of the Photoshop selection tools, the edge of the selection feathered, and a Gaussian Blur applied. The contrast between the blurred and sharp parts of the image gives the appearance of a shallow depth of field. This directs the viewer's eye to the main part of the image.

In the beach scene, which has a large depth of field courtesy of a wide-angle lens and a small aperture, the areas in both the foreground and background were defocused, directing attention to the reading man. A series of selections and blur amounts were used to graduate the sharpness from the subject to the other parts of the image. This has the effect of most closely replicating the depth of field effects created by a standard camera lens and aperture.

Photoshop tools/menus used:

- Selection tools (Magic Wand, Marquee, Lasso)
- Feather (applied to the edge of the selection)
- Gaussian Blur filter.

Step 2: Darkening specific areas

Dodging and burning is a traditional photographic technique that has been used for decades to help change and manipulate the tones in a photograph. Photoshop, again through the use of a series of feathered sections, allows the user to darken and lighten specific areas of an image.

Your first thought might be to use the Brightness/Contrast control to adjust the tones in the selected area, but this type of manipulation can produce very crude results. Instead, use your Levels control. If you carefully move the grey point in the dialogue box you will find that you can change the midtones without adversely affecting either the shadows or highlights. This solves the problems of clogged shadows, or blown highlights, that sometimes occurs when using the Brightness/Contrast control. Remember, with the selection "active", adjusting the levels will only affect the areas selected. The feathering will mean that the change in tone will happen gradually.

In the portrait, the forearms and the edge of the frame were darkened using this technique. The sky in the background, together with the foreground, were altered in the beach scene.

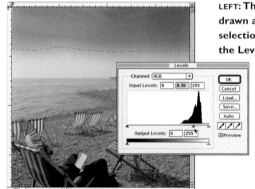

LEFT: The use of carefully drawn and feathered selections, together with the Levels dialogue, gives the user great control over the darkening or lightening of specific image areas.

Photoshop tools/menus used:
- Selection tools (Magic Wand, Marquee, Lasso)
- Feather (applied to the edge of the selection)
- Levels dialogue box.

Step 3: Saturation and desaturation

This technique, unlike the previous two, does not draw easy parallels from the world of traditional photography. Again, the user selects and feathers areas of the image to work on. Making adjustments in the Hue/Saturation dialogue box will then allow a change in the saturation of the colours in the image. Desaturate, and the image will gradually turn black-and-white; saturate, and the colours will become vibrant and, if pushed to extremes, garish.

In the portrait, the background was changed to become almost monochrome. To add even more contrast, the subject was then selected and its saturation increased. Back on the beach, the deck chairs were the obvious choice to saturate. Again, fore- and backgrounds were desaturated.

Photoshop tools/menus used:
- Selection tools (Magic Wand, Marquee, Lasso)
- Feather (applied to the edge of the selection)
- Hue/Saturation dialogue box.

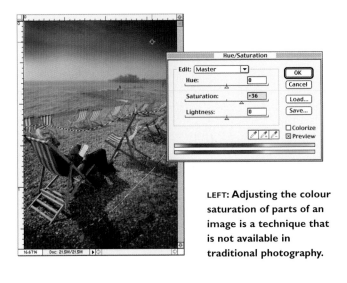

LEFT: **Adjusting the colour saturation of parts of an image is a technique that is not available in traditional photography.**

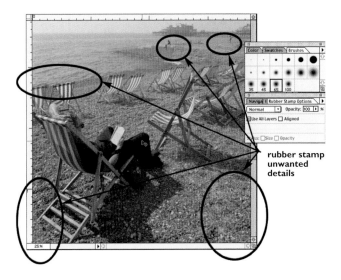

rubber stamp unwanted details

ABOVE: **Eliminating unwanted details from an image can improve the overall composition of the photograph.**

Step 4: Eliminating unwanted details

A lot of you will probably have used the Rubber Stamp tool before. As we have seen it's great for removing scratches and dust marks in all those restoration projects that the family insist on giving you. In the beach scene the Rubber Stamp, or Cloning tool was used not only to retouch dust marks but also to change whole sections of the image.

In the foreground, you will notice that the diagonal walls on the right and left sides have been replaced with more gravel. The sailing boat and countless people have been removed from the background.

When the boat and the life preserver were removed, the pier was repaired and, most significantly, the people in the mid-ground in the water, on the beach and sitting on the chairs have also been removed.

These adjustments add to the desired feeling of the isolation of the main subject, and provide an image that is now free of clutter.

Photoshop tools/menus used:
- Rubber Stamp or Cloning tool.

Tricks of the trade: Martin Evening's cross-processing effects

Difficulty level: 2
Programs: Photoshop

One of the most popular photographic techniques in the last few years has been the cross-processing of print and transparency films. There are two different ways of producing these distinctive images. You can process colour negative film in slide chemistry (E6) or colour slide film using the negative process (C41). Either way, you ended up with images in which the basic details remain but the tones and colours are changed.

By some careful manipulation of the colours in the image, it is possible to reproduce the results of cross-processing digitally without having to shoot or develop your film any differently than normal. Martin Evening, the undisputed guru of Photoshop for photographers, uses a digital technique which uses the Curves function to introduce casts and compression image tones. Define the characteristics you want.

To start the process it would be helpful to describe the characteristics of a typical image that has been shot on colour negative film and then processed as if it were a transparency. Immediately obvious is the yellowing of the light tones and the presence of a strong cyan cast in the shadow and midtone areas. Add to this compression, and consequential loss of detail in the highlight areas, and you are left with an image that contains some distinctive characteristics that we can replicate digitally.

To achieve Martin Evening's cross-processing effects, uses follow these steps:

Open a high key image
1. Adjust for brightness and contrast.
2. Change to 16bit mode.

Produce yellow highlight tones
3. Create a curves adjustment layer and change to the blue channel.
4. Peg a mid-point on the curve.
5. Lower the white point on the curve to introduce a yellow cast into the image.

Add more warmth
6. Change to the green channel.
7. Again, peg the mid-point and lower the high light level – this time not to the degree of the change in the blue channel.

Make the shadows cyan
8. Change to the red channel, peg highlight and shadow areas and then pull the midtone areas of the curve downwards to introduce a cyan cast.

Readjust the final contrast/brightness settings
9. Return to the composite (RGB) channel and adjust the overall brightness and contrast so that it is lighter and the skin tones are more blown out.

LEFT: The digital version of the cross-processing effect can be made from colour negatives that were processed as recommended, scanned and then manipulated using the Curves function.

RIGHT: Martin Evening's technique for replicating the cross-processing effect uses the Curves function in Photoshop to both compress tones and adjust image colours.

the art of
digital printing

Choosing your printers

A few years ago there was only one printing option capable of producing photographic results – Dye Sublimation. This system was based on transferring dye from donor ribbons and fusing it to a special transfer paper. The results looked and felt like continuous-tone photographic images. For a long time these printers held the high ground of digital printing. The downside to the image quality produced by these machines was the high cost of each print and the machine itself.

Today, thermal wax, solid inkjet and colour laser printers are all capable of reasonable results but in the last couple of years it is the inkjet printer that has taken the desktop digital market by storm. Led by the Epson company, manufacturers have continued to improve the quality of inkjet output to a point where now most moderate- to high-priced printers are capable of producing photographic-quality images. Add to this the fact that the price per printed sheet and initial outlay for the machine is comparatively very low and you can see why so many photographers area now printing their own images.

The only drawback with inkjet technology is that the prints have a short life compared to traditional photographic images. This lack of archival quality is a problem manufacturers are now working on. The latest top of the line photographic inkjet printers use pigment inks instead of the dye-based counterparts that feature in many of the home-use machines.

These inksets provide a much more stable print than their predecessors and the expected life of these images is now rivalling, and in some cases exceeding, the archival life of traditional photographically produced prints.

Though a lot of professionals still prefer to output critical work via digital versions of the standard photographic processor, many are now turning to this new ink technology as a viable alternative.

Image quality is everything when you are picking a printer. It makes sense to compare resolution, numbers of inks, price of the printer and its consumables, but the reason you are buying the machine is to make great images. Never make a purchase without seeing printed results. If possible, take your own file to the showroom and ask to have it output via several different machines. This way you will have a means of comparing exactly what each printer is capable of.

There is no doubt that modern-day inkjet printers are amazing pieces of machinery. The precision with which they can lay down minute coloured droplets in patterns that simulate a continuous tone photograph is nothing short of remarkable. That said, the average printer still has its limitations, or to be fair, its own imaging characteristics. The first part of the process of making great prints is getting to know these characteristics.

Testing your printer

When you start using a new printer, specialist types of inks or a different printing paper, you should carry out three simple tests to help you understand how the setup works.

Tonal testing

First, look at how the printer handles difficult tonal areas. In particular, you will find it very useful to be able to predict how a specific printing setup deals with delicate highlight and shadow details i.e. the region of an image that lies between 85% grey and 100% black, and 15% grey and 0% bright white.

The performance of each printer, ink and paper combination can vary greatly in this area. By printing a test image made up of some carefully prepared grey and

LEFT: The modern inkjet printer is capable of producing photographic-quality images right from your desktop.

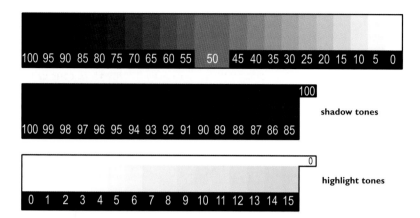

100 95 90 85 80 75 70 65 60 55 | 50 | 45 40 35 30 25 20 15 10 5 0

100

100 99 98 97 96 95 94 93 92 91 90 89 88 87 86 85

shadow tones

0

0 1 2 3 4 5 6 7 8 9 10 11 12 13 14 15

highlight tones

ABOVE: **Make a special greyscale image to test how your printer handles printing difficult areas like shadows and highlights. Use five per cent changes for each of the steps from zero to a hundred. Make two more scales with one per cent steps for highlights and shadows.**

colour scales, you can examine how each combination works and then compare the results from a variety of setups. In particular, look for the point in the highlight area where the last printed tone is no longer distinguishable from the white of the paper. In the shadows, locate the last step in the scale where dark grey becomes black.

Note down the exact percentages for later use. With these values known, you can then adjust the spread of the tones in the images with the assurance that delicate highlight and shadow detail will not be lost or be unprintable.

Colour testing

To help with further evaluation, you can also add a known image to the tonal scales, for example, one containing a mixture of skin colouring as well as a range of bright colours. Once printed, colour cast differences due to specific ink and paper combinations become more obvious. When trying to define the colour of your cast, look to the midtones of the image as your guide. Adjustments can then be made, either in the printer setup or via the image file itself, to account for the colour variations.

Print quality testing

The modern inkjet printer is capable of amazingly fine detail. The measure of this detail is usually expressed in dots per inch (dpi). A typical photographic-quality Epson printer is able to print at 2880dpi when set on its finest settings. Logic says that if you are to make the best-quality print from this machine then you will need to make sure that your image file matches this resolution. This may be logical but it is definitely not practical. A file designed to produce a 10 x 8 in. (254 x 203mm) print at 2880dpi would be about 1.35gb in size. Start playing with files this size and you will find that your machine will quickly have a coronary.

The answer is to balance your need for print quality with file sizes and image resolutions that are practical to work with. To this end, a printer was tested by outputting a variety of images with resolutions ranging from 100dpi through to 800dpi, all made with the machine set on its best-quality setting (1440dpi). The results showed that big changes in print quality were noticeable to the naked eye with resolutions up to about 300 dpi. Settings higher than this resulted in very little if any change in perceivable print quality. So, to get the best from the printer, its resolution was set to the finest it is possible to produce (2880dpi) and make files that have an image resolution of between 200 and 300 dpi.

With the tests now completed we have a set of parameters that can be used to adjust the characteristics of our images prior to printing.

LEFT: **Add to your tonal scales a test colour image that contains a range of bright colours as well as some skin tones.**

Preparing for printing – step by step

Use the steps below when preparing your images for print. By now you should be aware of, or use regularly, most of the techniques, but used together they will help push up the abilities of your printer and produce high-quality results regularly and consistently.

Step 1: Adjust contrast and brightness

To spread the tones of your image using the results of your test information, peg your black-and-white points.

PhotoImpact

1. Select Format>Tone Map from the menu bar.
2. Click on the Highlight Midtone Shadow Tab at the top of the dialogue box.
3. If the shadow areas of your test prints are clogged then move the shadow slider to the right. This lightens the dark tones.
4. Take note of the shadow value.
5. If the highlight areas of the test print are blown then move the highlight slider to the left. This darkens the light tones.
6. Take note of the highlight value.

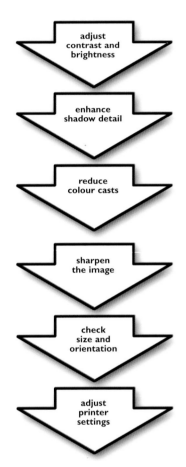

ABOVE: Once you have finished testing your machine, it is time to implement your knowledge in a series of print preparation steps.

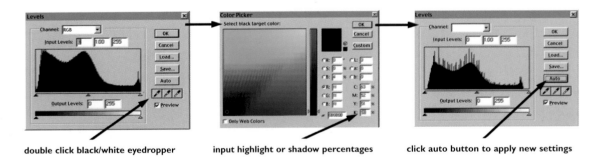

double click black/white eyedropper input highlight or shadow percentages click auto button to apply new settings

ABOVE: Use the information about how your machine prints shadow and highlight areas to peg your black and white points in the Levels dialogue. Applying the auto function will now spread, or constrain, your image tones to the range that your printer can output.

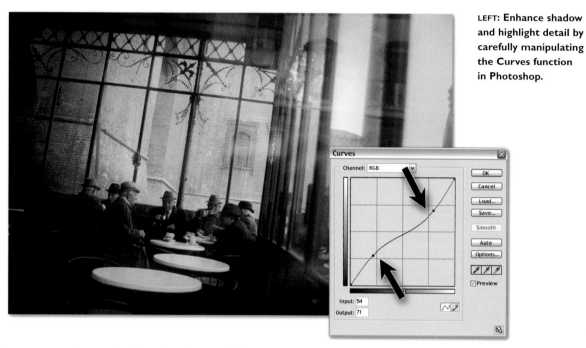

LEFT: Enhance shadow and highlight detail by carefully manipulating the Curves function in Photoshop.

7. Reprint your test image, checking the changes. If the results are not satisfactory make further adjustments and print again.
8. Continue this process until you can print all the tones in the test image.

Paint Shop Pro

1. Select Colour>Adjust>Highlight/Midtone/Shadow from the menu bar.
2. If the shadow areas of your test prints are clogged then move the shadow slider to the right. This lightens the dark tones.
3. Take note of the shadow value.
4. If the highlight areas of the test print are blown then move the highlight slider to the left. This darkens the light tones.
5. Take note of the highlight value.
6. Reprint your test image, checking the changes. If the results are not satisfactory make further adjustments and print again.
7. Continue this process until you can print all the tones in the test image.

Photoshop

1. Select Image>Adjustment>Levels from the menu bar in Photoshop.
2. Double click the black eye dropper in the dialogue.
3. Input the percentage of the black point from your test in the "K" section of the CMYK values.
4. Click OK to set the value.
5. Repeat the procedure inputting the white point.
6. Click the Auto button in the Levels box.

Notice that the histogram of your image has changed. The shadow and highlight information has moved towards the centre, catering for the characteristics of your printing setup.

Step 2: Enhance shadow detail
Even with the changes made above, a lot of images need particular help in the shadow and highlight area. Enhancing the detail here can be achieved easily by some subtle manipulation.

PhotoImpact

1. Select Format>Tone Map from the menu bar.
2. Click on the Map Tab at the top of the dialogue box.
3. Click the Show Control Points box.
4. Carefully move the shadow area point (second from the left) upwards and the highlight point (second from the right) downwards.
5. Click OK to finish.

Paint Shop Pro

1. Select Colours>Adjust>Gamma Correction from the menu bar.
2. Make sure that the Link box is checked.
3. Move any of the sliders to the right.
4. Click OK to finish.

Photoshop

1. Select Image>Adjustment>Curves from the menu bar in Photoshop.

2. Carefully push the curve slightly upwards in the shadow area and slightly downwards in the highlight region.
3. Click OK to finish.

These actions will increase the contrast of the shadow detail and reduce the contrast of the highlight area. When printing, both these steps will help produce images that display more detail in these difficult areas.

Step 3: Reduce colour casts

Photoshop has a range of techniques that you can use to reduce colour casts. Probably the simplest is the Variations control in Photoshop. Here the user can select from a variety of small thumbnails each displaying slight changes in colour.

PhotoImpact

1. Select Format>Colour Balance from the menu bar.

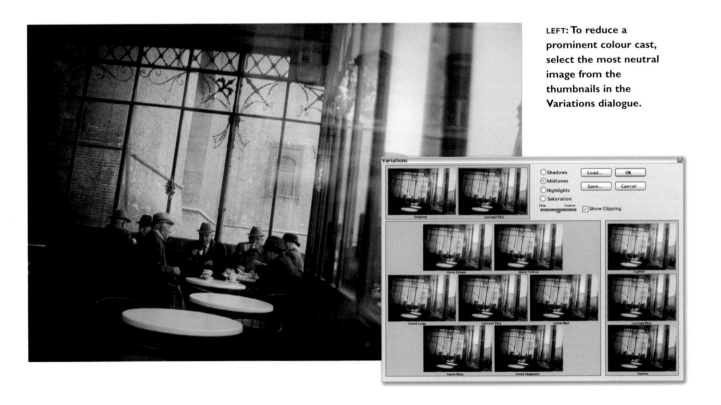

LEFT: **To reduce a prominent colour cast, select the most neutral image from the thumbnails in the Variations dialogue.**

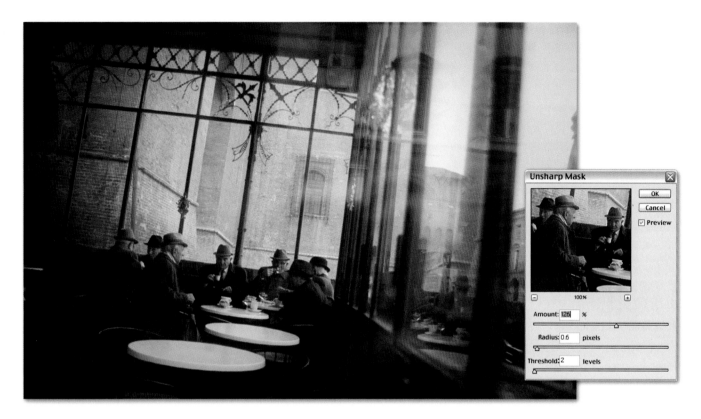

ABOVE: Digitally generated images can often be improved by the application of a little sharpening. In this example, the Unsharp Mask filter was used as it provides the most options for the user to control the sharpening effect.

2. Select the Presets Tab from the top of the dialogue.
3. Select the thumbnail that looks the most neutral. If a cast still exists, continue to select more neutral thumbnails until you are happy with the results.
4. Click OK to finish.

Paint Shop Pro

1. Select Colour>Adjust>Red Green Blue from the menu bar.
2. Move adjustment sliders until the image looks neutral.
3. Click OK to finish.

Photoshop

1. Select Images>Adjustment>Variations form the menu bar.
2. Click on the thumbnail with the least the colour cast.

3. Continue this process until the image is colour neutral.
4. Click OK to finish.

Casts that are the result of a particular paper and ink combination should be reduced by changes to the colour setup in the printer's software (see step 6).

Step 4: Sharpen the image

Digital files captured by scanning print or film originals can usually benefit from a little sharpening before printing. As with most digital controls, it is important to use any sharpening filter carefully as over-application will cause a deterioration in the appearance of your image. The Unsharp Mask sharpening tool as it offers the user the most control over the effects of the filter.

PhotoImpact

1. Select Effect>Blur and Sharpen>Unsharp Mask from the menu bar.
2. In thumbnail view it is a simple matter of selecting the preview with the sharpness that suits your needs. Users who want a little more control can click the Options button and adjust the Sharpen Factor and Aperture Radius sliders.
3. Click OK to finish.

Paint Shop Pro

1. Select Image>Sharpen>Unsharp Mask from the menu bar.
2. Adjust Radius, Strength and Clipping controls until the preview is acceptable.
3. Click OK to finish.

Photoshop

1. Select Filter>Sharpen>Unsharp Mask from the menu bar in Photoshop.
2. Adjust Radius, Amount and Levels sliders to achieve the desired effect.
3. Click OK to finish.

Step 5: Check print size/ paper orientation

Sometimes the scanning or camera software will save your file with image settings that are not suitable for the size of paper you are using. In these cases, you will need to change the size of your output. Photoshop has a couple of aids to help with checking that the size of your image suits that of the paper.

PhotoImpact

1. Select File>Print Preview from the menu bar.
2. Using the preview screen change the position and size of your image.
3. A title may also be added here.

Paint Shop Pro

1. Select File>Print Preview from the menu bar.
2. The basic layout of image and page can be checked with this dialogue.
3. If further changes are needed, select the Setup Button from the menu bar.
4. Adjust the scale and position of image before selection OK to finish.

RIGHT: **Check the print size using either the Image Size dialogue or the Print Preview located at the bottom of the work area.**

print preview image bigger than paper image smaller than paper

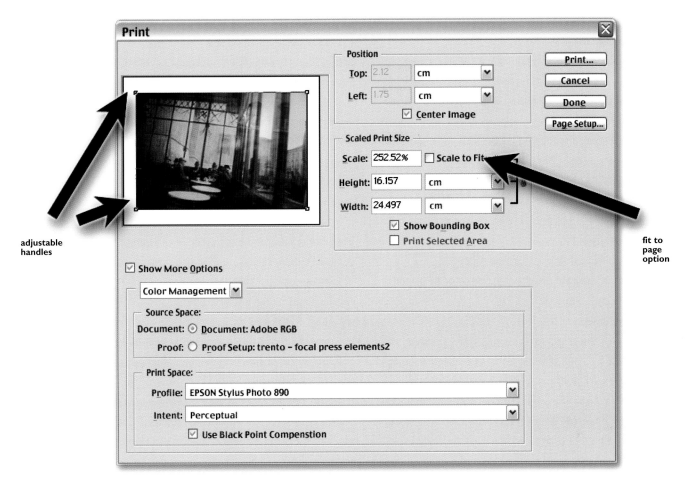

adjustable
handles

fit to
page
option

ABOVE: Photoshop 6 and 7 users benefit from an all-improved
Print Options Preview system located in the edit menu.

Photoshop

1. Select Image>Image size from the menu bar in
 Photoshop.
2. Input the paper size in inches or centimetres in the
 Image Size dialogue box.
3. Photoshop will then calculate the dpi need for the file
 in order to output a print of the dimensions you
 selected.
4. To doublecheck the settings you have chosen, move to
 the bottom left of the image window and, using the
 mouse button, click and hold next to the document
 info section of the bottom bar. This will provide you

with a print preview pop-up that shows an outline of
the image on the paper.

5. If the image resolution (or paper orientation) is not
 properly set, the image will show up as being too big,
 or small, on the paper.
6. If this occurs, either return to the image size dialogue
 and adjust your print size or adjust the settings in the
 Page Setup selection of the File menu.

NB: Users of version 6 & 7 of Photoshop will be in the
enviable position of now being able to interactively adjust
the image size prior to printing by using the new Print
Preview function.

Step 6: Adjust the printer settings

The printer's dialogue box contains an array of settings and controls that act as the last fine-tuning step in outputting your digital masterpiece. Most new users follow the automatic everything approach to help limit the chances of things going wrong. For most scenarios this type of approach will produce good-quality results, but those of you who want a little more control, will have to abandon the auto route.

There are several adjustments that can be made via the printer control:

• Paper size, orientation and surface type,
• Dots per inch that the printer will shoot onto the page (printer resolution), and
• Colour and tone control.

The surface of the paper is critical to how much of the detail produced by your printer and your image preparations ends up in the final print. Paper manufacturers have spent the last few years perfecting coatings that maintain the integrity of the inkjet dots whilst producing images that simulate a traditional photograph.

Choosing a paper type in your printer settings changes the dots per inch that the inkjet head will place on the paper. Papers with finer surfaces, or better coatings, can accept finer dot quality, or higher dpi settings.

You should always check the dpi after choosing a paper type as sometimes the selection that the program determines might not suit your needs. Some Lyson papers, for instance, have a rough-textured surface that would lead you to pick a Photo Paper setting from the dialogue. This, however, would result in the print head being set at 720dpi, half of what this type of paper can handle. To get the most from both the printer and paper, you would need to change manually, or customize, the dpi to the highest quality possible.

It is also at this stage that any colour change, or cast, that results from paper and ink combination, rather than from shooting conditions, is corrected. If, after your tests, you find that your prints all exhibit a shift of hue that is not present in the screen original, then changes can be made to the colour balance within the print dialogue box.

Some non-branded papers have a distinct magenta cast that is consistent throughout all prints. To correct this you can add more green in the printer's dialogue box until the resultant print is neutral, then save this setting for use with that combination of ink, paper and printer in the future. Using the printer's dialogue box to make paper- and ink-based adjustments means that you can always be assured that an image that appears neutral on screen will print that way.

paper type

colour adjustments

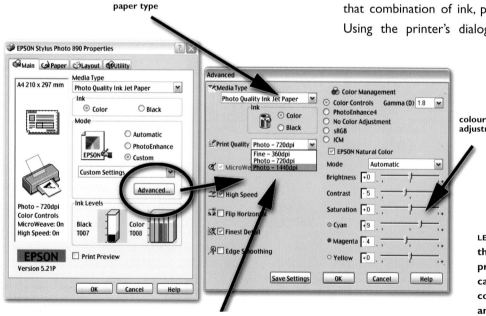

printer resolution

LEFT: Make the final changes to how the image will print using the printer's own dialogue box. Colour casts due to specific ink and paper combinations can be illuminated here and the settings saved for later use.

Inkjet paper characteristics

Weight

Paper weight is measured in grams per square metre. This factor, more than any other, affects the feel of the printed image. To give you a sense of different paper weights – photocopy paper is usually 80gsm, drawing cartridge 135gsm and standard double-weight photographic paper 200gsm. If your aim is to produce images that look and feel like the photographic real thing, don't underestimate the effect of paper weight. For the best effect, try to match the weight of your inkjet paper with its photographic equivalent. Weight can also be a factor in how much the paper ripples after it is printed. Heavy paper is more resistant to this effect.

Surface

Most photographers are particular about the surface of the photographic printing paper they use. Some manufacturers have reproduced their photographic paper surfaces in their inkjet range. Kentmere is a good example. K. Tapestry and K. Classic both have their textured photographic counterparts. Using these papers, it is possible to produce a mixed series of pictures containing both digital and traditional photographic images on similar paper bases – all the images will have the same look and feel despite their different origins.

Base colour

Inkjet papers come in a variety of colours which can range from subtle neutral tones to bright and vibrant hues. The base is coloured either by adding pigment during the paper-making process, in which case the colour is present right through the paper, or when the surface of the paper is treated to receive inks in which case the colour is only on the printable side of the paper. Care should be taken when using papers with a base colour as they will cause a colour shift in the printed image. The clever printer can make allowances for the shift by adjusting the digital file to account for the paper colour prior to printing.

Paper sizes

A3, A4, A5, and A6 as well as the traditional photographic sizes of 6 x 4 in. and 10 x 8 in. (152 x 102mm and 254 x 203mm) are all commonplace in the more popular paper types and surfaces. Panoramic sizes and rolls of paper are also available for the image-maker who prefers a wider format.

Price

Buying larger quantities than the normal pack of ten to twenty-five sheets will almost always get you a better price, and remember to shop around, there will always be someone who wants your custom a little more than the next guy.

Paper types

Glossy photographic

Designed for the production of the best photographic-quality images. These papers are usually printed at the highest resolution that your printer is capable of and can produce either photo-realistic or highly saturated colours.

Matt/satin photographic

Designed for photographic images but with surfaces other than gloss. The surfaces are specially treated so that, like the gloss papers, they can retain the finest details and the best colour rendition.

Art papers

Generally thicker papers with a heavy tooth or texture. Some in this grouping are capable of producing photographic-quality images, but all have a distinct look and feel that can add subtle interest to images with a subject matter that is conducive. Unlike other groups, this range of papers also has examples that contain coloured bases or tinted surfaces.

General purpose

Papers that combine economy and good print quality and are designed for general usage. They are different to standard office or copy papers as they have a specially treated surface designed for inkjet inks. Not recommended for final prints but useful for proofing.

Speciality papers

Either special in surface or function. This group contains papers that you might not use often, but it's good to know that they are available when you need them. The range is growing all the time and now includes such diverse products as magnetic paper, back light films (plastic based translucent media which are are viewed with a light from behind) and a selection of metallic sheets.

When trying to choose what stock is best for your purposes, compare on the basis of weight, surface, colour, sizes available, number of sheets in a standard pack, price per sheet and special features. When you have narrowed the field down, it is worth testing each with a print made using the same print settings, inks, digital file and printer. This will give you a visual comparison that will help you make the final decision.

storage

part two / chapter seven

Portable storage solutions

The good news about modern digital imaging is the high quality of the files produced by digital cameras and scanners. The bad news is that quality is directly linked with file size. Photographic quality means big files. Digital images are notorious for the amount of space they consume. A typical file that will print a photographic quality picture 5 x 7 in. (127 x 178mm) in size can take up as much as 9mb. A 10 x 8 in. (255 x 213mm) version can take up 20.6mb.

The storage of images this size on a hard drive is no real problem, but if you want to move them from one machine to another then you will face some difficulties. The humble floppy disk will only hold about 1.4mb of information. This is fine for word processing or spreadsheet files, but is not all that useful for good quality images.

Manufacturers very quickly became aware of the need for a large-capacity portable-storage solution for digital

ABOVE: The Iomega Zip drive, external version: Portable rewritable with a big user base.

5x7 in. print @ 300dpi = 9mb

6.4 floppy disks

10x8 in. print @ 300dpi = 20.6mb

14.7 floppy disks

ABOVE: Digital files take up a lot of space. The humble floppy disk drive was never meant for files this size.

photographers and other graphics professionals. A few systems have come and gone but the range of devices that we now have are bigger, faster and cheaper than ever before.

Zip disk

The Zip revolution started in 1995 when Iomega first released the 100mb removable cartridge and drive. Featuring a disk not much bigger than a standard 1.4mb floppy, this storage option quickly became the media of choice with photographers and graphic designers worldwide. The latest incarnation of the drive is not only smaller than its predecessor but, the new cartridge, is now capable of storing 750mb of your precious pictures. What's more, the new drive can still read the 100mb and read/write the 250mb catridges.

Zip disk

Capacity:	100mb, 250mb or 750 mb per cartridge
Speed:	Good, especially if being used as an internal drive or via the Usb or Scsi connections
Hardware needed:	Zip drive (parallel, Scsi, Usb and internal versions are available)
Consumables needed:	Zip cartridges (available in 100mb, 250mb and 750 mb versions)
Best Uses:	Portable read and write scenarios such as work between non-networked machines, incremental backups or important work in progress
Cost:	100mb cartridge: £6.50/US$10
	250mb cartridge: £7.50/US$15
	750mb Usb External drive: £139.00/US$170
Value for money:	£0.01/US$0.02 (cost per mb media only)
Positives:	Comparatively cheap and stable rewrite option; big user base
Negatives:	The person you are sharing your data with must also have a drive; cartridge prices

ABOVE: **As DVD writers and media become more affordable the DVD-R format is becoming more popular as a storage medium for digital shooters.**

DVD

DVD is fast becoming the storage medium of choice for the professional image maker. The technology comes in three distinct formats: DVD-R (write once), DVD-RW (re-recordable), and DVD-RAM (rewritable). These three formats each have unique applications:

• DVD-R: write-once archiving for video and data that you do not want to lose or accidentally erase

• DVD-RW: re-recordable DVD for video and data material that can be erased and reused again and again.

• DVD-RAM: rewritable DVD for mission critical data needing as many as 100,000 re-write cycles

The DVD-R format is the most compatible with dvd players and should be used where ever possible. As drive and disk prices continue to fall this technology is set to replace the CD as the digital photographer's main storage medium.

Superdisk

Capacity:	4.7Gb (4700mb)
Speed:	Good — fastest when connected via USB 2.0 or Firewire
Hardware needed:	DVD writer/rewriter drive (Firewire, Usb and internal versions available)
Consumables needed:	DVD disks
Best Uses:	Portable read and write scenarios such as collaborative work between non-networked machines, incremental back ups or important work in progress and now as camera "food".
Cost:	4.7gb disk: £4.50/US$6.00
	USB/Firewire External drive: £350.00/US$500
	Internal drive: £250.00/US$375
Value for money:	£0.0009/$US0.0012 (cost per mb media only)
Positive:	Now that drives and media have reduced in price this storage option is an extremely cheap way of storing images, text, movies and music.
Negatives:	Compatibility is increasing especially if the DVD-R format is used but some older DVD readers might have problems accessing the data on some disks.

CD-ROM

The CD is a stable and familiar format that is used universally for storing massive amounts of data cheaply. As recently as nine years ago, CD readers were an expensive add-on to your computer system. Now writers, and sometimes even rewriters, are thrown in as part of system package deals. The CD has become the floppy of the millennium and unlike the Iomega and Imation storage options the majority of all current computers have a CD drive.

Drives and media are available in two formats. "Write once, read many" or Worm drives (CD-R) are the cheapest option and allow the user to write data to a disk which can then be read as often as required. Once a portion of the disk is used it cannot be overwritten.

The advanced version of this system (CD-RW) allows the disk to be rewritten many times. In this way it is similar to a hard drive, however the writing times are much

LEFT: **CD Drive: Available in internal and external versions. This is still the cheapest way to store masses of image files.**

longer. Rewriters and the disks they use are more expensive than the standard CD writer and disks. The more recent drives can read, write and rewrite all in one unit.

Portable hard drive

A new category in portable storage is the range of portable digital hard drives available for photographers. These devices operate with mains or battery power and usually contain a media slot that accepts one or more of the memory cards used in digital cameras. The best known of these devices is the MindStor (previously called the Digital Wallet).

CD-ROM

Capacity:	650mb
Speed:	Good, especially if being used as an internal drive or via the Usb or Scsi connections
Hardware needed:	Internal CD drive
Consumables needed:	CD blanks in write once or rewritable versions
Best Uses:	Storage of large files; back up of data; transport of files or complex documents
Cost:	Standard CD blanks (write once): £0.20/US$0.35 Standard CD writer drive: £100.00/US$120 CD rewritable blanks: £1.00/US$1.50
Value for money:	Standard: £0.0007/$0.0009 (cost per mb media only)/Rewritable: £0.003/$0/0018 (cost per mb media only)
Positives:	Good value accessible back up and transport option
Negatives:	Slow write speeds

Portable hard drive

Capacity:	Depends on the drive used but typically 10 or 20Gb
Speed:	Good – fastest when connected via USB 2.0 or Firewire
Hardware needed:	Portable hard drive
Consumables needed:	None
Best Uses:	For downloading images from camera memory cards whilst shooting in the field. Can also be used as extra hard drive space.
Cost:	£4.50/US$6.75 USB/Firewire External drive - GBP 424.00
Value for money:	£0.04/US$0.6 (cost per mb media only)
Positives:	Excellent storage option for the digital photographer on the move. Combines on-the-road picture storage with the advantage of being able to be used as an extra portable hard drive.
Negatives:	Initial cost is a bit expensive.

External hard drives

With the ever-increasing need for storage and the desire of many users to be able to move their image archives from one machine to another, companies like Iomega are developing more an more sophisticated external hard drive options. Their latest offerings include capacities from 20 to 120gb and the choice of Firewire or USB connection.

RIGHT: **External hard drives from companies such as Iomega provide a very cost efficient method of accessing and moving large archives of images.**

External hard drive	
Capacity:	20gb –120gb (2000mb)
Speed:	Fast because of the USB 2.0 and Firewire connection
Hardware needed:	External drive
Consumables needed:	None
Best Uses:	Portable read and write scenarios such as work between non-networked machines, incremental back ups of important work and the safe keeping of whole image archives.
Cost:	Internal Drive: £250/$US375
	120Gb – £200/$US350
	80GB: £150/$US225.00
Value for money:	£0.001/US$0.03(cost per mb media only)
Positives:	Fast read and write times and massive amounts of storage.
Negatives:	Initial cost.

Web storage	
Capacity:	Depends on the provider
Speed:	Slow read and write – but how slow depends on your modem speed, cable modem owners have it made
Hardware needed:	Internet connected computer
Consumables needed:	None
Best Uses:	Worldwide sharing or collaborative working on small or highly compressed images, or as a backup option for the traveller
Cost:	Depends on storage plan
Value for money:	Depends on storage plan
Positives:	Nothing to carry; always available when your machine is connected; can be shared with others worldwide
Negatives:	Slow read and write access

Web storage

It's not a totally new idea to store data on the web, but it is only in recent years that commercial entities like big-vault.com and swapdrive.com have been making the whole notion a lot more viable. With the number of machines now connected to the net it is not unrealistic to use such a service as a virtual extension of your hard drive. Travellers especially will find this storage option a godsend, as it reduces the number of disks or Zips that you need to carry. But be warned, access times are not great.

LEFT: **Web drive: Great for those who need access all over the world and hate to carry luggage, virtual drive space is becoming more popular, but download times are still a bit of a concern.**

How to choose

With such choice it can be sometimes difficult to decide which product will best suit your needs. Think carefully about:

* how many images you are going to be working with
* how large those images will be

* what access time will you consider adequate
* whether you want to share them with others
* how much money you have to spend.

The answers to these questions will help you narrow down the solution to your storage needs.

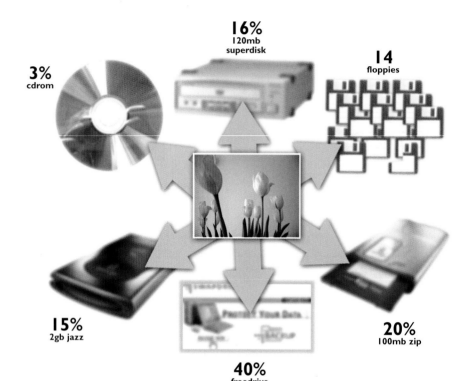

3%
cdrom

16%
120mb
superdisk

14
floppies

15%
2gb jazz

40%
freedrive

20%
100mb zip

LEFT: Just how much space will a high-quality digital file take up on different types of portable media? This example is a 10x8 inch print at 300dpi and 20.6mb.

Conserving your drive space

It is the very nature of the digital-imaging beast that as quality increases so does the space needed to store it. Here are a few tips to help conserve your drive space:

1. Use a file format that has compression built-in. Save your files using the TIFF format with compression turned on. This format does not use a compression technique that will degrade the quality of your images and it will save you space.
2. Be disciplined about how and where you store your images. By storing your images in an organized way you will quickly see and remove any duplicate and temporary files from your drive.
3. Make images that are the size that you need. Make decisions at the time that you are creating a digital file about what size you need that file to be. If you are only going to want to print a postage stamp-size version then there is no need to have a 20mb file.
4. Be careful about using different colour modes. A RGB colour file is 25% smaller than its CMYK equivalent. Only use the CMYK mode if you have a definite reason for doing so.

Where does the image file go when you save it

One of the most difficult concepts for new computer users is the fact that so much of the process seems to happen inside a obscure little box. Unlike traditional photography, where you can handle the product at every stage — film, negative and print — the digital production cycle can seem a little unreal. Where your image actually goes when you store it is one of its mysteries.

PC

The devices that are used to store digital information are usually called drives. In PC terms they are labelled with letters — "A" drive is for your floppy disk drive and "C" drive your hard disk. It is possible to have a different drive for every letter of the alphabet but in reality you will generally only have a few options on your machine. If, for instance, you have a Zip and a CD drive then these might be called "D" and "E" drives.

Mac

If your platform of choice is the Macintosh system then you need not concern yourself about the letter names above. Each drive area is still labelled but a strict code is not used.

Within each drive space you can have directories (PC) or folders (MAC). These act as an extra way to organize you files. To help you understand, think of the drives as drawers within a filing cabinet and the directories as folders within the drawers. Your digital files go into these folders.

RIGHT: **How you organize your images on your drives will affect how efficiently you will use the space that is available to you.**

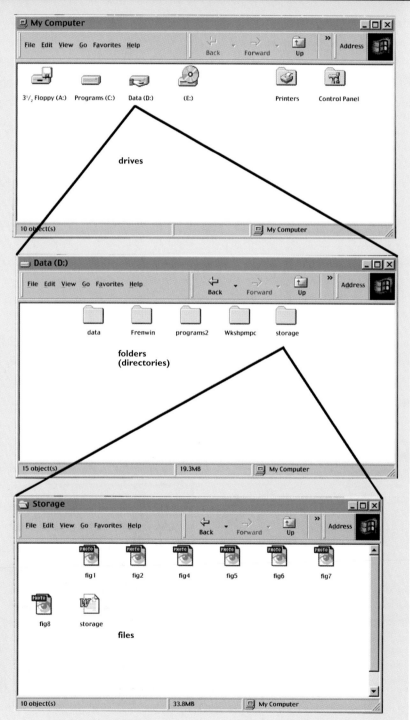

321

File formats

The storage of your digital masterpieces is really a two-step exercise. First, you need to decide where the image should be saved. Second, you have to select the file format which will be used to save the image. Having now discussed the "where" of the process, we shall dedicate some time to looking at "how" our images can be stored.

Digital imaging files can be complex things. In their simplest form they are a description of each picture element, its colour and brightness and its physical whereabouts within the image. With the increased sophistication of image-editing programs and our demand for complex graphics has come a range of purpose-built file formats that encompass a host of "value added" features that are beyond this basic file.

Layers vs flat files

The original image-editing programs performed all their manipulations on the basic file. At the time this didn't seem too much of a problem as we were just happy (and amazed) that we could actually change sections of an image digitally. But as designers and photographers increased their under-standing of the new medium they also increased the complexity of the manipulations they wished to perform.

Working with a flat file became more and more restricting. Eventually the software developers incorporated the way that graphic designers had been working for years into image-editing programs. They took the idea that if you separate parts of an image onto transparent layers then you can manipulate each part without affecting the rest of the image. If the image is then viewed from the front, all the layers appear merged and the picture looks flat – just as if it were a basic file.

As the image files of the time were all flat, the software developers also developed formats that would allow the storage of the separate layers. With the integrity of each layer intact it was then possible to return to work on a specific element of an image at a later date.

Photoshop file format or PSD

The Photoshop file format, or PSD, is an example of a format that will save editable layers separately. Each layer can be manipulated individually. Groups of layers can be linked

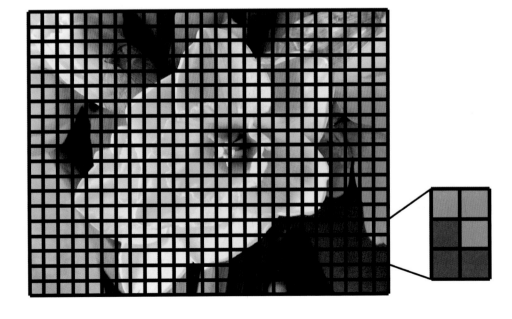

LEFT: **The basic digital file defines the colour, brightness and position of each pixel that makes up the image.**

and moved or merged to form a new single layer with all the elements of the group. Text layers remain editable even when saved and in the latest version of the software, special effects, such as drop shadows, can be applied to each layer automatically.

This extra flexibility does come at a cost. Layered files are bigger than their flat equivalents. With the size of modern hard drives this is not really something to be worried about. A second consideration is that formats like PSD are proprietary, that is they only work with the programs that they originated from. This only becomes a problem if you want to share files with another piece of software and maintain the layers. No common layer formats have emerged yet, each software manufacturer preferring to stick with their own file types.

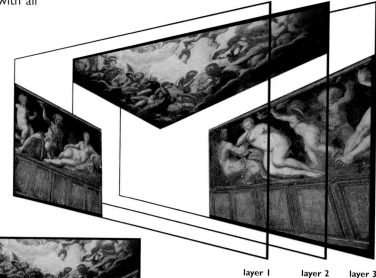

layer 1 layer 2 layer 3

ABOVE: A layered file appears to be similar to a flat file except that parts of the image are separated on individual layers. Each layer can be edited and changed separately from the other parts of the image.

ABOVE: Photoshop uses a layers dialogue box to control the positioning and features of each layer in the image.

Compression

Imaging files are huge. This is especially noticeable when you compare them with other digital files such as word processing files. A document that may be a hundred pages long could easily be less than one per cent of the size of a single 10 x 8 in. (255 x 213mm) digital photograph. With files this large it soon became obvious to the industry that some form of compression was needed to help alleviate the need for us photographers to be continuously buying bigger and bigger hard drives.

A couple of different ways to compress your images have emerged over the last few years. Each enables you to squeeze large image files into smaller spaces but one system does this with no loss of picture quality – lossless compression – whereas the other enables greater space saving with the price of losing

BELOW: **TIFF** and **JPEG** both have in-built compression schemes for reducing the space taken up by your images when saved to disk.

original file

file: 3.50mb

TIFF (comp)

file: 1.90mb

JPEG (comp = 1)

file: 0.059mb

JPEG (comp = 6)

file: 0.162mb

JPEG (comp = 12)

file: 0.450mb

fuzziness

blocks of colour

general blur

edge halos

LEFT: **To reduce the size of images, JPEG uses a compression system that loses detail from your image. High levels of this type of compression will cause your image to degrade and display a variety of artefacts.**

some of your image's detail – lossy compression.

Initially you might think that any system that degrades your image is not worth using, but sometimes the image quality and the file size have to be balanced. In the case of images on the web they need to be incredibly small so that they can be transmitted quickly over slow telephone lines. Here some loss in quality is preferable to images that take four or five minutes to appear on the page.

The main compression formats that are used the world over are JPEG (Joint Photographer's Experts Group) and TIFF (Tagged Image File Format).

JPEG

JPEG uses a lossy algorithm to attain high compression ratios. By using a sliding scale from one to twelve you can control the amount of compression used to save your image. The more compression you use the more noticeable the effects (artefacts) of the process will be.

TIFF

TIFF on the other hand uses a totally different system, which results in no loss of image quality after compression.

For these reasons TIFF is a format used for archiving or sharing of work of the highest quality. Most press houses use TIFF as their preferred format. JPEG is used almost exclusively in the world of image transmission and the web. In this realm file size is critical and the loss of quality is more acceptable. This is especially true if the image is to be viewed on screen where some artefacts are less noticeable than when printed.

Web features

The Internet in its original form was text based. Now the web is very definitely a visual, some might say a multimedia, medium. When you view a web page for the first time all the information on that page has to be transported from the computer where it is stored down the phone line to your machine. The pictures, animations and text that make up the page might be coming from almost anywhere in the world. It's a simple fact that the larger the file sizes of these components, the longer it will take to download and display the page on your machine.

File formats for web work

For this reason there are several file formats of choice for web work. Each is suited to specific types of image files. There is no one format that can be used for all the visual parts of your pages.

JPEG is best used for continuous-tone photographs. GIF is designed for images with a limited number of flat colours and works best with logos and animated banner ads. PNG is a fairly new file format which has a wider colour range than GIF and better handling of transparency as well. This is a great format for users cf Version 4 browsers or higher.

SVG and JPEG 2000 are two extremely new formats that offer improvements over the web formats we currently use. SVG is a vector-based system that provides not only smaller file sizes but also sharp images at any screen size. JPEG 2000

caption

keywords

categories

credit

copyright

origin

ABOVE: **With some formats it is possible to include some text along with the image data in one file.**

is a complete tune-up for the millennium of the old compression system. It features new user-controlled flexibility, less apparent artefacts and better compression to boot.

Customizing images for the web is so important these days that all the major image editing packages have sophisticated functions or wizards that will help you squeeze your images down to size without losing too much quality (see "Save for Web Option in Photoshop", page 329).

Annotations

Some file types allow the user to attach text information to the main image file. This feature allows press agencies and picture libraries to store captions, bylines, dates and background information all in the one format. This extra information is hidden from view when you first open the file in an image-editing program, but can usually be read and edited via an information window somewhere in the program.

Photoshop gives such access through highlighting the File>File Info selection. Here you can view and edit entries for captions, keywords, categories, credits and origins. Some third-party image browsers can also search the captions and keyword entries. These categories are part of an

Cross-platform concerns

The two major computer systems used by photographers the world over are the Macintosh and the IBM clone. Each system has its advantages and drawbacks. What is important to understand, though, is the basic fact that not all the people you will want to share images with will be using the same hardware as you. If you know this to be the case then you must select a file format that can be used by both systems equally. TIFF, JPEG and PSD formats are useable on both platforms (see "Top Tips for Cross-platform Saving" page 329).

information standard developed by the Newspaper Association of America (NAA) and the International Press Telecommunications Council (IPTC) to identify transmitted text and images. File information can be added in the following formats PSD, TIFF, JPEG, EPS and PDF.

Choosing a file format

It's great to have such a choice of image file formats but the big question is what format should you use. There is no simple answer to this. The best way to decide is to be clear about what you intend to use the image for. Knowing the "end use" will help determine what file format is best for your purposes (see table below).

At scanning or image-capture keeping your files in a TIFF format is a good option. This way you don't have to be concerned about loss of image quality but can still get the advantage of good compression and you can use the files on both Mac and IBM platforms.

When manipulating or adjusting images, using the PSD or Photoshop format is a safe bet, as this allows you great flexibility. You can use, and maintain, a load of different layers which can be edited and saved separately. When sharing your work, you can regularly supply the original PSD file so that last-minute editing can continue right up to going to press. If, on the other hand, you don't want your work to be easily edited, you can supply the final image in

Vector vs raster

The digital graphics world uses two main ways to describe images — one is raster or bitmapped and the other is vector.

Raster images are made up of a grid system that breaks the image down into tiny parts or picture elements (pixels). At each point on the grid, the position, colour and brightness of each pixel is recorded. All digital photographs are stored in this format. Programs like Photoshop and Paint Shop Pro work exclusively with this type of image.

Vector images are very different. They work by mathematically describing the shape of flatly coloured objects within a space. Logos, sophisticated text manipulations and CAD drawings are all examples of vector graphics. Programs like Illustrator, Corel Draw and Freehand create images that are stored as vector graphics.

ABOVE: Raster and vector files are completely different ways of describing a digital image. All photographic images are stored in raster or bitmapped format.

an IBM TIFF format with all the layers flattened.

If the final image is to be used for the web, you can save it as a GIF, PNG or JPEG file, depending on the numbers of colours in the original and whether any parts of the image contain transparency. There is no firm rule here. Size is what is important so try each format and see which provides the best mix of image quality and small file.

File type	Compression	Colour modes	Layers	Additional text	Uses
Photoshop (.psd)	✘	RGB, CMYK, Greyscale, Indexed colour	✔	✔	DTP, Internet, Publishing, Photographic
GIF (.gif)	✔	Indexed Colour	✘	✘	Internet
JPEG (.jpg)	✔	RGB, CMYK, Greyscale	✘	✔	DTP, Internet, Photographic
TIFF (.tif)	✔	RGB, CMYK, Greyscale, Indexed colour	✘	✔	DTP, Publishing, Photographic
PNG (.png)	✔	RGB, Greyscale, Indexed colour	✘	✘	Internet

ABOVE: Different file formats are suitable for different applications and have a variety of in-built features.

compression level

JPEG type

RIGHT: The JPEG dialogue box in Photoshop allows the user to choose the level of compression that the image will be saved with.

The major raster formats

JPEG – Joint Photographic Experts Group

This format provides the most dramatic compression option for photographic images. A 20mb digital file which is quite capable of producing a 10 x 8 in. (225 x213mm) high-quality print can be compressed as a JPEG file so that it will fit onto a standard floppy disk. To achieve this the format uses a lossy compression system, which means that some of the image information is lost during the compression process.

The amount of compression is governed by a slider control in the dialog box. The lower the number, the smaller the file, the higher the compression and more of the image will be lost in the process.

You can also choose to save the image as a standard baseline or progressive image. This selection determines

platform

compression

ABOVE: The TIFF dialogue box in Photoshop gives the user the choice of which platform to save for and whether compression is used.

how the image will be drawn to screen when it is requested as part of a web page. The baseline image will draw one pixel line at a time, from top to bottom. The progressive image will show a fuzzy image to start with and then progressively sharpen this image as more information about the image comes down the line.

This is a great format to use when space is at a premium or when you need very small file sizes.

TIFF – Tagged Image File Format

This is one of the most common and useful file fomats. Images in this format can be saved uncompressed or using a compression algorithm called LZW, which is lossless. In other words, the image that you "put into" the compression process is the same as the one you receive "out". There is no degradation of quality.

When you save you can choose to include a preview thumbnail of the image, turn compression on and off and select which platform you are working with. Most agencies and bureaus accept this format but nearly all stipulate that you supply work in an uncompressed state. Opening a compressed image takes a lot longer than opening one that is saved without compression.

Use this format when you want to maintain the highest quality possible.

GIF – Graphics Interchange Format

This format is used for logos and images with a small number of colours and is very popular with web professionals. It is capable of storing up to 256 colours, animation and areas of transparency. It is not generally used for photographic images.

PNG – Portable Network Graphics

A comparatively new web graphics format that has a lot of great features that will see it used more and more on websites the world over. Like TIFF and GIF the format uses a lossless compression algorithm that ensures what you put

in is what you get out. It also supports partial transparency (unlike GIF's transparency off/on system) and colour depths up to 64bit. Add to this the built-in colour and gamma correction features and you start to see why this format will be used more often.

The only drawback is that it only works with browsers that are Version 4 or newer. As time goes by this will become less and less of a problem and you should see PNG emerge as a major file format.

PSD – Photoshop's native format

This file type is capable of supporting layers, editable text and millions of colours. You should choose this format for all manipulation of your photographic images. The format contains no compression features but still should be used to archive complex images with multiple layers and sophisticated selections or paths. The extra space needed for storage is compensated by the ease of future editing tasks.

Top tips for cross-platform saving

1. Make sure that you always append your file names. This means add the three letter abbreviation of the file format you are using after the name. So if you were saving a file named "Image 1" as a TIFF, the saved file would be "Image1.tif", a JPEG version would be "Image1.jpg" and a Photoshop file would be "Image1.psd". Photoshop users can force the program to "Always Append" by selecting this option in the "Saving Files" section of preferences.
2. Mac users: save TIFF files in the IBM version. When saving TIFF files you are prompted to choose which platform you prefer to work with, choose IBM if you want to share files. Mac machines can generally read IBM tiffs but the same is not true the other way around.
3. Mac user: save images to be shared on IBM formatted disks. If you are sharing images on a portable storage disk, such as a Zip, always use media that is formatted for IBM. Mac drives can usually read the IBM disk but IBM machines can't read the Mac versions.
4. Try to keep file names to eight characters or less. Older IBM machines have difficulty reading file names longer than eight characters.

Save for web option in Photoshop

The latest version of Photoshop has a "Save for Web" function that enables direct comparison of an image being saved in a range of different web formats. This gives web professionals a quick and easy way to test particular compression settings and to balance file size with image quality. GIF, JPEG and PNG formats can all be selected and the compressed results compared to the original image.

EPS – Encapsulate PostScript

Originally designed for complex desktop publishing work, EPS is still the format of choice for page layout professionals. It is not generally used for storing photographic images but worth knowing about.

JPEG2000

The original JPEG format is a decade old and despite its continued popularity it is beginning to show its age. Since August 1998 a group of dedicated imaging professionals (the Digital Imaging Group – DIG) have been developing a new version of the format. Dubbed JPEG2000, it provides twenty per cent better compression, less image degradation than JPEG, full colour management profile support and the ability to save the file with no compression at all.

With its eyes firmly fixed on the ever-increasing demand for transmittable high-quality images, JPEG 2000 will undoubtedly become the default standard for web and press work.

SVG – Scalable Vector Graphics

Unlike the two most popular web formats today – JPEG and GIF – SVG is a vector-based file format. In addition to faster download speeds, SVG also comes with many other benefits such as high-resolution printing, high-performance zooming and panning inside of graphics and animation. This format will challenge the current dominant position of GIF as the premier format for flat graphic images on the web.

Glossary

ADC or Analogue to Digital Converter Part of every digital camera and scanner that converts analogue or continuous tone images to digital information.

Agitation The act of gently shaking a developing tank during film processing to ensure an even spread of developer over the emulsion.

Aliasing The jaggy edges that appear in bitmap images with curves or lines at 45 degrees. There are anti-aliasing functions in most image-editing packages that use softening around the edges of images to help make the problem less noticeable.

Ambient Light Any light — natural or artificial — available for the photographer to shoot by.

Angle of View The maximum angle which a particular lens allows you to see through the viewfinder. A 24mm lens has a wider angle of view than a 400mm lens.

Aperture The adjustable opening in a lens which controls the amount of light allowed to fall on the film emulsion.

Aspect Ratio The relationship between the width and height of a picture. The maintaining of an image's aspect ratio means that this relationship will remain the same even when the image is enlarged or reduced. The aspect ratio can usually be found in dialogue boxes concerned with changes of image size.

Autoexposure A setting on the camera which automatically selects the shutter speed and aperture combination to use.

Autofocus An electronic system whereby the lens focuses automatically.

"B" Setting A setting which keeps the shutter open for the whole time the shutter release button is depressed.

Background Printing A printing method that allows the user to continue working while an image or document is being printed.

Ball and Socket A type of head for a tripod which allows seamless movement in all directions.

Barrel Distortion A fault where straight lines in a picture seem to bulge outwards, seen more commonly with wide-angle lenses.

Batch Processing The application of a function or a series of commands to several files at the same time. This function can be useful for making identical changes to a folder

which is full of images.

Bit or Binary Digit The smallest part of information that makes up a digital file. It has only a value of 0 or 1. Eight of these bits makes up one byte of data.

Bitmap The form in which digital images are stored, made up of a matrix of pixels.

Bracketing Taking a series of shots of a difficult scene, under, at and over the suggested exposure, in order to ensure a correct result.

Brightness Range The range of brightnesses between shadow and highlight areas of an image.

Burning in Allowing extra light from the enlarger to reach a selected part of the paper during printing.

Byte A unit of digital data storage containing eight bits. A byte can have any value between 0 and 255.

C-41 The process used to develop colour negative films.

Catchlight A small highlight in a portrait subject's eyes.

CCD Charged coupled device — a light-sensitive chip comprised of a grid of pixels, each of which produces an electrical output proportional to the amount of light striking it.

CD-ROM A compact disk used for storing digital data for use on computers. A CD-ROM can hold up to 650 megabytes of data.

Clip Test When a small section of film is processed before the remainder of the roll, to see whether any adjustments to the processing are required.

CMYK Cyan, Magenta, Yellow and black — the colours used in inkjet printers, and in commercial print reproduction.

Colour Cast When a slide or print displays a bias towards one particular colour.

Colour Temperature A scale expressed in degrees Kelvin (K°), which defines the colour of natural and artificial light.

Compression A process which reduces the number of bits in an image so that it takes up less storage space or can be transmitted more quickly. The JPEG file format is the most popular one which uses compression.

Contact Print A print on which all negatives from a roll of film are exposed at their actual size. This is then used for reference when deciding which negatives to enlarge.

Contrast The difference between the bright and dark areas of a print or negative.

Contre-jour Another term for shooting into the light.

Converging Verticals The distortion created when tilting the camera upwards to photograph an object (usually a building) which has straight sides. It can be corrected with perspective - or shift-control lenses.

CPU (Central Processing Unit) Also known as the microprocessor, it controls all the data received by the computer, and carries out all instructions given.

Cropping Cutting out unwanted parts of the image around the edges in order to improve the composition.

Data Binary information.

Diaphragm The eight blades which make up the lens aperture.

Differential Focus Choosing a wide aperture setting in order to render a certain part of the picture blurred.

Digitize The act of converting analogue information into digital data.

Dodging Placing an object between the enlarger lens and the printing paper in order to lessen the exposure in a particular area.

Download The transfer of data from one source to another.

Dpi Dots per inch, a measurement of print or scanner resolution the more dots per inch the higher the quality.

Duotone A greyscale base image with the addition of another single colour other than black. Based on a printing method in which two plates, one black and one a second colour, were prepared to print a single image.

Dynamic Range The measure of the range of brightness levels that can be recorded by a sensor.

E-6 The process used to develop colour slide films.

Emulsion The light-sensitive chemical coating on photographic films and papers.

Enhancement Changes in brightness, colour and contrast designed to improve the overall look of an image.

Enprint The standard machine print used by photographic processing laboratories.

Exposure The quantity of light allowed to fall on to the film or paper emulsion, decided by a combination of shutter speed and aperture setting.

Exposure Value (EV) The suggested combination of shutter speed and aperture setting at a given light level.

Extension Tube A hollow tube placed between lens and camera which allows close-up or macro photography.

Fast Film Film of ISO 400 or higher, which allows the use of faster shutter speeds and/or smaller apertures than would be possible with slower films.

File Format The method by which a data file is stored. There are numerous different file formats, including TIFF, PICT and JPEG.

Fill-in Flash A burst of low-intensity flash, normally used to add catchlights to the eyes or to brighten a dull scene.

Film Scanner A device which converts slides and negatives into digital data.

Film Speed The ISO rating of a photographic film.

Filter In digital terms, a filter is a way of applying a set of image characteristics to the whole or part of an image. Most image-editing programs contain a range of filters that can be used for creating special effects.

Flare Stray light that falls on to the film, reducing contrast and causing washed out-colours.

Flatbed Scanner A device which converts prints, text documents, etc. into digital data. They resemble photocopiers in operation.

Floppy Disk A low-cost storage disk which can hold up to 1.4 megabytes of data.

Focal Length The distance between the optical centre of the lens and the film, when the lens is focused on infinity.

Focal-plane Shutter The type of shutter used in all SLR cameras.

Fogging The effect of light leaking on to a film or paper emulsion before it has been processed.

F/stop The number (e.g 1.8, 5.6, 8, 11) used to indicate the size of the aperture.

Gamma The contrast of the midtone areas of a digital image.

Gamut The range of colours or hues that can be printed or displayed by particular devices.

Gaussian Blur A filter which, applied to an image or a selection, softens or blurs the image.

Gb A unit of computer memory equal to 1024 megabytes.

GIF A popular file format used to store images on the internet.

Greyscale A monochromatic scale consisting of up to 256 tones of black and grey.

Guide Number An indication of the flash output required for correct exposure.

Hard Disk The area inside the computer which stores the software and files.

High Key A scene made up predominantly of bright tones.

Histogram A graph that represents the spread of pixels within a digital image

Hue The colour of the light as distinct from how light or dark it is.

Icon Graphic symbol used to represent a file or folder. It is opened by the user clicking on it.

Image Editing Software A program designed to display, process and manipulate images.

Image Layers Images in both Photoshop and Paint Shop Pro can be made up of many layers. Each layer will contain part of the image. When viewed together, the layers appear to make up a single image. Special effects and filters can be applied to layers individually.

Incident-light Reading A reading where the light falling on to the subject is measured.

Inkjet Printer A type of printer which uses nozzles to spray ultra-fine dots of ink on to paper. Inkjet printers are the most popular for domestic use.

Internet A network of computers around the world, connected by telephone line.

Interpolation A method of increasing apparent resolution by inserting additional pixels based on the values of those around them.

ISO An abbreviation of International Standards Organization, which sets the internationally accepted standard for determining film speed.

JPEG A popular file format which compresses digitized photographic data.

JPEG2000 The latest, more flexible, release of the JPEG format.

Latitude The ability of a film to give an acceptable result, even if underexposed or overexposed. Print film has a wide latitude.

Layer Opacity The opacity or transparency of each layer of a layered image. Depending on the level of opacity of the layer,

parts of the layer beneath will be more or less visible. You can change the opacity of each layer individually by moving the opacity slider in the Layers palette.

LCD or Liquid Crystal Display A type of display screen used in preview screens on the back of digital cameras and in most laptop computers.

Low Key A scene made up predominantly of dark tones.

Megabyte A standard unit used to measure computer files and memory. A Megabyte is equal to 1024 bytes.

Megapixel A CCD chip containing over one million pixels.

Mirror Lock-up A function available on some cameras which locks open the mirror before the exposure is made. This reduces the risk of camera shake, which can happen when the mirror flips up and then back down again.

Modelling Light A continuous light source on studio flash units which demonstrates the effect that the flash will have on the subject.

Modem Connects a computer to a telephone line in order to share data with others.

Monitor The computer screen.

Monochrome Either a black and white picture, or a colour picture made up of a variety of tones of just one colour.

Motor Drive A device which winds on the film automatically, sometimes at very high speed.

Multimedia The combination of sound, text, graphics, video and still images.

One-touch Zoom A zoom lens which allows the user to adjust the focal length and focus using the same barrel.

Optical Resolution The resolution at which a scanner actually samples the original image. This is often different from the highest resolution quoted for the scanner as this is scaled up by interpolating the optically scanned file.

Overexposure When too much light is allowed to reach the film, resulting in bleached-out highlight areas.

Palette A type of menu within image-editing programs that allows the user to select changes in colour or brightness.

Pan and Tilt A tripod head which allows movement from side-to-side and up-and-down.

Panning The act of making an exposure while following a moving subject with the camera.

Parallax The difference between what is seen through the viewfinder and what is taken by the lens when using a rangefinder-type camera. It is noticeable particularly when shooting close subjects.

PC Socket A socket on the camera into which a flash sync cable can be plugged.

Peripheral A printer, scanner or other device that can be connected to a computer.

Photo CD A digital image storage system which uses compact disks.

Photoshop A popular professional image-processing and manipulation program by Adobe.

Pixel (Picture Element) The smallest building block from which digital images are made up.

Pushing When a film is uprated to a speed higher than its ISO rating.

Quantization The allocation of a numerical value to a sample of an analogue image. Part of the digitizing process.

RAM (Random Access Memory) The temporary memory created when the computer is on. Software/files are stored here while they are being used.

Rear-curtain Flash When the flash is triggered at the end of the exposure of a moving subject.

Rebate The edge of the film, which shows details about type of film, frame number, etc.

Reciprocity Failure Exposures which are too short or too long for the film emulsion to cope with, resulting in underexposure and colour casts.

Reflected-light Reading A reading where the light reflected from the subject is measured.

Resolution A measurement of the amount of information contained in a digital file or achievable by a capture or output device. Usually described in terms of pixels per inch (ppi) or dots per inch (dpi).

RGB Red, Green and Blue — the additive system of colour filtration used by computer monitors.

SCSI A type of connection for plugging peripherals into computers.

Slave Flash An off-camera flash containing a cell which triggers the unit at exactly the same time as the on-camera flash is fired.

Spot Meter A lightmeter or TTL metering mode which takes a reading from a very small area of the frame.

Stock A printing term referring to the type of paper or card that the image or text is to be printed on.

Stopping Down Reducing the aperture in order to allow less light on to the film emulsion and to increase depth-of-field.

Sync Speed The fastest shutter speed at which a correct exposure is ensured when using flash.

Teleconverter An accessory which increases the focal length of a lens. The most common types are 2x and 1.4x.

Test Strip A strip of paper used during a test to determine the correct exposure for a print.

Thumbnail A low resolution preview version of a larger image file used to check before opening the full version.

TIFF or Tagged Image File Format Is a file format that is widely used by imaging professionals. The format can be used across both Macintosh and PC platforms and has a lossless compression system built in.

TTL Meter Abbreviation for Through The Lens — the camera's inbuilt metering system.

TWAIN A software protocol for exchanging information with image-capture devices such as digital cameras and scanners.

Underexposure When too little light is allowed to reach the film, resulting in loss of shadow detail.

USB (Universal Serial Bus) A cross-platform interface for the connection of peripherals.

Vignetting A darkening at the corners of the frame, caused when using a lens hood too small for the angle of the lens.

VRAM (Video Random Access Memory) A graphics card in the computer that controls how many colours you can see on the screen.

Waist-level Finder Most commonly found on medium format cameras, this allows the photographer to compose by looking down into the viewfinder, while holding the camera at waist level.

Index

Picture credits

The publishers would like to thank the following sources for their kind permission to reproduce the pictures in this book.

Reference numbers for each of the photographs are listed below, giving the page on which they appear in the book and any location indicator (t – top, b – bottom, l – left, r – right, m – middle).

All Digital Photography images copyright Philip Andrews unless otherwise stated:

Ailsa: 240; /**Adobe:** 232, 233, 238, 239; /**Agfa:** 210; /**Ailsa McWhinnie:** 26, 30t, 35t, 35m, 35b, 37b, 44, 61tl, 61bl, 61tr, 61br, 129; /**Andrew Stevens:** 143t, 146, 147, 148b, 153, 161; /Andrew Wing: 172bl, 172, 173b, 173t, 174t, 174b, 175bl, 175bm, 175tr, 175mr, 179tm, 179bm, 180bl, 180br, 180bl, 180b; /**Angela Hampton:** 25b, 56t, 56b, 58tl, 58ml, 58mr, 58tr, 59tl, 59bl, 59tr, 59mr, 65bl, 79b, 81m, 83, 88b; /**Bron Elektronik Ltd.:** 133; /**Bronica:** Introphoto: 49tr, 50; /**Canon:** 21bm, 21ml, 23br, 114, 205, 213; /**Chris Rout:** 80, 82bl, 104tl, 104tr, 105bl, 105br, 112, 115, 120, 124r, 124ml, 124m, 138tl, 138, 139; /**Colin Varndell:** 100, 104tl, 104tr, 141, 142tl, 145, 148t, 150, 151, 152br, 153t, 154, 155bm, 155br, 155bl, 157bl, 157br, 158, 159, 160, 162t, 162bl, 162br; /**Corbis Images:** Ed Young: 82t; /**Corel:** 234, 235; /**Damien Demolder:** 16, 135; /**Dan Reader:** 85tl, 85tr; /**Elinchrom:** 137t, 137b; /**Epson (UK) Ltd.:** 220r; /**Getty Images:** Al Bello: 109; /Adam Pretty: 8tm, 107; /**Halesway Advertising & Marketing:** 49, 51; /**Hasselblad:** 36; /**Imation:** 316m; /**Iomega:** 195, 203, 215, 316tr, 317; /**Israel Rivera:** 250, 274, 276; /**Jasc:** 226, 227; /**Jenoptik (UK) Ltd.:** 22; /**Joe Cornish:** 15, 17, 18, 34r, 39b, 67bl, 68t, 70m, 71b, 71l, 72, 98, 102br, 103br, 187t; /**Karen Andrews:** 200, 201, 253, 254, 255, 256, 265, 287, 288, 289, 290, 324, 325; /**Kodak Ltd.:** 204, 206; /**Lastolite:** 136; /Clare Arni: 126, 134; /**Laurie Campbell:** 23bl, 76, 77tr, 90; /**MGI:** Roxio: 226, 227; /**Minol:** 108, 121t; /**Magnum Photos Ltd.:** Martin Parr: 128; /**Manfrotto:** Robert Wyatt Photography/courtesy of KJP: 29; /**Michael Busselle:** 8tl, 31, 39t, 40, 41, 43bl, 45, 46-47, 55, 61, 68b, 69t, 69b, 70t, 81t, 83br, 83bl, 87, 91b, 94, 182; /**Microsoft:** 228, 229; /**Mike Kipling Photography:** 33b, 43t, 65tr, 65t, 66, 70b, 73tl, 88br, 89t, 92t, 99, 101tr, 106l, 106r, 121, 131b; /**Millennium Images Ltd.:** 79t, 81t, 82, 163; /**Minolta (UK) Ltd.:** 30br; /**Niall Benvie:** 14, 37tr, 73b, 74, 75, 82br, 152; /**Nick Meers:** 71tr, 190t; /**Nigel Atherton:** 13bl, 13r, 20, 21mr, 22br, 33t, 34l, 43br, 67tl, 78, 89b, 95b, 103tl, 119; /**Nikon (UK) Ltd.:** 19, 22t, 23t, 111, 211; /**Nova Darkoom Equipment Ltd.:** 164, 165, 166, 167; /**Patrick Hamilton:** 194, 207, 209; /**Pentax:** 13bl; /**Polaroid:** 220l; /**Richard Bailey:** 171, 177, 179bl, 179tr, 184; /**Rosemary Calvert:** 85bl, 86; /**S.I.N.:** 131t; /**Science Photo Library:** Microfield Scientific Ltd.: 143b; /**Steve Austin:** 24bl, 24br, 25l, 25r, 42, 48, 54, 64, 67tr, 73, 91, 92bml, 92br, 92bl, 92bmr, 95t, 101bl, 102tl, 142b; /**Steve Day:** 38, 50b, 52, 185; /**Steve McAlpine:** 291t, 291b; /**Tim Daly:** 219; /**Tim Gartside:** 27, 28l, 28r, 93, 97, 186, 187b, 188, 190b, 191t, 191b, 192, 193; /**Ulead:** 230, 231; /**Wacom:** 241; /**Wildlife Watching Supplies:** Kevin Keatley: 77bl, 77tl, 77br

Every effort has been made to acknowledge correctly and contact the source and/or copyright holder of each picture and Carlton Books Limited apologizes for any unintentional errors or omissions, which will be corrected in future editions of this book.